Drawing Boundaries

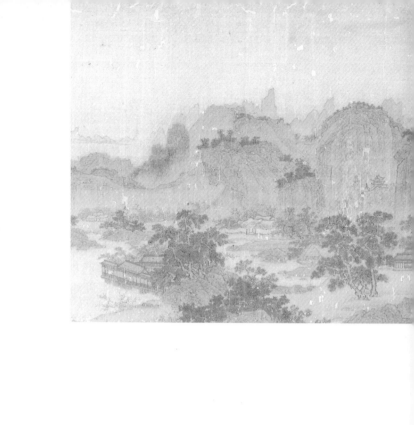

Drawing Boundaries

Architectural Images in Qing China

Anita Chung

University of Hawai'i Press
Honolulu

Publication of this book has been supported by a grant from the Metropolitan Center for Far Eastern Art Studies.

Library of Congress Cataloging-in-Publication Data
Chung, Anita.
Drawing boundaries: architectural images in Qing China / Anita Chung.
 p. cm.
Includes bibliographical references and index.
ISBN 0-8248-2663-9 (hardcover: alk. paper)
1. Architecture in art. 2. Buildings in art.
3. Painting, Chinese—Ming-Qing dynasties, 1368–1912. 4. Architectural drawing—China.
I. Title.
ND1412.C6C485 2005
758'.7'09510903—dc22

 2004005885

To my parents

Contents

Color plates follow page 118.

Acknowledgments

THIS BOOK OWES a great deal to others. Over the long process of research and writing, I have received valuable advice, constructive critiques, and useful suggestions from teachers, colleagues, and friends, to whom I owe a debt of gratitude. I am especially grateful to Professors Ju-hsi Chou, Mayching Kao, and Robert Hillenbrand for their careful reading and comments on parts or all of the manuscript and for offering me unfailing support over years. I also owe thanks to Professor Craig Clunas for his scholarly advice and kind encouragement. Particular thanks are due Puey-pang Ho and Desmond Hui for materials, references, and advice on Chinese architecture. I am equally grateful to Grant Evans for his advice on social anthropology and for his inspirational example and support.

For financial and institutional support while I was conducting the research, I would like to acknowledge the University of Hong Kong, the Taipei Trade Centre Exchange Scheme, the Tsui Family Foundation Scholarship for Academic Exchange, the University of Edinburgh, National Museums of Scotland, Andrew W. Mellon Foundation, and the Cleveland Museum of Art. In addition, I wish to acknowledge the following people for granting me the opportunity to examine original architectural paintings during my visits to museums or art institutions: Yang Xin, Shan Guoqiang, and Nie Chongzheng of the Palace Museum; Lu Changsheng of the Museum of Chinese History; Wang Hongxun of Rongbaozhai; Xie Yongnian of the Central Institute of Fine Arts; Shan Guolin of the Shanghai Museum; Li Kunsheng of the Yunnan Provincial Museum; Lin Poting of the National Palace Museum; Mino Yutaka of the Osaka Municipal Museum of Art; Tomita Jun of the Tokyo National Museum; Maxwell Hearn of the Metropolitan Museum of Art; and Yang Xiaoneng of the Nelson-Atkins Museum of Art. Special thanks are due Madam Xia Weixia and James Wang for their gracious hospitality when I conducted my research in Beijing.

Finally, I would like to thank my publisher for the interest in my book. Special thanks are due the editors and the external readers, whose comments and assistance greatly helped to improve the text.

Introduction

CHINESE ARCHITECTURAL paintings, or *jiehua* (a term explained in chapter 1) in general, are important visual documents for exploring the sensibilities and ideas of various individuals or groups of people toward material things in the external world. Unlike the natural subjects favored by Chinese painters to express cosmic principles or personal feelings, architecture is a constructed artifact appreciated for the beauty of its construction. As a complex form of human fabrication, architecture has a technological basis and requires accurate calculations and compliance with structural rules. As an essential component of material culture, architecture involves ownership or property right and is the emblem of power, status, and identity. Thus paintings of architecture acquire symbolic significance because they materialize cultural achievements as well as particular modes of experiencing. We are curious to inquire what symbolic and cultural values might have been attributed to this genre to suit the needs of successive historical periods.

Architectural painting has not attracted as much scholarly attention as it should. This type of work does not appeal to those who favor Chinese literati painting or prefer a more subtle approach to creativity. Because architectural painting entails meticulous description of physical appearances and was mostly practiced by professional painters, it is often regarded as an "inferior" art. Another reason for former neglect has to do with the assumption of pictorial fidelity to actual architecture, which means that technical analyses of building motifs may be required. To those without the knowledge of Chinese building technology, this subject may appear too difficult to approach. Architectural painting thus remains a subject to which minimal research has been devoted.

Recent studies have only partially redressed the situation. The surveys by Li Zhichao (1957), Maeda (1975), Ling (1982), Wang Yaoting (1984), You Xinmin (1989), and Fu Xinian (1998) largely focus on the history and the techniques of *jiehua*. The National Palace

Museum in Taipei has organized two special exhibitions on architectural paintings: Jiehua tezhan in 1986 and The Elegance and Elements of Chinese Architecture in 2000. All these studies and exhibitions have contributed to our knowledge of this subject, but we also begin to feel the obstacles attending the study of Chinese architectural painting. The paucity of surviving works by early major masters has posed problems in reconstructing a chronological history. We wonder if the existing scanty materials are original paintings by early famous masters or simply works attributed to them. In this regard, the studies by William Trousdale and by Wang Teh-yu have reminded us of the danger of reconstructing *jiehua* history with attributed works. Moreover, we also feel the need to further investigate those concepts associated with architectural representation or to learn about the social functions and cultural implications of this unique painting genre, which is so much oriented toward rationality in Chinese aesthetics. Most of the studies have largely dealt with the historical development and stylistic diversity of architectural painting, emphasizing in particular the pictorial representation of architectural space. A systematic framework for an integrated history of *jiehua* that involves concepts, themes, styles, meanings, and patronage is yet to be established.

It is also worth mentioning that our present limited knowledge of Chinese architectural painting is often affected by the perception (and sometimes the prejudice) of the literati who were the authors of art theories and art criticisms in traditional China. Many writings of the literati, at least as early as the eleventh century, regard the scholar-painter Guo Zhongshu (d. 977) as the greatest exponent of the genre and therefore hold Song dynasty (960–1279) architectural paintings in high esteem. An enormous admiration for the great Song tradition has unfortunately put the works of the later periods in the shade. With very limited surviving paintings to verify such claims, however, Guo Zhongshu's paintings and indeed the overall Song achievements in this field will never be fully known and are likely to continue to be mythologized. Then why should we focus only on the Song tradition and neglect the richness of existing later materials? Why should we perpetuate a biased view held by the high elite and neglect other works done by professional painters?

Any attempt to assess a work of art must be historically and culturally contingent, especially when concepts of aesthetic value could be very much shaped by traditions, race- or class-consciousness, the politics of tastes, or even subjective judgments.[1] The failure of art historians to view architectural painting as something more than an aesthetic and technical phenomenon or to place it within the other modes of social activity has led to their prejudice against this type of painting. But the meanings of works of art lie in the particular contexts in which they are experienced and interpreted.

This book has no ambition to be an exhaustive history of Chinese architectural painting, and its scope is limited to the Qing dynasty (1644–1911). It aims to highlight the cultural significance of Qing architectural images by incorporating them into patterns of life experienced by individuals or groups and by examining themes and styles that spoke to the

needs of contemporary society. This, I believe, will give a new way of thinking about Chinese architectural painting. I chose to study the Qing dynasty because this period witnessed an impressive resurgence of the genre—an artistic phenomenon that is sufficiently strong to sustain scholarly interest and inquiry—and because this period has left behind a massive amount of reliable materials for research. Unlike other existing works on Qing architectural paintings—for example, the studies by Nie Chongzheng and by Yang Yongyuan—this book is concerned not only with art-historical studies of artists and styles but also with cultural interpretations that devote attention to patronage, symbolic content, functions, and meanings of art.

Of all the Qing *jiehua*, only those produced within the time frame of the Kangxi (1662–1722), Yongzheng (1723–1735), and Qianlong (1736–1795) periods will be included. This era of more than a hundred years was the golden age of *jiehua* production under the Qing. The architectural images under examination are taken not only from architectural painting but also from works of other subject categories, such as narrative, genre, and topographical paintings. My selection is contingent on the symbolic content and the stylistic features of the architectural elements in a given work. As far as region is concerned, I focus mainly on the production within the court in Beijing and outside the court in Yangzhou, so that the discussion will note some parallels and contrasts between imperial and private patronage. Because of space considerations, Yangzhou has been chosen as a case study to represent *jiehua* production outside the court. Its choice is appropriate, for under mercantile patronage, Yangzhou's art scene was vibrant and prosperous enough to rival that of the capital. Like Beijing, Yangzhou had immense financial resources to draw painters from other cities and provinces. The traffic of painters between regions encourages us to view the two art centers of Beijing and Yangzhou as part of a larger network for cultural diffusion on a national level. Readers may notice some limitations, as there is still insufficient space here to present a comprehensive picture of the overall Qing attainments in the field of *jiehua*, which pertained to both elite and mass cultures across the country. While comprehensiveness is not feasible, the studies here form the starting point for a better understanding of the genre.

Painting, Architecture, and Culture

My interest in this topic began with a concern with the methodology adopted in some of the studies of Chinese architectural history and architectural representation. Since Chinese architectural paintings are said to give faithful historical representations of actual buildings, some architectural historians, out of an initial interest in the builder's art, have also devoted attention to pictorial images and used them as visual evidence to help reconstruct architectural history.[2] To some degree, pictorial representations supply clues as to the types, general appearances, and layouts of architecture. But any uncritical reliance on pictorial images as "accurate" illustrations of actual constructions is a matter of method-

ological concern. Just as architectural historians employ pictorial images to reconstruct past buildings, art historians examine features of architectural motifs to seek for evidence that helps in the dating and authentication of ancient paintings.[3] But they also recognize that dating paintings by dating buildings painted in them may not be conclusive.[4] As Trousdale observed, "Architectural analysis . . . cannot be called upon to supersede critical judgment and aesthetic sense, for little enough is known about early building, and contemporary descriptive texts often pose difficult problems in technical interpretation."[5]

Although the close relation between architectural painting and building is indisputable, it is equally important to note that painters were dealing with the construction of pictorial images, not the construction of actual buildings. Painters tended to adhere to pictorial conventions or past models in their artistic approach. They might modify earlier prototypes in accordance with current architectural practices, but whether they faithfully and accurately depicted actual buildings in paintings remains questionable. And whatever the actual capacity to achieve a so-called accurate representation at a particular historical time, the painter's perception of architecture—which was produced under specific historical and cultural circumstances—was neither universal nor timeless. The way painters experienced the material world, the modes of architectural thinking articulated through paintings, the symbolic meanings of architectural paintings—all these underwent changes over time. Thus we cannot assume that the relations between painting and building remain historically constant.

Perhaps what is more important is to distinguish between painting and architecture without necessarily assuming that architectural painting is an instrument for reflecting prevailing building styles. Painting and architecture are two different aesthetic products, and each plays a role in displaying various kinds of conventions, virtuosity, and symbolic values, which may coincide or diverge. To fully understand their relation, we need to widen the scope of interdisciplinary studies by examining both of them in the wider sphere of culture.

The definition of culture in this book is based on the dynamic approach now adopted in social anthropology. Past studies of culture often mistakenly assumed that it is a set of defined characteristics shared timelessly by a population of homogeneous individuals. Recent anthropological analyses have pointed to the complexity of cultural change and the diversity of views and beliefs held by different members of society.[6] This new approach attempts to get away from past assumptions and is concerned with how different individuals and groups participate in various cultural discourses about the contents or meanings of their lives. Because these meanings undergo transformations in response to political, social, and economic changes, culture (taken in its anthropological sense) is defined as an ongoing process of the construction of human meanings. This process involves many recognizable key symbols within culturally identifiable parameters. While different groups may share some of these symbolic reference points in their discourses about culture, they may not share others.[7] It is through this never ending process of debating and selecting the relevant symbols that peoples who are differently positioned in social relations construct

their particular way of life. The participation of political, social, or economic institutions in this process also means that culture can be easily used as a tool for claiming legitimacy for their discourses and can become a political, social, or economic strategy.

How does painting, or art in general, fit into this definition of culture? The most common use of the word "culture" to refer to art, architecture, music, and literature is indeed based on the idea that culture "describes a general process of intellectual, spiritual, and aesthetic development."[8] Since art manifests itself in the form of objects, there has been a tendency to fetishize these objects as "high" art (culture), thereby obscuring the actual social and cultural process that brought the art object into being.[9] Such fetishization also obscures the on-going cultural processes that continue to validate, or recognize, these manifestations as art. It is these processes to which Clifford Geertz draws our attention when he speaks of "art as a cultural system."[10]

If we regard painting and architecture as two separate symbolic forms in the general sphere of culture, both will become primary documents that seek various places in an active process of meaning making. They will become constructions of various kinds, making use of pictorial images or tangible forms to express culturally framed sensibilities. The relationship between architecture and architectural representation lies not in pictorial fidelity to building construction but in the similar function of each as a cultural system. Only by abandoning the assumption that architectural painting depicts the objective world may we fully realize its incorporation of symbolic dimensions. We are therefore concerned with how Qing architectural representations tell us about the process of meaning construction through architectural images, actual and imaginary alike.

The images of Chinese architecture display well-defined boundaries of space and intricate links between parts and components, thereby making them a potent form for expressing the cultural dialogue on "order" in a Confucian framework. This conception of order was shared by most individuals or groups within Chinese society and was central to many Chinese cultural debates. It is therefore not surprising that the quest for political and social order under the Qing emperors, especially the establishment of a new "world order" under Qianlong's "universalism,"[11] was expressed visually through architectural representation. Courtly images of architecture also appealed to some outside the imperial realm because the images represented an aspect of material culture favored by those who led or desired to lead an extravagant life. The images were relevant to those who were concerned with cultural differentiation as a means to assert status within a hierarchical society and were particularly meaningful to those who were socially mobile, such as officials, merchants, and nouveaux riches. By contrast, the Confucian scholars who disdained flamboyance would prefer simple thatched huts. Thus, my cultural analysis of Qing architectural images aims to trace the anticipated participants in their cultural discourses, to understand their choice of symbols, to find out which symbols were taken from the past or borrowed from elsewhere in the process of constructing meaning.

When the Qing art critic Wang Gai (active ca. 1677–1705) reasserted the value of *jiehua* in the *Jieziyuan huazhuan*, he remarked that *jiehua* provided the "rules" and was the "jade precept" for mastery of brushwork. He expounded,

> Some who believe themselves independent claim that they follow no rules. Actually, the stage at which one is most free in brushwork is the time when, in attempting to surpass the ancients, one is most keenly aware of their presence and methods. . . .
>
> It may be observed that the ancients worked without rules only because they first paid careful attention to technique. One cannot work daringly without taking great pains. Drawing by *jiehua* cannot be put down as work only of artisans. The method should be examined and studied. Its practice is similar to the disciplines of Chan Buddhism. Those who study Buddhism must begin first with its disciplines, so that for the rest of their lives they will not stray or be involved with evil influences. *Jiehua* is the jade precept for a painter and the first step for a beginner.[12]

Interestingly, this passage is also a statement on the pattern of artistic change, as highlighted in the lines "the stage at which one is most free in brushwork is the time when, in attempting to surpass the ancients, one is most keenly aware of their presence and methods." According to Wang Gai, *jiehua* provided the technique and the method upon which innovations were based. This artistic evolution—which is marked by the dualistic relationship between continuity and change—can also be applied to the wider sphere of culture.

As culture frames the way *jiehua* painters employed the appropriate skills to translate their perceptions of man-made objects into artistic expressions, the studies here are concerned with conventions and types, as well as with stylistic transformations that served to articulate contemporary views. The pictorial conventions to be studied include the linear treatment of architectural forms, the grouping of buildings to articulate a space-time conception, and the placement of architecture in a natural environment. I will also examine how different kinds of cultural institutions were active in forming the sensibility of a particular period. Among the artistic factors, the weight of the past in creative endeavors, the transmission of styles from teachers to disciples, the innovative impulses of painters, the prevailing art theories and styles, the constraints imposed by different patronage systems, and the importation of European representational techniques are some essential aspects to be considered. And because other cultural practices such as religious beliefs and philosophical systems are integral parts of the Chinese present, their interaction with painting is also an important issue in my cultural analysis of Qing architectural representation.

In the first chapter, I seek to define *jiehua* and propose a number of concepts and conventions that had been related to architectural representation since the Song dynasty. The development of the genre during the Ming dynasty (1368–1644) will be analyzed with careful consideration of how the Ming circumstances had provided the prior conditions for the impressive upsurge of *jiehua* in the subsequent Qing period. The second chapter discusses patrons and painters of *jiehua* during the Qing. It also lays out the framework within which detailed thematic studies of Qing architectural images in the later chapters can be fitted.

The paintings commissioned by the Qing emperors will be examined in the third and fourth chapters, and those produced for private patrons at the art center of Yangzhou will be studied in the fifth and sixth chapters. Categorizing the pictorial data thematically will help to facilitate comparative studies of the works produced under different patronage systems, and my discussion follows this order of sequence: contemporary, historical, and mythical themes. The styles, symbolism, functions, and meanings of works from each thematic category will be examined within particular cultural contexts. The concluding chapter summarizes the results of the studies and evaluates the achievements made in architectural painting during the Qing.

The chapter structures adopted here may appear artificially neat and too simplistic in comparison to the extensive picture in reality, which was marked by diverse complexity or a lack of cohesion. But readers should be reminded that this book, with its particular framework, is largely directed to making sense of selected works through an investigation of their meanings for the anticipated audiences within specific contexts. In the discussion of style, this book reveals an ethos of the Qing period expressed through architectural representation. It identifies the period's style as well as various representations in Beijing and Yangzhou. Although certain issues have yet to be investigated—such as individual painters' styles, the specific roles of each artist in renewing the *jiehua* tradition, and the development of the genre in other urban areas—this study provides a wider framework for further investigation, verification, and modification. The stylistic accomplishments of individual painters are explicable only if we accept the collective advances made in the genre, only if we are sure of the goals they sought in a wider cultural context.

The *Jiehua* Tradition

1

ARCHITECTURAL PAINTING IS often categorized as *jiehua,* but this classificatory term has never been clearly defined. Is *jiehua* a subject category of Chinese painting? Or is it a representational technique for rendering fixed objects such as buildings, furniture, chariots, and weapons? Confusion arises because of the changing meanings of this term in art history. A review of its various usages in literary records will show that *jiehua* is an evolving term, having different meanings at different times. Yet there are observable boundaries within which the term is intelligible. An attempt to define *jiehua* in what follows will set out the parameters of the term in art history.

Before I define *jiehua,* it is necessary, first, to introduce two related terms, "line-brush" *(jiebi)* and "ruler" *(zhichi),* which are the tools used for producing straight lines in Chinese painting. These terms were mentioned in the literature well before the appearance of the term *"jiehua."* Zhang Yanyuan (ca. 815–?), author of the *Lidai minghua ji* (847), stated that the great master Wu Daozi (active ca. 710–760) was able to depict weapons and buildings without resorting to line-brush and ruler.[1] By implication, line-brush and ruler were commonly used by Tang painters (except Wu) in the representation of man-made objects. There is no lack of paintings to verify this, although surviving works were done by unknown artists and are hinterland products in art-historical parlance. For example, the wall paintings in the tomb of Prince Yide (682–701) (fig. 1.1) and in the Mogao caves at Dunhuang show the adoption of the ruled-line technique in Tang architectural representation. Architectural motifs in these early paintings serve the basic role of distinguishing environment and defining context: in the tomb paintings of Prince Yide, the watchtowers and the surrounding walls enclose the otherworldly home of the deceased and prohibit the entry of evil spirits; in the Dunhuang illustrations of the Pure Land of the West, the grand architectural compounds define sacred realms that also denote the ritual mandala.[2] In each of

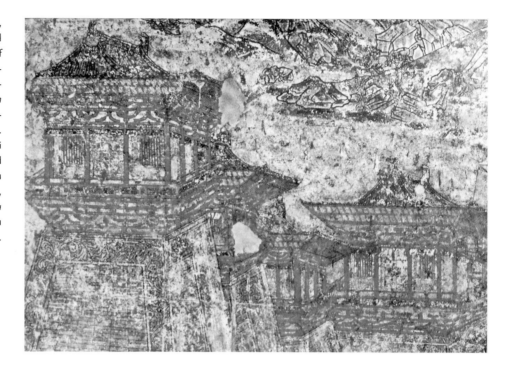

these examples, the definition of the architectural context involves the marking of sym-bolic boundaries with the aid of line-brush and ruler. However, when the Tang critic Zhang Yanyuan mentioned this technique in a passage in praise of Wu Daozi's emancipa-tion from limitations, he was actually expressing his disapproval of this mechanical method of drawing. Zhang further expounded, "If one makes use of line-brush and ruler, the result will be dead painting."[3]

The term *"jiehua"* was probably introduced in the Northern Song period and was used to refer to drawing aided with line-brush and ruler. Guo Ruoxu employed this term in a passage on architectural representation in the *Tuhua jianwen zhi* (1074):

When one paints wooden constructions *(wumu)*, calculations should be faultless *(zhesuan wukui)*, and the linear brushwork should be robust. [The architecture] should deeply penetrate space *(shenyuan toukong)*. When one [line] goes, a hundred [lines] slant *(yiqu baixie)*.[4] This was true of the work of painters of the Sui [581–618], Tang [618–907], and Five Dynasties [907–960] down to Guo Zhongshu and Wang Shiyuan [tenth century] at the beginning of this dynasty. Their paintings of towers and pavilions *(louge)* usually show all four corners with brackets arranged in order. They made clear distinctions between front and back without vio-lating the rules. Painters nowadays mainly use a ruler to mark out the boundaries *(jiehua)* right away. In the differentiation of bracketing their brushwork is too intricate and confusing, and fails to impart any grandeur and easy elegance. . . .[5]

How can one paint constructions if he does not understand about Han halls, Wu halls,

beams, columns and brackets, ridge purlins, cross-beams, king posts . . . "hanging fish" and "stirring grass" gable decorations, ridge-supporting tiles, in-and-out ridges, and so on? Few enough are the painters who have been able to give all these a detailed investigation; how much more so [is that true] in the case of the observers![6]

As this passage shows, the original usage of the term "*jiehua*" is closely associated with, but not equivalent to, architectural painting. Whereas paintings of architectural subjects were called "wooden constructions" (*wumu*) or "towers and pavilions" (*louge*), the technique of marking out the boundaries (*jie*) and drawing (*hua*) the outlines was termed "*jiehua*." Moreover, the initial usage of this term was disparaging. While Guo Ruoxu was criticizing the *jiehua* technique used by his contemporaries, he was emphasizing that early masters did not rely on rulers but could produce robust brushwork in architectural representation. Presumably, in the time of Guo Ruoxu, the *jiehua* technique was so commonly applied that it had provoked criticism.[7] But it is important to note that Guo's disapproval was directed merely at the *jiehua* technique, not architectural painting per se.

Significantly, when the term "*jiehua*" appeared in the literature, architectural painting had already been recognized as an independent genre that Guo Ruoxu referred to as "wooden constructions" or "towers and pavilions." This development started as early as the Tang period and was indicated by Zhu Jingxuan's (active ca. 806–840) classification of the various painting genres in the *Tangchao minghua lu*. Architectural painting was recognized as an independent genre in Zhu's classification, but it was also the least important in his order of priority.[8] Zhang Yanyuan, in the *Lidai minghua ji*, also expressed a similar negative attitude against architectural subjects by saying that there was "nothing about them which life-movement could seek to embody and nothing which spirit resonance might strike to equal."[9]

However, this negative view gradually disappeared during the Song. That Guo Ruoxu praised the achievements of the early masters and discussed those qualities to be desired in architectural representation indicated that the genre had attracted scholarly attention and had come to be considered a worthy topic for art criticism. The Song imperial catalogue *Xuanhe huapu* (ca. 1120) further revealed the disappearance of the negative view against architectural painting. It also recognized, for the first time, that architectural representation was not easy:

When painters took up these subjects [i.e., buildings, boats, oars, and chariots] and completely described their formal appearance, how could it have been simply a question of making a grand spectacle of terraces and pavilions, or doors and windows? In each dot or stroke one must seek agreement with actual measurements and rules. In comparison with other types of painting, it is a difficult field in which to gain skill.[10]

According to the Song imperial catalogue, the need to follow "actual measurements and rules" made architectural painting "a difficult field in which to gain skill." This new view

contested the old idea that architectural subjects were not worthy of depiction. Obviously, the Song period witnessed not only a change of attitude toward architectural representation, but also an expansion in the technical and conceptual range of the genre. There was an active process of redefining the meanings of the genre, and new ideas and criteria were drawn in the discussion of architectural painting.

In the *Xuanhe huapu*, paintings of architecture are named "palaces and chambers" (*gong-shi*), and this subject category includes other man-made objects such as boats, oars, and chariots. These are all grouped together because the representation of man-made objects requires attention to "actual measurements and rules," not because they are the subjects to which the *jiehua* technique can be applied. So, during the twelfth century, there was still a clear distinction between subject matter and technique, at least as far as their names were concerned.

From the Yuan dynasty (1341–1368) onward, the term "*jiehua*" became one of the subject categories synonymous with architectural painting. This is evident in the *Hualun* by Tang Hou (active ca. 1322–1329):

> In discussing painting, ordinary people will certainly say that it has thirteen categories with landscapes at the top and *jiehua* at the bottom. For this reason, people regard *jiehua* as the easiest to do. They are unaware that even wood engravers and artisans are not able to exhaust the subtle aspects of high and low or looking down and up, square and circular or crooked and straight.[11]

The thirteen genres of Chinese painting referred to above were defined and ranked during the thirteenth century.[12] Tao Zongyi (active 1360–1368), in the *Nancun chuogeng lu* (1366), ranked landscape painting the sixth and architectural painting the tenth.[13] Thus the saying "landscapes at the top and *jiehua* at the bottom" actually had no literary support. However, when landscape painting and *jiehua* were juxtaposed in that particular context, the latter became a subject category. This permutation in the meaning of *jiehua* was also reflected in the way the Yuan critic accounted the history of architectural painting which, from then on, became the history of *jiehua*:

> Each of the various categories of the ancients' paintings had its masters. There was no one in *jiehua* during the Tang. In the succeeding Five Dynasties there was only one man, Guo Zhong-shu, and a few others such as Wang Shiyuan and Zhao Zhongyi [tenth century], and Dong Yuan (d. 962). . . . Recently, I have seen the Hanlin academician Zhao Mengfu [1254–1322] teach his son Yong [1289–ca. 1360] to do *jiehua*, while saying, "In all other kinds of painting, it may be possible to fabricate [the subject] to deceive people, but in *jiehua* there has never been anyone who did not apply himself diligently in accord with the rules." This is the truth.[14]

For centuries, Guo Zhongshu had been hailed as the greatest master of architectural painting. He was initially doctor of letters of Posterior Zhou (951–960). After a brawl at court, he was dismissed and made revenue officer at Guangdong. Later he resigned and gave up

public office, wandering off into various regions of Shanxi, Shaanxi, and Henan. During the Song period, Emperor Taizong (r. 976–997) summoned him to court to serve as keeper of archives in the Imperial Academy of Learning. Because of his unruly, undisciplined behavior, Guo was cashiered again, this time to Shandong, and died on the way. Even his death was described as a legend: "His corporeal body dissolved [and he was immortalized]."[15] Known for his eventful, nonconformist, and unrestrained life, Guo Zhongshu paradoxically mastered a "difficult" field that demanded observance of architectural rules. He excelled in fine-line drawing and was able to paint with great ease and freedom, especially in the excitement of drink. This is best revealed by the story of the artist and the rich wine dealer's son who loved the art of painting. The son offered Guo some excellent wine with the plea that the artist paint for him. Guo took a very long roll of paper, painted at the beginning section a small boy holding on to a line on a reel and at the end a paper kite. In between he drew a line several tens of feet long, displaying his exceptional skill in line drawing.[16]

In addition to Guo Zhongshu, Wang Shiyuan, a judicial inspector of Song, was another painter of merit who was also praised for not having to rely on a ruler to mark out the boundaries of architectural forms.[17] However, both Guo Zhongshu and Wang Shiyuan were considered as *jiehua* masters during the Yuan dynasty, regardless of their freehand drawings of architectural subjects. In another example, the Yuan art critic Yuan Jue (1266–1327) called Guo Zhongshu and Wang Shiyuan "the best of all *jiehua* masters" notwithstanding the negative connotation of the term "*jiehua*" in their time.[18]

Why was there a shift in the meaning of the term "*jiehua*" in the Yuan dynasty? If the introduction of this term by Guo Ruoxu suggested a common adoption of the ruled-line technique by his contemporaries, a consequent shift in its meaning to refer to architectural painting might indicate an increased popularity of the technique, despite Guo's criticism. Thus the term eventually became a general designation for the genre. As there is no indication of disapproval against the use of ruler in these Yuan writings, there might have been a softening of hostile attitudes.

Unfortunately, surviving architectural paintings of this period, especially those by major masters, are too limited to reveal the development. Wang Zhenpeng (active ca. 1280–1329), a professional painter of the Yuan court, was well known for his mastery of architectural subjects. Under the auspicious of the Yuan imperial family, Wang Zhenpeng painted his famous *Dragon Boat Regatta on the Jinming Pond*: one for Renzong (r. 1312–1320) while he was still heir apparent and another for Princess Sengge (ca. 1283–1331).[19] But a profusion of later copies of this painting has obscured the past so that we are uncertain about the original styles of Wang Zhenpeng. Did Wang adopt the *jiehua* technique in architectural rendition, as shown in the extant versions of the *Dragon Boat Regatta* (fig. 1.2)?

Surviving works by Wang Zhenpeng's disciples, Li Rongjin (active mid-fourteenth century) and Zhu Pao (fourteenth century), may supply some clues about the legacy of their master. Both Li Rongjin and Zhu Pao were lesser-known painters in art history. We do not know their biographies, but we may give much credence to the authenticity of their extant

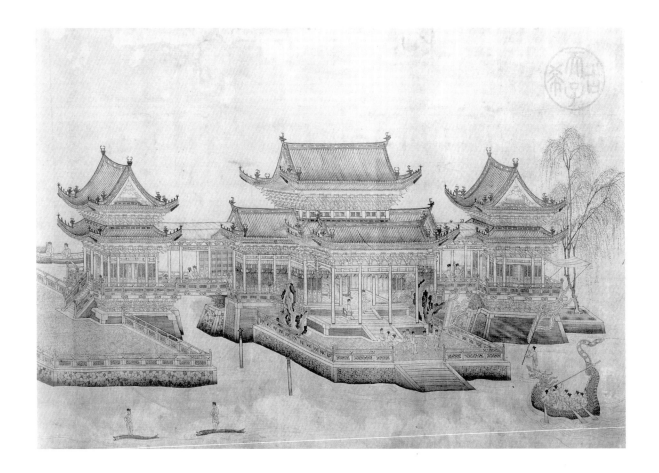

paintings (because of the tendency to interpolate a famous master's name, not that of a lesser-known painter, in ancient Chinese painting). Li Rongjin's *Han Palace*, which features precise renditions of complex structures and minute details, is a superb example of Yuan *jiehua* (fig. 1.3). The careful arrangement of the architectural forms builds up a monumental compound punctuated rhythmically with open spaces, height variations, and natural elements. Numerous fine-line details and repetitive surface patterns add to the finesse of the architectural images. A similar style is also observed in Zhu Pao's illustration of the Lotus Sutra, which includes elaborate *jiehua* elements such as a pagoda, a gate, masonry terraces, and some scaffolding (fig. 1.4). Notably, the contours of the buildings in both Li Rongjin's and Zhu Pao's paintings are drawn with the aid of a ruler. The wealth of narrative details and the intricacy of designs testify to the technical complexity of *jiehua*. This consistency of style may represent the legacy of their teacher and reveal Wang Zhenpeng's consummate skill in architectural representation, which, not surprisingly, should be of a higher quality, as he had earned a considerable reputation at the Mongol court. If these surviving works by Wang's disciples truly reflect his original styles, if Wang's achievements

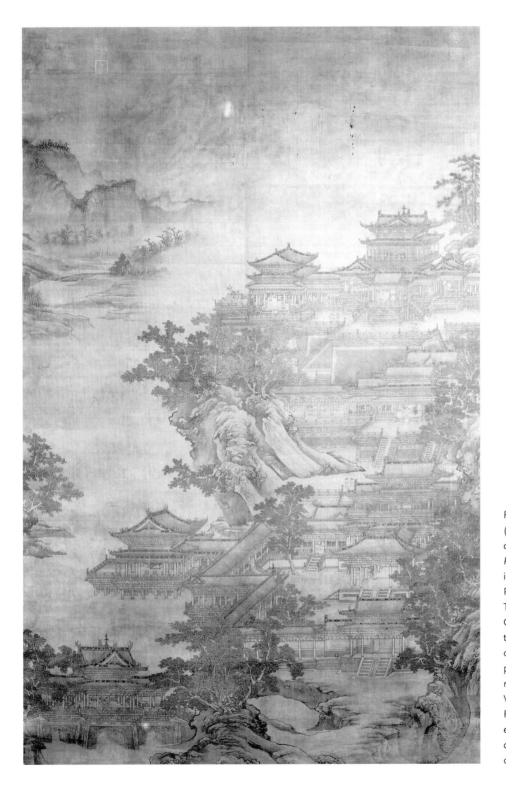

Fig. 1.3. Li Rongjin (active mid-fourteenth century): *The Han Palace*. Hanging scroll, ink on silk. National Palace Museum, Taipei, Taiwan, Republic of China. This is an important surviving example of Yuan architectural painting that probably reveals the styles of Wang Zhenpeng, Li Rongjin's teacher. The emphasis on fine-line detail is a characteristic of *jiehua* of this period.

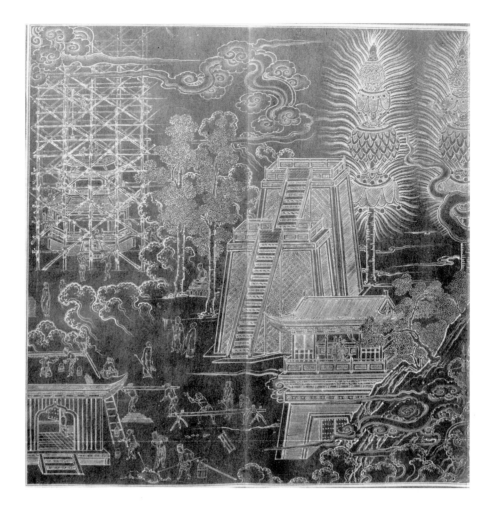

Fig. 1.4. Zhu Pao (fourteenth century): *Illustration of the Lotus Sutra*. 1330. Section of folding booklet in gold on blue paper showing elaborate architectural representation. National Palace Museum, Taipei, Taiwan, Republic of China.

in this field really succeeded in lowering the prejudice against *jiehua*, then these existing Yuan examples of *jiehua* may explain the final disappearance of the negative connotations related to *jiehua*. They may also explain the ultimate nonloaded usage of the term to refer to architectural painting.

From the Yuan period onward, *jiehua* has been continually interpreted as both subject category and technique. In English, modern scholars have been employing the term "ruled-line painting" or "boundary painting." Given that "*jiehua*" has sometimes been interpreted as a subject category, the term "ruled-line painting" is inappropriate because freehand drawing had been an admirable style of architectural representation. The inclusion of Guo Zhong-shu into the category of "ruled-line painting" also seems odd and incorrect.[20] "Boundary painting," a term suggested by Western scholars as painting "done by marking out the exact proportions by means of lines,"[21] seems more appropriate for describing the nature of architectural representation or *jiehua*.

The Great Tradition

The relationship between past and present and the creative tension between tradition and innovation are the central issues in Chinese art-historical studies. To put the development of Qing architectural painting in an art-historical context, this section examines some major characteristics of architectural representation during the Song and Yuan periods, centering on the major concepts, conventions, and styles that had been developed in relation to the genre. Broadly speaking, the Song and Yuan represented a remote past to Qing artists, and the achievements of the ancients were part of the Qing inheritance. Our problem is to delineate what later artists could receive from the past. This delineation will provide us with a background for understanding what would be deemed relevant and what would be discarded in the works of the Qing.

There is no intention here to outline the evolution of architectural painting during these periods. We only have glimpses of a blurry past illuminated by scanty materials. And since works of major masters have vanished without a trace, we have to draw on textual records and other works by lesser painters for discussion. But the writings of art critics—who were scholars in traditional China—may not necessarily relate to surviving works by professional painters or craftsmen. On occasions where literary records cannot be verified because the paintings are not extant, it is difficult to know whether the descriptions are of the *ideal* or the *actual* achievements made in the field. Thus it is important to note the limitations of our existing available materials, not to assume that the textual and the pictorial necessarily reflect each other. And because the paucity of extant materials makes it difficult for us to fully understand the dynamism of change in the Song and the Yuan, we should not assume a cohesive continuum.

Conceptions and Conventions

In comparing the qualities of architectural paintings during the past and the present, the Song critic Guo Ruoxu, in the *Tuhua jianwen zhi*, enumerated some criteria of value that offered subtle insights into the conceptions and conventions in relation to the genre.

Faultless Calculation and Right Proportion

According to Guo Ruoxu, "painters of the Sui, Tang, and Five Dynasties down to Guo Zhongshu and Wang Shiyuan at the beginning of this [i.e., Song] dynasty" accomplished "faultless calculation" (*zhesuan wukui*) in architectural representation. Such an achievement is also recorded by Li Zhi (1059–1109) in the *Huapin* and is further elaborated as follows: "Guo Zhongshu used *hao* [an infinitesimal unit of length] to mark off *cun* [an inch], *fen* [a tenth of an inch] to mark off *chi* [a foot], *chi* to mark off *zhang* [ten feet]; increasing thus with every multiple, so that when he did a large building, everything was to scale and there were no small discrepancies."[22]

It is illuminating to note that the above passage echoes another one in the Song builders' manual *Yingzao fashi* (1103), in which the method of scale drawing is described as "using *chi* [a foot] to mark off *zhang* [ten feet], *cun* [an inch] to mark off *chi*, *fen* [a tenth of an inch] to mark off *cun*, *li* [a unit of length equivalent to a third of millimeter] to mark off *fen*, and *hao* [an infinitesimal unit of length] to mark off *li*, in order to draw on a wall surface the cross section of a building."[23] The similarity of wording implies that ancient architectural paintings, in the eyes of Song art critics, were as accurate as scale drawings. By implication, architectural paintings could be used as design drawings in building construction, as all the measurements were to scale.

Besides Guo Zhongshu and Wang Shiyuan, two other artists were specifically remembered for this achievement. Zhao Zhongyi, painter-in-attendance of the Hanlin Painting Academy of Posterior Shu, was mentioned in the *Tuhua jianwen zhi* as having painted a work titled *General Guan Yu Erecting the Jade Springs Temple*. He reproduced an entire framework, all shown without a single flaw. The prince ordered his architect to comment on it and was told that it was "faultless."[24] Liu Wentong (early eleventh century)—who served at the painting academy during the reign of Zhenzong (r. 998–1022)—was recorded in the *Shengchao minghua ping* as having drafted the designs for the construction of imperial palaces.[25]

It is impossible to verify these records because we have neither paintings nor buildings. Even if the paintings and buildings were still in existence when the Song texts were written, one wonders if a pictorial image, being drawn to scale on a two-dimensional surface, is an "accurate" record of the real thing. No matter how convincing a pictorial image is, there are limits of objective likeness in representation.[26] In eyeing an actual building, a painter is provided with a rich variety of architectural information. To translate the visual experiences into painting, the painter first has to narrow down this flux of architectural experiences by submitting them to schemata or methods.[27] If he wishes to further achieve "faultless calculation," he may have to modify or correct the schemata.[28] The schemata and the modifications that are adopted to conjure up a convincing architectural image— an image that embodies the idea of "faultless calculation"—are of concern. And if modifications of schemata involve mathematical calculations, it is important to find out what they are. Are these calculations as complex as those adopted in building practices?

In actual construction, the measurements of every single architectural component in a structural framework must be accurate. The *Mujing*, a Song treatise on architecture written allegedly by Yu Hao (ca. 965–ca. 995), provides the evidence that architectural proportions had been formulated as desirable standards since the Song period. Shen Kuo (1031–1095) cited the *Mujing* in the *Mengxi bitan* (ca. 1086) and recorded the methods described in this book.[29] It is stated that buildings have three units of proportions *(fen)*: the section above the crossbeams follows the "upperwork unit" *(shangfen)*, the section above the ground floor follows the "middlework unit" *(zhongfen)*, and everything below that (e.g., platform, foundations, paving) follows the "lowerwork unit" *(xiafen)*. Both the upperwork and mid-

dlework units are derived from simple mathematical division, and the various dimensions must match those of the beams or the columns in fixed proportions. As for the lower section, the gradient of the ramp is based upon the lowerwork unit, which is derived from the relation between the heights above the ground of the two ends of an imperial litter when carried by human beings during an ascent. In other words, the proportions of a human body (e.g., the length of extended or downstretched arms, elbow height, shoulder height) are taken into consideration.[30]

As indicated by the *Mujing*, the proportion system in an actual building involves mathematical relationships between the dimensions of almost all components in a wooden framework. All the dimensions are calculated in accordance with the desired height, width, and depth of a building. Toward the end of this passage about the *Mujing*, Shen Kuo mentioned that builders of his times abandoned the proportions recorded in this book and preferred a more precise system: "Builders in recent years have become much more precise and skilled than formerly. Thus for some time past the old *Mujing* had fallen out of use. But [unfortunately] there is hardly anybody capable of writing a new one. To do that would be a masterpiece in itself!"[31] Apparently, when Shen Kuo wrote the *Mengxi bitan* in the eleventh century, no great architectural book other than the *Mujing* dealt specifically with architectural proportions. Fortunately, in 1103, there came Li Jie's *Yingzao fashi*, which provided more elaborate rules and standard dimensions for the achievement of proportions in architecture. The new method prescribed a modular system for every measurement of a building. According to this modular system, the dimensions and proportions of different parts of a building are expressed in terms of the *cai*, *qi*, and *fen* of various standard sizes or grades of lumber.[32] Although we do not know whether the *Yingzao fashi* expresses the subjective view of a literatus about the ideal proportions in architecture or summarizes the accumulated experiences of builders in actual constructions, this book is a revealing example of how general standards have been revised for the perfection of architectural proportions.

Do architectural representations require calculations of similar complexity? We cannot tell with certainty, as little is known about the paintings, not to say the kind of mathematical calculations applied to the images, of Guo Zhongshu, Wang Shiyuan, Zhao Zongyi, and Liu Wentong—all remembered to have achieved "faultless calculations." However, in our existing corpus of early architectural images, we find a degree of simplification in the representation of individual components or the links between parts. The calculations involved in pictorial representation, if required, could not have been as complicated as those in actual construction.

More significant is that architectural painters relied on preexisting conventions in representation. Such pictorial conventions can be observed in surviving early examples of architectural representation such as the tomb paintings of Prince Yide (see fig. 1.1). To render an architectural form, the artist shows two sides of a building: one side lies parallel to the picture plane; the other recedes diagonally into deep distance. Often, the side that con-

fronts the viewer frontally is the side view of the building, where we find an inverted-V roof profile. To achieve "faultless calculation," the artist would correct the schema. The slight discrepancies in measurement that make an architectural image mathematically inaccurate can be overcome by pictorial devices that play a trick on one's perception and transform a "false" visual image into one perceived as "faultless." For example, the size of each identical component should appear uniform throughout. The artist must also consider the correspondence of positions and parts. On the whole, it is the achievement of verisimilitude in architectural representation that makes an image look faultless. It is also the quality of orderliness in the arrangement of parts that enables us to associate a visual image with our understanding of architectural rules. Our knowledge and perception of architecture help transform an inaccurate image into a convincingly faultless one.[33] "Faultless calculation," in that regard, is the equivalence of verisimilitude in pictorial representation. The term is used specifically in the discussion of architectural subjects or other man-made objects that require rules and measurements in their construction.

Further, "faultless calculation" also implies achieving a general sense of proportion that corresponds to one's knowledge and perception. As we have seen, by the Song period, the idea of proportion had attracted scholarly attention and had evolved into sets of principles relating to building construction that affected people's perception of architecture. Once proportions had become culturally determined characteristics of architecture, any distortion of the standards would be psychologically disturbing. This was especially true when the perceived order was disrupted or when structures showed signs of leaning over. Thus, closely related to the conception of right proportion were the ideas of orderliness and order in the representation of fixed forms.

Viewed from the cultural standpoint, the quest for faultless calculation and right proportion corresponded to what Neo-Confucianism had emphasized regarding moral qualities, correctness, and proper behavior. The ideal proportions reinforced the idea of order and harmony so ingrained in Chinese cultural life. The sense of stability, as conveyed by an orderly structure, expressed a confidence in these core values. In this regard, architectural painting can be interpreted as a genre celebrating order, harmony, correctness, and rationality. Even Guo Zhongshu—who appeared to be a vagrant contemptuous of society—was submitting himself to a genre that required control and discipline. The following passage by Li Zhi in the *Huapin* is telling:

> Confucius spoke of [being able to] "follow out what his heart desired without transgressing the right." Zhuangzi spoke of those who are "wild and reckless indeed, and yet, tread in the way of magnanimity." Here was one who, as a man, was just as unconventional as the latter types, yet, as a painter, had quite as much discipline as the former. Thus one knows the subtle principles (*li*) of the world easily and spontaneously attains a happy mean [as in this painting of Guo Zhongshu]. However, to make Guo act [as a person] in an orderly and calculated way was exhausting.[34]

The practice of architectural painting, according to Li Zhi, is comparable to "knowing the subtle principles (li) of the world." Arguably, Song architectural specialists were making use of the rules and measurements of external forms to express internalized cultural values, although this was not explicitly stated in literary sources.

Structural Clarity

If architectural representation served to reproduce order, so did structural clarity. Guo Ruoxu mentioned a variety of building components in his discourse on architectural painting, stressing the need to understand the physical properties and structural relationships of a building. This suggests that architectural depiction, to the Song critic, was a process of objective representation involving penetrating observation and full knowledge of the builders' art. His writing exemplified the tendency toward exquisite precision in Song architectural representation so that every architectural component is appreciated for its own right. There was also an emphasis on the links between individual components within a structure.

We may refer to two surviving masterpieces to verify this direction toward a high degree of structural clarity in architectural representation: *Transport Carts at the Mill*, attributed to Wei Xian, now in the Shanghai Museum (plate 1), and *Going up the River on the Qingming Festival*, by Zhang Zeduan (eleventh–early twelfth century), now in the Palace Museum, Beijing (fig. 1.5). Strictly speaking, both are genre paintings incorporating incidentally meticulous depictions of architectural subjects. *Transport Carts at the Mill* is a visual document showing an aspect of life of those involved in the business of milling. There is an imposing tower that houses a waterwheel-driven mill, providing the architectural setting and working space for flour production. Here, the close relationship between architecture and human activity is strongly emphasized: raw grains are transported to the terrace on the left of the tower and then carried into the mill for grinding into flour, which later is sifted on the terrace on the right. The elaborate structures, especially the mechanics of the waterwheel-driven mill, are depicted with such precision that our attention is drawn to their beautiful designs and practical functions. The same is true of the depiction of the wine shop and its flamboyant decoration in the corner of the scroll. The other remarkable example, *Going up the River on the Qingming Festival*, joins *Transport Carts at the Mill* in revealing the predilection for incorporating abundant architectural elements into genre painting at a similar time.[35] Capturing the urban prosperity of Bianjing (modern Kaifeng), this painting contains a diversity of architectural motifs (such as bridge, city gate, shop, and house) familiar in daily life. We enjoy viewing the smallest, fascinating structural details of the architecture as much as the bustling human activities. We take delight in appreciating the physical qualities of things and in recognizing the close relationship of human beings with the physical world.

In both paintings we notice a careful consideration of the architectural details and the links between parts so that every structural component suggests a practical function. For ex-

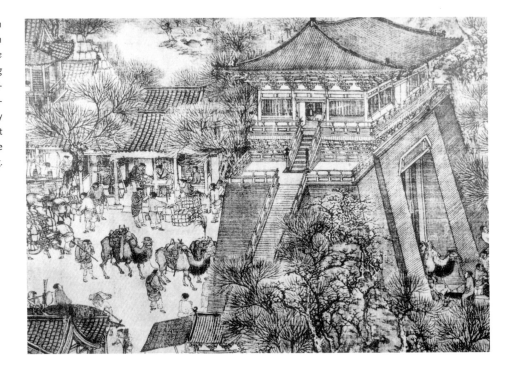

ample, the brackets *(dougong)* from the tower in *Transport Carts at the Mill* or from the city gate in *Going up the River* are rendered with great precision. Shading gives mass to the forms, and we recall how the blocks *(dou)* and arms *(gong)* serve their practical functions in the transmission of load from above to below. Interestingly, the degree of structural clarity reveals a close relation with, if not necessarily a reference to, the drawings in the builders' manual *Yingzao fashi* (fig. 1.6). Volumes 29–34 of this architectural manual consist of drawings illustrating various details of construction as well as plans, cross sections, and decorations of structures.[36] From these drawings, painters of architectural subjects could no doubt gain a better knowledge of the structural relationships between the various architectural components. The builders' manual might have served as a useful reference for modifying the schemata in architectural representation, but nevertheless we should not rule out another possibility that Song architectural paintings—which took verisimilitude as the goal—had already achieved a degree of structural clarity so much so that the established pictorial conventions were also adopted in the builders' manual. In any event, the close relationship between architectural painting and printed illustrations in the *Yingzao fashi* confirms that structural clarity as a quality to be desired in architectural representation was attained no later than the early twelfth century.

Although painters might have fully understood the structural framework of a Chinese building, there was still a problem of pictorial integration. The complex architectural structures in *Transport Carts at the Mill* reflect such a representational problem. Here, the

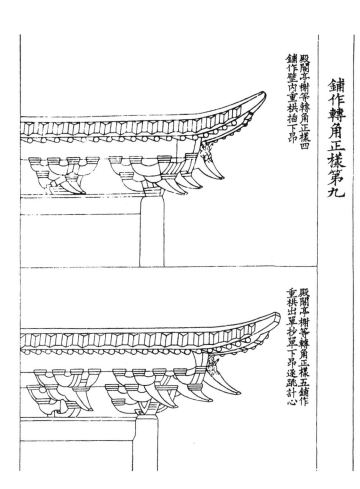

鋪作轉角正樣第九

殿閣亭榭等轉角正樣四
鋪作壁內重栱插下昂

殿閣亭榭等轉角正樣五鋪作
重栱出單抄單下昂逐跳計心

Fig. 1.6. Page from the *Yingzao fashi*, published in 1103, illustrating the bracket set at the corner of a building. The drawings in the *Yingzao fashi* might have enhanced the painters' understanding of Chinese building construction.

waterwheel-driven mill is placed centrally within a pile-supported tower. A wide expanse of interior space provides the working space for grinding the grains, and this seems to reflect the improvement in columniation in Northern Song architecture so that there is a wider central bay for utilitarian purposes.[37] Stylistically, the design of this tower is comparable to that of the Main Hall of Longxing Temple at Zhengding in Hebei province (fig. 1.7). This actual example represents the earliest existing structure featuring a similar design of four projecting porticoes on the four sides, each having a gable-and-hip roof *(xieshan)* facing out. (The difference is that the hall has a double-eaved roof and is erected on a platform foundation.) This beautiful design, as the architectural historian Liang Sicheng (1901–1972) has observed, is rarely seen in surviving early structures but is often depicted in Chinese painting.[38]

With an actual building as reference, we notice that the projecting portico in front of the tower is missing in the painting, and hence the *xieshan* roof that faces out becomes structurally meaningless. The depth of this part of the roof is quite shallow, unlike the protru-

The *Jiehua*
Tradition

23

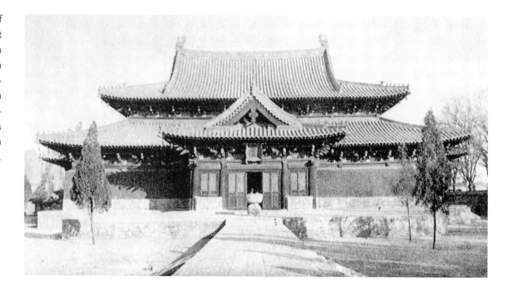

sion at the back. In comparison with a later version of the same theme by probably a Yuan artist (as hinted by the style of the landscape depiction) (fig. 1.8), now in the Liaoning Provincial Museum, the earlier version of *Transport Carts at the Mill* does not show a faithful architectural representation.

We may ask: Was the omission of the front portico a result of the artist's simplification? Or did the painter face a technical problem when representing the front view of a complex structure? Before we answer these questions, we may also refer to another example, the Jin dynasty (1121–1234) architectural painting on the south wall of the Yanshan Temple at Fanshi county in Shanxi province (plate 2). Because the main tower in this architectural painting also has a projecting portico in the front, it provides an additional reference for our comparison with the structure in *Transport Carts at the Mill.*

The architectural painting from the Yanshan Temple is significant art historically because of the available information on its authorship and date of production. The Jin court artist Wang Kui, at the age of sixty-eight, with his assistant Wang Dao, completed this wall painting and others in 1167. We do not know much about these artists. However, if Wang Kui was sixty-eight years old in 1167, he was twenty-eight when the Northern Song court fell to the Jin in 1127, and he was possibly a Northern Song academy artist who had acquired the skill of architectural depiction before the dynasty fell. Since the Jin followed the path of artistic developments of the Northern Song, it is likely that the wall paintings at the Yanshan Temple shed light on the achievements already made during the Northern Song. They are therefore important supplements to our data on Northern Song architectural paintings, which so far lack firmly documented works by major artists. Of course, one may expect even higher quality from the works of major masters.

Like the tower in *Transport Carts at the Mill*, the central structure in the Jin wall paint-

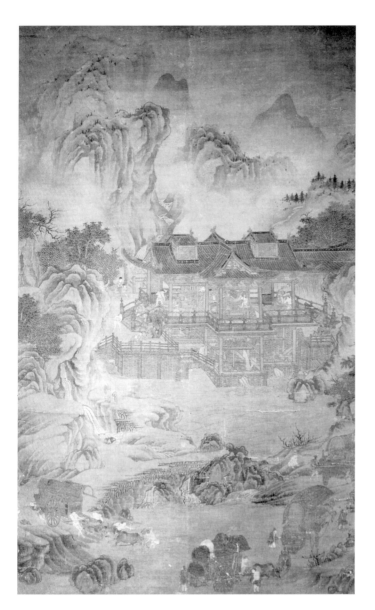

Fig. 1.8. Artist unknown, Yuan dynasty: *Transport Carts at the Mill*. Hanging scroll, ink and color on silk. Liaoning Provincial Museum. Although there is a faithful representation of the architecture, pictorial clarity gives way to descriptive complexity. From Liaoning sheng bowuguan cangbao lu bianji weiyuanhui, ed., *Liaoning sheng bowuguan cangbao lu* (Hong Kong: Sanlian shudian; Shanghai: Shanghai wenyi chubanshe, 1994), 24.

ing reveals a struggle for structural clarity as the painters rendered the front view of the building's protruding unit. The common solution is to add an inverted-V gable in the middle of the longitudinal roof plane to indicate a roof extension in the opposite direction. Whereas the front portico is missing in the mill tower, there is one extending from the central building in the Jin painting. This front portico is defined with slanting lines that recede into depth and that also articulate the front-and-back relationship of the structure. An overall sense of spatial recession is further reinforced by the diagonal thrust of a flight of steps and

The *Jiehua*
Tradition

by the stairways leading up to the terraces. This Jin painting—which shows an advance in the representation of a front portico—is just a work by lesser-known professional painters. It is highly probable that it adheres to old, commonplace practices and may reveal little of the advances made elsewhere by major artists in the same period.[39] Following the same trend of thought, even if *Transport Carts at the Mill* does not show the advance made in the representation of a front portico, we can accept the likelihood that there were, at the same period, other higher-quality works that are now lost.

Transport Carts at the Mill bears the inscription "Respectfully painted by Wei Xian," but the left side of each of the four characters is cut off. Traces of some words were discovered during remounting, revealing a further inscription, of which only the surname "Zhang" and the word "submitted" *(jin)* could be seen.[40] Since the Wei Xian signature is an interpolation, and since this painting reveals a certain degree of structural clarity achieved by another painter whose name has been removed,[41] one could infer greater achievements from the lost works of the famous master. And for these reasons, we should not necessarily assume that the later version of *Transport Carts at the Mill* in the Liaoning Provincial Museum reflects a much later accomplishment in achieving structural clarity in architectural representation. The advances may be due to the ready availability of a better prototype. Because paintings by major masters have vanished without a trace, the historical development of architectural painting is difficult, if not impossible, to trace in adequate detail.

Further, it is interesting to point out a paradox here. The Song version of *Transport Carts at the Mill*, which does not present a well-articulated structure of the mill, is a higher-quality work than the later version. The implication here is that a good painting may not be an accurate architectural depiction, and an accurate representation may not be a good painting. The omission of the front portico of the mill in the Song version, though a technical deficiency in architectural representation, liberates the artist from the constriction of verisimilitude. Since the structure of the mill is itself complicated, pictorial clarity plays a role in suggesting the complexity of the architectural design. And if the mill is to be shown as operating, the artist has to present a cross section that automatically excludes the front portion. While structural clarity is pursued in the later version, the faithful depiction mitigates the degree of suggestiveness in Chinese painting. By implication, the aforementioned aesthetic concerns in architectural representation, which center on the idea of formal likeness, are not necessarily the criteria for excellence in Chinese painting. In brief, good representation need not be good art.

Spatial Organization

Before we examine the organization of an architectural compound in painting, it is necessary, first, to find out how an architectonic form is represented pictorially. Guo Ruoxu, in the *Tuhua jianwen zhi*, mentioned that the architecture "should deeply penetrate space"

and that "when one [line] goes, a hundred [lines] slant." These comments refer specifically to the representation of architectural space on a two-dimensional surface. *Yiqu baixie* is the means, *shenyuan toukong* the end: the great number of slanting lines yields an architectural image of depth. Liu Daochun, in the *Shengchao minghua ping*, also mentioned this representational technique, which he called *yixie baisui*: "When one [line] slants, a hundred [lines] follow."[42] Technically speaking, *yiqu baixie* or *yixie baisui* involves an orchestration of oblique lines to give a strong diagonal movement. It is a pictorial convention for representing architectonic forms on a two-dimensional surface. How? First, the artist arranges one side of the structure (either the front or the side view) parallel to the picture plane.[43] Then he presents the adjacent side with a layout of "a hundred [lines]" that slant and recede into distance. These lines not only define localized architectural space but also link up the front and the back of a building. Perhaps the mention of "a hundred" lines is no exaggeration if we consider the vast number of oblique lines required for showing the projection of different architectural components (e.g., roofs, balustrades, terraces, stairways, platforms, and ramps). Moreover, when near and far buildings are connected with corridors or walkways, the intervals between distances are also defined with receding lines.

As early as the Tang period, Chinese painters had used a diagonal layout of a hundred lines to render a grand architectural complex. This is best exemplified by the celestial palaces depicted in some of the wall paintings at Dunhuang. Take the example of Cave 172, which illustrates the Pure Land of the West (fig. 1.9). The symmetrical composition has the dual functions of drawing the worshiper into an ordered, religious world and creating the impression that the Buddha at the central axis extends his blessings toward the worshiper.[44] As for the architectural representation, slanting lines have been used in at least three different ways. First, the central hall (the principal building along the central axis) is rendered with two pairs of converging lines: an upward-sloping pair to show the up-tilted ground plane and another but downward-sloping pair to raise up the corners of the flying eaves and expose the rafters below. Second, the side pavilions in oblique projection have all the slanting lines parallel to each other. Third, respective pairs of oblique lines along the left and right edges of the platforms are all slanting in a converging manner. A point to emphasize is that all these oblique lines only define localized penetration of space as the lines pertain to individual structures. There is no tendency for them to extend beyond the depth of the architectural image that is being defined.

We wonder why there were different uses of multiple lines and why the artist did not organize these lines by means of a single system. It may be argued that a pseudo-scientific system was under way, but evidently it was not the intention of the Chinese painter to develop a single system or to relate all views of the architectural compound in a set position and grade. Instead, the principle of the moving focus was being practiced, and the painter made clever use of lines of movement to compel our eyes to turn in every direction to encompass the whole architectural scene. Because of these different uses of multiples lines, the focus

The *Jiehua* Tradition

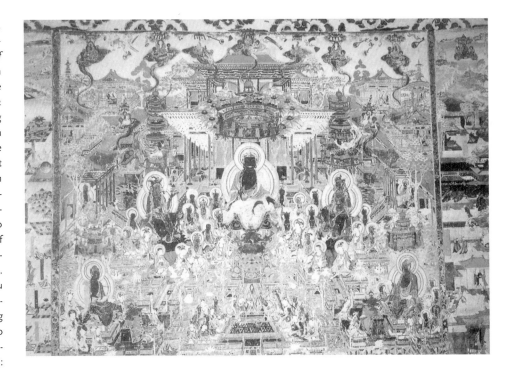

Fig. 1.9. Artist unknown, Tang dynasty: *Illustration of the Pure Land of the West*. Mid-eighth century. Painting on the south wall of Cave 172 at Dunhuang showing the different ways in which slanting lines have been used to suggest penetration of space in architectural representation. These various linear patterns serve to intensify the effect of movement in an architectural compound. From Zhongguo meishu quanji bianji weiyuanhui, ed., *Dunhuang bihua (xia)*, Zhongguo meishu quanji huihuabian 15 (Shanghai: Shanghai renmin meishu chubanshe, 1988), 80–81.

of the viewer is always shifting.[45] We see in an extended manner and then relate all views of the architectural compound in our mind. This concern for the extended relationship of objects is expressed most explicitly in a passage by Shen Kuo in which he criticized the failure of Li Cheng (919–967) to capture "the larger view from the small":

> When Li Cheng painted such buildings as pavilions or towers on a mountain, he always did the flying eaves as if one was looking up at them. The explanation is given that one is viewing what is above from below, just like a man on the level ground looking up at house eaves sees their supporting rafters. This theory is wrong. . . . In such things as buildings, one would not see inner courtyards or events happening in the rear lanes if looking up from below. . . . Master Li apparently did not understand the method of taking the larger view of the small, but his distinctions of height and distance naturally had a subtle rational order. How could this just be a matter of raising up the corners of buildings?[46]

Evidently, the ancients aimed to represent an architectural compound that allowed the viewer to see "inner courtyards or events happening in the rear lanes." To achieve this, there should not (indeed, there cannot) be strict homogeneity of position and direction for the viewer. Moreover, there is no restriction on the way the oblique lines conform to a diagonal layout. They can be parallel, converging, or even diverging. The coexistence of various linear patterns, as shown in the Dunhuang wall painting, simply indicates the intention to intensify the effect of movement through an architectural compound.

Let us once again refer to the architectural depiction in the Jin wall painting, in which the organization of buildings is intended to invite the viewer to wander through an artfully designed compound (see plate 2). This remarkable *jiehua* is utterly architectural and linear. The architectural compound consists of high masonry terraces, storied towers, halls, and galleries. Innumerable lines knit up intricate structures that are, so to speak, suspended in voids. Through the device of the moving focus, the viewer's attention is constantly shifting while he or she wanders in imagination through the compound.[47] How is this achieved? A scrutiny of this painting will reveal that buildings of varied distances are arranged laterally against a high, tilted background.[48] To relate one building to another, our eyes must move left and right and also up and down. Such movements are guided by the contours of the buildings and are accentuated by the rhythmic variations of the architectural heights. The lines extend in every direction. Whereas the contours of the roofs draw our eyes to go left and right, those of the steep stairways lead the eyes to move up and down. Such linear rhythms heighten the sense of relatedness of the buildings. Our eyes leap from one distance to the next, despite the intervals between near and far structures. It is by means of the moving focus, the extended perception of objects, as well as the interplay of opposite forces that all views of the compound are tied together. Visual unity is then achieved.

Surviving examples of Southern Song architectural paintings are mostly small in scale and are often close-up scenes of structures at particular spots.[49] The architectural forms are often juxtaposed with voids that suggest distance and atmospheric moods. Moreover, there is an emphasis on the extension of architectural space to increase the lateral movement in time. In spite of these small-scale examples, however, we should not conclude that Southern Song painters depicted only secluded architecture of the humblest type. If *Going up the River on the Qingming Festival* presents such an impressive scale in architectural rendering, it is unlikely that Southern Song painters had never attempted a similar or even a more ambitious venture. Architectural paintings, perhaps, served to reflect the extravagant styles and lavish entertainments of the court in Hangzhou. One may also consider the possibility that there were works anticipating the grand palace in the *Dragon Boat Regatta on the Jinming Pond* depicted by Wang Zhenpeng in the subsequent Yuan period.

The different versions of Wang Zhenpeng's *Dragon Boat Regatta on the Jinming Pond* give us an idea of how Wang organized an architectural compound along a handscroll. The architectural organization permits movement from structures to structures, from compounds to compounds. Even if the platform foundations of the buildings are not connected, there are flying galleries or humped bridges that maintain a continuous extension of interior and exterior spaces (see fig. 1.2). And if we examine the composition of *The Han Palace* by Li Rongjin, a student of Wang Zhenpeng, we find that most of the diagonals are slanting in the same direction (see fig. 1.3). Apparently, there is a deliberate attempt to maintain a consistent visual order in the organization of the so-called hundred lines. The courtyards duplicate to grow in distance. The resultant monumental compound is marked with a high degree of complexity, elaboration, and refinement.

Critics tend to discuss architectural and landscape paintings separately, as if they have no relation to one another. Yet surviving paintings show the tendency to incorporate architecture with landscape, suggesting an inseparable relation between the two. Although unity of architecture with nature is not a stated criterion of value in Song writings, it is, in fact, crucial in Chinese architectural thinking.

For example, Guo Ruoxu mentioned that architectural renderings should "show the four corners" and "make clear distinction between front and back." These are technical concerns in architectural representation, but such concerns reveal the symbolic correlation between architecture and the cosmic forces of nature. The "four corners" relate to the four cardinal points,[50] the "front and back" to the orientation of Chinese architecture in the direction of the Earth's axis (i.e., south-north direction).[51] There are other examples confirming the close relationship between architecture and nature in Chinese architectural thinking. Since the Zhou period eleventh century–256 B.C., the Chinese had projected in city planning the concept of order in the universe. The *Kaogong ji* has specified complex rules governing city planning: a city should be laid out to form a square, with twelve gateways on the city walls (three on each of the four walls) and nine vertical and nine horizontal avenues within the city. The ancestral temple was on the left, the altar of Earth on the right; the court and the palace in the front, the marketplace at the back.[52] The emphasis was on an axial, symmetrical layout that symbolically correlated with orientations and the twelve months of a year. This principle of axiality in city planning is reflected in present-day Beijing, which still preserves the palace and other important temples of old imperial China. In addition, the ancient Chinese took full advantage of natural growth in architectural design but did not force trees or plants to form straight lines or geometric patterns.[53] The art of geomancy, or what the Chinese call *fengshui*, is to locate the physical structures for both the living and the dead in sites where the cosmic forces are in harmony.[54] Thus Chinese architecture has never been thought of apart from the cosmic order.

Architectural painters may simply place the structures in voids, giving rise to works that are starkly architectural. However, they are not satisfied with the mere representation of architecture. They often add in landscape elements to suggest the inseparable relationship between architecture and nature, just as landscape painters add one or two mountain towers to suggest the human presence in nature. Pictorially, an extended relationship between architecture and landscape involves an integration of two different sets of motifs and schemata. *The Han Palace* by Li Rongjin suffices to explain the principle for pictorial integration (see fig. 1.3). In this painting, architecture imparts a sense of monumentality and assumes a predominant position in the composition. Yet it does not dominate nature. The architectural and landscape subjects stand apart and are placed in separate sections of the space-time continuum. And when the architecture is juxtaposed with the natural subjects, tensions between them are inexhaustible: between the confined architectural space and the infinite

natural space, between the static man-made structures and the life-movement in nature, between the carefully controlled straight outlines and the free-flowing undulating strokes, between the lucid architectural delineation and the evocative landscape depiction. The integration of architecture and landscape is therefore not a mere coordination of different sets of vocabularies in pictorial design. It is also a juxtaposition of two contrasting ways of seeing. Because of the moving focus, our eyes shift constantly from one way of seeing to the other, and the mind adjusts correspondingly to connect these very different experiences. The result is a wedding of the artificial and the natural. Harmony between architecture and landscape is also achieved by such an ingenious use of the creative tensions between opposite forces.

Antiquity

Antiquity as an important concept associated with architectural painting can be revealed by the critics' evaluations of Guo Zhongshu's paintings. According to Li Zhi, Guo's paintings are "more than exquisitely precise." They show "aloofness, simplicity, profundity, and a spirit free from worldly contamination."[55] According to the *Xuanhe huapu*, his works are "lofty and antique." It had never been easy for the common people to understand his paintings, and there were those who laughed at his works without having seen them.[56] Further, the *Xuanhe huapu* records the following story: "Once there was a man from Qiantang [present-day Hangzhou] surnamed Shen, who collected the works of [Guo] Zhongshu. Every time when he showed [Guo's paintings] to other people, they would laugh loudly. Only after several years did Guo's paintings start to be appreciated and were commented as 'these are the brushwork of Zhongshu!' "[57]

This account shows that Guo Zhongshu's paintings did not start to be valued until later years. Why did people laugh at his works? Was it because of the "lofty and antique" quality so that his paintings looked unusual to the eyes of later audiences? Was antiquity a concept originated by Guo Zhongshu, or was that a quality projected onto his works by later critics? Unfortunately, there are no surviving paintings of the artist to allow such theories to be tested.

In what way were Guo Zhongshu's paintings "antique"? Perhaps he was "antique" in his linear brushwork, "antique" in the painting style of the artist who refused to use a ruler to guide his lines, "antique" in the architectural styles, or "antique" in flavor as a result of these combined factors in his works. In this respect, several attributes of the artist are noteworthy. First, Guo Zhongshu had profound scholarship in philology. He had written the *Hanjian* and the *Peixi*, which were both philological studies on ancient Chinese scripts. Second, both the *Shengchao minghua ping* and the *Xuanhe huapu* mention that he applied the calligraphic brushwork of Chinese seal scripts to painting.[58] The brushstrokes of seal scripts are written like iron wires. Each stroke has equal strength, with its beginning and ending

stroke being concealed. When this technique is applied to painting, the result, it is often believed, is an "antique" flavor in brushwork. Third, Guo Zhongshu might have used the flying-eave-and-exposed-rafter style in architectural representation. This particular mode of depiction—which can be observed in earlier works such as the tenth-century architectural landscape discovered at Yemaotai—had been abandoned since the eleventh century.[59] All the above factors might have made later critics pay attention to the special quality of Guo Zhongshu's paintings, a quality regarded as "antique." No matter whether this tenth-century master had originated a movement for restoring the past *(fugu)*, there was no doubt of the association of "antiquity" with the name of Guo Zhongshu in the eleventh and twelfth centuries.

Why did such an "antique flavor" only start to be valued in the eleventh and twelfth centuries? The acceptance of antiquity as an attribute of architectural painting revealed the climate of antiquarianism in the eleventh and twelfth centuries. The period also witnessed Li Gonglin's and Mi Fu's participation in the movement for returning to the past in Chinese art.[60] The concern for antiquity in architectural painting might suggest the development of a new mode of architectural representation in a new era, so that the paintings of a tenth-century master would look simple, unusual, and "antique" in the eyes of later people. Comparatively speaking, technical virtuosity, complexity, and intricacy must have been fully attained in architectural painting during the eleventh and twelfth centuries, so that art critics shifted their interest back to the "antique" flavor or the "simplicity" of past paintings.[61] At all events, the notion of antiquity from then on became an important criterion for value in Chinese architectural painting.

The Alleged Shrinkage during the Ming

The art critic Xu Qin, in the *Minghua lu* (colophon dated 1673), made the following remark on the development of architectural painting since the Ming period: "There were only a few painters who specialized in this genre during the Ming. Recently, people favored the brushwork of the Yuan [i.e., the calligraphic styles of the great Yuan masters] and viewed *jiehua* practitioners as lowly artisans. Sooner or later, *jiehua* will completely disappear."[62]

We are told that there was a shrinkage in the field of *jiehua*, that there were only a few *jiehua* specialists during the Ming, and that this lack of interest was due to the increasing popularity of literati painting, which eventually hampered the development of architectural painting. There was a degree of truth in this argument. Because of the influence of literati theories, verisimilitude had to make way for personal expression in Chinese painting. If literati styles were pursued, it was almost impossible to carry out precise description of details in architectural representation because literati artists tended to use abbreviated forms and expressive brushwork to evoke human feelings. In contrast, *jiehua* artists included abundant descriptive details to articulate complex architectural rules. So when

literati painting entered the mainstream, *jiehua* waned. The situation intensified when Dong Qichang (1555–1636) and his friends advocated the theory of the Southern and Northern schools and considered the former as the "correct" and "orthodox" lineage of Chinese painting. Consequently, *jiehua* was associated with professional painting or the Northern school tradition.

Xu Qin predicted that *jiehua* would completely disappear. But was it true? As it turned out, *jiehua* did not vanish altogether. It survived the passage of time and was revived under the Qing. Thus it is important to reconsider whether the genre had really lost its importance during the Ming as we are led to believe. *Jiehua* and literati painting might seem to be mutually exclusive, but *jiehua* had not been completely crushed. As will be shown in what follows, within the Ming court, *jiehua* was continuously practiced (although a fair proportion of extant works were done by anonymous painters), and outside the court, the famous artist Qiu Ying (ca. 1494–1552) excelled in architectural painting and was able to gain appreciation from the literati class. There were also specialists of topographical or genre paintings who tended to incorporate *jiehua* elements into their works.

Moreover, it is not enough to consider only the mainstream of Chinese art. The Ming period witnessed an active involvement in *jiehua* on a broader front because it was widely practiced by artisans who specialized in various craft forms. It is most unfortunate that critics and art historians tend to neglect the richness of such materials. Dong Qichang's theory of the Southern and Northern schools—which is prejudicial and judgemental in nature—best demonstrates the hierarchy of art defined at a particular period in traditional China. Because of the preference of the time, literati painting reached the apex of the art hierarchy. *Jiehua* might have failed to attract scholarly attention at the uppermost stratum of this hierarchy, but it survived on the intermediate and base levels that lay below and supported the apex.[63] It is precisely on the middle and base levels that *jiehua* showed vitality and did so on a much broader front during the Ming. For the purpose of understanding the developments of the genre during this period, we focus on two particular issues: first, the stylistic characteristics of Ming architectural depiction; second, the divergent developments of the genre. Only by understanding the trends already in motion can we appreciate their effect on the Qing developments.

Ming architectural paintings do not seem to display the same range of representational concerns shown in Song and Yuan examples. Unlike their predecessors, almost no *jiehua* specialists of the Ming are recorded in literature as having achieved faultless calculation and right proportion. Instead of attributing this lack to stylistic degradation, we may consider the possibility of perceptual change in a new era, so that architectural images were not as much associated with the idea of accuracy as in the Song. Nevertheless, the ideas of faultless calculation and right proportion were embodied in certain pictorial conventions. Although there is no record of the achievement of faultless calculation and right proportion during the Ming, there is no proof of the abandonment of the related pictorial conventions in architectural representation.

Certain Ming court paintings (narrative works in particular) take verisimilitude as a desirable quality. The incorporation of architectural elements into works that depict the imperial procession or the royal pleasures suggests that *jiehua* was practiced within the court and that *jiehua* specialists were summoned to court service. Although little is known about this aspect of Ming court art, there are surviving examples such as *The Pleasures of Emperor Xuanzong within the Court* (in the Palace Museum, Beijing),[64] *The Pleasures of Emperor Xianzong on the Lantern Festival* (in the History Museum, Beijing),[65] and *The Emperor's Procession* (in the National Palace Museum, Taipei).[66] The architectural images in these narrative paintings achieve formal likeness in the interest of providing a convincing background for the imperial activity. We still observe in these images an orderly arrangement of parts to create an impression of compliance with architectural rules.

The availability of two architectural paintings by the Ming court painter An Zhengwen (active early sixteenth century) in the Shanghai Museum, *The Yueyang Tower* and *The Yellow Crane Tower* (figure 1.10) confirms the imperial patronage of *jiehua* at this time.[67] Little is known about An Zhengwen, except that he held the position of battalion commander (*qianhu*) on appointment to the Hall of Wisdom (Zhengzhi dian). In his renderings of famous historic architecture, the painter might have relied on earlier prototypes, and his architectural images still observe the rules governing the correspondence of parts and positions. Interestingly, if formal likeness was pursued during the Ming, we cannot really enjoy a simple articulation of the structural relationship of the brackets in the wooden framework. It was indeed the architectural style of the Ming to diminish the size of the brackets in proportion to the building, and an increase in the number of the intermediate bracket sets further transformed these structural components into a band of ornamental motifs. Consequently, the pictorial image that reflects these architectural changes shows a greater number of but smaller and more closely packed structural components.

Other examples of Ming architectural representation reveal the tendency to sacrifice structural clarity for a new manner of architectural representation. We may refer to the works of Shi Rui (active ca. 1426–1470) and Qiu Ying to illustrate this direction of stylistic change. Shi Rui, a native of Qiantang (present-day Hangzhou), was a court painter appointed during the Xuande reign (1424–1435). He was best known for his blue-and-green landscapes and his meticulous renderings of architecture. Xu Qin, in the *Minghua lu*, gave the following complimentary remark of Shi Rui's *jiehua*: "His towers and terraces are delicate, exquisite, and secluded. They are full of splendor and orderliness."[68] *Greeting the New Year*, one of the finest extant works by Shi Rui, in the Cleveland Museum of Art, confirms the artist's achievements in the field of *jiehua* (fig. 1.11). It also reveals a new style of architectural configuration developed in the Ming period. Here, the architecture and the figures are tiny in comparison with the high mountains that stretch out across a horizontal expanse. The architectural structures are tightly pressed to each other so that the halls, the side galleries, and the side rooms all form a compact unit with minimal intervals in between (plate 3).

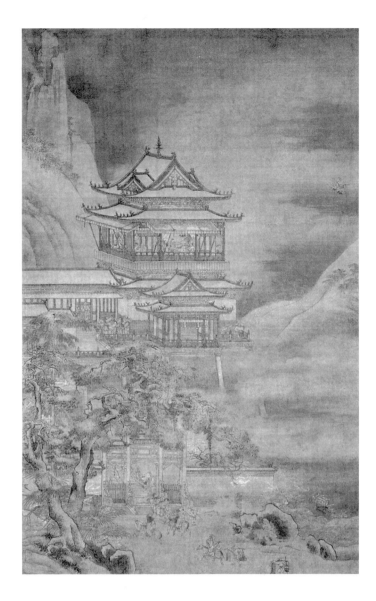

Fig. 1.10. An Zhengwen (active early sixteenth century): *The Yellow Crane Tower.* Hanging scroll, ink and color on silk. Shanghai Museum.

Significantly enough, this new style of architectural configuration also appears in Qiu Ying's architectural landscape *Dwelling of the Immortals,* now in the National Palace Museum, Taipei (fig. 1.12). Coming from a humble family, Qiu Ying earned his early living as a painter's apprentice, and this background probably allowed him to learn *jiehua* while he was making copies and imitations of ancient paintings. His lodging with important art collectors might have also offered him extra opportunities to learn from ancient *jiehua* masters. In *Dwelling of the Immortals,* the buildings are clustered together, the in-between space is reduced, and the volumes of the middle structures are negated. Such a rendition may

The *Jiehua*
Tradition

35

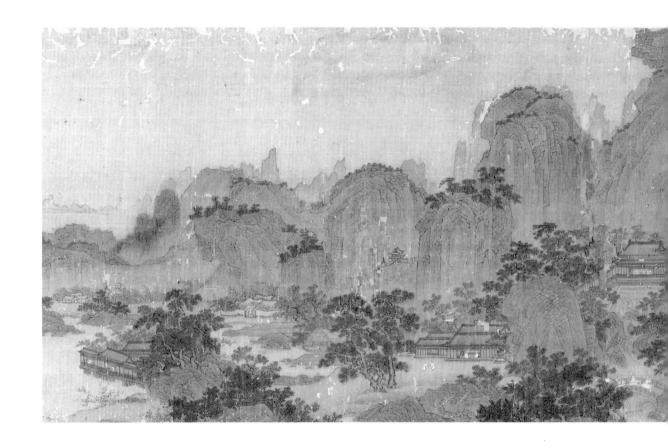

tolerate a degree of transparency in the exterior layer of the architectural compound, yet it prevents penetration into the inner core (fig. 1.13).

Such stylistic transformations, as indicated from both Shi Rui's and Qiu Ying's paintings, marked the Ming departure from the great advances made in the past. They also epitomized a new vision in Ming architectural representation. The depiction of delicate buildings in "blocklike" appearance inevitably resulted in the loss of structural clarity, a quality so valued in Song architectural representation. Although the Ming painters followed certain architectural rules in the placement of parts, there was no intention to focus on the practical functions or the structural beauty of individual components within these tiny architectural images. Even when the exterior layer of an architectural compound was presented, the interplay between solids and voids within the compound was never emphasized. In fact, these changes represented the further development of a new manner of architectural configuration, which had been set forth since the Yuan. In an anonymous Yuan architectural painting titled *The Jianzhang Palace*, now in the National Palace Museum, we notice a similar reduction of intervals between structures so that the palace appears cramped in space (fig. 1.14). The impression of compactness is further enhanced by the

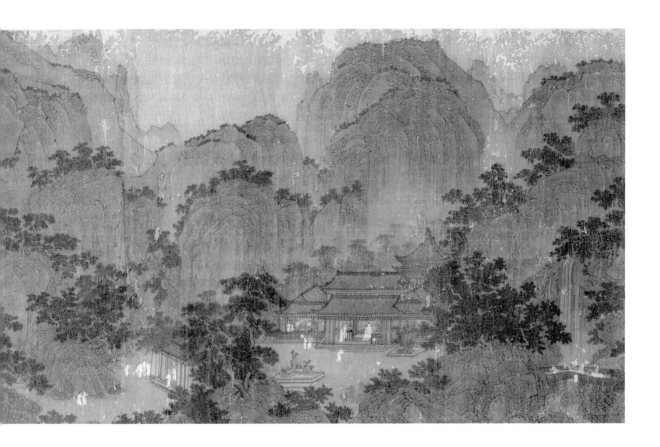

dense array of lines and the inclusion of lavish architectural details. When compared with the Ming examples, this Yuan architectural painting conveys a sense of monumentality achieved by a continual duplication of the architectural units in both vertical and horizontal manners. By contrast, Ming architectural renderings do not display a similar ambitious venture. Both Shi Rui and Qiu Ying give a large portion of their paintings to landscape depiction, and their architectural images appear small and delicate.

Consequently, even though Ming *jiehua* specialists continued to show a close relationship between architecture and nature, there was a changing relationship in scale, in precision, and in the overall impression between architecture and landscape. In most cases, we observe either the scatter of discrete architectural images in landscape settings or the dwarfing of architectural compounds by towering mountains. Not only was there a change of architectural images from large to small, from monumental to delicate, there was also a loss of precision of details. All these changes seem to suggest that *jiehua* was on the wane, that architectural representation was subordinate to landscape depiction during the Ming. Moreover, when architecture is juxtaposed with landscape in a Ming composition, we observe a pictorial tension between the mountain forms and the architectonic structures. The

Fig. 1.11. Shi Rui (active ca. 1426–1470): *Greeting the New Year.* Section of handscroll, ink, color, and gold on silk. ©The Cleveland Museum of Art, 2002. John L. Severance Fund, 1973.72.

The *Jiehua* Tradition

Fig. 1.12. (Right) Qiu Ying (ca. 1494–1552): Detail of *Dwelling of the Immortals*. Hanging scroll, ink and color on paper. National Palace Museum, Taipei, Taiwan, Republic of China.

Fig. 1.13. (Below) Detail of Fig. 1.12. The architectural representation may show a degree of transparency in the exterior layer of the compound, but it prevents penetration into the inner core. The confined architectural space is a startling contrast to the boundless space of nature.

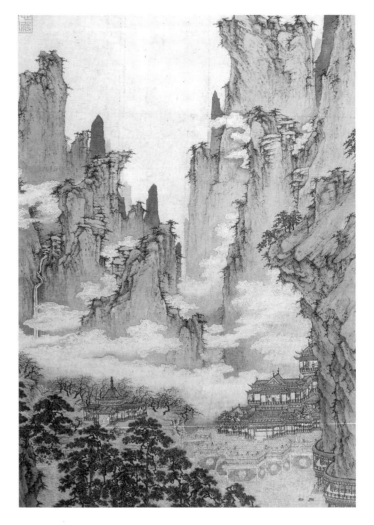

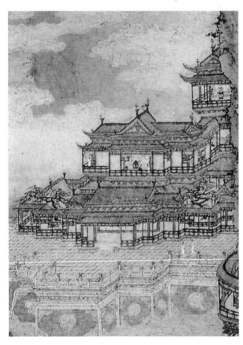

planar rendition of mountains (a typical Ming style of landscape depiction) is essentially incompatible with the pictorial convention for architectural representation, whereby a hundred lines help define the localized penetration of architectural space.

There is no evidence showing that the Ming *jiehua* artists were participating in any movement for restoring the past through architectural painting. Although there was no deliberate attempt to promote the concept of antiquity along with creative endeavors, artists were conscious of past models, and their works never totally departed from tradition. More important, antiquity as a fundamental concept associated with architectural representation, especially with the great exponent Guo Zhongshu, could be invoked any time to introduce artistic change and innovation.

Beyond the mainstream of Chinese painting, *jiehua* showed vitality in various craft

The *Jiehua* Tradition

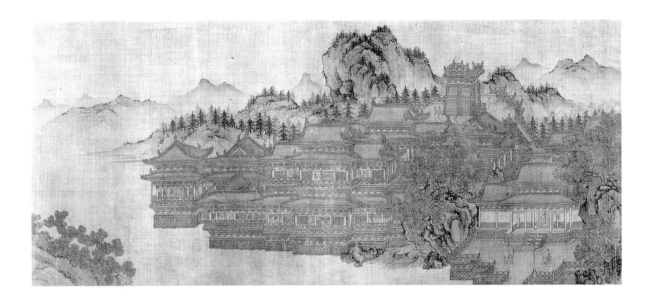

Fig. 1.14. Artist unknown, Yuan dynasty: *The Jianzhang Palace*. Handscroll, ink on silk. National Palace Museum, Taipei, Taiwan, Republic of China.

forms, testifying to its divergent developments during the Ming. I do not intend to suggest that earlier architectural representations were to be found only in the art of painting. During the Ming period, however, various factors contributed to a heavier use of architectural images in other craft forms. As printing flourished, *jiehua* was widely adopted as a type of printed design. Printing also made possible the spread of art knowledge, as pattern books were made available to craftsmen. It was no coincidence that the use of pictorial decoration in various craft forms became phenomenal during the Ming. Despite the fact that fewer and fewer painters specialized in architectural painting, a lot of architectural images were employed in woodblock prints, ceramics, wood and bamboo carvings, jade carvings, and lacquerware (fig 1.15). In fact, the very characteristic of architectural representation, its emphasis on meticulous description of minutiae, filtered into other craft forms, which also display exquisite precision in workmanship.

Because of space considerations, I am not going to examine the various media and investigate how *jiehua* took its form in Ming decorative arts. But it is important to notice the divergent developments of *jiehua* as it became widely practiced by craftsmen. More important, the new vision manifested in the works of major masters (such as Shi Rui and Qiu Ying) might not have been reflected in the works of ordinary craftsmen who relied on earlier prototypes for pictorial reference. Thus, past traits did not disappear entirely and, in fact, could be preserved in media other than painting.

Take the example of late-Ming woodblock prints. The *Chengshi moyuan* provides design references for ink-cake carving, in which traditional architectural themes and *jiehua* techniques are included as decorative programs (fig. 1.16). Other prints of the late-Ming period illustrate episodes from dramas or vernacular fiction, depicting the climaxes of plots,

The *Jiehua*
Tradition

Fig. 1.15. Wang Ming (fifteenth century): Circular dish with design of the Pavilion of Prince Teng. Carved polychrome lacquer. The British Museum. This dish bears an inscription indicating that it was made in 1489 by Wang Ming of Pingliang, Gansu province.

courtship of lovers, or daily activities of various social strata. Because of the illustrative function of these prints, the foci were often placed on the human drama, and architectural elements served to frame human activities or to provide the necessary spatial setting. To render interior space, simple architectural elements (such as a roof, a latticed door, or floor tiles) were depicted; occasionally, screens or panels suggested space partitioning. Outside the roof boundaries was exterior space, such as a garden enclosed with walls (fig. 1.17). Significantly, while printmakers were incorporating architectural motifs to indicate indoor and outdoor human activities, they were simultaneously expressing a spatial conception of architecture. Architecture was conceived and represented as functional space that permitted penetration. This conception was not a new phenomenon. It had been shown in Song paintings and was preserved and continued to be adopted in other media.

A Literary Response: The Writing of Tang Zhiqi
(Early Seventeenth Century)

Let us recall our observation of the divergent developments of architectural representation during the Ming. Although *jiehua* might not have been prevalent in the mainstream of Chinese painting, it was nevertheless a significant element in Ming decorative arts. In painting, the stylistic transformations that occurred during the Ming signified a departure from the past, a departure that could have triggered a response in the succeeding Qing dynasty, especially inasmuch as past conventions and conceptions had been preserved in other media that were available in the commercial art market. If artists were to redevelop *jiehua* as a painting genre, they had to elevate this type of work from a mere decorative function and bring it back to an upper level of the art hierarchy where creativity was valued.

The circumstances had already triggered a response in the art literature. In a passage about architectural representation in the *Huishi weiyan*, Tang Zhiqi wrote,

To paint towers, terraces, temples, and dwellings, one must follow in the footsteps of the ancients. Painters nowadays fail to draw the brackets and windows of towers and pavilions. They merely use blue and green pigments or inlays of gold and mother-of-pearl to cover up [the poor drawings]. This is ridiculous! Every block and arm of a bracket has its front and back. There are those with two-tenths in side view and eight-tenths in front view; those with projecting tips or flying tips; those with tapering ends or smooth ends. If there is the smallest discrepancy, [the depiction] will lose a great amount [of accuracy]. How can it claim full completion?

Depicting a tower or a pavilion is not difficult. If ten steps away is a tower, five steps away is a pavilion, there will be a lot of penetrations, a lot of arrangements, a lot of variations, and a lot of brackets. Columns, balustrades, and railings encompass the surroundings; flowers and trees enhance each other; roads and paths extend irregularly. Any repetition is not acceptable to the eye.

When learning how to draw towers and pavilions, one should first learn from paintings such as *The Palace of Nine Perfections, The Afang Palace, The Pavilion of the Prince of Teng, The Yueyang Tower*, or others, in order to get close to the manners of the ancients. Otherwise, even if the portrayals are meticulous and magnificent, they are just fabrications.

When the ancients portrayed towers and pavilions, they would intertwine the structures with flowers and woods or set them off with trees and rocks because flowers, woods, trees, and rocks show contrasts of the dense and the pale, the large and the small, the dark and the light—all of which serve to differentiate between near and far structures. Moreover, some architectural portrayals are refined and detailed over the upper half, then blurry at the lower half. These are "the theories of distance and proximity, of the above and the below" (*yuanjin gaoxia*). The wise can certainly understand these. Are they to be fully explained with word or speech?

To draw a picture of tower and pavilion on silk, there must be eight or nine, three or four figures to embellish the scene. Then there will be life-movement. When portraying temples, one may consider a desolate one, or add just one or two old monks who look peaceful and

Fig. 1.16. (Left) Woodblock-printed design for ink cake illustrating a historical *jiehua* theme. Page from the *Chengshi moyuan*, published in 1606.

Fig. 1.17. (Right) Illustration for an episode from the *Mudan ting huanhun ji*, published in 1617. Architecture is here conceived as functional space, and this type of architectural representation is commonly found in Ming woodblock prints.

calm. It will be wonderful if there are also old, austere trees, for there is no temple that does not contain old pines, old cypresses, tall branches, or screens of trunks. To arrange them properly with the artist's brush is to take delight in nature. Artists should follow and practice these as exercises.[69]

By saying that "painters nowadays fail to draw the brackets and windows of towers and pavilions," Tang Zhiqi referred to the loss of structural clarity in Ming architectural depictions. Although he reasserted the importance of avoiding "the smallest discrepancy" in architectural renderings, there was no elaboration of the Song idea of accuracy. Instead, he expounded on the organization of buildings and the incorporation of natural elements to create a built environment. It seems that he was responding precisely to the stylistic developments of Ming *jiehua*, focusing mainly on the aspects of structural clarity, spatial organization, and the integration of architecture with landscape.

Tang Zhiqi suggested a number of artistic solutions. He reaffirmed the traditional concern for structural clarity, stressing the need to observe the front-and-back relationship of every architectural component. The organization of an architectural compound should offer "a lot of penetrations," "a lot of arrangements," and "a lot of variations." He also suggested adding figural and natural elements to architectural compositions, affording the

built environments with certain auras. To get close to "the manners of the ancients," artists should follow the models of *The Palace of Nine Perfections, The Afang Palace, The Pavilion of the Prince of Teng,* or *The Yueyang Tower:* apparently, Tang Zhiqi was alluding to the idea of antiquity so valued in the tradition of *jiehua.* Yet he did not explain what "the manners of the ancients" were and how painters should approach these historical themes.

If the above passage represents a literary discourse in response to the Ming developments of architectural paintings, then what were the artists' reactions? Beyond the artistic realm, there were also political and social changes that would influence artistic developments. What happened after the change of dynasty and how did the new environment affect the development of *jiehua* during the Qing?

The *Jiehua*
Tradition

43

Patrons and Painters | 2

LATE-MING CHINA WAS enjoying the splendor of a rich economic and cultural life. Artistic accomplishments in painting, woodblock printing, porcelain, lacquer, and carving—many of which contained *jiehua* designs—were proofs of material prosperity that resulted from urbanization and commercialization in the Yangzi region. This splendor of material prosperity reflected the many transformations that took place in society and, at the same time, cloaked other inherent problems that undermined the administrative power of the Ming court. Increased elite leadership and intervention in local community life, despite its positive influence, was a reflection of the inability of the Ming government to control everything. Imperial extravagance, official corruption, abuse of power by eunuchs, falling revenues, natural disasters, and domestic rebellions all eventually led to dynastic decline. Although the declining Ming court could not afford to support much artistic activity, the effects of the political downfall on the budding urban culture—which was sustained by private markets—were far less clear. But the widespread turmoil that resulted when the Ming collapsed meant that setbacks were unavoidable.

Meanwhile, beyond the Great Wall, in the northeastern area of Manchuria (the area encompassing present-day Liaoning, Jilin, and Heilongjiang provinces), a tribal confederation of diverse peoples—most of whom claimed descent from the Jurchens who founded the Jin dynasty—was strengthening solidarity by "inventing" a Manchu ethnicity and creating a powerful state that was to become a formidable threat to Ming China.[1] These changes were accomplished under the rulership of Nurhaci (1559–1626) and his successor Hong Taiji (r. 1626–1643). In 1636 Hong Taiji made himself an emperor and named his empire Qing. While the Ming government was shaken by political, social, and economic troubles, the Qing military force—which was organized under the Eight Banners and made up of

peoples of many origins, including Manchu, Han Chinese, and Mongol—was already set to cross the Great Wall. In 1644 the Ming collapsed after the rebel Li Zicheng seized Beijing. The Qing force was invited by General Wu Sangui (1612–1678) to join him in recapturing Beijing.

The Qing seizure of Beijing and the enthronement of the Shunzhi emperor (r. 1644–1661) in the Forbidden City marked the beginning of a new dynasty to restore order in China. But the new order was restored only after a long process of further conquest, destruction, and slaughter within the vast country of China. The "barbarian" invasion led to strong local resistance: in the city of Yangzhou, for example, there were the memories of Manchu brutality and bloody slaughter; in Jingdezhen, the major ceramic production center, there was massive destruction at the time of the Wu Sangui uprising. Although the opening decades of the Qing dynasty were a period of great turbulence and social upheaval in China, art developments were not curtailed as a result of historical events. The political reality, paradoxically, had the effect of promoting literati painting, a high form of the Chinese scholar's art that called attention to the private vision of imagery and the expressive purpose of painting. Scholars who were greatly disturbed by the Manchu conquest chose to withdraw from civil service, to retreat into a quiet life of retirement, or to turn to Buddhism for solace; some later changed their decisions and viewpoints, yet they all devoted themselves to writing and painting. Whether they adopted a conventional or an idiosyncratic, expressionistic style of painting, they produced some of the most superb artworks of the period. Architectural paintings by professional *jiehua* painters were commissioned by royal patrons in the imperial palace or by private patrons in the commercial market. The revival of *jiehua* during the Qing—which occurred on a very impressive scale—was to take place only when political stability, demographic recovery, and economic rehabilitation had been achieved after a period of consolidated Qing rule. Such conditions were offered under the successive rulership of the Kangxi, Yongzheng, and Qianlong emperors.

Under the long, stable reigns of these three emperors, the Qing restored social order in China and reached the height of its political power. In this golden age of the Qing architectural paintings were increasingly demanded within the court for symbolic communications and were revived outside the court as a result of the commercialism and professionalism of painting. Some of the social and cultural transformations that took place in this long period—such as the rise of the merchant class, increased mercantile patronage of the arts, and the vogue for garden culture—gave architectural painting the room to flourish outside the court, making it a suitable medium for responding to social and cultural changes. The overview of the patrons and painters in this chapter will seek to find out the reasons for the impressive upsurge of *jiehua* during the Qing, the patrons' motives, the effects of patronage on art productions, and the painters' backgrounds and experiences of art and architecture, as well as their choices and constraints.

Inside the Court: The Imperial Orders

In view of the Chinese antagonism against the "barbarian" invasion, the Qing rulers were conscious to present themselves as the protectors of China's cultural traditions. Indeed, as Pamela Crossley observed, the Qing conquest regime assumed dominance over many other cultures but patronized only a small number. "The reason for their selectivity is obvious. They incorporated into their own self-representation those cultures that enhanced the emperorship and, by extension, the empire."[2] China was a fundamental component of the Qing empire, and thus Chinese culture was supported by the conquest regime.

The Qing court maintained the Ming political structures, reintroduced the civil service examination system, supported the official Confucian orthodoxy, adopted Chinese rituals and religious practices, and sponsored artistic activities. Painters were summoned to court service, and the court academy was eventually set up to serve as an instrument of imperial policies. The practice of calling painters to court service had started as early as the Shunzhi years, and painters were recruited by means of examination.[3] However, because of the paucity of materials, we have only very limited information about painting at the Shunzhi court. Only three painters—Huang Yingchen, Meng Yongguang, and Wang Guocai—are known to have served within the court during this period.[4] We do not know whether court-painting activity was performed by such a small number of painters or whether the painting academy had been formally established in this early stage.[5]

The *Guochao yuanhua lu* (1816) by Hu Jing has provided us with a general, if not comprehensive, survey of the types of paintings produced under the auspices of the Qing emperors. As the list in the preface shows, Qing court painters produced works about "the celestial bodies, topographical views, pacification, warfare, the recapture of the frontier, portraits of military generals, ceremonies of state, industrial and farming scenes, tribute missions, and various other scenes to glorify the dynasty."[6] Judging from these painting themes, one may conclude that Qing imperial patronage of Chinese painting served initially to repair the Manchu image and ultimately to gild the empire. But it was unlikely that the Manchu rulers—who themselves learned Chinese language, poetry, calligraphy, and even painting—did not develop any genuine interest in Chinese art. After all, they wished to establish themselves as exemplars of civil and military attainment.

All the Kangxi, Yongzheng, and Qianlong emperors showed enthusiasm for Chinese art, but their devotion to art varied according to their different interests and concerns at different historical times. The number of court painters employed and the quantities and types of works produced under each reign period offer insights about the varied degree of attention that each of these royal patrons gave to Chinese painting. Equally important are the varied personal concerns or motivations behind imperial patronage and thus the various means by which the interests of the emperors were served. This dynamism of Qing court painting had been reflected in the area of architectural representation. As we shall see, cer-

Patrons and
Painters

tain changes can be detected with regard to the development of architectural painting from the Kangxi to the Qianlong period. First, an increasing number of *jiehua* specialists were employed. Second, production expanded in scale and scope, and architectural images were used increasingly for dissemination of political ideas. Third, the Qianlong emperor's intense involvement with directing art programs and his repeated commissioning of certain works were a hint of the changing symbolic significances that he assigned to architectural painting.

The Kangxi emperor's attitude toward art was clearly stated in the following lines: "When we have no important business, we can indulge a slight interest in painting and calligraphy."[7] To this charismatic ruler, the affairs of state were priorities, especially when the Qing conquest was still fresh in the mind of the Chinese. The state during the Kangxi period had to generate political legitimacy for the Qing regime, win the allegiance of the Han Chinese, bring eminent scholars into government service, fight the war against the Three Feudatories (resistance forces of three Han Chinese generals in south and southwest China), bring economic recovery to the war-ravaged areas, supervise water-control projects, fortify the borders, and deal with Mongolia, Turkestan, and Tibet. Given all these pressing concerns, it was not surprising that political business took priority over artistic pursuits. Court paintings allowed the Kangxi emperor to construct the imperial image, but this pragmatic ruler was more concerned with the actual accomplishments of the Qing empire. Viewed from this perspective, one of the major contributions of the Kangxi emperor was the establishment of a firm imperial base and a stable political environment that allowed for a "slight" interest in painting and calligraphy. Significant imperial patronage of painting occurred mostly in the second half of the Kangxi era.

No matter how slight the imperial interest, the emperor's pragmatism, to some extent, determined the development of Qing court painting under his patronage. Here, there is no intention to suggest that the Kangxi emperor was the director of the painting projects undertaken within the court. As Howard Rogers noted in his study of Qing court painting, the Kangxi era may be characterized as "a period of freedom from regimen and control."[8] Many painters were called to court for specific projects, and they were free to accept private commissions. In fact, it was the emperor's choice of certain themes and styles that mattered. For instance, by commissioning Orthodox school artists to produce landscapes or flower and bird paintings that appealed to the Chinese scholars, the Kangxi emperor presented himself as the upholder of the revered traditions of literati painting. In this connection, the appointment of such influential scholar-official artists as Wang Yuanqi (1642–1715) and Jiang Tingxi (1669–1732) to high civil office was meaningful and critical, as this ensured the continuity of the Orthodox traditions within the court. The ruling regime also required didactic illustrations and pictorial documentaries that fitted into a broader program of state propaganda. Such imperial commands were basic, and the orders from the Kangxi emperor were relatively undemanding. However, because many of these paintings contained *jiehua*

elements, specialists of architectural subjects were called to court service. The seemingly basic demands had the effect of reviving *jiehua* in the remaining years of the dynasty.

During the Kangxi reign, there were at least the following *jiehua* specialists working inside the court: Jiao Bingzhen (active 1689–1726), Leng Mei (late seventeenth–eighteenth century), Shen Yu (active early eighteenth century), Wang Yun (ca. 1652–after 1731), and Jin Kun (active ca. 1717–ca. 1749). Despite this relatively small team of *jiehua* specialists, this period witnessed experimentation with new techniques and themes, both of which offered possibilities of novelties for the development of *jiehua* in the subsequent years. More important, the potentialities of architectural images as fitting vehicles for enhancing Qing imperial authority were subsequently explored.

Jiao Bingzhen was the most influential *jiehua* artist in the Kangxi court. Working in the Imperial Bureau of Astronomy where European astronomy, mathematics, and the European calendar were introduced by missionaries,[9] Jiao adopted linear perspective (known to the Chinese critics as "the methods from the Western Seas" or *haixifa*)[10] in Chinese architectural painting. Through his student Leng Mei,[11] his influence was extended to the Qianlong academy, and his styles almost became the standards from which court *jiehua* painters deviated little. The entry on Jiao Bingzhen in the *Guochao yuanhua lu* states, "[Jiao] Bingzhen worked in the observatory. He fully understood astrological calculations and mastered the Western [representational] methods. Shengzu [i.e., the Kangxi emperor] praised his art for its [assimilation of] mathematical principles."[12]

Significantly, the Kangxi emperor's acceptance of European painting methods had provided possibilities for their further development within the court. This was an example of the Qing adoption of various cultural elements in its own making, and in that regard, the "synthetic" painting style of Jiao Bingzhen—which incorporated traditional Chinese representational techniques with European methods—was a typical Qing product in both an art-historical and a cultural sense. Yet the symbolic significance of this new *jiehua* style should not be overstated. For example, *Album of Landscape and Architecture*, by Jiao Bingzhen, now in the National Palace Museum, Taipei, represents the artist's experimentation with a new mode of architectural representation (fig. 2.1). But we also find his application of the new *jiehua* style in works of other themes, as if there are ready formulae for assimilation into various contexts. This is evident in Jiao's famous work *Album of Agriculture and Sericulture* (fig. 2.2) or his *Album of Virtuous Empresses in Successive Dynasties*.[13] I will elaborate on the reasons and the nature of the borrowing of the European techniques later in this chapter and will discuss the symbolic function of the new *jiehua* style, if any, in my discussion of individual paintings (see chapter 3).

When the Kangxi emperor demanded estate portraiture and visual documentaries of his accomplishments, the architectural images in these paintings (regardless of styles) provide views of the Qing palace and the Qing empire. *Jiehua* became vehicles for symbolic communications. Examples include the representations of the Summer Palace at Rehe (Bishu

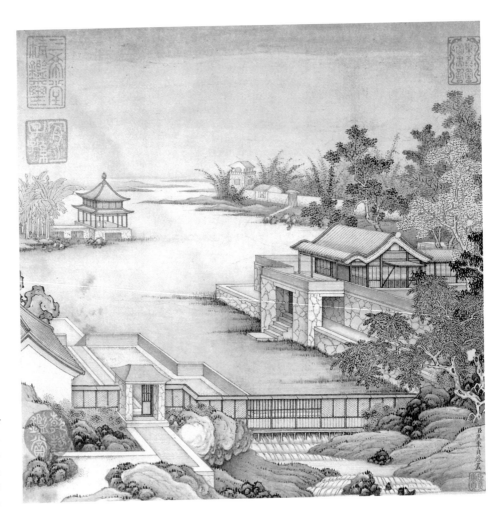

Fig. 2.1. Jiao Bingzhen (active 1689–1726): Leaf from *Album of Landscape and Architecture*. Ink on paper. National Palace Museum, Taipei, Taiwan, Republic of China.

shanzhuang), a palace built as a strategic base for unifying neighboring peoples. In response to the imperial orders, the court painter Leng Mei, a student of Jiao Bingzhen and a specialist of both figural and architectural subjects, portrayed the overall view of the Summer Palace (see chapter 3). The scholar-official Wang Yuanqi painted *The Views of Rehe* and *The Thirty-six Scenes of the Summer Palace at Rehe*.[14] Shen Yu, a Chinese bannerman and then treasurer of the Imperial Household Department, painted a set of illustrations of the garden's thirty-six scenes.[15] This set was additionally made into copper engravings by the missionary-artist Matteo Ripa (Ma Guoxian, 1682–1754). And when the emperor requested visual documentaries of his southern inspection tour, Wang Hui (1632–1717), a master of the Orthodox school, was summoned to court service and became the supervisor of the *Kangxi Southern Inspection Tour*. This painting project lasted from 1691 to 1695. As its scale exceeded the capacity of a single artist, a team of painters—many of whom were Wang

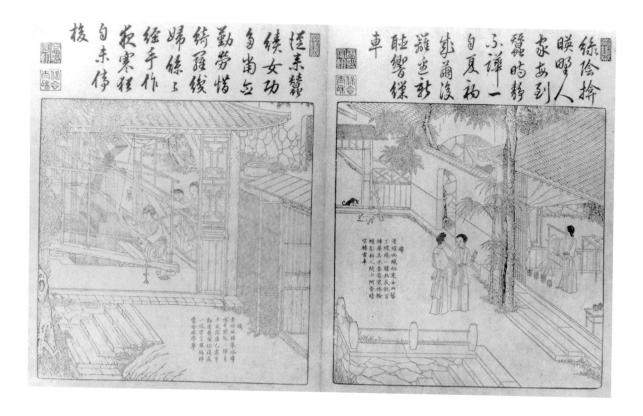

Hui's students—also participated in it. During this time, the *jiehua* and landscape painter Wang Yun was active at court. Since he was recorded as having served the inner palace from 1687 to 1704,[16] it is possible that Wang Yun was responsible for the architectural representation in the *Kangxi Southern Inspection Tour*. The *Zengxiu Ganquan xianzhi* confirms that Wang Yun participated in this project.[17] Another painting project of considerable scale was *The Kangxi Emperor's Sixtieth Birthday Celebration*, which also was a collaborative venture involving the participation of *jiehua* painters. Wang Yuanqi was the project supervisor; he not only headed a special bureau established for this commission but also completed a draft copy of the painting in 1714. The final version of the painting—which consists of two scrolls—was produced in 1717 under the leadership of Leng Mei.[18] The painter Jin Kun, a specialist of figure, flower and bird, and architectural paintings, entered the court probably because of this assignment.[19] Both Leng Mei and Jin Kun were to become eminent *jiehua* painters in the future Qianlong academy. Presumably, there were other *jiehua* painters working in the Kangxi court, as the completion of such magnificent projects undoubtedly required more painters who probably left the court after working on specific commissions.[20]

The rising interest in the use of painting to gild the imperial image during the late Kangxi era anticipated the future development of court painting in the subsequent periods.

Fig. 2.2. Jiao Bingzhen (active 1689–1726): Leaf from *Album of Agriculture and Sericulture*. Woodblock print. Although European linear perspective is used to render the architecture, it is not exploited for symbolic communications.

Increased imperial patronage of Chinese painting led to an expansion of the court academy during the Yongzheng period. In addition, detailed records of the imperial orders and the art activities conducted within the court were kept. Information on art productions in each of the various workshops (*zuo*) operated under the Bureau of Manufactory (Zaobanchu), Imperial Household Department,[21] was filed in an archive titled Zaobanchu gezuocheng huoji Qingdang (hereafter *Qingdang*).[22] Imperial demands for paintings were listed chronologically under "Huazuo" (the painting workshop). All these detailed records suggested that the Yongzheng academy (officially named the Painting Workshop in the palace archive) had been developed into a highly institutionalized structure.

As for the development of *jiehua*, some degree of continuity with the Kangxi era was reflected in the nature and the functions of architectural representation in the Yongzheng period. The emperor too commissioned narrative paintings that contained *jiehua* elements to facilitate narration and symbolic communications. The most notable example is the *Sacrifice at the Altar of Agriculture*, which depicts the Yongzheng emperor's participation in the ritual ceremonies held at the altar of agriculture. Although this work (like many imperial portraits or works rendering imperial pleasures) does not bear the painter's signature, it made obvious that the practice of calling *jiehua* painters to court service continued unabated.

The Yongzheng era continued to be a period of experimentation with *jiehua* techniques and themes. A significant development was the emperor's appreciation for the art of Giuseppe Castiglione (Lang Shining, 1688–1766), inclusive of the trompe l'oeil effect that the artist was capable of producing. Castiglione entered the court in the previous Kangxi period but was only assigned to the enameling workshop during his early years in Beijing. The imperial preference for Castiglione's art did not become acute until the Yongzheng years. A major reason for this change was, perhaps, the Yongzheng emperor's recognition of the aesthetic and practical functions of Castiglione's paintings in an architectural context. As the archival records confirm, there were increasing demands on Castiglione's paintings for the interior decoration of the emperor's favorite palace, the Garden of Perfect Brightness (Yuanming yuan). Castiglione was also responsible for instructing court painters in European painting techniques; this instruction had the effect of accentuating the borrowing of the foreign techniques in Chinese architectural painting. It is worth noting that Jiao Bingzhen and Leng Mei—the leading *jiehua* artists who mastered perspective drawing during the Kangxi years—were not active at the Yongzheng academy. One of Jiao Bingzhen's extant works, *Album of Genteel Ladies*, in the Palace Museum, Beijing, was inscribed with Prince Bao's poems, suggesting that Jiao might still have been working in the court in the early Yongzheng period (when Hongli started collecting in his teens). Yet Jiao's artistic production in the Yongzheng period was limited. His student Leng Mei seems to have withdrawn from the Yongzheng academy (there are no records of his painting activity during this period).[23] In such circumstances, Castiglione's role in promoting European perspective drawing became critical. Declaring himself a pupil of Andrea Pozzo, Castiglione assisted Nian Xiyao (d. 1738) in the Chinese translation of the *Perspectiva Pic-*

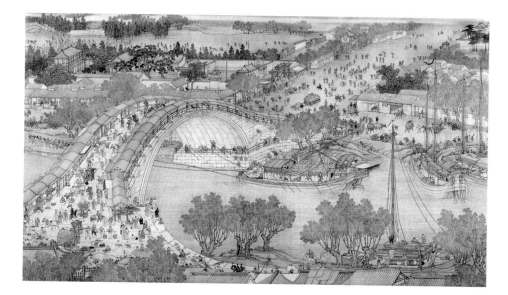

Fig. 2.3. Chen Mei (1694?–1745) and others: *Going up the River on the Qingming Festival*. Section of handscroll, ink and color on silk. National Palace Museum, Taipei, Taiwan, Republic of China.

torum et Architectorum (1698). The first edition, titled *Shixue jingyun*, was published in 1729; the second edition, *Shixue*, was published in 1735.[24] This text represented the interest of the Chinese intelligentsia in European linear perspective during the Yongzheng period.

Another notable accomplishment of this period was the production of the Qing court version of *Going up the River on the Qingming Festival* (fig. 2.3). This project revealed not only a sustaining interest in *jiehua* and genre painting in the Qing court but also a new tendency to reinterpret an old painting theme to serve the present. Obviously, *jiehua* specialists were not lacking in the Yongzheng academy, and this particular project was jointly undertaken by Chen Mei (1694?–1745), Sun Hu (active ca. 1728–ca. 1746), Jin Kun, Dai Hong (active ca. 1728–ca. 1745), and Cheng Zhidao (active 1726–ca. 1772) from 1728 to 1736. In a collaborative project like this, it is not necessarily correct to assume that all those who signed a work full of architectural elements were *jiehua* specialists. Chen Mei, Sun Hu, and Jin Kun had painted architectural subjects in their own works and were no doubt skilled in architectural representation. Dai Hong was recorded in the literature as a specialist of flower and bird painting,[25] and Cheng Zhidao was an expert of landscape and flower painting.[26] Whether or not they also practiced *jiehua* is difficult to tell. Cheng Zhidao later participated in the production of *Spring Morning in the Han Palace*, *Celebrating Feng*, and *Ice Skating* in the Qianlong period, and all these works contain rich architectural elements. It was probable that he himself was a specialist of architectural subjects.

A head count of those who practiced *jiehua* in the Yongzheng court should also include the Chinese bannerman Gao Qipei (1672–1734), who, being a scholar-official artist, painted at imperial command.[27] Gao Qipei was known for his finger painting, but he also painted architectural subjects. His extant architectural landscape of 1722, now in the Palace Mu-

Patrons and
Painters

seum, indicates that he practiced architectural painting well before he was called to court service in 1723.[28] According to the *Zhitou huashuo* by Gao Bing, when Gao Qipei was stationed in Zhejiang province, he employed the Yangzhou *jiehua* painter Yuan Jiang (active 1680–1740) to assist him in the application of color washes.[29] Gao was the prefect of Wenzhou at Zhejiang in 1705,[30] and he probably developed his interest in architectural representation while working with Yuan Jiang at that time. The academy painter Ding Guanpeng (active 1726–1770), a newcomer who entered the court in 1726,[31] painted architectural subjects, although he was better known for his figure and Buddhist paintings. He was more active and eminent in the subsequent Qianlong academy.

During the Yongzheng period, Hongli had already expressed his personal interests in art patronage and art collection. While yet a prince, Hongli commissioned Chen Mei to paint the *Album of Landscape and Architecture*, Sun Hu to paint the *Album of Figures in Snow*, and Jin Kun to paint the *Album of Poetic Scenes with Birds*. All these works bear the poetic inscriptions of Hongli and are signed by each painter without addressing himself as "your servant" *(chen)*.[32] They all contain *jiehua* motifs that largely serve as narrative elements.

Soon after Hongli ascended the throne to be the Qianlong emperor, however, certain immediately noticeable changes marked a climax in the development of architectural painting under his reign. The Qianlong academy was expanded with a larger team of *jiehua* specialists. It entered into a new phrase of prosperity unsurpassed in any other periods under the Qing. Painting productions magnified in scope and increased in quantity, as confirmed by a tremendous rise in the number of entries recorded in the archival records. The Qingdang records of this period no longer use "the Painting Workshop" to refer to the institution in which court painters worked but instead introduced two new names, the Ruyi Studio (Ruyiguan) and the Painting Academy (Huayuanchu), to indicate that court-painting activities were conducted by painters of these two separate units.[33] That two divisions were functioning together as the Qianlong academy was a hint of its expansion as well as the vast number of painters serving within the court.[34] The *jiehua* specialists Leng Mei,[35] Chen Mei, Jin Kun, Sun Hu, Ding Guanpeng—who were already active in the preceding eras— continued their court service. Other *jiehua* painters active in this period included Shen Yuan (active ca. 1736–ca. 1746), Yu Xing (active 1737–ca. 1760), Zhou Kun (active 1737–ca. 1748), Zhang Tingyan (active 1744–ca. 1768), Yao Wenhan (active 1743–ca. 1773), Zhang Gao (active mid–eighteenth century), Cao Kuiyin (active ca. 1739–ca. 1752), Xu Yang (active 1751–ca. 1776), Jin Tingbiao (d. 1767), Yang Dazhang (active ca. 1766–ca. 1794), and Xie Sui (active ca. 1761–ca. 1787). Many of them were versatile professional artists who painted various subjects besides architecture.

By employing such a large team of court painters who could paint architectural subjects, the Qianlong emperor certainly realized the potentiality of architectural images to serve the emperorship and the state. Some of the painting projects of the preceding eras undoubtedly provided the Qianlong emperor with inspiration, for almost everything that had been produced previously, especially during the glorious days of his grandfather's reign, would

then become prototypes for similar commissions under the Qianlong reign. A typical example was the painting project *Qianlong Southern Inspection Tour*, which, like the Kangxi set, consists of twelve scrolls and provides a visual documentation of the imperial journey. The expansions of the Summer Palace at Rehe and of the Garden of Perfect Brightness were also commemorated pictorially. Paintings of state ceremonies, royal celebrations, imperial pleasures, historical and didactic themes—many of these include meticulous architectural representation—were commissioned as well.

The burgeoning production of *jiehua* during the Qianlong era was also characterized by the adoption of a wider scope of themes and their constant reinterpretation to meet the excessive demands of the emperor. The presence of a group of *jiehua* painters within the court allowed for more imperial requests for any other *jiehua* themes, old or new alike. Moreover, ancient architectural paintings available in the Qing imperial collection propelled constant reinterpretations of old masterpieces. It is worth noting that the Qing court version of *Going up the River on the Qingming Festival* was completed in the opening year of the Qianlong reign. After the completion of this project, many other similar paintings with extensive cityscape representation were produced under the auspices of the Qianlong emperor. Other traditional *jiehua* themes, such as famous historical palaces or the "new Feng" (based on the story that to please his father, the Han emperor Gaozu reconstructed his home city of Feng in Chang'an) (fig. 2.4), were reinterpreted in different versions). "Spring morning in the Han Palace," a classical theme of Chinese figure painting, was interestingly transformed into a *jiehua* theme.

This trend had important implications for the development of *jiehua* during the Qianlong era. Significantly enough, architectural images as fitting vehicles for meaning construction did not need to be confined to actual views of the Qing palaces or the Qing empire. They could be borrowed from history and myth, imagined and invented, in order to articulate contemporary views. Moreover, with a new ideal of universal rule under the Qianlong emperorship, Chinese architectural images as icons of a cultural tradition were subjected to the imperial power to become distinct from those of the other cultures within the Qing empire.[36] And when the Chinese, Manchu, and Tibetan cultural icons were juxtaposed in a single painting, such as the 1748 version of *Spring Morning in the Han Palace* (see chapter 4), the convergence of cultures was meant to entertain the Qianlong emperor's interest in viewing the Qing multicultural empire on an elevated imperial plane. The Qianlong emperor—who gave painters assignments and approved draft copies of paintings—was the director of all these art programs. More than previous emperors, he was able to explore Chinese architectural images to the fullest extent, making *jiehua* an appropriate medium for reinforcing his political ideology. As I will show, architectural representation under the Qianlong reign revealed the unique personal interests of the emperor and was used to express his universalist ideology, which, in the words of Crossley, was "distinctly centered upon [the emperor] himself, as the sole point where all specifics articulated."[37]

In short, the dynamism of architectural representation during the successive Qing courts

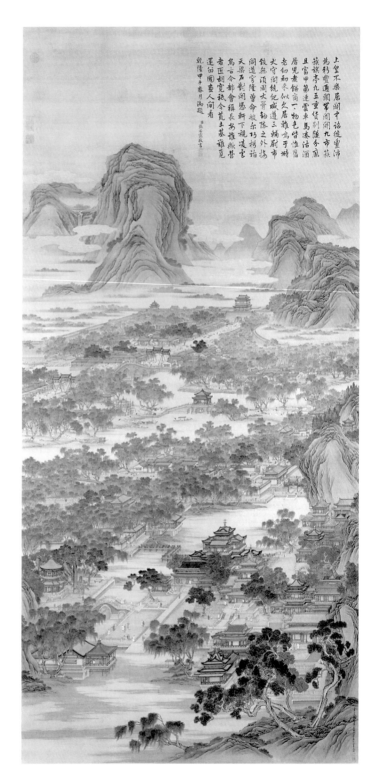

上皇不樂居聞中論德重沛
萬物豐通閣薈閣閣九市薈
薈薇亭九五重債別隆夯箕
且富甲第連雲東馬湊沽酒
屠見煮餅尚一物先皆惟編
老初和泰似久居雜鳴于城
火守閣閣紀臧通三輔尉市
致無須聞大晉帥綮係之外揚
閶道寫隆曾命敬不巧揚詒
天景石劃聞愚軒下視凌雲
萬古今都會繇長為誰敬營
音匠胡寬統今荒士基誰覓
還向圖畫人間有
乾隆甲子春月御題

Fig. 2.4. Tangdai (1673–after 1751) and others: *New Feng*. Hanging scroll, ink and color on silk. National Palace Museum, Taipei, Taiwan, Republic of China.

revealed the varied concerns and interests of the three emperors at different points in Qing history. From experimenting with European modes of representation to reviving traditional techniques and themes, from using architectural images as background elements to purposefully manipulating the *jiehua* medium and its tradition for disseminating political ideas, such developments were diverse and multifaceted.

Jiehua Painters at the Imperial Court

Although the aforementioned artists were important *jiehua* specialists of their time, biographical information on these professional painters is lacking because of their low social status. Instead of concentrating on their individual artistic careers, I intend to shift the focus of attention toward the artists' collective experience as court painters. Here, I am concerned, in particular, with two aspects: first, what it meant to be a *jiehua* painter serving at the Qing imperial court; second, how the court service exerted an influence on an artist's pattern of experience and painting activity.

A painter working inside the court had to serve at imperial command, regardless of his status and educational background. The *jiehua* specialists mentioned above were either scholar-official artists or professional academy painters (often referred to as *huahuaren*). Scholar-official artists who entered the court by civil service examination and who held official positions in the regular bureaucracy had high social status. Despite their bureaucratic appointments, they nevertheless were required to paint for royal patrons. Although architectural representation was regarded as an inferior art and did not appeal to scholar-official artists, several practiced the genre, especially under the authority of the emperors. For example, painters of the Qing court who specialized in architectural subjects included Jiao Bingzhen, who headed the Imperial Bureau of Astronomy; Shen Yu, who was treasurer of the Imperial Household Department and later the academician reader-in-waiting in the Grand Secretariat;[38] and Gao Qipei, who was appointed as chief minister in the Court of Imperial Entertainment and then vice-minister of the Ministry of Justice when he was serving in Beijing in the 1720s.[39]

Professional *jiehua* painters entered the court academy by means of painting examination, official recommendation, or self-introduction. Unless there are records in the literature, we do not know how individual painters entered the court; presumably, most of them were recruited by painting examination. We do, however, have information about how certain *jiehua* painters were, or could have been, recruited. For example, Wang Yun was recommended by Song Lao (1634–1713), governor of Jiangsu province.[40] Leng Mei was likely recommended by his teacher Jiao Bingzhen, as both Jiao and Leng came from Jiaozhou in Shandong province. Their teacher-disciple relation might have begun well before both artists were summoned to court service. Self-introduction by painters was also accepted during the Qianlong period. Both Xu Yang and Jin Tingbiao seized the opportunity of the imperial southern inspection tours and presented their art to the Qianlong emperor. They

were then offered high positions in the painting academy. In 1751 Xu Yang presented his work to the emperor, who was then visiting Suzhou. Xu was appointed first-class painter, having the same privilege and rewards as his seniors Ding Guanpeng and Yu Xing.[41] As one of the most significant *jiehua* painters—one who completed the *Qianlong Southern Inspection Tour* and many other important projects during the Qianlong period—Xu was offered the official title of provincial graduate *(juren)* and later promoted to secretary of the Grand Secretariat, ranked 7b, in the Qing bureaucracy.[42] Jin Tingbiao, a specialist of figural and architectural subjects, was summoned to court service after submitting his *Album of Lohan in the Baimiao Style* during the second southern inspection tour in 1757. His works were much treasured by the Qianlong emperor and were often inscribed by the imperial hand. After the death of Jin in 1767, the emperor requested that Jin's paintings be removed from the palace walls and preserved. He also granted Jin a seventh-grade official title, but whether the appointment was made before or after the artist's death is uncertain.[43]

Although imperial commands reigned supreme within the court, the degree of control exercised by the emperors over court painting varied. As mentioned earlier, during the Kangxi period, painters enjoyed a relatively high degree of freedom and could receive commissions from other patrons during their tenure at court. For instance, the Yangzhou painter Wang Yun served at the imperial court for seventeen years, but only two of his paintings are recorded in the imperial catalogue *Shiqu baoji*,[44] probably because many of the works he completed during his court service were done for other Manchu princes and private patrons. It is recorded that Prince Kang once burned a painting by accident and requested a replacement from court painters. Only Wang Yun could do it satisfactorily, and thereafter, Prince Kang had such a great liking for his art that the prince granted Wang a jade seal when the latter left Beijing in 1704.[45] Besides painting for Prince Kang, Wang Yun also worked in collaboration with Wang Hui on private commissions.[46]

The Qianlong emperor exercised great control over painting activity. During his reign, there were many instances where a scholar-official artist was commanded to work together with a professional *jiehua* painter on a single work, despite their difference in social status.[47] The Qianlong emperor often demanded topographical works of actual places he visited, and such works contain rich architectural images amid natural environments. Scholar-official artists such as Dong Bangda (1699–1769), Qian Weicheng (1720–1772), Li Shizhuo (ca. 1690–1770), and Zhang Ruocheng (1722–1770)—who were all working in the Orthodox styles of landscape painting—had to collaborate with *jiehua* painters in such works. In 1745 the scholar-official artist Dong Bangda and the professional painter Shen Yuan collaborated on a work depicting Fragrance Hill (Xiangshan) and another rendering Meandering Hill (Panshan).[48] In 1750 the landscape painter Zhang Ruocheng and the *jiehua* specialist Zhang Gao jointly painted the overall view and the individual scenes of the Summer Palace at Rehe.[49]

As most of the court painters came from southern China, they were often called southern craftsmen *(nanjiang)*. Of the southerners, Wang Yun came from Jiangdu (Yangzhou),

Chen Mei from Songjiang (Shanghai), Zhou Kun and Yu Xing from Changshu, Cheng Zhidao and Xu Yang from Wuxian (Suzhou), Jin Kun and Zhang Gao from Qiantang (Hangzhou), and Jin Tingbiao from Wucheng (Huzhou). The geographical mobility seemed to be one way: from south to north. However, on occasions where painters returned home because of illness, retirement, or family matters, there was a reverse direction in geographical mobility.

A brief account of the biography of Chen Mei will reveal the implication of geographical mobility on art development. Chen Mei was summoned to serve at the painting academy in 1726.[50] According to the *Guochao yuanhua lu*, during the Yongzheng period Chen was granted a special leave to go home for marriage. Later, after an eye injury, he got another permission to return home for retirement.[51] The archival record provides further information about this artist.

> The sixteenth day of February of the twenty-eighth year of the Qianlong reign [1763]:
>
> Your servant received a document from the Bureau of Manufactory in the Hall of Mind Cultivation (Yangxin dian). . . . The document states, "The painting *Going up the River on the Qingming Festival* was painted by Chen Mei. The artist might have brought back the draft to the south. Look into this matter and reply with a memorial to the throne." . . .
>
> As instructed, your servant investigated into the matter. Chen Mei was a native of Louxian, Songjiang. . . . He died in the tenth year of the Qianlong reign [1745] without any spouse and offspring. He had a younger brother Huan who ran a business for livelihood. When asked if his brother Mei had ever brought back the draft of *Going up the River*, he said he had never seen this painting or heard anything about it. Despite my effort to find the draft from all of Chen Mei's remaining paintings and old papers in the house, I could not find it. What his brother said was true.[52]

The above archival record mentions that Chen Mei did not marry but he did return home after retirement. More important, it reveals that painters might have taken drafts of court paintings to the south, although this was probably prohibited. If they did, court painting styles might have been spread to other parts of the empire in the same way that imperial publications were. On the other hand, before painters were summoned to court service, they were working in regional styles and must have attained a degree of technical virtuosity that enabled them to become court painters. By implication, geographical mobility of court painters, whether from south to north or vice versa, made possible the spread of various styles generated within the country.

That professional painters were eager to enter the court academy (as indicated by the tactic of self-introduction) was a hint of the attraction of court service. Besides prestige and financial rewards, court painters also enjoyed more benefits than they otherwise would have. The rare opportunity to travel to Beijing and finally to the interiors of the Forbidden City or the Garden of Perfect Brightness offered *jiehua* painters the best direct experiences of majestic imperial architecture, an exposure that in turn inspired their architectural paint-

ings. Court painters were also given the opportunity to view ancient paintings in the imperial collection or to interpret these works in their creative endeavors. Those not working at the court academy would have had little chance to gain access to a rich collection of ancient paintings comparable to that of the imperial collection.

For instance, the Qing court reinterpretation of *Going up the River on the Qingming Festival* certainly required an earlier prototype for reference. This was also true for other reinterpretations of ancient works. As stated in the archival records, in 1736 Shen Yuan was shown a version of *Spring Morning in the Han Palace* (the artist's name was not specified), and Shen was asked to reinterpret the painting with his own modification.[53] In the same year Chen Mei was presented *Celebrating Feng* by Qian Xuan (ca. 1235–before 1307) and was commanded to paint a new version based on it.[54] In 1738 Tangdai, Chen Mei, and Sun Hu were ordered to collaborate on the *New Feng* based on an earlier version by Lesser General Li (Li Zhaodao, ca. 675–741).[55] In 1747 Jin Kun, Cao Kuiyin, and Zhang Gao jointly reinterpreted the *Wangchuan Villa*.[56]

By offering court painters ancient paintings for imitation and reinterpretation, royal patrons (the Qianlong emperor in particular) played an active role in training and cultivating talents at the imperial court. Yet court painters were also conditioned to the imperial preference for particular styles and traditions. *Jiehua* painters of the Qianlong academy were commanded to model themselves on Jiao Bingzhen and Leng Mei, and this edict certainly had the effect of ensuring the continuity of the styles and traditions favored by the emperors. We may cite a few examples from the archival records for verification. In 1748 Shen Yuan was asked to copy Jiao Bingzhen's *Figures in Architecture and Landscapes* and to paint another version in the same style.[57] Yao Wenhan was commanded to paint with reference to the drafts of the *Four Preludes of Famous Gardens* by Leng Mei.[58] In 1749 Ding Guanpeng and Shen Yuan were asked to paint an album of genteel ladies based on the prototype by Jiao Bingzhen.[59] Evidently, the court academy had a steady supply of painters who could paint in the styles favored by the emperors.

Court *jiehua* artists were also exposed to European modes of representation. This exposure was the most direct within the court, as the court painters had the opportunity to meet European missionaries including the Jesuits, the Dominicans, the Franciscans, and the Augustinians. This exposure was also precious at a time when missionary activity in the country was restricted. These missionaries were working inside the court to gain acceptance from the emperors, in the hope that they would ultimately be permitted to preach their religion in the Qing territories. The missionaries had no choice but to obey imperial orders and entertain the emperors' varied interests in other aspects of their cultures, not just the religion that they represented.[60] To the Chinese court painters, these missionaries were both their instructors of foreign representational techniques and their counterparts who too were serving at imperial commands. Giovanni Gherardini (b. 1654) was the first to teach oil painting at the Kangxi court. He was said to be a painter of architectural perspective whose paint-

ings on the ceiling and the walls of the Church of Our Savior in Beijing had made a great impression on the Chinese.[61] Ferdinand Verbiest (1623–1688), an assistant of Johann Adam Schall von Bell (1591–1666), was granted an official position at the Imperial Bureau of Astronomy during the Kangxi era.[62] It was in that same institution that Jiao Bingzhen acquired the knowledge of Western geometry and perspective drawing and applied them to Chinese architectural painting. As mentioned earlier, Castiglione assisted Nian Xiyao in the translation of the *Perspectiva Pictorum et Architectorum* during the Yongzheng period. Later, Castiglione and Jean Denis Attiret (Wang Zhicheng, 1702–1768) were responsible for instruction in oil painting and linear perspective in the Qianlong academy.[63] A selected group of court painters including Shen Yuan, Ding Guanpeng, Zhang Weibang, and Wang Youxue were students of the foreign techniques.[64]

The coming of European missionary-artists to China had led to a Sino-European contact in art. This contact was particularly meaningful in architectural representation because the introduction of linear perspective and of light and shade for three-dimensionality could enhance the effect of verisimilitude, a desirable quality in Chinese architectural painting. But it is important to understand the degree of borrowing and the way Chinese painters created a new style in which foreign elements were blended with traditional techniques.

Linear perspective is a system of representing three dimensions on a flat surface based on the laws of optics. When a single viewpoint, or the height of the eye from the ground, is set, one gets the position of the horizon and the vanishing point to which all parallels or orthogonals converge. All these will determine the heights and sizes of various objects placed in varied distances. The system assumes a stationary point and a picture plane as an "open window" through which a continuous spatial continuum can be seen.[65] To apply linear perspective to the representation of a Chinese courtyard, the European painter presents the north-south axis of the compound in a vertical manner so that it also falls on the axis of symmetry of the picture plane. The receding lines converge to the vanishing point that lies on the central axis. It is under a geometrical organization of all the buildings that the architectural framework is tied together to achieve pictorial unity (plate 4). When the Chinese painter employed the foreign technique in architectural representation, however, he tended not to feature the centrality of the vanishing point. He neither included a "concrete, material sign" in the composition nor gave it any symbolic meaning.[66] By presenting the axial way diagonally (not vertically as to be shown in the European depiction), he placed the vanishing point beyond the left or the right margin of the picture plane (plate 5).

Since linear perspective was a novelty to Qing Chinese painters, they were at an early stage of comprehending the new system and tended to relate it to what was familiar to them. They still followed the traditional convention of *yiqu baixie*, whereby spatial recession was defined diagonally by slanting lines and the axial way was presented in a diagonal manner. The new system, however, did provide them with a new possibility for organizing the converging diagonals. It also enabled them to order their experiences of architecture by pre-

Patrons and
Painters

senting the intervals between structures. In this regard, the new, "synthetic" style was particularly meaningful, as it marked a Qing departure from the Ming manner of representing impenetrable structures.

The constant association of the newly introduced foreign techniques with what was familiar to the Chinese painters was also reflected in the writing of Nian Xiyao. Nian translated and adapted the *Perspectiva Pictorum et Architectorum* by Andrea Pozzo. In his preface to the second edition, *Shixue*, he explained the reason for borrowing the foreign techniques and applying them to architectural representation: "[To depict] towers, pavilions, vessels, and objects in compliance with the rules without discrepancy, we cannot exhaust all the principles nor make the greatest accomplishment unless resorting to the Western methods." Acknowledging his indebtedness to Castiglione, who taught him linear perspective, Nian stressed the importance of understanding "the Western methods." He expounded,

For every aspect of linear perspective—such as facing upward, converging, overturning, sloping, reversing, viewing from below or above—there is no single aspect that does not begin with a point. If we study thoroughly the principle of one point, [we will notice that] this is not solely possessed by the West. Nor is this missing in our Central Territory.

When we view an object, the near appears large and the far appears small. It must have its principle—just as the Five Mountains are the largest in size, and when viewed from far away, their size diminishes with increasing distance until they end up as tiny dots. A mustard seed is the smallest in size, and if placed at a distant spot, it cannot be seen even though we look deeply through a tiny hole. Beyond the limits of our sight, the principle of one point still applies.

To reason from this, all things can be as tiny as one point, and one point can give rise to all things. Since they all originate with a point, this is the initial point *(toudian)*. Points extend to form lines, and lines defines things. Although things have categories and are different from points and lines, these categories are but different names. The principle remains the same. If a thing is placed five *chi* [i.e., five feet] in front, it is of a certain size; if placed one *zhang* [i.e., ten feet] in front, it is of another size. Points that mark them off are called distant points *(lidian)*. Whether near or far, the distance has a fixed principle.

Use this method to depict a building and arrange all things neatly so that the viewer feels that he is walking through the steps, entering the door, and ascending to the innermost recess of a hall without recognizing that this is only a painting. Or try to paint something to be hung from the center. Its height, concavity, flatness, slope, and every facet will be seen. Try also to borrow the light and throw it on all things. Then shadows will become obvious. There is no viewer who does not call them the real things.

Things borrow *yinyang* to become convex or concave; buildings are concealed and exposed to get dim and deep. Aren't they the wonders of the Western methods? It is difficult to fully expound the methods. All we need to know is, first, to begin with a point and a line to get the near or far distance. Then, examine *yinyang* to clarify the substance and the function of things. Further, seek the heavenly light to achieve the wonders. In this way, divergence or convergence,

similarity or difference—all changes of the divinities will be presented in these three processes. . . . One may say that the changes of all categories of things are due to the development of points and lines. The study of vision is the vehicle for investigating the origin of these methods.[67]

Drawing upon the common visual experiences of the Five Mountains and a mustard seed, Nian stressed that the one-point principle was also found in Chinese cultural tradition. He related these observations to the law of optics in the West: the relationship between point, line, and thing is that between the point at which the visual rays pass through the lens of a human eye (point), the visual ray (line), and the image projected upon the retina (thing). He therefore arrived at the idea that "all things can be as tiny as one point, and one point can give rise to all things."

However, Nain failed to understand that the different cultural orientations of European and Chinese artists had developed very different ways of seeing and representing. When he discussed the Western representational concerns of light and shade, he borrowed the native idea of *yinyang*. Particularly revealing was his conclusion that "the changes of all categories of things are due to the development of points and lines," a statement that shows he was relating the newly acquired scientific knowledge to the native idea of the changes of nature. His writing reveals that preexisting native conceptions were impossible to discard overnight.

Nevertheless, Niao's writing tells us specifically why the Chinese would be fascinated by "the wonders of the Western methods": "the viewer feels that he is walking through the steps, entering the door, and ascending to the innermost recess of a hall, without recognizing that this is only a painting." The fascination with pictorial illusion explained why the new methods had been applied to interior decorations so that walls and ceilings gave the appearance of extended space from the interior (fig. 2.5).[68] Such potentialities of "the Western methods" were also acknowledged by those who did not prefer the new techniques. The negative comment of Zou Yigui, a scholar-official artist at the court, is revealing:

> The Westerners are skilled in geometry. Thus when they depict light and shade and distance they are precise to the last detail. All the human figures, houses, and trees in their paintings have shadows trailing behind them. The colors and brushes they use are completely different from those used in China. When they paint a scene, the perspective is presented as from broad to narrow, calculated mathematically. Their mural paintings depicting palaces look so real that one is almost tempted to walk into them. Students of art may benefit somewhat if they learn a few such clever techniques. However, being completely lacking in the mastery of the brush, such painting, though elaborate, is after all nothing but craftsmanship, and therefore cannot be classified along with paintings of quality.[69]

The debate about the pros and cons of the European representational methods was itself sufficient to reveal the excitement and the tension felt by the Chinese painters about the importation of the foreign techniques. These different attitudes must have been felt more

Fig. 2.5. Artist unknown, Qing dynasty: Painting affixed on the wall of the Lodge of Retiring from Hard Work (Juanqin zhai) in the Forbidden City. Such paintings, referred to as *tieluo* in Chinese, created the illusion of extended space and were used for the interior decorations of Qing palaces. From *Orientations* 26, no. 7 (July/August 1995), 52.

intensively within the court, where the emperors were fascinated with European art and other scholar-official artists disparaged the new techniques.

Let us sum up the discussion about conditions within the court that might have exerted an influence on *jiehua* painters. Because of the imperial demands for architectural paintings and other works on topographical views, pacification, or state ceremonies, a substantial group of *jiehua* artists—many of whom were southerners—were recruited. While working at the imperial court, they were open to new sources of inspiration: ancient paintings in the imperial collection, experiences of grand imperial palaces, and foreign representational techniques. However, experimentations in both themes and styles were subjected to imperial authority. Artistic endeavors were restrained by the demands and approval of the emperors, the major patrons of architectural paintings during the Qing.

Outside the Court

Prosperity returned to major towns and cities after a period of consolidated Qing rule. The influential studies of William G. Skinner provide a framework for analyzing geographical regions and economic networks in premodern China. Positing a division of premodern China into nine macroregions that transcended provincial boundaries, Skinner identifies

a "core" and a "periphery" of each macroregion. The core covered the most densely populated and highly commercialized portions; the periphery covered the sparsely populated areas with a low level of commercialization. Within this core-periphery relationship was an integrated system of "central places," which exhibited a hierarchy of markets, a close relationship between village and town, and a transfer of resources (e.g., capital investment, population, skill, wealth, cultural amenities) from lower to higher levels of the hierarchy, as well as a regular migration and sojourning of the population.[70] Beijing in the macroregion of northern China and Suzhou in the macroregion of lower Yangzi were the central metropolises during the early- and middle-Qing periods. Other major cities such as Hangzhou, Nanjing, and Yangzhou were regional metropolises in the urban hierarchy.

It was no coincidence that the resurgence of architectural paintings took place in all these urban centers. As mentioned earlier, court painters were mostly southerners coming from Suzhou, Hangzhou, Yangzhou, or other major southern cities, and there was a migration of painters to the court, where architectural paintings were in great demand. Those who traveled northward to become court painters were but a tiny minority of the population. Many other professional painters relied on private commissions and sold paintings in various urban centers.

Outside the court, art developments were much more complex because of the dynamic nature of social and economic activities. As networks of roads established economic and cultural ties between important cities, diffusion of cultures among urban places had great implications on the spread of art. If we also consider the geographical mobility of the population as well as the networks of merchants (who were a highly mobile occupational group and who tended to commission works of art), then architectural paintings should not be popular in just one or two major centers but should spread to the whole country.[71] In addition, myriad craftsmen or lesser painters sometimes added architectural elements to portrait paintings, New Year paintings, prints, lacquerware, or porcelains. The scale of *jiehua* production within the country was substantial.

The Case of Yangzhou

To understand the production of architectural paintings outside the court, I focus on Yangzhou. I chose to study Yangzhou because of various considerations. First, Qing Yangzhou earned its reputation as an important art center, with productions sponsored by private patrons. Mercantile patronage in Yangzhou was so substantial that it almost rivaled imperial patronage in Beijing during the middle-Qing period. Second, garden construction was in vogue in Yangzhou, and this trend had the effect of promoting the revival of architectural painting. Third, prominent painters of Yangzhou origin a left behind spectacular works. The existence of a regional school, the Yuan school, further confirmed that massive production of architectural paintings was sustained by huge demand.

Yangzhou assumed economic prominence because of the Lianghuai salt business. Salt merchants amassed tremendous wealth and constructed private gardens, transforming Yangzhou into a beautiful garden city.[72] The image of the city, as recorded by Li Dou in the *Yangzhou huafang lu* (preface dated 1795), was best revealed in the saying that "Hangzhou is famous for its mountains and lakes, Suzhou for its markets, and Yangzhou for its gardens."[73] The *Yangzhou huafang lu* also provides many examples showing that garden culture in Qing Yangzhou was more than the mere acquisition of private estates. It also entailed a whole set of social and cultural practices including elegant gatherings, sociability between hosts and guests, and commissions of works to immortalize gardens and events. In that sense, Yangzhou's garden culture was indebted to that which once flourished in Ming Suzhou. This heritage was made possible because of the location of Yangzhou. Belonging to the Jiangbei region geographically (the part to the north of the Yangzi River), Yangzhou nevertheless lay within Jiangsu province during the Qing and was often regarded as a Jiangnan city.[74] Constructions of southern-style gardens and pursuits of the garden culture that was once popular in Suzhou exemplified the southern appeal of this Jiangbei city. In addition, Yangzhou lay between north and south China and was endowed with a network of waterways, including the Grand Canal and the Salt Transport Canal. Not only did the Lianghuai salt trade benefit from the communication network; the network also made cultural diffusion possible, and thus Yangzhou became the locus for interchange of ideas and cultural practices generated within the country.

Merchants and gardens did not represent the whole picture of seventeenth- and eighteenth-century Yangzhou. There were other spaces and other peoples, even though the merchants' gardens were dominant in the city.[75] Yangzhou's population was a conglomeration of numerous groups from various social strata. Besides the Yangzhou natives, there were sojourners and tourists who came to the city because of its economic opportunities or beautiful scenery. The influx of population as a result of economic prosperity was substantial, and the composition of society was on a significant scale for painters to explore the art market.[76]

Who were the patrons of architectural paintings in Yangzhou? What were their motives behind the commissioning of such works? There are no ready answers to these questions. Potential patrons include officials, gentry, and merchants, and individual reasons for commissioning works of art varied. The prosperity of Yangzhou garden culture certainly had great implications for the development of architectural painting, as garden owners increasingly requested portrayals of their own gardens. But other patrons demanded *jiehua* of various subjects, such as works depicting historical buildings or the immortals' paradise. So it was a matter of taste or individual preference in the choice of particular painting themes and styles. In the interpretative studies in later chapters, I posit the meanings of various themes in an attempt to detect some possible reasons for private patronage of *jiehua* outside the court.

Yangzhou *Jiehua* Painters

Famous *jiehua* painters from Yangzhou include Li Yin (late seventeenth–first half of eighteenth century), Yan Yi (1666–after 1749), Wang Yun, Yuan Jiang, and Yuan Yao (active ca. 1740–ca. 1780). All these painters, except Yuan Yao, were active in the late Kangxi and Yongzheng periods. Li Yin was active at a slightly earlier time, whereas Wang Yun, Yuan Jiang, and Yan Yi were contemporaries.[77] Yuao Yao, the disciple of Yuan Jiang, belonged to the next generation of Yangzhou *jiehua* practitioner, who extended the longevity of the Yuan school into the Qianlong period. As the lives of all these professional painters were mentioned only briefly in standard biographical texts, we do not know much about their biographies and activities.

Li Yin is commonly mentioned together with Xiao Chen (late seventeenth–first half of eighteenth century) in literary records.[78] The *Yangzhou huafang lu* mentions that they enjoyed equal prominence in painting,[79] but we are not sure whether critics considered them as rivals in architectural painting. Xiao Chen was better known as a poet-painter who excelled in rendering figures and snow scenes.[80] Architectural renderings in his paintings often provide the setting for human activity, especially in works with anecdotal themes. Unlike Li Yin, Xiao Chen did not seem to have specialized in architectural representation. By contrast, the achievements of Li Yin in the genre of architectural painting were much emphasized in literature.[81] According to the *Shuhua sojian lu* by Xie Kun (second half of the nineteenth century), Li Yin's architectural images are well proportioned: "Even an experienced carpenter fails to find any discrepancies between his images and actual buildings."[82] The praise was to liken Li Yin's architectural paintings to the works of the Song masters.

Yan Yi was the student of Li Yin, from whom he learned architectural representation.[83] Wang Jun, in the *Yangzhou huayuan lu*, remarked that Yan Yi reached a level of sophistication in his outlining *(gou)* and hacking *(zhuo)* techniques that was unsurpassed by Yuan Jiang.[84] Despite his technical virtuosity, Yan Yi did not seem to have enjoyed much recognition. Wang Jun lamented that an artist as skilful as Yan Yi had never been mentioned or praised in any literary record. Fortunately, Wang happened to see several tens of Yan Yi's works and recognized his accomplishments.

The painter Wang Yun had served at the Kangxi court for seventeen years before he left Beijing in 1704. After that, his life was not mentioned in any literary sources. Judging from an extant work of 1715, *The Garden of Repose*, about an actual garden in Yangzhou, it is likely that Wang Yun returned to his native place, Yangzhou, where he painted for private patrons.[85] His painting activity continued even at the venerable age of eighty. This is indicated by his inscription in one of his paintings, now in the Yangzhou City Museum, which states that he was eighty years old in 1731.[86]

Yuan Jiang is today the best-known *jiehua* painter from Qing Yangzhou, partly because

he left behind numerous works and partly because a group of disciples extended his influence beyond his scope of activity. Recent studies have attempted to remove the mysteries of his life, especially the doubts about his alleged court service in the Yongzheng era as well as his period of activity,[87] yet these studies have not arrived at a consensus regarding these two aspects of the artist's biography.

Regarding Yuan Jiang's alleged court appointment, primary sources such as the *Guochao huazheng xulu* (1739) by Zhang Geng and the anonymous text *Huaren buyi* mention that he was a painter-in-attendance at the inner court. The latter even specifies his appointment to the Outer Hall of Mind Cultivation (Wai Yangxin dian).[88] The *Yangzhou huafang lu*—which was published later than the *Guochao huazheng xulu*—does not mention Yuan Jiang's court service. Nor do the imperial catalogues *Shiqu baoji*, *Shiqu baoji xubian*, and *Shiqu baoji sanbian* record any works by Yuan Jiang in the imperial collection. Moreover, visual evidence does not show the use of the official title *chen*—an expected practice when a court painter signed a work—in Yuan Jiang's signature.[89] From this array of information, Nie Chongzheng of the Palace Museum argues that Yuan Jiang had never served at the court academy. This argument is further supported by his examination of the palace's archival records, which give no indication of Yuan Jiang's activity in the Yongzheng academy.[90] Richard Barnhart, however, offers another interpretation of Yuan Jiang's "appointment to the Outer Yangxin Palace," suggesting that the painter might have served in the palace for Prince Yi, who was enfeoffed during the years 1723–1730. His argument is based on a surviving painting in the William Ahern collection of East Providence that bears a seal of Prince Yi.[91] The evidence seems to match with literary records in many respects, but without any other evidence to confirm the relationship between Prince Yi and Yuan Jiang, a collector's seal in a lone example is insufficient to establish their connection or confirm Yuan Jiang's court service.

Yuan Jiang had probably traveled to Beijing at the beginning of the Yongzheng era. An entry in Guo Weiqu's *Song Yuan Ming Qing shuhuajia nianbiao* records that Yuan Jiang painted a landscape painting at Yantai (Beijing) in 1724, and this source is based on Guo's examination of the painting.[92] In addition, an undated work by Yuan Jiang in the Phoenix Art Museum is based on the theme of civil service examination, a rare theme in Yuan Jiang's repertory. Could this painting have been requested when Yuan Jiang was staying in the capital?[93] Even with these examples, one can, at most, ascertain that this Yangzhou artist had traveled to Beijing.[94] Unless new evidence comes to the surface, existing materials are insufficient to prove his service at the imperial court, whether he worked at the command of the emperor or for any Manchu prince.

Scholars give different accounts about Yuan Jiang's period of activity. The period was generally accepted as the Kangxi and Yongzheng eras.[95] Yet different views arise because Yuan Jiang dated his works with cyclical years only, and any misplacement of his paintings in chronological order will involve a sixty-year deviation.[96] As Ju-hsi Chou has observed, the sixty-year interval is critical as it may confuse a young novice's works with those of a ma-

-ture artist.[97] From the various lists of Yuan Jiang's dated works compiled by scholars, one can establish the time frame of his activity as from the 1690s to the 1730s. Paintings falling outside this range have been regarded by Cahill, Barnhart, and Nie as the "later works of the 1740s." Cahill has remarked on the decline in quality in such "later" works,[98] to which Chou responds by suggesting the possibility of "redefin[ing] the symptoms as reflecting the hand of a novice painter."[99] Alfreda Murck reattributes all the "later works of the 1740s" back to the 1680s.[100]

However, if we take into account the availability of Yuan Jiang's disciples, who extended the longevity of his art into the Qianlong period, there is another possibility: that those works of the 1740s were actually painted by Yuan Jiang's disciples but signed with the master's name. The incipient attempts of the disciple of the Yuan school should be different from those of the novice Yuan Jiang, as the disciple would display in his art a range of motifs and schemata inherited from the master.[101] Consequently, it may be necessary to examine the art of the Yuan school as a whole.

There is ample evidence showing that Yuan Jiang's styles were followed by his many disciples, among whom Yuan Yao was the most prominent. The kinship of the two Yuans, if any, has always been difficult to verify. The *Huaren buyi* states that they were father and son,[102] whereas the *Qinghua shiyi* suggests that they were uncle and nephew.[103] No matter—it is my contention that Yuan Yao was a generation younger than Yuan Jiang and that the former learned directly from the latter. Yuan Yao's dated works fall into the range from 1739 to 1780, commencing when Yuan Jiang had ceased his production, and his period of activity lasted for some forty years. The respective periods of activity of the two Yuans confirm their teacher-disciple relation, not what Barnhart has suggested—that they were almost exact contemporaries and were probably brothers.[104] Perhaps the period of activity of Yuan Yao can be extended back to some twenty years earlier (1720s) when he studied architectural depiction with Yuan Jiang, who was then a mature artist.

Other disciples of the Yuan school include Yuan Mo, Yuan Xue, and Yuan Shao, who are all represented by only a few surviving paintings in the style of the Yuan school.[105] Their common surname Yuan may suggest the kinship of the group, but one cannot establish their relations without any biographical records. There was also a lesser-known painter named Tan Song, whose painting in the Metropolitan Museum of Art displays a stylistic resemblance to the works of the Yuan school.[106] If a number of such artists can be detected, if their individual extant works are scanty, we may suspect that the Yuan school was operating in a studio administered by Yuan Jiang and later by Yuan Yao.

The formation of a regional school that functioned practically as a studio certainly had the effect of accelerating production of architectural paintings in Yangzhou. This studio production to meet market demands also sheds light on the power of market force on art production. By specializing in a particular painting genre and developing a set of motifs and schemata to attract customers, Yuan Jiang established a trademark of his own. When fame was achieved, his works were in great demand, and the maintenance of a studio be-

came necessary. This whole situation reflected the success of the school in the commercial art market.

Generally speaking, professional painters working under private patronage in Yangzhou were different from their counterparts at court in many ways. Although they shared the experiences of professionalism, outside the court there was not any formal institution to provide painters with institutionalized experiences (e.g., viewing the imperial collection or learning the styles favored by the emperor). Instead of the supreme force of the imperial command, the market force, or the demands of individual patrons, affected painters' activities. The experiences of individual painters varied. What they all shared was the common experiences of living in Yangzhou, a prosperous urban center, and the things that urban prosperity could offer. Few city residents were unaware of typical urban landmarks, such as city walls, moats, drum and bell towers, Confucian and city-god temples, magistrates' offices, military barracks, and examination halls.[107] Besides these important landmarks, there were numerous restaurants, shops, theaters, private mansions, and even garden villas in urban areas. Another important component of urban culture was literacy, which was stimulated by the flourishing of the printing industry. Illustrated novels, dramas, poems, textbooks, and painting manuals attained wide circulation, implying that painters were not unfamiliar with the pictorial images found in prints.

The opportunity for individual painters to gain access to ancient paintings depended on the relations between them and private collectors. In Qing Yangzhou, one who was invited to an elegant gathering held in a private garden had a higher chance of viewing works of art in private collections. And if the artist established webs of connections with garden owners, officials, or scholars, this web also increased the opportunity to see more private collections. The architectural landscapes of Li Yin, Yan Yi, Yuan Jiang, and Yuan Yao often bear inscriptions indicating the intentions of these painters to imitate the styles of certain Song masters. There was a conscious attempt to revive the academic landscape tradition stemming from Guo Xi (c. 1020–1090). The monumental landscapes rendered by these Yangzhou painters feature a sequence of dynamic movements of interlocking forms to establish a predominant structure of towering height. The serpentine mountain movement exemplifies a new trend of landscape configuration developed in seventeenth-century Yangzhou (figs. 2.6 and 2.7).

If Song monumental landscapes had served as a point of departure for these professional painters, we may ask if they had ever seen the original works of Guo Xi or other Song paintings. Li Yin's inscription on his landscape of 1702, now in the Freer Gallery of Art, is worth mentioning:

Of all the Guo Xi paintings I've seen, about half were genuine and half fakes. The genuine ones that I happened on, I genuinely studied, and the fakes I studied as fakes. But from the time of my boyhood, my understanding hasn't been too profound, and it is easy to confuse the two. Altogether, I must have come upon some hundreds of thousands. All of those who esteem me

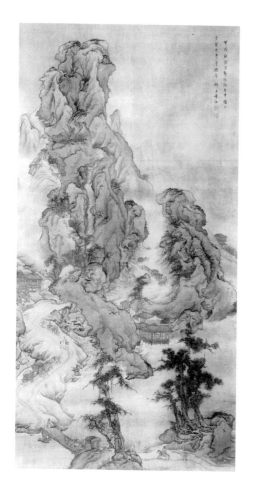
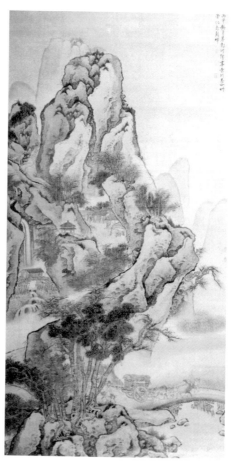

Fig. 2.6. (Far left) Yuan Jiang (active ca. 1690 – ca. 1740): *Carts on a Winding Mountain Road.* 1694. Hanging scroll, ink and color on silk. The Nelson-Atkins Museum of Art, Kansas City, Missouri (Purchase: Nelson Trust), 31-151. The artist states in the inscription that he is making a copy of Guo Xi's (c. 1020 – 1090) painting. What is presented, however, is a new vision of landscape characterized by the flow and flux of the mountain movement to suggest an underlying organic structure.

Fig. 2.7. (Left) Yan Yi (1666 – after 1749): *Landscape with Travelers in the Manner of Guo Xi.* 1716. Hanging scroll, ink and color on silk. Palace Museum, Beijing. Here, the rock masses mount up to towering heights. The mountain movement ascends to the summit, then is continued with a fall, expanding back to envelop a valley in which some *jiehua* elements are found.

take me to be a genuine Guo Xi. Because of this, people compete in offering me money and gifts to get my paintings, afraid that they will be too late.[108]

As Cahill has pointed out, it matters little whether Li Yin was familiar with any genuine works of the Song master. What matters is his reinterpretation of the Guo Xi manner,[109] as Li Yin had established his reputation as a practitioner of the Guo Xi style. If his painting was taken as "a genuine Guo Xi," his works would certainly exert an influence on other painters, whether they had seen the originals or not.

Yuan Jiang was reported to have initially studied the style of Qiu Ying, but during his middle years, he made a big stride after he obtained an anonymous copy of the sketches (*huagao*) by the ancients.[110] Without any further information about the contents of these sketches, we do not know how the copy inspired Yuan Jiang. Other than the mention of the sketches, there is no further account about how Yuan Jiang learned from the ancients. Had he ever served as a painter-in-residence in wealthy families and gained access to private col-

Patrons and Painters

Fig. 2.8. (Above) Monk Shizhuang (late seventeenth–first half of eighteenth century): Leaf from *Eight Topographical Scenes of Tiantai* showing the use of heavy shading for three-dimensionality. 1706. Ink and color on silk. Private collection.

Fig. 2.9. (Right) Artist unknown, Qing dynasty: *City Gate at Suzhou*. 1734. Woodblock print, color filled. The Ohsha'joh Museum of Art. This dated piece suggests that professional artists and craftsmen working outside the court were familiar with European perspective drawing no later than 1734.

lections? There is an oral account in mainland China saying that both Yuan Jiang and Yuan Yao had stayed for an extended period with the Wei family in Taiyuan, Shanxi province. According to the same source, many of the surviving paintings of the two Yuans were sent from Shanxi to the antiques stores in Beijing at the beginning of the twentieth century.[111] If these painters had stayed in Shanxi for an extended period, would that fact also imply the accommodation of the whole studio in the Wei family? Notably, objects moved and merchants were a highly mobile group. Merchants might bring back paintings they acquired in Yangzhou when returning to their hometowns. There is so far a lack of evidence to verify the painters' sojourn in Shanxi or their acquaintance with the Wei family.

For Yuan Yao and other members of the Yuan school, their roles as the inheritors of the school also meant that they would use their master's works as the major, if not the only, source of inspiration. With the exception of Yuan Jiang, the founder of the school, the rest

of the Yuan school painters were producing under certain stylistic prescriptions. This happened especially after the school had become famous or when patrons specifically demanded works representative of the school. In this regard, the Yuan school painters were not unlike their counterparts at the court academy, as all these professional painters were participating in team productions. While court painters were working in response to the imperial demands, the Yuans were repeating established styles in order to perpetuate the school's reputation.

Another aspect for comparison was the artists' contact with Western art. Unlike their court counterparts, who worked together with European missionary-artists, Yangzhou painters did not directly receive any formal instruction in European art. Because the Kangxi emperor was dissatisfied with the papal stance on Chinese rites,[112] Christianity was banned outside the court, and missionaries, except those serving at court, were expelled. However, contact with foreign things that appeared within the country did not cease. As mentioned earlier, Yangzhou's geographical position made possible the exchange of ideas and cultural practices that occurred in both northern and southern China. Yangzhou architecture, for instance, had incorporated some foreign elements. In the *Yangzhou huafang lu*, a building near the Green Poplar Bay (Luyangwan) is recorded to have the following exotic designs:

> In front was a verandah, fenced with a balustrade. Behind that was a spacious hall, which appeared like a thousand suites of rooms. Each turn around the house gave one a new sense of bewilderment. One would hear the chime of bells and make his turns accordingly because there was a clock in the building and the bells would synchronize with each turn one took. On one wall were paintings of mountains and rivers, oceans and islands. On the opposite there was a mirror under a light, which reflected the painted scenes. Above was a dormer, which allowed sky light and cloud shadows, sunshine or moonlight to add their parts to the exquisite sight.[113]

We also find evidence of the borrowing of foreign stylistic elements in painting. *Eight Topographical Scenes of Tiantai*, a rare set of paintings by the monk Shizhuang (late seventeenth–first half of eighteenth century), take in such foreign elements as cast shadows and light and shade in representation (fig. 2.8).[114] This album confirms that painters working outside the court were also conscious of the importation of European art. Shizhuang, a student of Zha Shibiao (1615–1698), befriended famous artists of the day. His monastery in Yangzhou was a "painting-boat" (*shuhuafang*) frequented by artists,[115] and Western art was probably one of the topics discussed by artists who gathered at his monastery.

In another cultural center, Suzhou, New Year paintings had incorporated perspective drawing, as indicated by the *City Gate at Suzhou* (fig. 2.9). How did Suzhou printmakers acquire the foreign representative techniques? It still remains to be established whether they learned the new representational techniques from painters in service at the court or from other Western prints coming via Guangdong port.[116] Inasmuch as prints allowed circulation to a wider audience, the employment of the foreign representative techniques in this particular medium made possible a widespread awareness of the new methods. Given

the geographical mobility of the Qing population, it was highly probable that Yangzhou painters had the opportunity to see these prints.

As we have seen, the resurgence of architectural paintings in Yangzhou was a result of economic prosperity, which in turn affected the material and cultural life of the urban population. Outside the court, even if there was no institutionalized program for painters to learn from the ancients or from the foreigners, there were other mechanisms that provided them with various sources of inspiration. Paintings in private collections, copies of the ancients' sketches, the master's works in a studio, and folk art were all possible sources for professional *jiehua* painters working outside the court.

The Qing Imperial Domains

COURT REPRESENTATIONS I

3

A FAIR PROPORTION OF Qing court paintings, whose original functions were to commemorate the glories of the emperors and to project images of rulership into the cultural patterns of their subjects, portray royal palaces and record state events. Qing imperial estate portraiture overlaps with the traditional category of *jiehua* because they both feature architecture as the principal subject. But many other Qing court paintings of contemporary themes, whether narrative or genre paintings, contain rich architectural images that had political symbolism. Part of the interest of this subject, especially in the context of a collaborative project, lies in the political significance of images and hence the potentially polysemic messages of a work. In this chapter I will point out how architectural images in these court paintings served as symbolic forms through which meanings were constructed. I will also examine how styles were directed, at least in part, toward casting themes in certain ways that signified this process of construction of meaning.

In an attempt to address their Han Chinese subjects, the Qing emperors presented themselves as Chinese-style monarchs and took on different modes of life governed by the moral code of Confucianism. The ultimate purposes, as suggested by recent historical studies, were to exercise Qing imperial control and to achieve "transcendence of monarchy over other cultural authorities of the realm."[1] In the process of defining themselves within a specific cultural frame, the emperors relied on various architectural settings as designated imperial space in which they performed the appropriate ritual actions. They also relied on grand palaces as outward physical manifestations of the awe and majesty of the imperial presence. In relation to these were various boundaries, abstract or physical, that were required to enhance Qing imperial authority—for example, the social bound-

aries between the Qing ruler and all his subjects and between the Son of Heaven and the Chinese people, the cultural boundaries that separated the diverse cultures coexisting under the Qing, or the physical boundaries of the royal palaces and of the Qing domains at large. All these boundaries were key elements in the ordering of the Qing empire, and they were also the essential ingredients contributing to the meaningful lives of the emperors. In this study I identify three different types of contemporary architecture that were relevant to the process of boundary making through pictorial representations: ritual spaces, imperial palaces, and cities. Despite this classification, it is important to note the occasions where the dividing lines between categories are blurry. For example, both palaces and cities could be used for conducting rituals, and the Qing imperial palace was in itself a forbidden city in the capital. For the convenience of thematic and stylistic analyses, however, it is useful to identify these three categories of architecture and to study each of them in relation to the pictorial conventions of narrative, topographical, and genre paintings.

Ritual Space

As conquerors, the early Qing emperors had to legitimize their rule and their new sovereign power in China. Legitimacy involves the basic issues of what gives the ruler and his or her government the right to exercise power and what makes the people believe a government to be legitimate. In premodern China the right of an emperor to exercise power was justified by the Mandate of Heaven. The emperor performed state sacrifices to Heaven and Earth to symbolize his taking up of the position as Son of Heaven. Because of this marriage between religious and political forces, the outcome of political changes appeared to be unalterable and unchallengeable by human beings.[2]

Besides relying on Heaven's mandate for power legitimization in China, the Qing regime pursued policies of patronage, control, and manipulation of Chinese culture, under which Chinese religious beliefs and practices were continued. The Qing approach to Chinese religion was to impose a structure on Chinese religious life without dictating the content.[3] According to the Qing structure of Chinese institutional religion, official sacrifices were categorized into three levels: grand sacrifice (dasi), middle sacrifice (zhongsi), and common sacrifice (xiaosi). Grand sacrifices were performed by the emperors to Heaven, Earth, the imperial ancestors, as well as land and grain. Of all these worships, the ones to Heaven and Earth—which were performed respectively during winter and summer solstices—were the supreme form of state offerings. Middle sacrifices were offered to the Sun; Moon; the god of agriculture; the god of sericulture; the spirits of wind, rain, thunder, clouds, mountains, and rivers; the emperors of previous dynasties; and sages, wise men, and so on. These sacrifices were undertaken by the emperor, the empress, or delegated officials. Common sacrifices included those devoted to the god of war, the god of literature, the three emperors, the god of fire, the god of dragon, and the city god. These sacrifices were performed by local officials at cities from Beijing down to the district level. All the aforementioned ritu-

als were graded to reflect the Chinese concern with hierarchical order, and they had the effect of placing the Son of Heaven within the Chinese cosmic order and thus reinforcing the boundary between the emperor and his subjects. In addition to their Manchu shamanic observances, the Qing emperors participated in Chinese state sacrifices on the grand and middle levels and followed other Buddhist or Daoist practices.

Paintings in commemoration of the emperor's ritual actions, like the rituals themselves, served to reiterate Qing imperial authority. These paintings often contain architectural elements that define ritual space for structed human activity. *Jiehua* of this type—viewed in the context of narrative painting—makes full use of the horizontal format of a Chinese handscroll to present a course of events. Architectural images are narrative elements that specify a venue as well as vehicles for symbolic communication. When scenes and acts reinforce each other, the ritual theater being depicted becomes spatially and temporally dynamic. All these effects bring the commemorative function of a narrative painting into effect.[4]

Sacrifice at the Altar of Agriculture, a two-scroll set depicting the state worship to the god of agriculture, Xiannong, is one of the most important surviving court paintings showing a middle-level religious sacrifice in which the emperor participated. Although the authorship and the exact year of production are unknown, the portraits of the Yongzheng emperor in these two scrolls suggest that these were commissioned under his reign. The first scroll depicts the emperor's procession toward the altar of agriculture; the second portrays the ceremony of the first plough after the worship at the altar.[5] Because of the religious significance of the altar—which is also a major *jiehua* element in this set—I choose to focus on the first scroll for detailed analysis (fig. 3.1).

Scroll 1 begins with an imperial procession toward the altar of agriculture. There is a clear indication of the processional route. The altar—which is the final destination of the procession—is a simple square structure symbolizing the element Earth. It is decorated in accordance with the Chinese ritual regulations recorded in the *Daqing huidian*.[6] On the altar are two yellow shelters: one covers the spirit tablet of the god of agriculture and various sacrificial objects, including precious bronzes, wine, food, animals, and lighted candles;[7] the one on the opposite side shelters the emperor during the worship. Only a few officials are allowed to ascend the altar, and their specific locations are also stated precisely in the ritual handbook. Below the altar are musicians and high officials, who are standing attentively to wait for the emperor's arrival.

Technically, this scroll displays very simple *jiehua* technique whereby ruled lines mark out the boundaries of the route and the altar. These lines define a continuous ritual space and help suggest a sequence of subsequent events that are about to take place. As the point of origin, the route, and the final destination are clearly defined, the viewer expects the procession to turn direction and progress toward the altar. The entourage will stand below the altar while the emperor, probably with a few officials, will ascend the sacred space. Because of the directional indication of this well-defined ritual space, the course of events can be anticipated without a full record of every single deed of the participants.

Fig. 3.1. Artist unknown, Qing court academy: *Sacrifice at the Altar of Agriculture*, scroll 1, showing the Yongzheng emperor's procession to the altar of agriculture. Handscroll, ink and color on silk. Palace Museum, Beijing. From Gugong bowuyuan, ed., *Qingdai gongting huihua* (Beijing: Wenwu chubanshe, 1992), pl. 43.

Symbolically, the use of *jiehua* to define an architectural environment for the imperial ritual activity serves to position the Qing emperor in the Chinese hierarchical order. In this painting we witness power moving in the space-time continuum defined by the *jiehua* work. While the emperor is walking along the passage, he is symbolically passing through a process of affirming his position as Son of Heaven in the Chinese cultural tradition—a tradition that grants him special power to communicate with the gods at high levels. The elevated altar to which he ascends to worship in the presence of the god of agriculture is a meeting point that connects the sacred and the mundane. By performing ritual sacrifices on this altar, the emperor becomes the intermediary between the god of agriculture and his Chinese subjects. So even though the sacrifice is a ceremony for praying for a bumper harvest,[8] it has great significance in perpetuating status distinction. The long passage and the elevated altar help convey the political message. *Jiehua* is here manipulated to carry nonartistic connotations. The lines not only define the architectural space but also mark out symbolically boundaries of power, boundaries of hierarchies, and boundaries of the elevated position of the emperor.

However, to the Qing emperors, the process of boundary making was complex and multifarious. The promotion of Chinese religion was only part of the strategy of rulership. As rulers of diverse peoples, they required "flexible culturally specific policies" for different subject peoples in different parts of the empire.[9] Qing court representations of state ceremonies—such as the southern inspection tours that aimed at the Chinese subjects or the

formal receptions that enlisted the support of neighboring peoples—shed light on the Qing "simultaneous" expression of imperial intentions in multiple cultural frames.[10]

The painting project *Kangxi Southern Inspection Tour* by Wang Hui and others was the first of the large-scale narrative works commissioned by the Qing court. But because of concern with the hierarchy of the Qing ritual order, I have discussed the *Sacrifice at the Altar of Agriculture* (a visual document of a religious ritual) before I proceed to this set of work. Of the twelve scrolls of the *Kangxi Southern Inspection Tour*, I chose to focus on the final scroll because it is among the few examples of Qing architectural paintings that portray the Forbidden City in Beijing. This scroll depicts the return of the Kangxi emperor and his entourage to the capital in his second tour (1689) (fig. 3.2). The imperial architecture depicted here includes a series of towers and gates that stand on the central axis of the imperial city: Hall of Supreme Harmony (Taihe dian), Gate of Supreme Harmony (Taihe men), Meridian Gate (Wu men), Gate of Correct Demeanor (Duan men), Gate of Heavenly Peace (Tianan men), Gate of Great Purity (Daqing men), South-Facing Gate (Zhengyang men), and Gate of Everlasting Stability (Yongding men). The representation of individual buildings follows the convention of arranging all the oblique lines in an approximate parallel manner to indicate spatial recession. The strong pull of the diagonals makes the structures look elongated. There is also a tension between the lateral movement of the entourage and the diagonal pull of the buildings.

The translation of a specific route onto the horizontal format of a Chinese handscroll is a consistent pictorial solution throughout the twelve scrolls of the *Kangxi Southern Inspection Tour*. With this method, the theme of travel is visualized and the direction of movement is presented.[11] But in some scrolls of this monumental set, the vantage points are sometimes shifted, so that specific sites are presented from their most favorable angles and are approached from a direction opposite the line of travel.[12] Scroll 12 simply presents the central axis of the imperial city horizontally along the scroll. Also noteworthy is that the Kangxi emperor did not follow the route depicted here. Instead, he entered Beijing via the Gate of Literary Virtue (Chongwen men) and went directly to offer his condolences for the death of Prince An (d. 1689) before returning to the Forbidden City.[13] We may ask why this scroll presents a straightforward route that was not actually taken by the emperor in his journey. One possibility is that the painters wanted to emphasize the ritualistic nature of the imperial journey. As Maxwell Hearn has observed, the painters might have been more concerned "to balance Scroll One with a virtually symmetrical depiction of the retinue that would provide a formal closure to the series."[14]

If the ceremonial procession is essential for highlighting the ritualistic nature of the imperial tour, does it mean that the architectural elements are subordinate to the retinue in this scroll? I think not. Here, the ritual space is as important as the ritual performance. The depiction asserts the interdependence of human activity and architectural space in a ritual ceremony. To the participants, the architectural compound is a setting for prescribed ritual behaviors and feelings; to the beholders, it is a theatrical stage for the ritual drama.

Fig. 3.2. Wang Hui (1632–1717) and others: *Kangxi Southern Inspection Tour*, scroll 12, showing the return of the Kangxi emperor to the Forbidden City. 1692–1695. Handscroll, ink and color on silk. Palace Museum, Beijing. From Gugong bowuyuan, ed., *Qingdai gongting huihua* (Beijing: Wenwu chubanshe, 1992), pl. 20.

More significant, although scroll 12 is simple in compositional design, its pictorial structure visualizes the spatial conception of the imperial city. The representation does not regard architecture simply as building forms or volumetrics but also considers the directional invitation as well as the spatial organization of a compound. Defining the physical space in between the individual structures, the painters arrange alternate solids (buildings) and voids (open areas) to create a lateral rhythm and to offer the viewer a series of architectural experiences as one moves along the scroll. This rhythmic sequence is immediately intelligible because of the clarity and simplicity of the pictorial structure. And although the viewer is invited to move laterally while unrolling the scroll, the pictorial tensions are inexhaustible. As one reads the scroll from right to left and moves away from the Forbidden City depicted in the first section of the painting, the reversed travel of the retinue from left to right will draw the viewer back to the palace. The upward and downward movements of the buildings also regulate the pace of the viewer's architectural experiences.

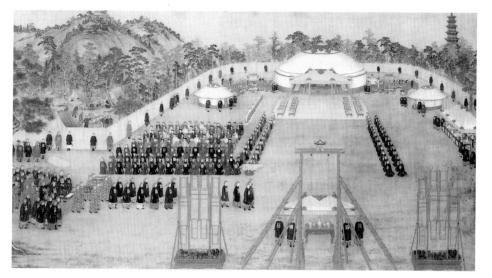

Fig. 3.3. Giuseppe Castiglione (1688–1766) and others: *Imperial Banquet at the Garden of Ten Thousand Trees*. 1755. Hanging scroll, ink and color on silk. Palace Museum, Beijing. Despite the use of linear perspective, there is an unusual asymmetry of the composition to divert attention from the vanishing point. Here, the Qianlong emperor is the symbolic center. From Gugong bowuyuan, ed., *Qingdai gongting huihua* (Beijing: Wenwu chubanshe, 1992), pl. 57.

When this physical setting is blended with colors and music and is devoted to structured bodily movements that are assigned symbolic significance, it becomes behaviorial and sensory space suitable for crystallizing the power of the Qing emperor. To reinforce the political significance of this ritual environment, there are only limited depictions of commoners' activities. Shops are shuttered; citizens are directed away from the ritual space. The emperor's movement is constrained by strict security and ceremonial etiquette. Presented here is an architectural environment intended for a concentration of suggestions, of connotations, of emotions, and of authority.[15]

The aforementioned pictorial convention for representing Qing ritual ceremonies might have inspired the European missionary-artists who too were commanded by the emperor to depict state ceremonies.[16] The *Imperial Banquet at the Garden of Ten Thousand Trees* is recorded in the palace archive as a collaborative work of Castiglione, Attiret, and Ignatius Sichelbarth (Ai Qimeng, 1708–1780) (fig. 3.3). It depicts the occasion where the Qianlong emperor received the submission of the Mongolian Durbot tribe in 1754. Its composition is similar to that of scroll 1 of the *Sacrifice at the Altar of Agriculture*, except that the imperial procession is approaching the scene from left to right and linear perspective is adopted in the representation of the ritual space. Significantly enough, despite the use of European linear perspective, there is an unusual asymmetry of the composition to divert the viewer's attention from the great ceremonial yurt, beyond which the vanishing point of this perspectivally constructed space falls. Instead, the Qianlong emperor is the symbolic center and the focus of attention of this narrative painting. The modification of the pictorial device to highlight the imperial presence signifies the new style of rulership under the Qianlong reign. The dominant image of the Qianlong emperor in this painting, like some of the self-portraits he commissioned, is a representation of his self-image as a universal ruler, and this

Qing Imperial
Domains

conception of himself is further reinforced in this pictorial document that captures his movement in the ritual space to impose his awe and majesty on the consciousness of the Mongols. As Pamela Crossley noted, the representation conveys the idea that the emperor was the central point around which all things revolved, and through his actions, he gave meaning to all participants in the imperial enterprise.[17]

Paintings that commemorate the festive occasions of imperial birthdays present totally different architectural environments that separate these settings from the solemn, dignified ritual space devoted to religious or diplomatic events. The emperor's birthday, together with New Year's Day and the winter solstice, were the three great festivals in the Qing calendar. An imperial birthday was marked by sumptuous official ceremonies as well as splendid decorations in the palaces and the capital. Precious gifts from various regions were offered,[18] sentencing of convicted criminals was suspended, and animal slaughter was prohibited on that day. Behind the festivity and the strict etiquette lay the political implications of the event, as these official celebrations were additional programs that served to enhance imperial authority and to get a firmer grip on ideological control. Thus imperial birthday celebrations were also commemorated in Qing court paintings, and painters essentially followed the formulaic mode of defining a ritual space horizontally as in a typical Chinese handscroll and then added other narrative details to denote a totally different architectural environment. In *The Kangxi Emperor's Sixtieth Birthday Celebration*, for example, we find elaborate ornamentation of the theaters, kiosks, and archways as well as joyful activities that transform the setting into sensory space, filling it with music, operas, chatters, and colors (fig. 3.4).

Imperial Palaces

If ritual actions enhanced imperial authority through structured body movements in space and time, then grand palaces realized national greatness through real, physical forms. The Forbidden City—a palace featuring symbolic centrality in the Middle Kingdom—was the most important palace in China proper. The Qing's occupation of this palace not only signified its formal assumption of sovereign power to rule over China but also symbolized a simultaneous inheritance of its cultural tradition, which included, in addition to the architecture itself, the Confucian conception of political and social order made manifest through design. As noted, for example, the central axis of the Forbidden City within the imperial city was transformed into a ritual theater in scroll 12 of the *Kangxi Southern Inspection Tour*. Under the auspices of the Qianlong emperor, Xu Yang depicted an aerial view of the palace compound in his marvelous work *Springtime in the Capital*, now in the Palace Museum, Beijing. Although it is a rare example of architectural painting that offers a comprehensive coverage of the Forbidden City, this work essentially depicts the imperial city, and I will discuss it in the next section in the context of cityscape depiction under the Qianlong reign.

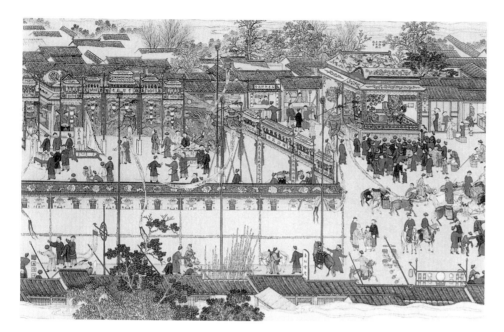

Fig. 3.4. Leng Mei (late seventeenth–eighteenth century) and others: *Sixtieth Birthday Celebration of the Kangxi Emperor,* scroll 1. 1717. Detail of handscroll, ink and color on silk. Palace Museum, Beijing. From Gugong bowuyuan (Palace Museum), ed., *Art Treasures from Birthday Celebrations at the Qing Court* (Hong Kong: Chinese Arts and Crafts, n.d.).

Comparatively speaking, the Summer Palace in Rehe and the Garden of Perfect Brightness were more frequently depicted by Qing court painters to fulfil the imperial demands. Unlike the Forbidden City—which was a Ming palace occupied by the Qing conquest regime—both the Summer Palace in Rehe and the Garden of Perfect Brightness were newly constructed palaces commissioned under the glorious reigns of the Kangxi, Yongzheng, and Qianlong emperors. The construction of these palaces asserted the acquisitive power of the conquest regime and reinforced the pattern of dominance and submission in Qing rulership and diplomacy.

The Summer Palace in Rehe was built as a border fortification in the north of the Qing empire. Although the Chinese name of this palace—Bishu shanzhuang—seems to suggest that the palace was a mountain retreat for escaping the summer heat, it was actually used for holding state ceremonies, receiving neighboring peoples who were brought into submission, meeting foreign envoys, and performing the hunting ceremony.[19] During the Qianlong period, another thirty-six scenes were added to its original thirty-six scenes, forming a total of seventy-two scenes in this palace. To justify the construction and the lavish extension, the Qianlong emperor wrote,

The imperial ancestor [i.e., the Kangxi emperor] who initiated the construction of this villa beyond the Great Wall did not intend to entertain his own pleasurable tours but to bequeath it to the following ages. Bearing Heaven's mandate, he pacified the neighboring states at all times. For territories that had not been taken, he added them to his domain. For states that had not

Qing Imperial Domains

shown their allegiance, he offered them honorific titles. The different tribes of the forty-eight banners had all abandoned their isolation beyond the Great Wall. . . .

For the period preceding the three sovereigns [i.e., Xia, Shang, Zhou], it was beyond our discussion. After the three sovereigns, the dynasties that had enjoyed the longest period of rule were the Han, Tang, Song, and Ming. But all these four dynasties manifested one [underlying pattern of political change]: birth and thereafter rebellions. Why is it? The withdrawal of Heaven's blessing [from a failing dynasty] is due to human indolence. In view of this, the imperial ancestor never had the idea of pleasure in his head, and this was true even after the defeat of the Three Feudatories. The hunting ceremony was performed either twice or thrice every year. Was it that he had never considered the use of money and manpower?[20]

Paintings of the Summer Palace—or what we may call estate portraiture—replicate its physical appearance to fulfill certain functions. There are two types of portrayals: one that inclines toward mapping and offers a broad panoramic view of the royal estate, another that provides more direct encounters with individual scenes to illustrate imperial poems. No matter whether the royal estate was represented in its entirety or in partial views, the grandiose representations suggest that these paintings were themselves sites for meaning construction. Like the actual constructions, they had a symbolic essence.

The Summer Palace at Rehe, one of Leng Mei's extant works in the Palace Museum, Beijing, captures the physical appearance of the royal estate during the Kangxi period (fig. 3.5). Combining mapping, topographical conventions, and *jiehua* work, this painting provides a large, panoramic view of the palace. It not only enabled the emperor to grasp from a height its impressive scale but also reveals the vision of the emperor who took an interest in seeing the royal domain in its entirety.[21] The idyllic beauty of the topography and the rustic simplicity of the architectural design (a marked contrast to the formality of the Forbidden City) alluded to the Qing conceptualization of the Manchu identity and the claim of the remote Changbaishan region as the imperial family's ancestral home.[22]

Another important feature of this painting is the creation of a spherical center in the composition to highlight the lake area. Stylistically, this is indebted to the tradition of topographical painting, as the topographical painter often pinpoints characteristics of the terrain while capturing the physical appearance of a site. The representation of a lake or circular watercourse may result in a prominent sphere—a pictorial effect commonly found in Ming topographical paintings (fig. 3.6).[23] When introduced to Leng Mei's portrayal of the Summer Palace, this particular topographical code highlights a particular scene, "Fungus Path and Cloud Dike" (Zhijing yunti).[24] This scene featured the fungus-shaped Ruyi Island, which was among the first to be constructed in the palace. The building depicted in this scene was used as the emperor's residence and office, and the island was the center from which other scenes were organized in a radiating manner. Thus it was the heart and the political center of the royal estate.

Fig. 3.5. Leng Mei (late seventeenth–eighteenth century): *The Summer Palace at Rehe.* Hanging scroll, ink and color on silk. Palace Museum, Beijing. This work captures the original appearance of the Summer Palace before its extension in the Qianlong period. From Gugong bowuyuan, ed., *Qingdai gongting huihua* (Beijing: Wenwu chubanshe, 1992), pl. 131.

Fig. 3.6. Qian Gu (1508–1578): "The Little Venerable Garden," leaf from *Sketches from a Travel Album*. Ca. 1570. The water channels flow along the islets, forming a sphere in the composition. Ink and color on silk. National Palace Museum, Taipei, Taiwan, Republic of China.

The use of a radiating pattern in the organization of the Summer Palace could be interpreted as a powerful manifestation of the dual pattern of "core" and "periphery." The political symbolism of such an architectural design was made obvious with the later construction of the Outer Eight Temples (Wai bamiao) in the vicinity, which intensified the contrast between the "inner" and the "outer."[25] Design manipulation in actual construction had promoted a symbolic use of the architectural environment. What Leng Mei contributed through painting was to highlight the architectural feature so that the pictorial representation was itself a mechanism to convey political messages. The symbolic center—one that expands and coheres—perfectly expresses the ideal of empire unification. It acquires additional meaning in a work that presents the complete view of a Qing palace designed to reinforce dominance over the expanding empire.

The Kangxi emperor who commissioned this painting also sponsored empirewide cartographic projects to map the territories using more accurate European techniques. As Laura Hostetler observed, the credit for the decision to employ European Jesuits to survey the empire lay with the emperor himself.[26] In Leng Mei's depiction of the Summer Palace, he too employed European linear perspective in architectural representation, a painting style favored by the Kangxi emperor. Did the employment of European representational techniques in this painting play a role in conveying political messages? If accuracy was the criterion in European map-making enterprises, then it is possible that the employment of lin-

ear perspective in Leng Mei's painting would give an impression of accuracy, at least as far as architectural representation was concerned. This perception was significant, as it would make the estate portraiture look convincing and real, which in turn would enhance the political significance of the painting. The Kangxi emperor certainly saw good reason to accept the use of linear perspective in royal estate portraiture. But we must not forget the synthetic nature of *The Summer Palace at Rehe*, which exemplifies the blending of Chinese and European elements, as well as the interplay between mapping, topographical, and *jiehua* conventions in a single work.

Despite the employment of linear perspective in architectural representation, a close scrutiny of Leng Mei's painting will show an observance of native conventions in composition. For example, we observe a lateral rhythm in the pictorial structure. As we move our eyes from right to left, we see a chain of hills leading to a vast plain in the middle of the painting and then to another chain of hills on the left. There is no continuous ground plane as in a perspectivally constructed space. Our viewpoint is shifted from a high-distance view to a deep-distance view and then to a high-distance view. The central plain that contains the houses, the islets, and the lakes is not treated as a continuous whole. And if this vast plain is to be viewed with a single eye at a stationary point so that it is represented in foreshortening, the effect of linear perspective should as well guide the way we look at the clusters of buildings from the same angle of vision. But Leng Mei's painting does not show this feature, and indeed it was not his intention to adopt a single system or multiple systems of linear perspective to organize all the motifs in his painting.

Leng Mei used different pictorial conventions to represent the architecture and the landscape. In the architectural representation, the use of linear perspective is unmistakable. A careful examination of the architectural images reveals that the receding diagonals of individual courtyards remain parallel throughout their length. Yet these lines extend to relate the various groups of buildings and meet at a vanishing point beyond the left margin of the painting (fig. 3.7). When he organized the landscape and the architecture within the composition, Leng presented a series of differing views. What are the unifying devices that hold the painting together? Leng Mei introduced various forms of complementary opposites to lead the viewer to turn in every direction and to travel through distances in this large compound. While the receding diagonals of the buildings are leading the eye toward one direction away from the painting, the undulating movement of the mountains, the meandering watercourses, and the irregular contour of the islet are guiding the eye to turn in all other directions to encompass the whole (see fig. 3.5). All of these devices serve to increase and regulate the movement of the eye so that the viewer can tie the different parts of the composition together.

This integration of diverse subjects in a work incorporating various pictorial conventions had presented a great challenge to the court painter. The same representational problem required a much more careful consideration in the case of a collaborative project completed by different hands. We shall examine this with the example of *The Forty Scenes of*

Fig. 3.7. Detail of fig. 3.5 showing how the slanting lines serve to define spatial recession in architectual representation and relate one courtyard to the other.

the Garden of Perfect Brightness, a project done by the Orthodox landscape painter Tangdai and the *jiehua* specialist Shen Yuan under the auspices of the Qianlong emperor.[27]

The Garden of Perfect Brightness was situated in the western suburbs of the capital. The Kangxi emperor commissioned this pleasure garden and gave it to his fourth son, Yinzhen, who, after ascending the throne to be the Yongzheng emperor, made it the principal imperial garden.[28] Because of his love for this garden, he spent an extended period there, turning it into his regular residence and imperial office.[29] His son Hongli—who grew up in this garden and lived in the Eternal Spring Fairy Hall (Changchun xianguan)—also attached deep sentiments to it. After he had become the Qianlong emperor and formally inherited this imperial estate, he spent enormous sums for its expansion, adding to the preexisting scenes to complete the famous forty scenes of the garden.[30] In a letter of 1743 Jean Denis Attiret recorded his observation as follows:

You will not fail to conclude and rightly so, in all I have told you that this pleasance must have cost an immense fortune; in fact only one prince, ruler of a state as vast as China, could have made such an expenditure and finish, and in so short a time, such a prodigious undertaking; for these buildings are only the work of twenty years, and he who started the pleasance was the emperor's father [i.e., the Yongzheng emperor], the [Qianlong] emperor is only adding to it, embellishing it.[31]

The Garden of Perfect Brightness was a significant Qing construction to lodge the sovereign. Although this garden incorporated a diversity of scenes intended for the imperial enjoyment, several were designed in ways to express the Qing vision of rulership and had heavy political overtones. Scene 1, "Central and Great, Glorious and Bright" (Zhengdai guangming), was used for formal functions. Scene 2, "Diligent in Government and Friendly with Officials" (Qinzheng qinxian), was the office where the emperor read provincial reports and met officials. Both scenes have an architectural design that follows the principle of symmetry and axiality. Scene 3, "Nine Continents Clear and Calm" (Jiuzhou qingyan), related to the other eight scenes around the Rear Sea (scenes 4–11) to symbolize the Nine Continents. The Qianlong emperor's description of this scene offered insight into its political symbolism:

> In its surroundings are streams that flow to all directions, resembling the nine streams of River Xunyang [also named the Nine Rivers (Jiujiang)]. Zou Yan [of the Zhou dynasty] said that the Lesser Sea was encircled by the Nine Continents, which were then circumscribed by the Great Sea. This scene offers a metaphor of the creation of all things, doesn't it?[32]

The Nine Continents was considered as "a metaphor of the creation of all things," one that expressed the Chinese conception of all territories under Heaven.[33] The designation of the Nine Continents in the imperial garden exemplified the Qing adaptation of Chinese rhetoric to express its mission of creating an empire that encompassed all lands.[34] Moreover, saying had it that Yu (the founder of the legendary Xia dynasty) divided his territories into nine provinces and expressed them tangibly by nine cauldrons. The nine provinces, or the nine cauldrons, were traditionally regarded as Chinese symbols of political authority. The Qing also borrowed such symbols as part of the ideological vehicles for legitimizing its imperial enterprise. Because of the symbolic significance of the Nine Continents, these scenes were juxtaposed with scenes 1 and 2 as an expansion of the political center of the imperial garden. Also integrating with the center were various other types of architecture and scenes to represent the different "worlds"[35]—such as the Ancestral Temple, Buddhist monasteries, Confucian scholars' retreats, Daoist paradises, and Manchu hunting grounds—that built up a magnificent Qing garden. The design of this imperial garden therefore expressed the idea that the universal emperor exerted control over all aspects of life.

The diverse architectural designs of this imperial garden are presented in a surviving set

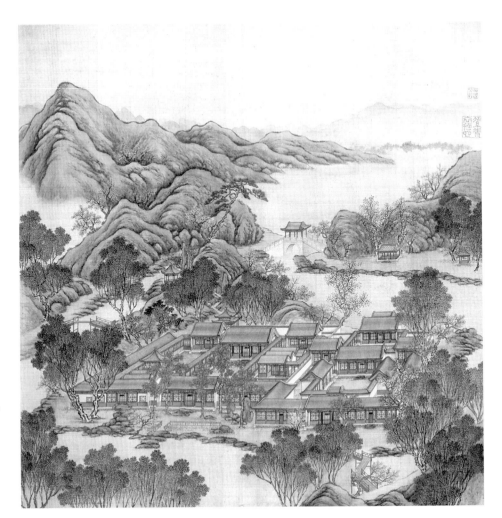

Fig. 3.8. Tangdai (1673–after 1751) and Shen Yuan (active ca. 1736–ca. 1746): Scene 12, "The Eternal Spring Fairy Hall." Leaf from the *Forty Scenes of the Garden of Perfect Brightness*. 1744. Album leaf, ink and color on silk. Bibliotheque Nationale, Paris.

of two albums titled *The Forty Scenes of the Garden of Perfect Brightness*, now in the Bibliotheque Nationale, Paris. This type of representation was intended to illustrate the imperial poems about the different scenes of the garden, and it is very different from an estate prospect, or an estate map, which offers an entire view of the whole. Theoretically, the disparate depictions—which emphasize the interplay between poetry and painting—offer a sense of immediacy as well as a more direct encounter and engagement with the different scenes of the garden. However, the tension between the grandiose view and the personal experience is everywhere present in these court-sponsored representations that, in practice, serve to glorify the emperor's ultimate authority over the different "worlds" and the luxurious modes of life that he enjoyed.

The Forty Scenes of the Garden of Perfect Brightness, like the garden design itself, com-

bines different modes of representation. In this collaborative painting project, the division of tasks was clearly specified: Tangdai painted the landscape; Shen Yuan painted the architecture. Presumably, both Tangdai and Shen Yuan had a general idea of the reconciliation between the different conventions used for representing landscape and architecture, as they were required to submit painting drafts for imperial approval. Many of the leaves suggest that Tangdai—who was a student of the Orthodox master Wang Yuanqi and a prestigious Manchu painter serving at the court—painted the landscape first and then left an approximate blank area for Shen Yuan's later addition of the architectural images (fig. 3.8).[36] In Tangdai's landscape depiction, there is often a momentous flow of energy or forces—or what he called *qishi*—in the mountain movement.[37] The technique of "opening and closing" *(kaihe)* is brought into play: the rock masses gather up *(he)* into the mountain ranges, and the open space expands *(kai)* to allow for the placement of the buildings.[38] In this way, Tangdai successfully made use of his landscape to enliven the inanimate forms of the buildings to be inserted into his composition. The *jiehua* specialist Shen Yuan was recorded to have learned linear perspective from Castiglione in the Qianlong academy, and he introduced his newly acquired techniques to the representation of the architectural images in this set of paintings. But because these works incorporate the landscape elements depicted by a different hand, the use of linear perspective can only be a localized phenomenon applied merely to architectural representation.

This work contains forty individual paintings of the famous scenes of the imperial garden, and its scale and quantity suffice to suggest the imperial grandeur. If quantity matters to our understanding of the propaganda art program under the Qianlong reign, then it is important to note that this extant album by Tangdai and Shen Yuan was not the only pictorial record of the Garden of Perfect Brightness. Under the auspices of the Qianlong emperor, there were other portrayals of this imperial garden. For example, it is recorded that Leng Mei rendered both the overall view and the individual forty scenes of the Garden of Perfect Brightness, but we cannot locate all such works.[39] The woodblock illustrations to accompany the imperial poems were published in the *Yuzhi Yuanming sishijing shi bing tu* in 1745.

Prosperous Cities

Of the cityscapes depicted in Qing court paintings, some are representations of important cities, such as the capital Beijing and the cities actually visited by the emperors during the southern inspection tours. These cities are depicted in the pictorial documentaries *Kangxi Southern Inspection Tour* and *Qianlong Southern Inspection Tour* as the venues for the events, the constituent parts of the Qing empire, and the ritual theaters in which the emperors performed the role of the Confucian monarch. There are, in addition, other cityscape representations devoted to the theme of a thriving urban center without any specification of a

city's identity. The various episodes depicted in such works constitute a vast social theater and offer insights into various aspects of social life. In this section I will first look at the representations of specific cities, then proceed to other cityscape depictions.

To a certain extent, the representation of the imperial city in Beijing is different from that of another city. Because of the political symbolism of the imperial city, the portrayal has to be specific and faithful to the real configuration, and this is best demonstrated in scroll 12 of the *Kangxi Southern Inspection Tour* discussed earlier. By contrast, the representation of vernacular architecture in other cities may enjoy a degree of flexible treatment. Throughout the twelve-scroll set of the *Kangxi Southern Inspection Tour*, there is a generic representation of vernacular architecture, no matter whether the houses belong to a northern or a southern city. No regional variations in terms of style and material are distinguished. Probably because the painters were coming from the south, all the houses depicted in this set have white-washed walls and grey-tiled roofs, and they resemble the actual design of southern vernacular architecture.[40] Those structures designed for commercial use have wooden plank doors or shutters that can be removed when the shops are open. When rows and rows of these structures are lined up along the avenues and the canals, they define grids of houses. And when a number of such grids are organized and enclosed by city walls, a city is conceptualized. There are specific boundaries (city walls) to demarcate this administrative and jurisdictional unit. There are also heightened commercial activities to make it an economically self-contained region. Structures such as bridges, archways, and transport networks link the grids together. Moving elements—human activity in particular—play an important role in the creation of an urban space (fig. 3.9).[41]

Among the vernacular architecture are landmarks including temples, shrines, pagodas, and office buildings with which the viewers can invest with historical, religious, and political connotations. In the *Kangxi Southern Inspection Tour*, names of important sites are labeled on cartouches. But apart from this information, which gives a region a specific identity, there is, in general, a common treatment of the different cities. In this connection, it is important to note that the project leader, Wang Hui, and his assistants did not accompany the Kangxi emperor on his journey. The painters were later summoned to depict the imperial tour based on fragments of visual records, and it is likely that they could at most incorporate famous landmarks without being fully aware of the specifics of each city included in the southern inspection tour.

To represent a vast city signifying the Qing imperial domain, painters introduced various compositional devices, adding a lot of variations to the pictorial structure. At times, mist and foliage are used to mask the details over a sea of roofs so that a large area is suggested without the artist's having to present the particulars. At others, there is a clear articulation of the spatial organization of architecture, and an orderly configuration of open areas and structures invites the viewers to move in and out of the architectural space. The inclusion of narrative details also contributes to a more substantial depiction of a city. Consideration is also given to the effect of distance on the architectural images. Because of the assump-

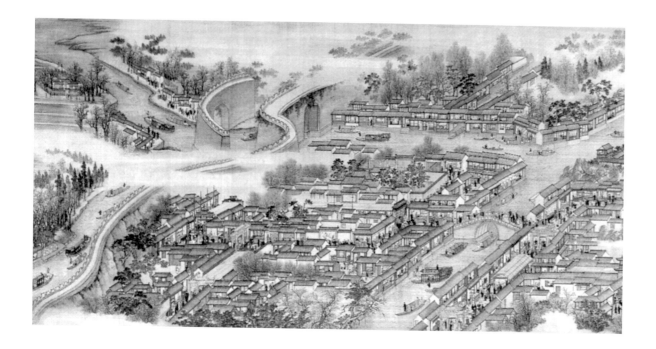

Fig. 3.9. Wang Hui
(1632–1717) and others:
*Kangxi Southern Inspec-
tion Tour*, scroll 9.
1692–1695. Detail of
handscroll showing an
extensive view of Shao-
xing, ink and color on
silk. Palace Museum,
Beijing. From Gugong
bowuyuan, ed., *Qingdai
gongting huihua* (Bei-
jing: Wenwu chubanshe,
1992), pl. 17.

tion of a high vantage point in city representation, the rooftops are relatively closer to the viewer, and they are clearly visible. The lower halves of the houses and their platforms are relatively far off, indistinct, and lost in the mist (a traditional Chinese pictorial convention for suggesting distance). In other words, height determines distance which in turn affects the distinctiveness of images. Tang Zhiqi, in the *Huishi weiyan*, had also referred to such representational techniques, which he called "the theories of distance and proximity, of the above and the below" (*yuanjin gaoxia*).[42] When these are applied to cityscape depiction to suggest scale, we find a panoramic view of a vast area of a city filled with alternate bands of rooftops and mist.

Comparatively speaking, the cityscape depiction in the *Qianlong Southern Inspection Tour* by Xu Yang is more focused at close range. The lowering of the high vantage point in the Qianlong set results in a more substantial rendering of the architectural images. Moreover, as Maxwell Hearn has observed, each scroll in the Qianlong set depicts less than a five-mile segment of the imperial route, except two scrolls that show as much as fifteen miles. This marks a difference from the Kangxi set, in which each scroll depicts a segment of thirty to a hundred miles.[43] Another stylistic variation is that Xu Yang adopted European representational techniques — such as foreshortening and scale alteration — to indicate the effect of distance on the architecture images. Yet he did not fully exploit linear perspective to the extent of defining the whole pictorial structure with the system, and I will examine this stylistic feature in detail with other examples of his works.

Xu Yang, among others, produced an impressive number of cityscape depictions under

Qing Imperial
Domains

the auspices of the Qianlong emperor. He painted two versions of the *Qianlong Southern Inspection Tour* (one on silk and the other on paper), in which there are representations of extensive urban views. These assignments demonstrate Xu Yang's technical command and his ability to deal with huge projects. In addition, he produced individual works to present views of Beijing, Suzhou, and anonymous urban centers. In 1759 he painted *Burgeoning Life in the Prosperous Age*, which is a long, marvelous handscroll depicting the urban prosperity of Suzhou.[44] Then in 1770 he painted *Springtime in the Capital* (plate 6), which captures the beauty of Beijing when covered with snow. Because of the significance of the capital city as a code of Qing rulership, I shall first examine the representation of Beijing before proceeding to the portrayal of Suzhou.

In *Springtime in the Capital*, the snow-covered city is conceived from a high vantage point. At first glance, it seems that linear perspective has been adopted in the ordering of the pictorial space. Coming from Suzhou, Xu Yang might have known the foreign techniques from Suzhou prints—which had featured selective borrowing of linear perspective since the Yongzheng period or earlier. If not, he certainly had the opportunity to learn the foreign techniques from his colleagues at the court academy. While undoubtedly a work incorporating new, foreign elements in architectural representation, Xu Yang's painting is not strictly governed by linear perspective. Significantly, the city is conceived as a series of demarcated spaces: each opens into the other but screened by walls, gates, or towers. Each continuum shows remarkable balance of solids and voids, verticality and horizontality in the placement of buildings and is organized individually by means of parallel, converging, or diverging lines. The use of mist further makes possible a jump of space-time and a shift of viewpoint in his representation. Implied from these conventions is a conception of space-time characterized by diversity, heterogeneity, and subtlety of transformation—a conception that is also expressed in the architectural design of the Forbidden City.[45]

Arguably, the architectural organization of the Forbidden City reveals a grand, structured vision in the ordering of political and social spaces in traditional Confucian society.[46] The organization of a series of demarcated spaces to achieve unity may symbolize the ordering of a centralized state by a bureaucratic form of government consisting of numerous administrative units, from the palace down to the metropolitan, provincial, and district offices. On the sociological plane, it may symbolize the Chinese organization of social space into a sequence of progressively smaller units, from state to province, city, town, community, and family.[47] If this kind of spatial organization expressed the Confucian ideal of order in the structuring of Chinese political and social spaces, then the Qing's takeover of the Ming palace would therefore entail a simultaneous inheritance—or in practice, the Qing manipulation—of this ideal to affirm centralization. The commission of this painting by the Qianlong emperor to represent the structured vision in turn made manifest the emperor's own vision of Qing centralized and expansive rule over the empire, in which China was a major component.

As mentioned earlier, *Springtime in the Capital* is a rare example of Qing *jiehua* that in-

corporates a full image of the Forbidden City. But it seems more appropriate to interpret this painting in the context of city representation than to see it merely as a palace portrayal. Unlike the representations of the Summer Palace in Rehe and the Garden of Perfect Brightness—which show the palaces as forbidden areas without any human figures—*Springtime in the Capital* includes genre elements to emphasize on the vigor of the Qing imperial capital at springtime. This links the painting to another impressive work done earlier by Xu Yang, *Burgeoning Life in the Prosperous Age*, in which Suzhou is shown as a thriving city cramped with people, houses, shops, restaurants, public buildings, boats, and so on. A study of eighteenth-century English urban prospects by Stephen Daniels reveals that a grandiose view of industrial London was intended "to unfold the vast resources of empire, in the countless traces of its commerce, its manufactures, and trade; to exhibit the productiveness of its public revenues, through the grand national spirit of industry and enterprise."[48] Similarly, the panoramic views of Beijing and Suzhou celebrated prosperity, but the purpose of these depictions was to glorify Qing imperial enterprise as the basis of progress and success, not the "spirit of industry and enterprise" as in the case of eighteenth-century England.

Burgeoning Life in the Prosperous Age is a remarkable summation of Xu Yang's versatile skill in landscape, figural, and architectural portrayals. In his inscription to the painting, Xu Yang wrote,

> The scroll begins with Mount Lingyan. One follows the eastern route from the town Mudu, passing Mount Heng and crossing Lake Shi, to call at Mount Shangfang. From the northern shore of Lake Tai, in between the Lion Rock and Mount He, one enters the city walls of Suzhou, [touring round] via the three city gates Feng, Pan, and Xu, and departing from Chang. Turning to the direction of Bridge Shantang, one reaches Tiger Hill (Huqiu), where the painting ends. In between these sites are high and steep constructions, solemn official buildings, beautiful mountains and rivers, fishermen, families engaging in farming and weaving, merchants gathering like clouds, and an assembly of vast marketplaces.

The areas covered in this scroll are extensive, including not only the city proper of Suzhou but also famous mountains and lakes in the vicinity. A diversity of human activity is included to exhibit agricultural productiveness and commercial prosperity. An unfailing sense of visual excitement compells one to take part in the bustle of the city. The dense composition, the rich information, the carefully controlled brushwork, and the subtly tinted washes all characterize Xu Yang's style in cityscape depiction. In addition to his masterful arrangement of the motifs, the houses are animated by the life-movement of the mountains, rivers, natural growths, and human figures.

Xu Yang's skill in dealing with a highly complex structure is made evident in figure 3.10, in which there is an eclectic use of both native and foreign compositional devices. Throughout the scroll, linear perspective is used in the representation of isolated groups of architecture. But even when rows of houses are arranged in a converging manner in a spatio-temporal continuum, they are juxtaposed with other rows that recede in a diverging manner in

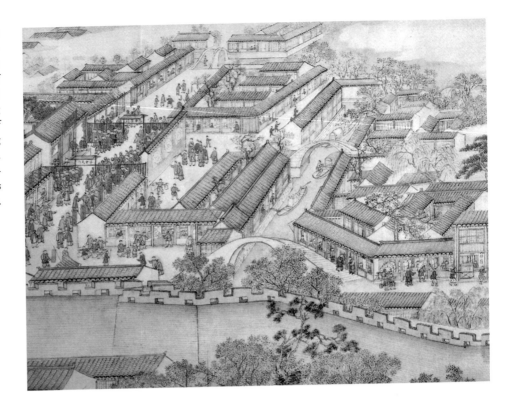

Fig. 3.10. Xu Yang (active 1751–ca. 1776): *Burgeoning Life in the Prosperous Age.* 1759. Detail of handscroll, ink and color on silk, showing the urban prosperity of Suzhou. Liaoning Provincial Museum. This painting was renamed *Prosperous Suzhou* in the 1950s.

the next continuum. Moreover, there is a clever use of such motifs as walls, waterways, and avenues to divide the composition into disparate units. To achieve structural unity, Xu uses various kinds of polarities, such as convergence and divergence, contraction and expansion, horizontality and verticality, rising and falling, inward and outward movements, which lead the audience to travel in all directions and to hold the various units together while wandering in the city. Through Xu's dynamic union of opposites in pictorial design, all the disparate units are knitted up to form a complex picture of prosperous Suzhou under the Qianlong reign.

The trend of representing broad panoramic views of Chinese cities might reveal the interest of the Qing emperors—who were in their high position—to inspect the empire from a height and to assert their acquisitive power. If this trend of development started incidentally in the pictorial document *Kangxi Southern Inspection Tour* (because an expansive treatment of a city is suitable for the theme of inspection), then the continuity of an expansive style in almost all kinds of cityscape renditions was certainly not the result of coincidence. This continuity of theme and style further suggests the symbolic significance of expansive views of cityscapes to the royal patrons, especially to the Qianlong emperor, who repeatedly demanded works displaying a broad panoramic view of a city, no matter whether

it was an actual Qing city, a Qing reinterpretation of a historic city, or any urban view in the eye of the Qing monarch.

To understand this trend of development, it is necessary to examine the court reinterpretation of *Going up the River on the Qingming Festival*, a project initiated during the Yongzheng period and completed in the opening year of the Qianlong period. This painting incorporates a substantial portion of city representation and features an expansive style to be followed consistently by *jiehua* painters of the Qianlong academy. Glimmerings of this new style can be traced early—for example, in the Ming reinterpretations of *Going up the River on the Qingming Festival*—whether the available prototypes were the genuine version by Zhang Zeduan or not (fig. 3.11). Anyone comparing the original version to a later copy—say, a version attributed to Qiu Ying in the National Palace Museum, Taipei—will find that the Ming copy adopts a relatively higher vantage point so that the onlooker is open to a wider view beyond the shop-lined avenue (fig. 3.12). More residences and gardens are incorporated as a result of this gain in the breadth of view, but being lost simultaneously are a sense of monumentality of the architectural images and a sense of intimacy of the scenes. Similar characteristics can also be observed in another copy identified as the *Yuan mifu* version in Dong Zuobin's (Tung Tso-pin's) study.[49] This version, unlike the one attributed to Qiu Ying, does not include a theater scene in the countryside and may possibly have been done slightly earlier. No matter—the differences between these scrolls and the original must have formed new codes affecting the Qing reinterpretations of the masterpiece. The Qing court version departs from these Ming copies in its more concrete representation of the architectural images as well as a more extensive coverage of the cityscape that recedes into far distance (fig. 3.13). The rocks that twist and turn into distance also convey a new physicality and dynamism. Moreover, a royal estate is included at the end of the scroll, as if this is an indispensable element of a capital city (although this might also be a result of the use of a later copy as prototype).

The completion of the Qing court version of the *Qingming* scroll in 1736 inspired many other similar examples of cityscape representations commissioned by the Qianlong emperor. With the 1736 version as prototype, Shen Yuan depicted another *Qingming* scroll distinguished by its absence of colors.[50] Moreover, two copies of *Imitating the Song Version of the View of Jinling (Nanjing)*, painted respectively by Yang Dazhang and Xie Sui, include similar thriving urban scenes.[51] Other adaptations of the type depict any prosperous urban center in the spirit of joy and festivity, such as *The Seven Luminaries* by Xu Yang and *Peace All Over the Nation* by Zhou Kun.[52] In addition to these depictions of urban views are the aforementioned representations of actual cities by Xu Yang in *Springtime in the Capital*, *Burgeoning Life in the Prosperous Age*, and *Qianlong Southern Inspection Tour*. Why were so many of these paintings produced within the Qianlong academy? What were the motives behind the production of these works under the auspices of the Qianlong emperor?

Although expansive views of cities in Qing court paintings expressed the imperial con-

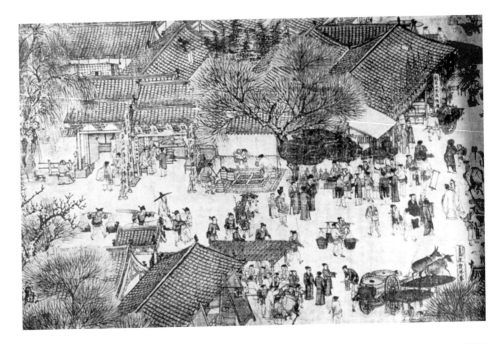

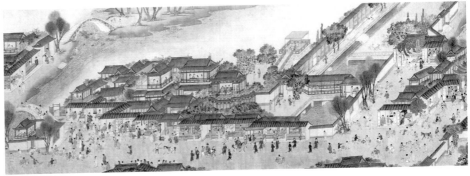

cerns with territories, boundaries, and political control, the symbolic meanings of such works during the Qianlong period should be interpreted in relation to the way the emperor looked at the already expanded Qing empire. These paintings of Chinese cities are very different from the set of drawings and copperplate engravings also commissioned by the Qianlong emperor to commemorate the conquests of the Dzungars and Uighurs during the years 1755–1761. If these engravings focus on the theme of military conquests of the border peoples, it is clear that the depictions of Chinese cities were meant to emphasize the Qing takeover of the territories within China proper. Relatively speaking, the concerns with territorial expansion were more pressing during the Kangxi and Yongzheng periods than in the subsequent Qianlong era. Conquest came gradually to a close over the long Qianlong reign,[53] with Mongolia, Tibet, Central Asia (Chinese Turkestan; the region later

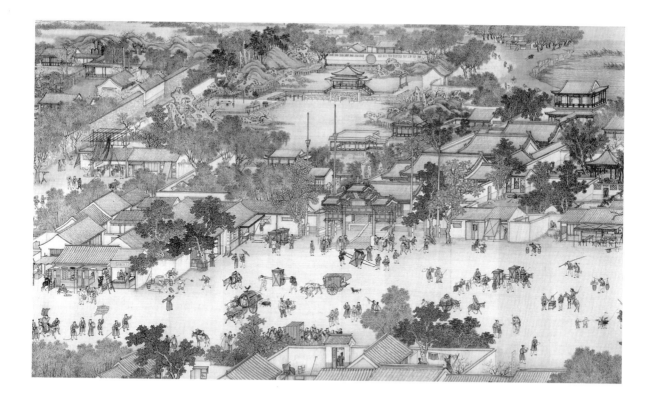

known as Xinjiang), and Taiwan all being brought into the Qing empire. The Qianlong emperor, paradoxically, demanded more and more paintings that represented images of the Qing territories—all of which lay within China proper. Thus Pamela Crossley has observed that the Qianlong emperor was concerned not so much with the physical boundaries as with the "spectacular ways of reflecting those boundaries through a central, translucent looking glass" that aimed to idealize rulership.[54]

Moreover, view of thriving urban areas conveyed the political message that peace and prosperity were enjoyed within the empire, a view that in turn served to gild the emperor's image. The political symbolism of such paintings was most explicitly stated in Xu Yang's inscription to *The Seven Luminaries*, a work depicting a joyous city in celebration of an occurrence of an auspicious astronomical phenomenon. This painting was done in 1761, two years after Xu Yang completed the panorama of Suzhou in *Burgeoning Life in the Prosperous Age*. In his inscription Xu wrote, "On 1st January, the 26th year of His Majesty's reign, at the first moment in the afternoon, the Sun and the Moon entered the lunar mansion Nu in the Yuanxiao Palace and joined each other. Mercury—which attached itself to the Sun—was in the lunar mansion Niu. The other four planets—Jupiter, Mars, Saturn, and Venus—were all in the Quzi Palace. They entered the two lunar mansions of Wei and Shi, resembling a string of beads." This astronomical phenomenon was interpreted as follows: "His Royal Highness assumes the virtues of modesty and propriety. . . . It is beyond doubt

Fig. 3.13. Chen Mei (1694?–1745), and others: *Going up the River on the Qingming Festival*. Detail of handscroll, ink and color on silk. National Palace Museum, Taipei, Taiwan, Republic of China. This version by a team of Qing court painters features solid rendering of forms, bright coloring, and the use of European linear perspective in architectural representation.

that [his rule] accords with the auspicious sign. So his bearing is made manifest to millions of people and is glorified by officials and civilians. Joy is all over the court. Your servitor Xu Yang of the art academy respectfully presents this painting to commemorate the event."

Was the prosperous age *(shengshi)* as peaceful as what these paintings show? Philip Kuhn's study of the nationwide "sorcery scare" of 1768 reveals the Qianlong emperor's deeper anxieties about the empire during the prosperous age. Rumors that sorcerers were "stealing souls" by clipping off the ends of men's queues occurred at a time when Qing economic growth was offset by the simultaneous great increase in the population. Vagrants and monks—who were socially marginal groups—became sorcery suspects. Black magic (the opposite of official sacrifice in the Chinese religious world) conveyed an image of public disorder and could be interpreted as an inauspicious omen. The Qianlong emperor feared seditious conspiracy and goaded his officials to action against sorcery. The hunt for sorcerers revealed deep-rooted problems of the routinization, inertia, and corruption of the bureaucracy. The crisis also convinced the Qianlong emperor of the degeneration of the Manchu bannermen as well as the decadence of Jiangnan culture in the south. As Kuhn puts the matter, "Fear and mistrust, admiration and envy: all marked the Manchu view of Kiangnan (Jiangnan), where soulstealing originated."[55]

Significantly enough, the emperor's fear of sedition in the Jiangnan region revealed that ethnic identity was a still major concern, and the ethnic feelings came back into prominence especially during political crises. In the next chapter, we will see how visual allusions to the Manchu identity and the personal interests of the Qianlong emperor got more and more overt in other architectural representations commissioned under his reign.

The Idealized Scheme

COURT REPRESENTATIONS II

4

ALTHOUGH THE QING EMPERORS adopted Chinese cultural symbols as part of their strategy to rule China, they were never alienated from their Manchu cultural roots. They made efforts to trace their origins, to understand their own history, to define their culture in terms of rites and cultural practices—such as shamanic worship, horse riding, shooting, and hunting—to differentiate themselves from the other cultural groups, and their efforts reinforced a sense of identity as the state grew.[1] The Qianlong emperor, in particular, manipulated cultural representations to foster an ideology of universal rule. This manipulation resulted in a more intense discourse on Manchu identity under his reign.

In the first part of this chapter I will describe how the political ideology of the Qianlong emperor was expressed pictorially, how the creative use of Chinese architectural images, when combined with other cultural icons, offers a metaphor of the Qing "cosmopolitanism" in the eyes of the Qianlong emperor.[2] I will study paintings inspired by history and myth, focusing especially on the various reinterpretations of a traditional theme—spring morning in the Han palace—commissioned under the Qianlong reign. Significantly, the constant reinterpretations and transformations of this theme provide insights into how history constitutes the relation between a present and its past. I am concerned with how the reconstruction of a Han palace—and by implication, the Han Chinese past—enabled the Qianlong emperor to articulate his own views.

In the second part of this chapter I proceed to the theme of the immortals' paradise. Although court representations of mythic architecture were not lacking, *jiehua* of this particular type were relatively scarce when compared to the other varieties of architectural paintings produced within the court or the productions outside the court. I will seek to find out the reasons for this phenomenon.

Spring Morning in the Han Palace

The classical representation of the theme "spring morning in the Han palace" presents a world of great elegance and grace, in which court ladies enjoy all sorts of refined activities: strolling, picking flowers, chasing butterflies, playing chess, brewing tea, dancing, conversing, enjoying music, playing with children, and making toilette.[3] In early representations —such as *Ladies of the Court*, now in the Cleveland Museum of Art (fig. 4.1)—the women's activities are set against a neutral background. The interrelationship between two or more figures helps indicate the discrete spatial continuum in which the women act. Later representations of the theme—as shown by the scroll by Qiu Ying in the National Palace Museum, Taipei—include architectural elements such as platforms, pillars, porticos, and open windows to define interior and exterior spaces (fig. 4.2). As the roofs of the buildings are not depicted, incomplete architectural images characterize the attempt of the Ming artist to situate the court ladies in a Han palace.[4]

When the same theme was reinterpreted during the Qing period, the tendency to represent, in addition to court ladies, an airy, encompassing architectural environment as a Han palace made the resultant work look like an architectural painting rather than a figure painting.[5] From the absence or limited inclusion of architecture in past versions to the portrayal of a grand palace compound in a collaborative court painting, the Qing transformation hints at some special meanings of the imagery of a Han palace. It is for this reason that I choose "spring morning in the Han palace" for detailed analysis.

Palaces of the Han (206 B.C.–A.D. 220)—which had long since collapsed and disappeared —had become history that was subjected to various interpretations and reconstructions by later people. Well before the Qing, writers and antiquarians had made efforts to reconstruct the past splendors of the various palaces that existed during the Han.[6] Reconstructions continue even in the present day, with the development of such disciplines as archaeology, art, and architectural histories. There is certainly a degree of permanence to the idea of Han palaces rather than their physical structures, and the reason lies in the potential use of the historical past to serve the present. As Wu Hung revealed in his study of the Western Han capital Chang'an as a "monumental city," even the literary accounts of Chang'an in Eastern Han rhapsodies or *fu* (some of the earliest existing materials from which many later reconstructions and understanding of Han architecture draw information) were but "retrospective reconstructions from present-minded vantage points."[7] Wu Hung's study draws our attention to the phenomenon that "there is not a single Chang'an, but a series of Chang'ans confined in their individual historical strata."[8] The same was true for pictorial reconstructions of any Han palace by Qing painters: Han palaces were but fabrications for use by people of the Qing.

Literary records might provide fragments of information about the various Han palaces, but given that the reality of the historical past was never fully known, could Qing painters perceive these palaces as separate entities and visualize them individually with a degree of

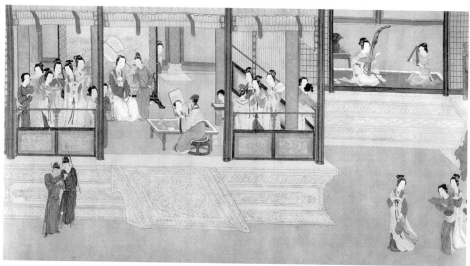

precision? And was it really their intention to reconstruct the image of a particular Han palace through the theme "spring morning in the Han palace"? It was likely that they conceived the different Han palaces as a homogeneous whole, confining them to stereotyped images that conformed to Qing perception of a splendid past. Moreover, the Han palaces in Qing paintings might simply be fantasies that painters accepted as real. Different individuals might have different views of a Han palace. Despite variations in details, however, their views of a Han palace were culturally structured and therefore fell within certain parameters. More important, within the court academy, it was the Qianlong emperor who re-

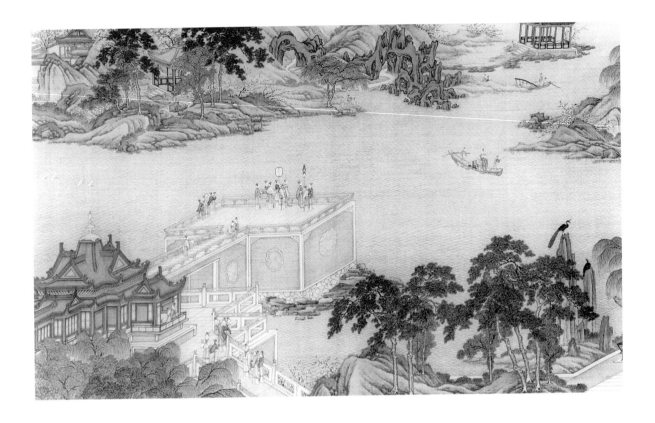

Fig. 4.3. Jin Kun (active
ca. 1717–ca. 1749) and
others: *Spring Morning
in the Han Palace*. 1738.
Detail of handscroll,
ink and color on silk.
National Palace Mu-
seum, Taipei, Taiwan,
Republic of China.

peatedly commissioned the various versions of *Spring Morning in the Han Palace*. His continual interest in the theme and his requests for painting drafts suggest that the emperor also played an active role in reinforcing certain visions of the reconstructed images of the past. The different representations were therefore a kind of mythmaking that was pertinent to the contemporary world, the world in which the patron and the painters lived.

Although many different versions of *Spring Morning in the Han Palace* were produced within the court academy,[9] I will focus on the versions of 1738, 1741, and 1748, which are all housed in the National Palace Museum, Taipei. All these versions are collaborative works completed during the Qianlong period.

In 1738 Jin Kun, Lu Zhan (active ca. 1736–ca. 1738), Cheng Zhidao, and Wu Gui (active 1726–ca. 1750) jointly painted a version measuring 37.2 x 596.8 cm (fig. 4.3). The activities of the court ladies are all arranged to occur in particular architectural settings: picking flowers in a garden, playing musical instruments within a hall, or viewing distant scenes from a masonry terrace. When the court ladies are placed in the encompassing built environment, they are reduced in size, and viewers' focus of attention is shifted toward the architecture.

In 1741 Sun Hu, Zhou Kun, and Ding Guanpeng painted another version slightly longer than the 1738 scroll (fig. 4.4). It measures 32.9 x 718.1 cm. In spite of variations in architec-

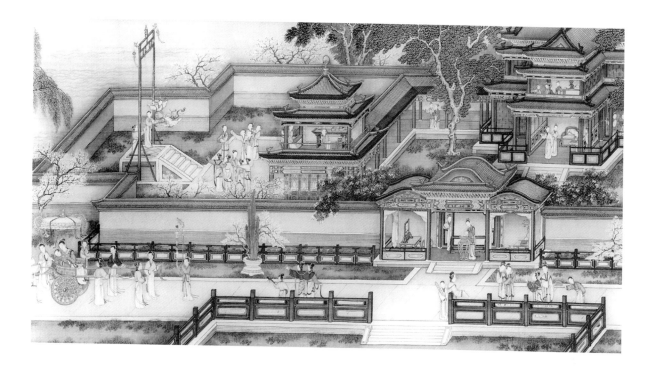

tural designs, the buildings in this scroll are as rich as those in the 1738 version. The lowering of the high vantage point reduces the projected distance from the viewer. Thus the figures and the architecture are relatively larger.

The third scroll under discussion was jointly painted by Zhou Kun, Zhang Weibang, Ding Guanpeng, and Yao Wenhan in 1748. Measuring 33.7 x 2038.5 cm, it is the longest of the three, almost three or four times as long as the previous two versions. There is an unfailing sense of monumentality, as reflected by the extraordinary length of the scroll and the number of the architectural images included in this painting. Such an abundance of architectural images dazzles the eyes, and the viewers' attention is directed to the architectural designs rather than the activities of the court ladies (fig. 4.5). Significantly, several unusual and unprecedented scenes are incorporated in this particular scroll. We find a ceremonial procession displaying insignia, pennants, and banners (fig. 4.6) as well as a performance of horsemanship in this Han palace (fig. 4.7). An expansive view of a distant cityscape is also included in the composition (fig. 4.8). Without the aid of the title, it is almost impossible to relate these new iconographical elements to the traditional theme of spring morning in the Han palace.

As I have noted, there were transformations in details when a Han palace was represented repeatedly. To set out the parameters of Qing collective perception of a Han palace (all these works were collaborative projects), I will analyze these three scrolls together to find out their similarities in architectural representation. Only when we know the com-

Fig. 4.4. Sun Hu (active ca. 1728–ca. 1746) and others: *Spring Morning in the Han Palace.* 1741. Detail of handscroll, ink and color on silk. National Palace Museum, Taipei, Taiwan, Republic of China.

The Idealized Scheme

105

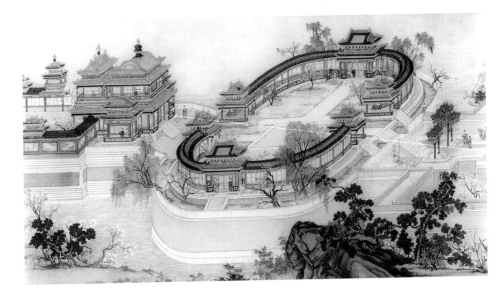

Fig. 4.5. Zhou Kun (active 1737–ca. 1748) and others: *Spring Morning in the Han Palace*. 1748. Detail of handscroll, ink and color on silk. National Palace Museum, Taipei, Taiwan, Republic of China.

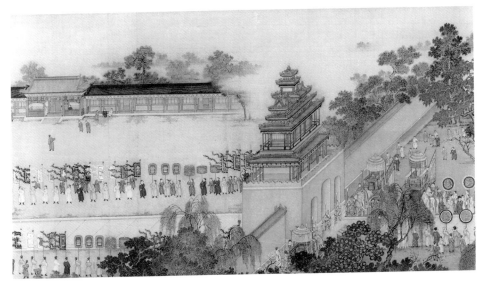

Fig. 4.6. Zhou Kun (active 1737–ca. 1748) and others: *Spring Morning in the Han Palace*. 1748. Detail of handscroll, ink and color on silk, showing the assembly of ceremony insignia, pennants, and banner. National Palace Museum, Taipei, Taiwan, Republic of China.

mon features can the critical transformations and variations—which culminated in the monumental version of 1748—be understood.

The Han palace in each of the three scrolls is magnificent and flamboyant. It is composed of gorgeously decorated buildings of various types. Fanciful buildings are distinguished by extraordinary heights and extensions. They are crowned with elaborate rooftops. Different types of roofs, including the gable-and-hip roof, pyramidal roof (*cuanjian*), hip roof (*wudian*), flush-gable roof (*yingshan*), and overhanging-gable roof (*xuanshan*) are presented in various versions: single-eaved, multiple-eaved, or cross-ridged. Rooftops may

The Idealized
Scheme

106

Fig. 4.7. Zhou Kun (active 1737–ca. 1748) and others: *Spring Morning in the Han Palace.* 1748. Detail of handscroll, ink and color on silk, showing the practice of horsemanship in the palace. National Palace Museum, Taipei, Taiwan, Republic of China.

Fig. 4.8. Zhou Kun (active 1737–ca. 1748) and others: *Spring Morning in the Han Palace.* 1748. Detail of handscroll, ink and color on silk, showing the distant view of a city from the palace. National Palace Museum, Taipei, Taiwan, Republic of China.

be further decorated with gilded ornaments such as a stupa, disc, globe, lotus, phoenix, or dragon. Galleries follow circuitous or serpentine routes; walls stretch out to form embracing curves. As for the overall layout of the palace compound, there are many irregularities, variations, and twists and turns. The spatial organization is intended to bring viewers into a world of delights.

What might have provided the basics for this collective perception of a Han palace? The idea of a splendid Han palace was probably based on a fabric of references: a set of codes from literature, a set of codes from past paintings, and another set of codes from actual con-

The Idealized
Scheme

temporary constructions. Any of these references, or their interplays in previous reconstructions, whether they faithfully represented historical reality or not, would become sources of knowledge that affected later representations of a Han palace.

Han rhapsodies often celebrate the awe-inspiring scale and majestic beauty of palaces through flowery language.[10] The writers of these rhapsodies were mostly officials or scholars, whose penchant for extravagant description of things had given pleasure to Han emperors and feudal princes.[11] To see how literary representations of Han architecture might have fired later imaginations or provided "historical" knowledge,[12] consider a section from an example of Han rhapsody, *Lu Lingguang dian fu*. This rhapsody by Wang Yanshou celebrates the Hall of Numinous Brilliance commissioned by Liu Yu, the lord of Lu (r. 154–129/8 B.C.). Because this palace survived intact despite the destruction of other palaces during periods of political chaos, the writer associated it with political power and legitimacy: "A divine intelligence rested here and supported it to preserve the Han house."[13] The great grandeur of this palace has been glorified with extravagant language as follows:

Viewing the form of that Numinous Brilliance:
Jaggedly jutting, tall and towering,
Precipitously poised, piled and peaked.
How terrifying,
How daunting it is!
High and haughty, unusual, unique,
Luxuriantly beautiful, broad and spacious!

Intricately conjoined and connected,
It stretches without bound!
By far the rarest thing in the world, it stands alone;
Ah, what a magnificent wonder, what a massive maze!
Sublimely it stands, mountain-like, twisting and twining,
Loftily spiring and soaring into the cerulean clouds.
Limitless, boundless, it rises tier upon tier,
Steep, layered and laminated like dragon scales.
Pure, clear, and candid, gleaming and glistening,
Fulgent, bright, and brilliant, it illumines the earth.
Its form is like the lofty heights of Piled Boulders Mount
And further resembles the awesome divinity of God's chamber.

Lofty ramparts are linked like ridges, joined like peaks;
Vermilion gateways, steep and stately, stand in pairs.
Its tall portals emulate the Changhe Gate;
Two chariots running abreast enter together.[14]

Was the Hall of Numinous Brilliance "a magnificent wonder" marked by "lofty heights" and "awesome dignity"? While literature provides fragments of information about this historic palace, it is difficult to establish a relation between the textual and the actual, especially inasmuch as limited examples of Han buildings exist today. The only surviving Han structures are stone gate-towers, stone shrines, and cave tombs, as well as funerary clay houses that reflect the structure of a storied building or the overall design of vernacular architecture. However, historical creditability of literary representation is not my concern here, and it is beyond the scope of this study to validate early writings on Han palaces. No matter how elaborate a literary description is, one cannot assume objectivity, as the writing could have served different possible purposes and can be allegorical or even fictional in nature.[15] Since the writing itself is subject to the mode of representation of a particular literary form, stylistic factors also make it difficult to make comparisons between categories.

Even assuming that a Han writer and a Han painter were both representing a contemporary palace in two different forms, one could expect dissimilarities resulting from the different conventions of actual architecture, literature, and painting. By the time Qing court painters depicted a Han palace, the actual architecture had already disappeared, but the idea of it was vaguely preserved in Han literature. Given the time span that separated the Han from the Qing, it is not surprising that Qing pictorial representations based on historical writings show discrepancies from historical reality. They simply represented the way Qing people visualized the mythical past through materials that themselves might show great discrepancies from the reality.

In addition, the allusive quality of Han rhapsody provides many unspecified areas for later imagination and interpretation of a Han palace. Another passage about the Hall of Numinous Brilliance reads as follows:

The design corresponds to the heavens,
Above, is modeled on the Loggerheads.
Deceptive and deceiving, it rises like clouds,
Peaked and pointed, laced and latticed.
In three compartments, four exteriors,
Eight sectors, and nine corners,
Myriad pillars, leaning in clusters,
Ruggedly rising, provide mutual support.[16]

The advance in representational schemes between the Han and the Qing provided Qing jiehua painters with a range of vocabularies and methods for visualizing and depicting a Han palace. The three versions of Spring Morning in the Han Palace exhibit a repertoire of architectural types inherited from ancient paintings. I will not trace these architectural types to their points of origin, in part because any such attempts would be questionable because of the paucity of past paintings to verify a claim. But there is no doubt that the

遠殿式

Fig. 4.9. Palace image from the first edition of the *Jieziyuan huazhuan* by Wang Gai (active ca. 1677–1705), ca. 1679.

great tradition of architectural painting had provided Qing painters with many possibilities of architectural renderings. Whether an architectural image in an ancient painting is real or imaginary, whether it first appeared in painting or in actual construction, when this image was passed down to the Qing, it affected the way later painters perceived ancient architecture.

Inside the court, painters had the opportunity to study ancient paintings in the Qing imperial collection. Prior to court service, these painters had received other painting instruction, and they could have referred to painting manuals or ancients' sketches for codified representational techniques and established canons. Already in the first edition of the *Jieziyuan huazhuan* (published in 1679) there is a whole spectrum of architectural images to go with instructions of the ancient methods of representation.[17] The palace image, as perfected by tradition and transmitted through this manual, is marked with descriptive complexity (fig. 4.9).

Combining the codes from literature with the codes from past representations, Qing court artists attempted to reconstruct a Han palace that was supposed to evoke a sense of history. Ironically, the attempts to designate a past in paintings were likely to be contradicted and counteracted by a simultaneous insertion of contemporaneous elements because the painter's visual perception of a historic Han palace was never separated from the contemporary world in which he was living. For example, ancient architectural designs transmit-

ted through paintings might later be adopted in actual constructions.[18] And while past paintings provided inspiration for contemporary constructions, the latter could also affect the way painters reconstructed the past. Thus the boundaries between past and present, fantasy and reality were never rigid.

There is ample evidence showing that the elaborate architectural designs in the three versions of *Spring Morning in the Han Palace* closely resemble actual constructions, especially the imperial architecture of the Qing. One typical example is the architectural design characterized by crossed ridges and a cruciform ground plan. This particular design features a protruding porch on each of the four sides of a building and is commonly found in ancient architectural paintings. It is adopted in both the imperial architecture and *jiehua* of the Qing. Surviving actual examples include the Hall for Receiving the Light (Chengguang dian) in the Round City of the North Lake (Beihai) and the four corner-towers and the pair of pavilions named Pavilion of Ten Thousand Springs (Wanchun ting) and Pavilion of a Thousand Autumns (Qianqiu ting) in the Forbidden City.

Moreover, the spatial organization of a vanished historic palace was often affected by painters' direct experiences and knowledge of actual, contemporary palaces. Painters might refer to the design principles adopted in contemporary pleasure palaces, translating similar spatial conceptions into paintings. In this way, the pictorial representation would provide the viewer with architectural experiences similar to actually walking in a real pleasure palace. In Qing imperial garden design, as exemplified by the Summer Palace in Rehe or the Garden of Perfect Brightness, an estate was divided into many scenes or miniature gardens.[19] Each scene was itself a microcosm with distinct theme, style, and function. It might be further divided into smaller sections by architectural and natural elements, such as walls, doorways, corridors, artificial hills, ponds, and so on. Yet every individual scenic region was linked to the others to form a unified whole. The appreciation of the entire garden involved transformations of space-time from section to section, from scene to scene. To realize this conception of space-time, painters had to plan the pictorial structure carefully and to present a series of diversified views to indicate one's shifting position in an ongoing mental journey. The separation and linkage of disparate scenes and the transformation of space-time were very subtle. The ending of a spatio-temporal condition bore the beginning of the other, and these were intricately linked together.[20]

Although the incorporation of these contemporaneous architectural elements might have made a pictorial reconstruction of a Han palace look "real" to the Qing people, it also blurred the historicity of the subject. Moreover, style played a role in reducing the sense of ethereality that was associated with the world of the mythical past. Despite alterations in details, all the 1738, 1741, and 1748 versions consistently show a solid, tangible style in architectural representation. All the lines, except the curves, are produced with the aid of a ruler. They show perfect evenness and steady discipline in the control of the brush. Because of this high level of precision and technical assurance, every structure is characterized with sharpness of edges and tangibility of forms. To highlight the distinct edges of struc-

tures, a white line is occasionally juxtaposed to the ink outline. There is also an effective use of graded washes to suggest volume. Contrasts of light and shade are used to emphasize the concavities and convexities of curved surfaces as well as the recessions of planes. Special attention is also given to the building materials, so that the substantial quality of things is greatly enhanced. Solid masonry platforms, glossy glazed tiles, cold and hard marbled terraces—all of them exemplify the attempt to capture the physical properties of every building material. Moreover, the use of colors greatly heightens the visual effect. A rich variety of bright, opaque colors is applied to fill the linear structures: yellow, green, blue, and purple colors for the roofs, golden yellow for the gilt decorations, white for the marbled terraces and balustrades, red for the painted woodwork, and different colors juxtaposed for the painted decorations under the eaves. The vividness of the colors reinforces the sense of texture and the solidity of the architecture. In sum, skill and effort are directed to very meticulous renderings of the Han palaces in these paintings.

The Synthesis

If *Spring Morning in the Han Palace* was traditionally appreciated as a work about the cultivated life of Chinese beauties (which was in conformity with the expectation of Confucian society), then a shift in focus toward architectural representation would lessen the role of the female figures in these Qing court paintings. The architectural images assumed an even more important role in bringing forth some other purposes of these paintings, purposes more than just the imperial wish to enjoy the beauties and their engagement in leisurely pursuits.

Comparatively speaking, the 1748 version contains the most abundant architectural images. The play with irregularity in architectural design is exploited to the extreme, and the dramatic effect is heightened to the greatest extent. More significant, the Han palace in this version has numerous architectural images that resemble actual Qing buildings. For instance, there are circular structures that resemble the Hall of Prayer for Good Harvest (Qinian dian) at the altar of Heaven (figs. 4.10–11). There is also a two-storied pavilion with a pyramidal roof and gilt decoration that is similar to the design of the Rain Flower Pavilion (Yuhua ge) in the Forbidden City (figs. 4.12–13). In addition, a group of buildings shows a composition in imitation of that of the Pavilion of Ten Thousand Happiness (Wanfu ge), the Pavilion of Extended Peace (Yansui ge), and the Pavilion of Eternal Health (Yongkang ge) in the Palace of Peace and Harmony (Yonghe gong). These structures are linked together by flying galleries (figs. 4.14–15).[21] In some buildings, gilded emblems embellish the rooftops, just as they do in Tibetan-style architecture (e.g., the design of the Palace of Peace and Harmony). As a teaching center of Tibetan Buddhism at the capital, this monastery was particularly meaningful to the Qianlong emperor, who manipulated religion and even created an image of himself as bodhisattva to exercise political control over Tibet and

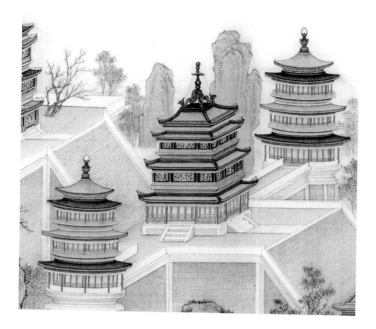

Fig. 4.10. Zhou Kun (active 1737–ca. 1748) and others: *Spring Morning in the Han Palace*. 1748. Detail of handscroll, ink and color on silk. National Palace Museum, Taipei, Taiwan, Republic of China.

Fig. 4.11. Hall of Prayer for Good Harvest at the altar of Heaven in Beijing.

Fig. 4.12. Zhou Kun (active 1737–ca. 1748) and others: *Spring Morning in the Han Palace*. 1748. Detail of handscroll, ink and color on silk. National Palace Museum, Taipei, Taiwan, Republic of China.

Fig. 4.13. The Rain Flower Pavilion in the Forbidden City, Beijing.

Mongolia.[22] The visual allusions to Tibetan architectural features were therefore politically significant.

As more and more contemporary architectural images are included in the 1748 version, a Han palace is represented as a Qing palace. This version also incorporates several unusual scenes that provide metaphorical allusions to the Qing: the assembly of ceremony insignia, pennants, and banners symbolizes Qing political authority in display; the performance of horsemanship is a component of Manchu culture and identity; and the distant cityscape offers a metaphor of governance of the Qing empire. Consequently, Han life is transformed into Qing life through the insertion of these new iconographical elements. Such critical transformations are not accidental. The continual interest in this historical theme and the multiple copies that came about in the Qianlong academy suggest that the emperor was not fully satisfied with the earlier versions. With the imperial commands, the theme was constantly reinterpreted and transformed until there was a version that rendered a Han palace more like a Qing palace and Han life more in line with Qing life. More significant, the Qing ruler—who was conscious of the long history of China—had to forge a relation to Han China's past in order to assume dominance and control. In the 1748 ver-

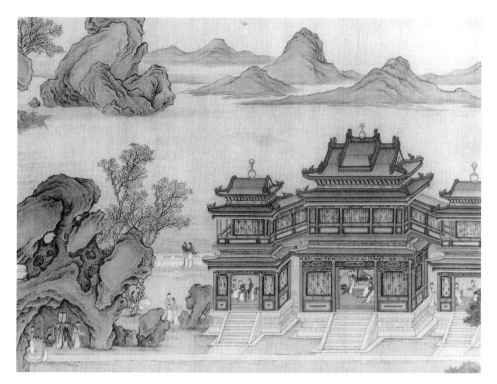

Fig. 4.14. Zhou Kun (active 1737–ca. 1748) and others: *Spring Morning in the Han Palace.* 1748. Detail of handscroll, ink and color on silk. National Palace Museum, Taipei, Taiwan, Republic of China.

Fig. 4.15. Pavilion of Ten Thousand Happiness and Pavilion of Eternal Health in the Palace of Harmony and Peace.

Fig. 4.16. Jin Tingbiao:
Palaces of the Immortals.
Hanging scroll, ink and
color on silk. National
Palace Museum, Taipei,
Taiwan, Republic of
China.

sion of *Spring Morning in the Han Palace*, the Han/Qing palace intended for subjugation to the Qing imperial system was combined with other cultural components so that the reconstructed architectural environment idealized the rulership and symbolized the unity of a diverse empire under the Qianlong reign.

As we have observed, the later the version, the more complex the design of a Qing-reconstructed Han palace. Descriptive complexity was a characteristic feature of Qing architectural representation that was intended to restore the legendary splendors of historic palaces. Significantly, this stylistic feature also occurs in the court representations of the immortals' palaces. For instance, Jin Tingbiao employed very similar architectural images in the *Palaces of the Immortals*, now in the National Palace Museum collection (fig. 4.16). What are the implications of this interchangeability of architectural images between historical and mythical themes? How does this overlapping of stock types provide insights into visions of the past as presented in Qing court paintings?

This overlapping suggests that history and myth were entwined in the visual imagination of the Qing painters, so that a historical past was also imagined as a mythical realm. Given that the past had been reconstructed to serve the present, the interchangeability of architectural vocabularies between the historical and the mythical realms had the effect of pair-

ing the Qing world with the immortals' paradise. The egocentric Qianlong might also have believed that the idealized image of his universal empire—herein immortalized through painting—was equivalent to the mythical realm.

Paradise on Earth

As we move on to images of mythic architecture, we notice a relatively limited production of court architectural paintings that depict the immortals' paradise. We do not find huge projects showing such a grand scale as *Southern Inspection Tour* or *Spring Morning in the Han Palace*. Nor do we find teams of painters working jointly on the theme of the immortals' paradise. Why? Was there lack of interest in this particular theme within the court?

The limited production of architectural paintings based on mythical themes was not due to the emperor's disinterest in the immortals' land. Beyond the category of architectural painting, we often find landscape depictions of the "caves of heaven" (*dongtian*), places where the immortals were thought to live.[23] The emperor also commissioned a variety of craft forms—such as porcelains, lacquerware, and carvings of jade, ivory, and bamboo—to convey the auspicious wish for immortality. Perhaps the crucial factor is what symbolic forms were chosen for transmitting what kind of messages. In this connection, the striking contrast in quantity between *jiehua* and architecture for the realization of a paradise is noteworthy. Despite the limited depictions of the immortals' palace in Qing court architectural paintings, there were actual constructions of "the immortals' paradise" within the Qing palaces. In other words, the paradise had to be constructed, not merely depicted, on a grand scale to fulfill the emperor's satisfaction.

The forty scenes of the Garden of Perfect Brightness were completed before Tangdai and Shen Yuan jointly painted the album in 1744. Several scenes in this garden were inspired by the Daoist idea of the immortals' paradise. Scene 34, "Another Cave of Heaven" (Bieyou dongtian), represented the thirty-six "caves of heaven." Scene 32, "The Fairy Islands and Jade Terrace" (Pengdao yaotai), had a design based on the idea that the Fangzhang Isle of the immortals was shaped like a *fanghu* jar, an ancient ritual vessel. Scene 29, "Elevated Region of *Fanghu*" (Fanghu shengjing), was based on the theme of the Fangzhang fairyland (plate 7). As the immortals' palaces were said to be made of gold and silver, the buildings in this particular scene had yellow-glazed tiles and white marble platforms to produce a similar effect of brightness and shininess. Fanciful overhanging galleries connected the buildings, offering an experience of traveling in midair. All these scenes provided the emperor with an illusion that he was, like the transcendent being, actually enjoying a paradise.

In addition, a special statue called dew basin carried by the immortal (*xianren cheng lupan*) had been erected in the Qing imperial gardens. Two of these statues are still preserved today in the North Lake (fig. 4.17) and the Garden of Perfect Brightness. The construction of such dates back to the Western Han period, when the cult of immortality was in vogue.

The Idealized
Scheme

Fig. 4.17. Dew basin supported by the immortal, North Lake, Beijing. This statue was designed for collecting morning dew to be taken as the elixir of everlasting life.

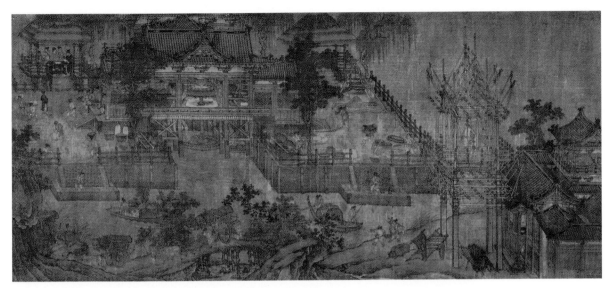

Plate 1. Attributed to Wei Xian (tenth century): *Transport Carts at the Mill*. Handscroll, ink and color on silk. Shanghai Museum. The achievement of structural clarity in this architectural representation suggests that the painter understood the physical properties of the depicted structures.

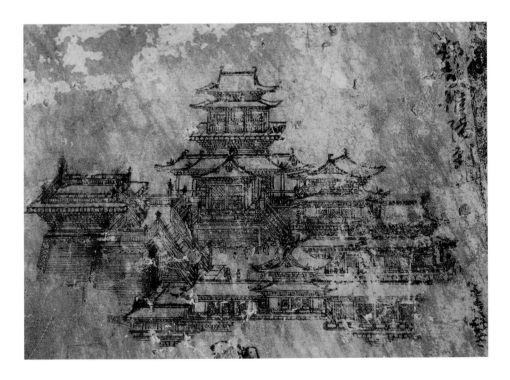

Plate 2. Wang Kui (twelfth century) and Wang Dao (twelfth century): *Architectural Scene*. 1167. *Jiehua* on the south wall of the Yanshan Temple at Fanshi county in Shanxi province. This Jin painting is an important surviving material that sheds light on the great Song tradition of Chinese architectural painting. From Chai Zejun and Zhang Chouliang, eds., *Fanshi Yanshan si* (Beijing: Wenwu chubanshe, 1990), pl. 106.

Plate 3. Detail of fig. 1.11 showing the dense arrangement of structures to form a compact architectural compound.

Plate 4. Anonymous European artist: "Diligent in Government and Friendly with Officials," scene 2 of the *Garden of Perfect Brightness.* Ink and color on paper. Bibliotheque Nationale, Paris.

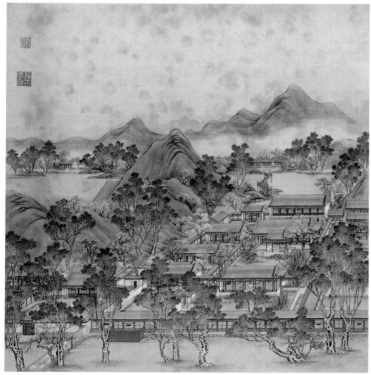

Plate 5. Tangdai (1673–after 1751) and Shen Yuan (active ca. 1736–ca. 1746): Scene 2, "Diligent in Government and Friendly with Officials," leaf from the *Forty Scenes of the Garden of Perfect Brightness.* Tangdai painted the landscape and Shen Yuan added the architecture. 1744. Album leaf, ink and color on silk. Bibliotheque Nationale, Paris.

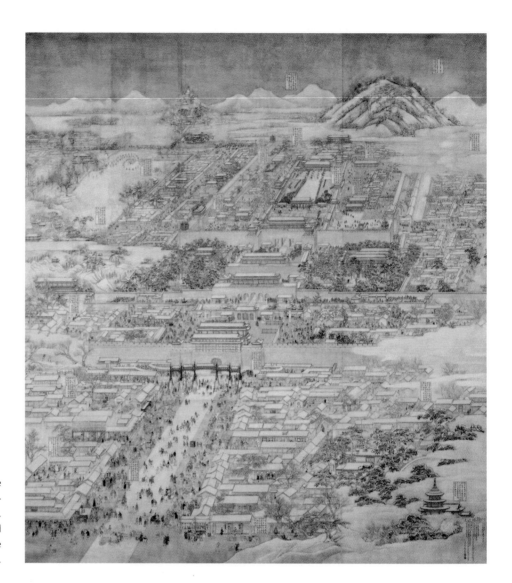

Plate 6. Xu Yang (active 1751–ca. 1776): *Spring-time in the Capital.* 1767. Hanging scroll, ink and color on paper. Palace Museum, Beijing.

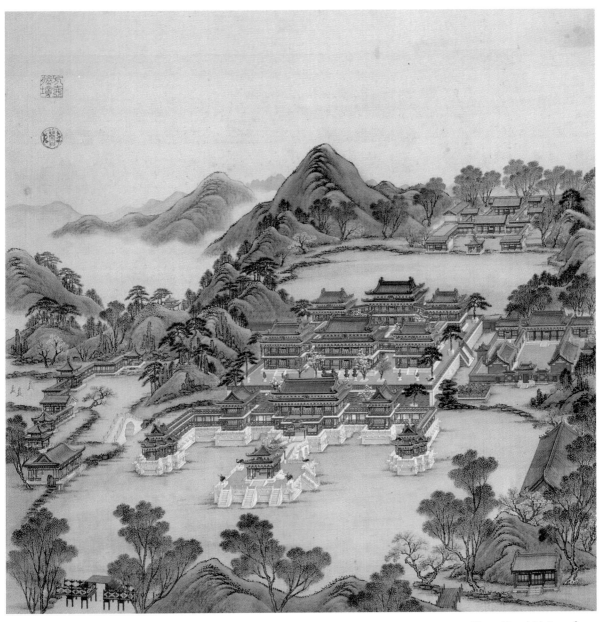

Plate 7. Tangdai (1673–after 1751) and Shen Yuan (active ca. 1736–ca. 1746): Scene 29, "Elevated Region of *Fanghu*," leaf from the *Forty Scenes of the Garden of Perfect Brightness*. 1744. Album leaf, ink and color on silk. Bibliotheque Nationale, Paris.

Plate 8. Yuan Jiang (active ca. 1690–ca. 1740): *The East Garden*. 1710. Handscroll, ink and color on paper. Shanghai Museum.

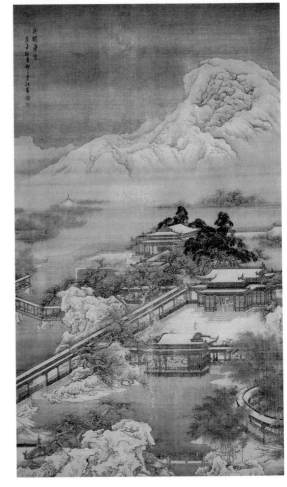

Plate 9. Yuan Jiang (active ca. 1690–ca. 1740): *Flying Snow in the Liang Garden*. 1720. Hanging scroll, ink and color on silk. Palace Museum, Beijing. From *Yuan Jiang Yuan Yao huaji* (Tianjin: Tianjin renmin meishu chubanshe, 1996), pl. 44.

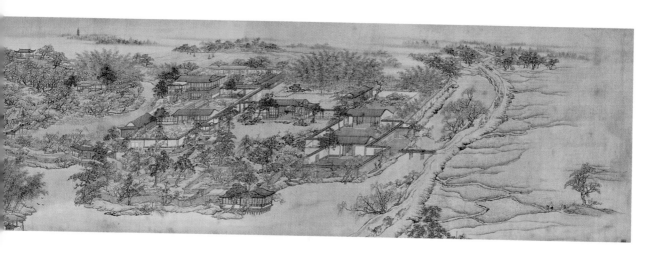

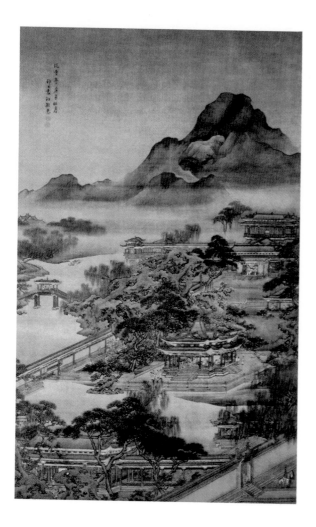

Plate 10. Yuan Jiang (active ca. 1690–ca. 1740): *The Deep Fragrance Pavilion.* 1720. Hanging scroll, ink and color on silk. Tianjin Museum of Art. From He Ruyu, ed., *Masters of Landscape Painting: Yuan Chiang and Yuan Yao* (Taipei: Art Book Co., 1984), pl. 13.

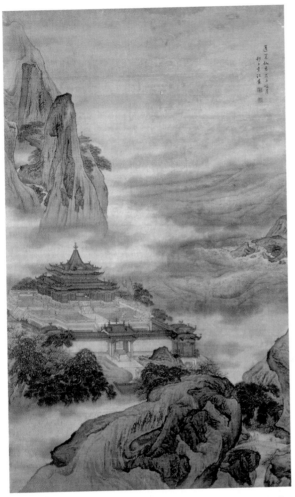

Plate 11. Yuan Jiang (active ca. 1690–ca. 1740): *The Penglai Isle of the Immortals*. 1708. Hanging scroll, ink and color on silk. Palace Museum, Beijing. Three mountains or islets, turbulent waves, and a grand palace compound—these are the standard iconographical elements in Yuan Jiang's representation of a fairyland.

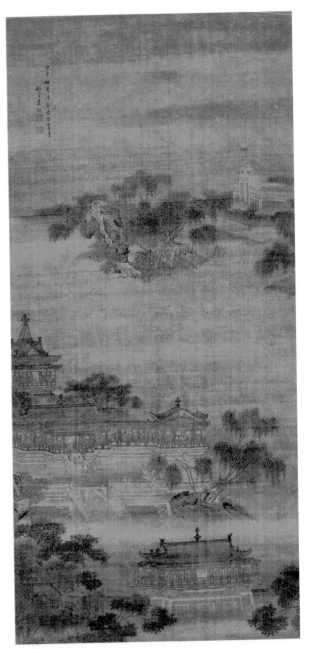

Plate 12. Yuan Jiang (active ca. 1690–ca. 1740): *Waterside Palace in Spring*. 1704. Hanging scroll, ink and color on silk. Shanghai Museum. In the distance is a dew terrace consisting of a tiered platform and a basin raised by an immortal.

The Han emperor Wudi was said to have collected morning dew above the Divine Terrace (Shenming tai) of the Jianzhang Palace and taken it with scraps of jade as the elixir of life.[24] The *Xidu fu* records this special construction as follows:

> They hoisted immortals' palm to receive the dew,
> Jutting forth from metal columns standing in pairs.
> Having transcended the turbidity of dust and dirt,
> They were refreshed by the clear essence of white vapors.[25]

The Qing imperial patronage of the cult of immortality provided another instance where history and myth were manipulated to serve the present. Given the magnitude of imperial power and national resources, many fantastic ideas of immortality could be realized architecturally for the material enjoyment of the emperor. In all these examples, Daoism became the key symbol in the cultural discourses of the Qianlong emperor, who preferred actual construction to architectural painting as the desirable symbolic form for meaning making. What messages were better conveyed through architecture?

First, architecture provided an illusion that the paradise had actually been attained. More important, only the Son of Heaven could possess such a luxurious and extravagant paradise on earth. In a hierarchical society where material conditions were used to advertise status, the actual constructions of scenes of paradise had the effect of enhancing Qing imperial power. Second, when a Daoist paradise was actually constructed alongside the Confucian ancestral temple, Buddhist monasteries, and Manchu hunting grounds within the Garden of Perfect Brightness, the idea of imperial dominance over all cultural traditions was heightened. These political and social meanings invested into architecture throw light on the reasons for not choosing *jiehua* in this particular context. We may speculate that the emperor did not see meanings other than the quest for immortality in architectural paintings of mythical themes. The idea of immortality had, in fact, been manifested in other art and craft forms commissioned by the emperor. Comparatively speaking, actual architecture, rather than architectural painting, provided the site for multiple discourses.

Whether the artistic programs were in the form of painting or architecture, whether they were related to history or to myth, they all presented grand visions of an idealized world where imperial power was wielded, wealth amassed, and pleasurable sensations heightened. The borrowing and ultimate transformation of a Han palace created the illusion of a Han airing of Manchu rule, yet the ultimate goals were to diminish the significance of Han Chinese and to foster an ideology of Qing universal rule. The actual constructions of scenes of paradise manifested the extravagance of the Qing imperial life, and these scenes were simultaneously immortalized in paintings of contemporary themes. All these artistic programs were interactive and were brought into a conjunction where history, myth, past, and present were intertwined in achieving an overall idealized scheme for Qing imperial aggrandizement under the Qianlong reign.

Moving Gardens

YANGZHOU REPRESENTATIONS I

5

BEYOND THE CAPITAL, there was also a resurgence of architectural painting in urban centers. As explained earlier, I decided to focus on Yangzhou as a parallel study because Yangzhou's private patronage of the arts, especially by rich merchants, had reached such an impressive scale that it could almost rival imperial patronage in Beijing. The existence of the Yuan school—which involved two generations of *jiehua* specialists—further indicated that the production of architectural painting in Yangzhou was sustained by market demand. Because there are numerous surviving works by Yuan Jiang and Yuan Yao, I will focus on their works.

There are certain notable differences between imperial and private patronage, such as a change of patron from the Qing rulers who oversaw the whole empire to an individual who took pride in possessing a private estate as well as a change in power from supreme imperial authority to the status invested in any social class. Although architectural images still offered sites for social and cultural engagements, the nature of meaning construction varied. The choice of themes also varied, and because of this, it is difficult to give every theme a parallel study. My studies of court and Yangzhou architectural representations are therefore confined to contemporary, historical, and mythical themes.

Ritual Activities in Private Gardens

In Qing Chinese hierarchical society, the emperors performed state rituals to reiterate political authority, whereas the social elite (including gentry, officials, and wealthy merchants) engaged in refined activities and lived a luxurious cultural life to assert social importance. The latter invited famous personages, poets, and artists to elegant gatherings in which they

tasted good tea or wine, composed poems, and enjoyed works of art in refined environments. These cultural practices were not ceremonial rituals that involved a fixed sequence of prescribed actions. Nevertheless, they were purposeful activities that occurred customarily in specially designed environments.

While conducting cultural activities in private gardens, individuals played visible roles in the creation or affirmation of their social images. In that sense, elegant gatherings were similar to state rituals, as both reinforced status distinction in a hierarchical society. Whereas state ceremonies in imperial settings were superpersonal and emotionally charged, literary and artistic gatherings in private gardens were informal and relaxed. Elegant gatherings also enabled selected members from the lower social strata to gain acceptance from the intellectual elite and to achieve upward social mobility. Shared interests in the arts as well as practical concerns for social networking brought the participants together in these gatherings. If similarity of culture was the basic social bond within the enclosure of a private garden, then dissimilarity of cultures differentiated these participants from those who were excluded. So while some of these participants were enjoying the benefits of fluidity of social boundaries, most of them were conscious of the need to guard their status. Implied here are the notions of upward mobility and cultural differentiation in Qing society, notions that were especially valid in the garden city of Yangzhou.

The quest for upward social mobility also created tensions between different social groups. The old gentry and scholar-officials often assumed leadership in literati culture, setting an example for rich merchants who, being motivated by the desire for upward social mobility, supported cultural activities in order to buy their way into the social elite.[1] Garden construction became their means to achieve the ends. So when the famous scholar Li Yu (1611–ca. 1680) talked about garden design in his *Xianqing ouqi*, he made clear conceptual distinctions between "refined elegance" *(ya)* and "vulgarity" *(su)*, between "technical awkwardness" *(zhuo)* and "craftsmanship" *(gong)*.[2] The boundaries between these contrasting terms might be blurry in practice. Yet these distinctions revealed two important social phenomena: first, the literati concerns with maintaining a distance from the "vulgar" merchants; second, the social tensions that resulted from the rise of the merchant class.

The merchants in Qing Yangzhou were wealthy enough to direct the course of the city's cultural life, and a group as vast as this could give rise to a rich variety of cultural expressions. In addition, the merchant community in Yangzhou was diverse. Although the majority came from Anhui province, others came from other provinces such as Shanxi and Shaanxi. The formation of different native-place associations was a concrete expression of the diversity of the group. And within the merchant class, there was also a concern to mark a distinction between the "refined" and the "vulgar" in accordance with the literati criteria of evaluation. The *Yangzhou huafang lu* supplies us with numerous examples of the diversity of the group. For instance, merchants such as the Ma brothers—Ma Yueguan (1686–1755) and Ma Yuelu (1697–after 1766)—hosted elegant gatherings in private estates, built up private

libraries, and supported men of letters. In contrast, other merchants indulged in all sorts of peculiar activities—such as throwing gold foils in the air, raising hundreds of horses, keeping mechanical female nude statues, or playing with Suzhou roly-poly—that the literati perceived as vulgar. Extravagance might be a common feature of these different modes of life led by the merchant class in Yangzhou, but one can make no easy generalization about mercantile culture.

Because of their different preferences, Yangzhou garden owners commemorated their gardens in different ways. These preferences explain the existence of two different types of representations in relation to garden culture: one focuses on a specific literary gathering that occurred in a garden setting; the other provides a portrait of a private garden. The first type normally portrays human figures in natural surroundings.[3] Important iconographic components such as scrolls, books, archaic bronzes, and other collected objects affirm the cultural roles of the participants.[4] Simple *jiehua* elements such as garden railings and furniture provide various spatial settings, and often a painted screen image—a painting within a painting—is incorporated for specific purposes. As Wu Hung says in *The Double Screen*, the architectural device of a painted screen "provides the painting with a basic spatial structure as well as an essential symbolic framework" for understanding cultural and situational contexts.[5] The second type of garden portrayal focuses on the physical appearance of a garden: its design, layout, and terrain. Although the garden image may call up memories of events, it is landscape architecture as private property that is celebrated and commemorated. The studies in this book examine this second type of garden representation.

Garden Portraits

Paintings of gardens served the primary function of replicating physical appearances, but they also had important implications in the social and cultural milieus. In the sense that these works served a commemorative function and provided the vehicle for active social claims, they had similar purposes as portrait paintings, despite the difference in subject matter, technique, and pictorial convention between the two artistic genres.[6] The important study of Chinese portrait paintings by Richard Vinograd has pointed out the dynamic character of the portrait *event*, which involves negotiations between sitter and artist or between a portrait image and its extended audiences.[7] The same idea can be applied to the inquiry into Qing garden portraits, especially when the subject is private patronage outside the court.

Within the palace, negotiations between emperors and court painters were institutionalized through the painting academy, and the patron-artist relationship was one of dominance and absolute obedience. Imperial commands that impelled artistic productions largely conditioned final outputs, so that paintings of royal estates had to do with glorification, expression of political ideology, and claims of status and identity. In addition, detachment was assumed when court painters rendered imperial gardens, partly because

these were royal properties where public enjoyment was forbidden and partly because the emperors' visions, as conveyed through garden images, were not supposed to provoke subjective judgments and personal feelings on the part of painters. The painter's contribution was mostly confined to the development of an aesthetics that would realize the unchallenged political motivations behind the production of an image.

Outside the court, the patron-artist relationship was not necessarily one of dominance and subservience. There might be social distance between garden owners and painters (as within the court) or social interactions between them. It would, therefore, be interesting to consider the kinds of negotiations that might occur between patron and painter, negotiations that would in turn affect the encounter between painter and subject. The painter's vision brings the issue of style, and it is equally important to understand the role of the painter in representing, or even transfiguring, a garden in ways that were acceptable to both patron and artist.

The East Garden by Yuan Jiang presents a panorama of the garden owned by Qiao Yu (plate 8). Although we do not know much about Qiao, he was apparently wealthy enough to acquire an elite lifestyle to impress the literati. He established a reputation through his East Garden so that important personages of the day, including Wang Shizhen (1634–1711), Song Lao, and Cao Yin (1658–1712), wrote poems and essays in commemoration of his estate.[8] Later I will investigate how his garden facilitated social networking. At this point, my concern is whether Yuan Jiang was also related to this network of connection. Precisely what was the patron-artist relationship?

Qiao Yu's elevated social position was indicated by the respectability he received from famous scholar-officials, regardless of the somewhat unclear social relations between garden owner and literati. Certainly, the social position of Qiao Yu, the garden owner, was a contrast to the lowly status of Yuan Jiang, the professional painter. Without any historical materials revealing their interactions, one can only assume a direct commercial transaction with regard to the commission of *The East Garden*. The negotiation between patron and painter, in this case, was probably conditioned by their different social levels and by the circumstance wherein Yuan Jiang had to meet the demand of his patron. It is likely that Yuan Jiang's portrayal had to fulfill the patron's basic expectation for verisimilitude. A careful comparison between Yuan Jiang's painting and the literary descriptions by famous personages confirms that the representation met the requirement for pictorial fidelity. The painting, as will be shown, was a functional medium for communication.

Cao Yin had traveled in the East Garden, named its eight individual scenes—the Hall of the Stave Tree (Qiju tang); the Tower of a Few Mountains (Jishan lou); Chanting Society by the West Pond (Xichi yinshe); Joy-Sharing Pavilion (Fenxi ting); the Veranda for Listening with One's Mind (Xinting xuan); the West Villa (Xishu); the Crane Spot (Hechang); and Fishermen's Huts (Yu'an)—and composed eight poems in praise of them.[9] Then the Jiading scholar Zhang Yunzhang (1648–1726) gave a thorough description of the

garden, providing an important literary reference for comparison with Yuan Jiang's pictorial representation:

The hall is called the Hall of the Stave Tree, a name derived from the line "the tamarisk trees and the stave trees" in the ode [in the *Shijing*].[10] Several ten paces in front of this hall are two knolls on which grow huge trees of over a hundred years old. These trees are facing the hall, and the one situated right in front of it and the most upright is a stave tree. At the back of the hall, a thousand bamboo are planted. Their green colors are fresh as though they have been washed.

Departing the hall and following the circuitous routes of the galleries towards the west, one finds the Tower of a Few Mountains. Ascending this tower, one gains a panoramic view of the various peaks in Jiangnan region, and if seated on low tables, one can lean over and gaze into the distance.

In front of the tower, by the side of the pond, is the Veranda for Listening with One's Mind. It is so called because listening is not with the ears, but with the mind. All the sound is here received with silence.

Going northward from the west of the veranda, passing the tower and then turning west, one finds cottages made of straw and reeds. Without any assembly of rafters and walls, these cottages are simply surrounded by railings on the four sides. When tired, one can rest and mediate or sit and lie there. The wide area can accommodate several tens of guests who come with flowing wine cups to recite poems. It is therefore named the Chanting Society by the West Pond. The West Pond is located right in front.

Further to the west is the Joy-Sharing Pavilion raised on a platform. The pavilion is characterized by the flying slopes of the roof. From it, one can view the crops and share the joy of harvest.

Two knolls are in the south of the pavilion. Following the paths to go up and down, one reaches the West Villa, where a vast expanse of cultivated land can be seen from the open window.

To the east of the West Villa are undulating hills and dense woods. The galleries are here raised on steep slopes, extending toward the middle of the marsh—the Crane Spot, for this area is intended for herding cranes and is designed in accordance with the words of Han Yu, "open galleries are overhung by precipitous cliffs."

Moving further to the east, one reaches the gate that is on the left of the Veranda for Listening with One's Mind. Following the mountain paths for several hundred paces, then turning south, one enters the Fishermen's Huts. In their front are wavy waters that can accommodate several tens of fishing boats.

To the northeast is an overhanging bridge along which visitors can enter the garden.[11]

These different scenes of the East Garden are described from a shifting point of view. If we follow the sequence of the above description and tour round the garden depicted by Yuan Jiang, we will interestingly find that the textual and the visual agree with each other

in the mapping of the garden. The architecture was the landmark for identifying every single scene.

While one can assume that Yuan Jiang had to meet the expectations of his patron, was there room for the artist's interpretation? Under the brush of Yuan Jiang, the garden looks enormous. Since the actual garden has long since disappeared, we are unable to discern whether the size is to scale (although the above literary description also conveys a sense of vastness of this garden). However, could there be a degree of exaggeration in Yuan Jiang's representation? No matter—one may argue that Yuan Jiang perceived the garden as what he represented. Assume that the professional painter was allowed into the private garden to depict its physical appearance. He must have been aware of the conspicuous consumption of physical space by the social elite. This perception of the garden could be related to a mixture of other nonarchitectural factors: social distance between patron and artist, variation in the material conditions of various social classes, or aspiration for upward social mobility. All these might lead to the perception that the garden was grand and large, as it was essentially an enrichment of the material condition of the prestigious class. In addition to the artist's perception, style plays a role in the representation of the image. Yuan Jiang assumed a high vantage point and offered a panorama of the garden, making it look large and expansive. His portrayal from a high vantage point is, nevertheless, different from the European approach of bird's-eye view, which organizes the whole continuously with a fixed angle of vision.[12] A scrutiny of Yuan Jiang's painting will show that he was using native conventions to render the topographical view.

In Yuan Jiang's other work, *The Zhanyuan Garden*, it is even more obvious that style plays a role in evoking a sense of vastness and spaciousness (fig. 5.1). Before I discuss the style of this painting, a brief digression to explain the availability of its different versions is necessary. Notably, two versions of *The Zhanyuan Garden* are extant: one is in the Cultural Relics Department of the Cultural Centre of Tianjin City;[13] the other is in the Metropolitan Museum of Art.[14] These two scrolls are almost identical, but a close examination reveals variations in the details of the architectural representation. The Tianjin scroll provides the names of the individual buildings; the names are missing in the New York version. Another difference is that in the New York version there are certain areas where the painter is hesitant to articulate the spatial relations of the subjects, and thus some narrative details are missing or incomplete (e.g., the thatched pavilion amid the rockeries). These differences suggest that this scroll was based on a prototype, perhaps the Tianjin version. It could have been reproduced by a disciple in the Yuan studio.

The modern colophon added to the Tianjin version identifies the Zhanyuan Garden as the former residence of Xu Da in Nanjing, which later became a regional administrative office. Xu Da was a general who assisted the first Ming emperor establish the dynasty. This identification of the garden has been cited in Nie Chongzheng's study,[15] but it is disputed by Guo Junlun, who claims there were two gardens with the same name during the Qing.

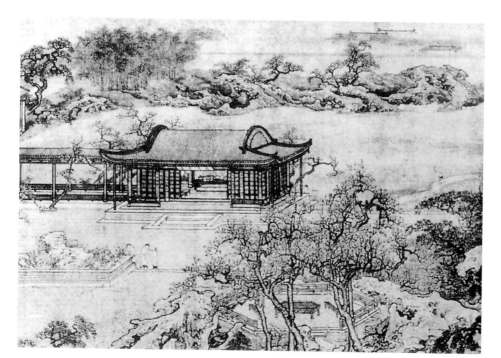

Fig. 5.1. Yuan Jiang (active ca. 1690–ca. 1740): *The Zhanyuan Garden.* Detail of handscroll, ink and color on silk. Cultural Relics Department, Cultural Center of Tianjin City. From He Ruyu, ed., *Masters of Landscape Painting: Yuan Chiang and Yuan Yao* (Taipei: Art Book Co., 1984), 11.

One was the villa of Qin Jianquan (which had long since been destroyed); the other was the former residence of Xu Da. As the latter was given its name by the Qianlong emperor during his southern inspection tour (i.e., some time after Yuan Jiang's period of activity), Guo points out that the one depicted by Yuan Jiang was probably the estate of Qin Jianquan.[16]

Although bounded by walls, the Zhanyuan Garden in Yuan Jiang's painting is remarkably large. Enclosed within its boundaries are various types of architecture, including halls, lounges, pavilions, waterside kiosks, galleries, bridges, and so on. There are also wide expanses of open areas such as courtyards, terraces, and ponds. The reading of this scroll, like the reading of *The East Garden*, involves transformation of space-time from one continuum to another. With an expansive treatment of the spatio-temporal continuum, space appears to stretch far and wide, and the sense of spaciousness and vastness is enhanced. And when stretches of up-tilted ground planes are presented, they give an impression of tangible physical spaces. These are physical entities that exist in their own right, constituting a grand, spacious architectural environment of the garden.

Return to Tradition

While Yuan Jiang was opting for a more substantial rendering of physical space, he also succeeded in reviving the traditional concern for clarity in architectural organization. This

Moving Gardens

representational concern in *jiehua*—which is evident in surviving Song and Yuan paintings—is less emphasized in some Ming architectural paintings but still preserved in the pictorial designs of various craft forms. When this past trait was revived in Qing representations of actual gardens, it interestingly served to convey a sense of grandeur, adding to the symbolic significance of private gardens in the social and economic milieu. Images of enormous gardens helped advertise the wealth and social station of their owners.

Another characteristic of Yuan Jiang's garden portrayals, as noted by the art critic Xie Kun, deserves attention. According to Xie, "[Yuan] Jiang used green ochre [for pale coloring] and added burnt ink for outlining [the architectural images]. His *jiehua* looks austere and antique. [Wang] Hanzao [i.e., Wang Yun] had the texture strokes laid down in pale ink. He then added intense green color washes [to fill the surface areas]. His *jiehua* looks bright and moist."[17]

The use of heavy ink lines in Yuan Jiang's architectural representation had been associated with the quality of austerity and antiquity.[18] We are not sure whether the development of this "austere and antique" style was related to Yuan Jiang's "progress" after he had allegedly obtained anonymous sketches of the ancients' works. Nevertheless, his surviving works provide the proof of his achievement. By following the ancient methods and employing ink lines of varied thickness and tonality, Yuan Jiang succeeded in giving contemporary subjects an "austere and antique" flavor. As a result of the restoration of antiquity in *jiehua*, his paintings played an evocative as well as descriptive role. They also transcended the grand into the sublime.

Motives and Meanings

The lure for a quiet life of retreat to devote to nature was the basic idea behind the construction of a scholar's garden. The humble hermitage could be a simple rustic hut surrounded by walls or hedges. Although scenes designed for elegant scholarly activities were not lacking in those vast gardens depicted by Yuan Jiang, his garden images were far from being humble. Generally speaking, *jiehua* of this type presents the physical appearance of a private garden and emphasizes its scale and entirety. Such paintings enabled the garden owner to advertise wealth and social station. Alluding to the privilege of ownership and luxurious consumption, this kind of garden portrait was an outward manifestation of status. When compared with the other type of representation—which includes portraits of famous personages as well as narration of an event that occurred in a private garden—it is interesting to note that a garden portrait could, by itself, allow the garden owner to establish networks of connection. If the other type of depiction served to record the development of social networks, then this particular type served to *foster* such networks. How could this be achieved?

Garden portraits not only replicated but also transfigured or transcended the aesthetic merits of the actual construction. They also allowed for ongoing social engagements by

celebrities who wrote in adoration of the beauty of the garden. To further understand this, it is useful to cite Wang Shizhen, who wrote on the East Garden:

> In the early spring of the *xinmao* year [1711], I received a letter from my student Yan Yanlai. On behalf of Qiao Yizhai [i.e., Qiao Yu], he requested that I contribute an essay about the scenery of the East Garden—his friend's estate. He also sent me a picture of the garden. As I unrolled the scroll and viewed the garden, I could sense man's feelings transferred into it. . . .
>
> This garden of Mr. Qiao is far away from the city proper in the midst of dense woods. There is a pure stream flowing nearby. Moreover, mountains are piled on high regions, and ponds are dug over low-lying areas. On the opposite shore, towering peaks confront each other. Rare plants and animals can be found in this garden. Every thing is located appropriately with careful design and planning.
>
> Since I have never visited the garden, I cannot fully describe its appearance. However, by viewing this picture, I feel that I am in a remote territory or amidst golden valleys.[19]

Interestingly, Wang Shizhen wrote an essay about the East Garden even though he had "never visited" this estate. Why did he agree to contribute an essay although he did not even know the garden owner? Here, the recommendation of his student—who acted as a middleman—was crucial. Wang's contribution of an essay was a polite convention in response to his student's request. But his contribution was more: the garden image stirred his memories and nostalgic thoughts, providing a meaningful occasion for Wang to express his own personal feelings. As mentioned elsewhere in his essay, Wang used to invite friends and bring wine to travel between famous scenic spots when he was living in Yangzhou during the Shunzhi period.[20] The joyous travels in the past were still vivid in his memory. Because of physical distance and old age, however, Wang had no opportunity to visit the East Garden (which was constructed at a later time) and to participate in its elegant gatherings. He lamented, "The former official of some fifty years ago is now whited-headed.[21] How fortunate that he can still hold the brush to record the beautiful scenery of this garden!"[22]

Then Wang Shizhen recommended the East Garden to Song Lao, to whom the picture of the garden was later forwarded. Song Lao discharged his social obligations, certainly with courtesy and reverence for Wang Shizhen, and contributed an essay:

> The garden of Qiao Yizhai of Guangling [Yangzhou] in the eastern outskirts of the city is called the East Garden. Master Cao of the Silver Terrace [Cao Yin] has composed eight poems in praise of it. Zhang Hanzhan [Zhang Yunzhang] of Jiading has written an essay praising it. My friend Wang Ruanting [Wang Shizhen], imperial secretary *(shangshu)*, has written something too. Assistant Military Commander *(canzhen)* Jiang presented me this picture at the request of Ruanting. I viewed the garden . . . and my poetic thoughts had been generated.[23]

The evocative use of the garden image as a vehicle for pondering personal experiences is also revealed in Song's essay. Since Wang Shizhen had already passed away by the time Song Lao contributed his essay, the request of a deceased friend for a literary work to cel-

ebrate the East Garden was answered with great sensitivities to issues such as passage of time, reality of old age, memories of friendship, and Song's past official duties in Jiangsu province: "Now Ruanting has passed away and I am retiring at my native place [in Henan]. By the fish ponds and the wheat fields of the Western Slope [i.e., Song's retreat], I no longer have dreams about Suzhou.[24] When I spread open the picture and the paper, I suddenly see the sceneries and customs of Huai'nan. This old man is greatly rejuvenated within his breast."[25]

Both Wang Shizhen and Song Lao mentioned in their essays a picture (tu) of the East Garden,[26] thereby shedding light on the practical functions of Yuan Jiang's garden portrayal and the like. Such a picture offered a vivid description of the garden, enabling its audiences to enjoy the beauty without actually visiting it. It also evoked personal feelings, as the audiences invested meanings into it. No matter what degree of pictorial fidelity, such an image functioned as a "moving garden." Significantly enough, as architectural paintings served as moving gardens, social connections could be established beyond the physical boundaries of actual gardens. Pictorial images, by themselves, were sufficient to bring forth the desired social effect in relation to garden culture.

Neither Wang Shizhen nor Song Lao specified the authorship of the picture or commented on its artistic quality. That the identity of the painter is unknown suggests that he was not connected with the social network involving the garden owner and his circle of acquaintances. As mentioned earlier, there is no evidence that Yuan Jiang had been invited to elegant gatherings or treated as an equal of the social elite. Although Yuan Jiang's paintings did find their way into the collections of the social elite, they were not material testimony of any cultivated connections with the scholar-official class.[27] The artist might have gained the privilege of entering into private domains when being asked to render private gardens.[28] Apart from that, however, commercial patronage had not yet brought forth fluidity of social boundaries, which came into being in the next generation when Yuan Yao continued with the enterprise.

The Next Generation

Yuan Yao seemed to be better received by the social elite of eighteenth-century Yangzhou. Unlike Yuan Jiang, he lived in an environment in which social mobility was encouraged. There was a relaxed social atmosphere as a result of economic growth, and wealth became increasingly important in determining one's social status.[29] As the size of the social elite grew both in absolute numbers and in relative percentage of the population, the chance of Yuan Yao's being accepted by the newly monied families also increased.

Yuan Yao was acquainted with He Junzhao, a Shanxi merchant who owned the He Garden. Also named the East Garden, the He Garden was completed in 1744. Li Dou, in the Yangzhou huafang lu, recorded a list of autographs of those who visited this garden, among

which was the artist's name "Yuan Yao, Zhaodao." This notation suggests that Yuan Yao had been invited as a guest of honor of the He Garden.[30] In 1746 Yuan Yao was commissioned to work on a set of paintings rendering twelve selected spots of the He Garden that, together with other poems, form the *Album of the East Garden*. According to Li Dou, Yuan Yao was employed (*zheng*) to paint this album,[31] and the way this was recorded (with the use of the word "employed") seemed to suggest a commercial approach to the exchange. However, when He Junzhao left Yangzhou, Yuan Yao and a group of artists dedicated to him a farewell album of paintings and poems titled *Parting at Guangling (Yangzhou)*, which is now in the Tianjin Antique Store.[32] Presumably, this was presented as a token of social relation, if not close friendship. Could there be fluidity of social boundary between the garden owner and the professional painter? If so, the new patron-artist relationship might enable Yuan Yao to involve himself in a circle of acquaintances and clients that would offer him new economic opportunities.

Does anything in Yuan Yao's garden portrayals indicate the changing patron-artist relationship or the artist's increased interactions with the social elite? Is there any effect on the encounter between painter and subject because of these changes? Surviving examples of actual garden scenes depicted by Yuan Yao include *The Scenery of the Han River* (an early work dated 1747) and *The Four Views of Yangzhou* (a late work of 1778), both in the Palace Museum, Beijing.[33] Instead of showing any stylistic transformations, they simply confirm that Yuan Yao was adopting the same range of motifs and schemata that he acquired from Yuan Jiang. Apparently, he was not ready to abandon the established styles of the school. This continuity of style also has important implications for the genre in general. As patrons demanded paintings of actual sceneries by *jiehua* specialists, there was an assumed expectation that these pictures would at least replicate the appearances of the subjects. Formal likeness was expected, and the resultant works tended to be descriptive. While meeting the basic requirement for verisimilitude, could the *jiehua* painter go beyond representation and transform the subjects into expressive forms? The attempt of Yuan Jiang to restore a sense of austerity and antiquity in *jiehua* by means of linear brushwork had proven to be an acceptable solution, and Yuan Yao adopted this means in the next generation.

"Refined Elegance" or "Vulgarity"?

Recall that two different types of paintings are related to the vogue of garden culture in Qing Yangzhou: the first type focuses on the literary gatherings that took place in a garden setting; the second presents the physical appearance and the aesthetic merits of a garden. Significantly, both types provide the sites of social claims and were motivated by the attempts to establish social networks in Qing society. Were there distinctions between "refined elegance" and "vulgarity" in the evaluation of these two different types of paintings that essentially serve similar social functions?

In the eyes of the literati—who were the art critics and connoisseurs of the day—the social status and painting styles of painters certainly affected the way their paintings were evaluated. Although one should probably not apply such terms as "refined elegance" and "vulgarity" in comparing these two types of works, the literati often considered *jiehua* as an "inferior" art because of its concern for verisimilitude in architectural representation.

Transmitting History and Myth

YANGZHOU REPRESENTATIONS II

6

PROFESSIONAL *JIEHUA* PAINTERS working outside the court, like their counterparts at court, were also inspired by history and myth in architectural representation. The Yuan school, for instance, had experimented with a wide spectrum of historical and mythical themes in order to meet the diverse market demands. Relying on private patronage, Yuan Jiang and Yuan Yao were exposed to commercial environments that governed their artistic productions. To them diversification was an economic strategy, and they differed from court painters who might have to constantly transform a specific painting theme (such as "spring morning in the Han palace") in order to fulfill the special requirements of a single patron.[1] In this chapter, I discuss how paintings of the Yuan school were inspired by history and myth, how they were conditioned by the painters' representational modes and by the preferences of the anticipated audiences.

The Splendid Past

As noted in chapter 4, "spring morning in the Han palace" was a classical theme in Chinese figure painting but was transformed into an architectural theme during the Qing. To *jiehua* specialists such as Yuan Jiang and Yuan Yao, this was a pure architectural subject. Although these painters might include a few court ladies in their architectural compositions, there was no attempt to focus on the refined activities of court ladies, which were symptomatic of the didactic overtone of this traditional theme. By presenting a Han palace at different times—such as on a spring morning or an autumn night—the Yuans managed to introduce some variety.[2] Certainly, the Yuans could not succeed in the commercial art market if they simply repeated this theme again and again. How could they compete with

other professional painters, such as specialists of figural subjects, who preferred a detailed depiction of human activity in a palatial setting? How could they compete with the other *jiehua* specialists? In fact, a Han palace was only one of the many historical themes favored by the Yuan school. Within the category of historic architecture were various themes adopted by the Yuans, including the Afang Palace (Afang gong) of the Qin (221–207 B.C.); the Liang Garden (Liang yuan) of the Han; and the Palace of Nine Perfections (Jiucheng gong), the Palace of Flowers of Purity (Huaqing gong), the Deep Fragrance Pavilion (Chenxiang ting), and the Hall of Green Wilderness (Luye tang) of the Tang (618–906).

The Palace of Nine Perfections, now in the Metropolitan Museum of Art, is one of Yuan Jiang's earliest renderings of a historic palace (fig. 6.1). It depicts the summer palace, long since destroyed, of the Tang emperor Taizong (r. 627–648). From the contents of a famous calligraphic work by Ouyang Xun (557–641), *Inscription of the Palace of Nine Perfections and the Sweet Wine Spring,*[3] we get some information about the lost grandeur of the palace. The Qing painter might have been inspired by literature, but how closely did the pictorial representation follow the textual account?

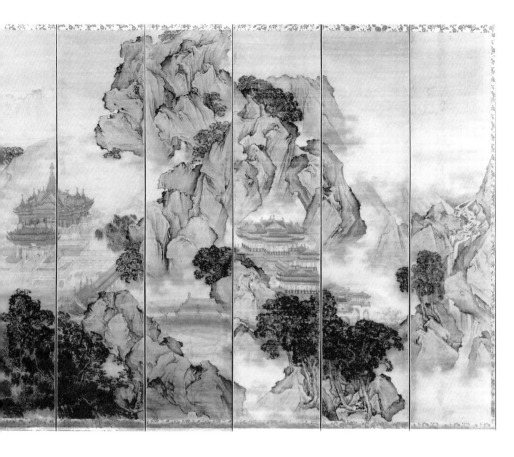

Fig. 6.1. Yuan Jiang (active ca. 1690–ca. 1740): *The Palace of Nine Perfections.* 1691. A set of twelve hanging scrolls, ink and color on silk. Metropolitan Museum of Art, Purchase, The Dillon Fund Gift, 1982 (1982.125a-1). This is probably the earliest dated work by the artist so far known.

A section of the *Inscription of the Palace of Nine Perfections and the Sweet Wine Spring* reads,

Palaces crown the hills,
Ponds flow through the ravines.
Pillars are hoisted above waters,
Watchtowers are erected on craggy cliffs.
Lofty pavilions stand on all sides,
Long corridors ascend from the four directions.
Beams stretch far and wide,
Terraces and kiosks form an irregular pattern.
A hundred vistas are offered
When viewing from below;
A thousand *ren*[4] of the precipitous slope are admired
When making a descent.

Transmitting
History and Myth

Pearls and jades shine upon each other,
Gold and green colors add radiance to themselves.

The *Inscription* also records the discovery of the Sweet Wine Spring at the palace site. Since this area did not have any source of water, the discovery of the spring was interpreted as an auspicious sign of benevolent rule.

Spring water gushes out,
Contained by stone balustrade
And channeled into a ditch.
The water is as pure as mirror,
Its sugary taste is as pleasant as sweet wine.[5]

Yuan Jiang's pictorial representation shows a splendid palace compound set in monumental mountains. There are magnificent halls, lofty towers, waterside pavilions, carved terraces, a rainbow bridge, jutting archways, and winding corridors. In the sense that Yuan Jiang's painting has successfully captured the grand size and the majestic beauty of the palace (which live on in literature), the visual and the textual representations echo each other. However, a close examination will reveal some pictorial variations in narrative details. For example, the palace in the painting is not crowning the hills but is, instead, situated in mist-filled valleys embraced by towering mountains. There are no watchtowers on craggy cliffs. The presence of a waterfall and a lake bring moisture to the supposedly dry mountainous area, which had no source of water before the discovery of a spring. But do these variations matter?

As I noted in chapter 4, any attempt to compare the textual and the visual representations will lead inevitably to the question of whether they have any common conventions of representation. In this particular case, we have the *Inscription of the Palace of Nine Perfections and the Sweet Wine Spring* as a literary reference, and its literary form is different from Han rhapsody, which tends to use flowery language. However, in the literary realm in general, architecture is often represented through allusion so that the writing fires the reader's imagination, encouraging one to further explore and complete the picture. Although the literary account of the Palace of Nine Perfections does provide a compelling picture of the palace's grand size and splendid beauty, the writer is not tied down to any specific description of the architectural details. The references to a variety of architectural types—such as palaces, watchtowers, corridors, terraces, and kiosks—suffice to suggest the grand scale of the compound. And if these are not convincing enough, the borrowing of nature as spatial reference, or the employment of such phrases as "stand on all sides," "ascend from the four directions," "stretch far and wide," have emphatically emphasized the magnitude of the palace. In contrast, Yuan Jiang's pictorial representation requires a repertory of visual vocabularies and a breadth of architectural details, especially if formal likeness is attempted. The allusions to spatial transformation in literary representation have to be artic-

ulated visually so that pictorial unity is achieved. Consequently, even though his pictorial reconstruction echoes the textual representation, the quest for specificity in *jiehua* also leads inevitably to dissimilarity between the two.

The representation of the Palace of Nine Perfections also brings out another interesting feature of this thematic category of architectural painting. Since there is no specification in the literature for establishing a straightforward relationship between architectural theme and image, it does not matter if there are pictorial variations in details, as long as the depiction echoes our memory of the historical past. And if a particular theme is a new experimentation that has never been dealt with by any predecessors, the lack of prototypes implies that the painter had to come up with a new way to give a historic estate its specific attributes. In the paintings of the Yuans, historic palaces are reconstructed in more or less the same way. It is impossible for us to make use of architectural images to conduct an iconographical analysis of each of the historic themes. Human activities or events might help suggest the historical functions and thus the different identities of different historic estates. But the same kind of event could occur in estates of similar nature. Imperial processions might take place in different royal estates; entertainment of guests could occur in both royal and private estates. The artist—who was conscious of representing a certain theme—might incorporate the relevant event in the composition. Without specific information on a historical event, however, the viewer cannot simply distinguish the venue. Identification remains difficult without the title. There is ample evidence of this phenomenon.

In *Escaping the Heat at Mount Li*, Yuan Jiang rendered the Palace of Flowers of Purity at Mount Li in Lintong, Shaanxi province (fig. 6.2). Emperor Xuanzong (r. 847–859) commissioned this pleasure palace, which he frequented with his favorite consort, Yang Guifei. It was first named the Thermal Spring Palace (Wenquan gong), and later the Palace of Flowers of Purity. Two lines in Du Mu's (803–852) poem *Guo Huaqing gong jueju sanshou* (quatrain 1, lines 1–2) describe the distant view of this palace:

> Turn and look back from Chang'an to embroideries heaped in piles;
> on the hill's high crest are a thousand gates standing open in rows.[6]

The Palace of Flowers of Purity rendered by Yuan Jiang shows extraordinary magnificence, echoing what the Tang poet had described as "embroideries heaped in piles." Yet the composition of this painting is almost identical to a section of the twelvefold composition (panels five to seven) of *The Palace of Nine Perfections* in the Metropolitan Museum of Art (see fig. 6.1). When both paintings present a grand palace against a monumental landscape setting, when both compositions incorporate the detail of an imperial procession approaching a palace, how can one differentiate between the Palace of Nine Perfections and the Palace of Flowers of Purity? Significantly, it is with the aid of the title *Escaping the Heat at Mount Li* that one can connect the motifs—a palace compound, misty atmosphere, craggy mountains, and an imperial procession—with the theme of the Palace of Flowers of Purity at Mount Li. Should the title be altered to *The Palace of Nine Perfections*, the

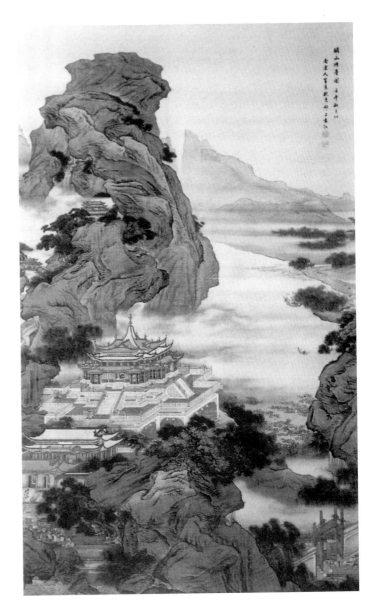

Fig. 6.2. Yuan Jiang (active ca. 1690–ca. 1740): *Escaping the Heat at Mount Li.* 1702. Hanging scroll, ink and color on silk. Capital Museum, Beijing. From *Yuan Jiang Yuan Yao huaji* (Tianjin: Tianjin renmin meishu chubanshe, 1996), pl. 7.

viewer will relate the same set of motifs to another theme, and the same architectural motif will become the image of another historic palace.

Similar characteristics can be observed in another pair of works: *Flying Snow in the Liang Garden* (plate 9) and *The Deep Fragrance Pavilion* (plate 10). The Liang Garden (also named Rabbit Garden) was the residence of Liu Wu (r. 168–144 B.C.), Lord Xiaowang of Liang. His court had gathered the most illustrious rhapsody writers of the Han, including Mei Cheng (mid-second century B.C.) and Sima Xiangru (179?–117 B.C.). As a private gar-

den, it had extensive grounds for hunting, fishing, animal husbandry, and horticulture. The garden was intended not only for the master's enjoyment, but also for entertaining guests. In the *Xijing zaji*, Ge Hong (283–343), describes the garden as follows:

> In this garden are Mount Hundred Souls consisting of the Shallow Skin Rock, the Ape-perched Cliff, and the Dragon Lodge Cave. In the Wild Goose Pond are the Crane Continent and the Wild Duck Islet. Conjoining palaces spread over a large area of several tens *li*. All sorts of fruits, trees, rare birds, and strange beasts fill the garden, where the lord and his guests often go hunting and fishing.[7]

The Deep Fragrance Pavilion was known as the place where Emperor Xuanzong enjoyed peonies in the company of Yang Guifei. It was said that the famous poet Li Bo (701–762) composed the *Qingpingdiao* at this particular spot. Thus the pavilion was perceived as a historical site recalling transient pleasures. In part 3 of the *Qingpingdiao* Li writes,

> Beauty to topple a nation in the company of famous flowers,
> They always succeed with His Majesty
> making him turn with a smile.
> Knowing that the spring wind may bring regrets unending,
> North of the Deep Fragrance Pavilion
> they lean on the balustrade.[8]

With limited information, Yuan Jiang reconstructed the Liang Garden and the Deep Fragrance Pavilion. Although these two structures existed in different periods in history—the Liang Garden was a Han estate, whereas the Deep Fragrance Pavilion was a Tang construction—they bear close resemblance to each other in Yuan Jiang's paintings. His architectural renderings do not allow us to differentiate between the two different themes. And in such huge compositions as Yuan Jiang's architectural paintings, human figures are relatively small in scale and are not easily identified. The foci are often placed on the architecture images or, precisely, the perceived bygone splendors of the past. Only on the exceptional occasions when the painter employed the album-leaf format did he give a more focused treatment of human activity in a small-scale composition.[9]

Because of the lack of precise information about the attributes of each historic estate, Yuan Jiang could repeat a certain composition and inscribe each rendition with a new title. By giving different titles to similar compositions, he could produce works of varied themes. With the assistance of pupils and division of labor in studio production, he could produce very similar works simultaneously.[10] The situation did not seem to change when Yuan Yao became the leader of the studio. The repetition of certain formulaic compositions may lead us to speculate that there was a conscious attempt to represent a certain historic theme by arranging certain motifs in a specific way. Yet the same old problem remained: there was no distinguishable relation between architectual theme and image.

For example, in the Shanghai Museum are two twelve-scroll panels titled *The Palace of*

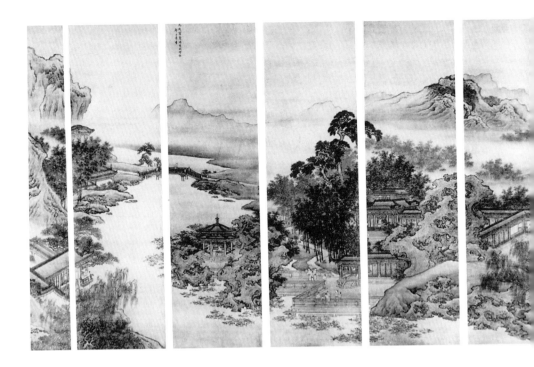

Nine Perfections whose compositions are similar.[11] Both paintings bear the signature of Yuan Yao; one is dated 1774, the other 1778 (fig. 6.3). Despite variations in the choice of architectural motifs, the layout of the palace and the terrain characteristics in both paintings are very similar. Let us assume that Yuan Yao had finally arrived at a specific composition for representing this particular palace. However, if we compare this compositional formula with that of *The Hall of Green Wilderness* (fig. 6.4), now in the Asian Art Museum of San Francisco, we will notice a similarity between the two. The rear portion of *The Palace of Nine Perfections* (scrolls 5 to 11) is similar to *The Hall of Green Wilderness*. Thus, under the brush of Yuan Yao, half of the Tang palace has a layout almost as same as the Hall of the Green Wilderness, the villa of the Tang statesman Pei Du (765–839) that was designed for literary gathering and self-realization. According to the *Jiu Tang shu*, there the Cool Terrace the Summer Hall sat among myriad trees in the Hall of Green Wilderness.[12] But was it comparable to a royal palace in appearance?

Because each historic palace lacks iconographical features, identifying a theme remains difficult, regardless of whether the Yuan school had arrived at a specific way for its representation. Yet the Yuans had a definite idea of how historic architecture should look. All their works consistently express a grand conception in architectural representation. The images demonstrate a high degree of complexity and intricacy. The commonly used architectural image shows a complex design with intersecting *xieshan* roofs and a spire attached to the center (as exemplified by the Deep Fragrance Pavilion, the main hall of the Palace of

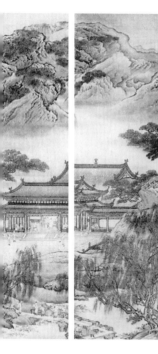

Fig. 6.3. Yuan Yao (active ca. 1740–ca. 1780): *The Palace of Nine Perfections.* 1778. A set of twelve hanging scrolls, ink and color on silk. Shanghai Museum. From Group for the Authentication of Ancient Works of Chinese Painting and Calligraphy, ed., *Illustrated Catalogue of Selected Works of Ancient Chinese Painting and Calligraphy* (Beijing: Cultural Relics Publishing House, 1986–) 5:162–163, Hu 1-3516.

Flowers of Purity). Being sufficiently elaborate, this architectural image has already been modified from a more flamboyant design presented in *The Palace of Nine Perfections* of 1691 (fig. 6.5). The complex structure in this early work of Yuan Jiang shows an additional unit of intersecting roofs and a central spire attached to each of the four corners of the building.

Yuan Yao inherited Yuan Jiang's established stock of form types, testifying to a continuity of the style of the school. It was no coincidence that other *jiehua* artists in Yangzhou also employed similar architectural images in their works. For instance, the same complex architectural design can be found in a fan painting by Li Yin, now in the Zhejiang Provincial Museum.[13] If there was a conception that a complex architectural design was suitable for expressing the grandeur of a historic building, this conception seemed to be shared by many *jiehua* painters of the Qing period. Notably, court painters also employed equally complex architectural motifs to convey the legendary splendor of a Han palace. In my earlier discussion of the Qing court productions of *Spring Morning in the Han Palace*, I have suggested various cultural institutions—such as literature, past paintings, painting manuals, and actual contemporary buildings—that might affect the painters' reconstruction of an ancient architecture. The interplay of all these factors gave shape to an architectural environment in which past and present, realities and fantasies were interwoven.

Past paintings no doubt provided painters with an important source of inspiration. There is a brief account saying that Yuan Jiang obtained anonymous sketches by the ancients and thereafter made a great progress in his art. Since we are uncertain of the contents of these

Transmitting
History and Myth

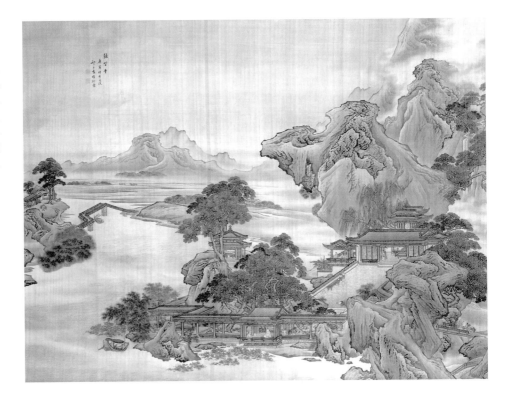

Fig. 6.4. Yuan Yao (active ca. 1740–ca. 1780): *The Hall of Green Wilderness.* 1770. Hanging scroll, ink and color on silk. Asian Art Museum of San Francisco, The Avery Brundage Collection, B70D1. Used by permission.

sketches, it is impossible to examine their influence on Yuan Jiang's works. But undoubtedly Yuan Jiang, like most professional painters working outside the court, was familiar with the architectural images found in other media. The elaborate architectural vocabulary favored by these painters had been particularly popular since the seventeenth century and had been employed by craftsmen in lacquer decoration,[14] woodblock illustrations,[15] maps,[16] and so on. Moreover, in the painting manual *Jieziyuan huazhuan*, the image of an imperial palace displays complex architectural details but does not bear a central spire. Instead, the pyramidal spire is a separate code suggested by the manual for representing a distant pavilion top. Obviously, *jiehua* painters had been modifying preestablished schematic forms to enhance the perceived grandeur of historic structures. Regardless of the origin of a certain architectural design, it is my contention that the invention or adaptation of a complex architectural image made manifest a grand conception that conformed to a Qing perception of the legendary splendor of historic architecture.

Just as Qing court painters reconstructed historic buildings with reference to actual palaces, Yangzhou *jiehua* painters also turned to contemporary architecture for concrete inspiration. Compared with their counterparts at court, these Yangzhou painters were less fortunate in the sense that they had no opportunity to enter royal palaces and to actually experience the scale and magnificence of imperial architecture. However, given the geo-

graphical mobility of Qing population, it is probable that these painters had seen some of the temporary residences built for imperial visits. While there is no proof of the existence of an actual Qing building with the same complex design found in some architectural paintings, it is unlikely that painters had not referred to actual buildings for substantial information. Halls, pavilions, galleries, walkways, and bridges were all common architectural

Transmitting
History and Myth

types available for reference. They provided a spectrum of architectural vocabularies for the formation of a vast compound.

Significantly, the grand vision of a historic estate was not confined to individual images. This vision was extended from isolated buildings to a vast compound, from sumptuous architecture to an encompassing landscape. For example, Yuan Jiang imparted a sense of spaciousness to emphasize the immense scale of a historic estate. He defined the intervals between front and back buildings, making use of such architectural devices as passageways, stairways, and ramps to lead the viewer to the furthermost part of a compound. In *Escaping the Heat at Mount Li*, the directional indication is especially clear (see fig. 6.2). After passing the gate and the hall, one is directed to ascend the tiered platform and to reach the most splendid building of the palace. The same characteristic is shown *The Liang Garden* and *The Deep Fragrance Pavilion* (see plates 9 and 10). In both paintings, the mountains are pushed backward into far distances, leaving much pictorial space in the foreground and the middle ground for architectural depiction. By widening the intervals between the buildings, Yuan Jiang succeeded in giving an appearance of spaciousness to these historic estates. By exposing large areas of ground planes, he also gave substance to physical space. In *The Deep Fragrance Pavilion*, there is an effective use of a diagonal walkway that burrows into deep distance (see plate 10). Because of the abrupt recession of the diagonals and the diminishing sizes of distant buildings, it is believed that Yuan Jiang was fully in command of European linear perspective.[17] In fact, the diagonal walkway is a traditional Chinese convention to define the boundaries of architectural spaces. Ming woodblock prints provide ample evidence of the use of this convention. Strictly speaking, Yuan Jiang, unlike the court painters, did not employ any linear perspective in architectural representation, although the possibility that European art influenced the formation of new visual habits in architectural representation cannot be ruled out. A close scrutiny of his painting will reveal that there is no tendency for the receding lines to converge in the distance. The diagonal walkway is almost parallel to the wall that cuts the lower right corner of the picture.

Alternative Discourses

If one assumes that literary representations of historic architecture fired the imagination of *jiehua* painters, it is equally important to realize that many of these writings lie within the framework of Confucian moral judgment. The awe of architecture had to be justified by the greater glory of imperial dignity and national greatness and, more important, by Heaven's blessing. Moreover, there was an emphasis on relative frugality to avoid the disapproval placed on extravagance in the light of political morality. These ideas had been deeply embedded in Chinese culture. In addition, to many Chinese scholars, historic architecture evoked melancholy or generated poetic feelings. Traditionally, the theme of ruined splendor had evoked nostalgia for the past and reflections upon moral history. This is demonstrated, for example, in the following lines by the Tang poet Xu Hun:

In the wasted Qin garden only birds fly still;
'Mid yellow leaves in Han palace cicadas shrill.
O wayfarer, don't ask about the days gone by!
Coming from east, I hear only the river sigh.[18]

Lamenting on the ruined Liang Garden, the poet Cen Shen writes:

Day and night at Liang Garden crows fly in a wild flurry;
Of the houses that crowned it,
Only two or three can still be distinguished.
Unaware that all who were once there are gone,
Flowers still bloom in the spring as long ago.[19]

Nostalgia evoked by vanished splendors of the past continued to be expressed in Qing literature. Writing in an elegiac mood in the *Yingshan caotang ming*, Wang Kaiyun expressed his personal sentiments about the architecture of the bygone days:

The love for home
Lives continuously now and then.
When yearning for the past,
The scholar heaves many a sigh.

.

[The Hall of] Numinous Brilliance is no longer the palace of the king of Lu.
[The Song of] Ears of Wheat hide the tears of the Yin official.
Below the fishing terrace
Was it not the former house of Yan [Guang]?
In front of the Han palace
A high column is the only sight!
My feeling of loss
Fills this inscription.[20]

Although historic architecture in the literary realm often provides the site for broader views about politics and intellectual thoughts, the paintings of the Yuan school do not share similar metaphorical content. Presenting the grandest of spectacles, the Yuans were not interested in the literary icon of ruined splendor. Their treatments of the themes therefore rule out the possibilities that their works were intended for the literati who, perhaps, were more concerned about memories rather than reconstructed sights of the historical past. Despite the loss of the potential lyrical and metaphorical power of historic architecture, the paintings of the Yuans conferred a new kind of power. Significantly enough, the Yuans had given tangible reality to their representations of the historical past, so that it did not appear to be spatially and temporally remote. Their works apparently answered the contemporary needs of their clientele. The intended audiences of their works could be wealthy

merchants, nouveaux riches, or those requiring such reinterpretations of the past to serve the present.

Power of History: To Patrons and Painters

What motives triggered the massive production of grand images of historic estates? Without any inscription or literary record, the meaning of a painting to patron and painter is never fully known. It has been suggested that *The Palace of Nine Perfections* at the Metropolitan Museum of Art might be a work commissioned by a rich Yangzhou merchant to celebrate the Kangxi emperor's visit to Yangzhou.[21] However, given the generic nature of almost all renderings of historic architecture by the Yuans, it is difficult to ascertain that a particular subject served to commemorate a special contemporary event. If *The Palace of Nine Perfections* is interpreted as a work celebrating the imperial visit to Yangzhou, a similar conclusion should be drawn for all the other works insofar as they contain the same set of motifs (palatial buildings and an imperial procession). In the absence of specific records, the above interpretation of *The Palace of Nine Perfections* is open to doubt. Perhaps we should treat these historic themes as a categorical whole and as a framework for reflection on the power of history to certain individuals and groups within Qing society.

It is conceivable that patron and painter, from respective viewpoints of consumption and creativity, made the past beneficial in very different ways. On the patron side, the motives behind the commissioning of these paintings were not recorded. One may speculate that these paintings enabled certain patrons to identify themselves with the cultural tradition, and this was a valid reason for rich merchants and nouveaux riches in seventeenth- and eighteenth-century Yangzhou, the potential consumers of these paintings. Why? In a society where prestige and upward social mobility were attained by education and civil service, merchants and nouveaux riches—who ascended the social ladder by wealth—could make use of these huge paintings to show their comprehension of history. In this connection, acquiring an architectural painting with historical subjects and displaying its grand composition in a hall was similar to possessing a tangible piece of history. History, in this respect, could enrich the world around them. Such paintings also played the role of legitimizing the present. By associating grand historic palaces with their own estates, rich merchants, especially garden owners, could legitimize their extravagant lifestyle and their conspicuous consumption.[22] Such visual images were also their monuments of pride.

As for the effect of the past on *jiehua* artists, it is necessary to differentiate between theme and style. Here, I am concerned with the meaning of historical themes for *jiehua* painters, not the technical aspect of how the *jiehua* tradition provided them with a repertoire of forms and styles. Significantly, painters might make use of historical themes to contemplate antiquity, an attribute of the past that was valued traditionally as one of the most important aesthetic qualities of *jiehua*. As we have noted, Tang Zhiqi suggested in the *Huishi Weiyan* that *jiehua* painters model their paintings upon *The Palace of Nine Perfections*, *The Afang*

Palace, The Pavilion of the Prince of Teng, or *The Yueyang Tower* in order to get close to "the manners of the ancients." He did not specify what aspects of these paintings would be beneficial to *jiehua* painters, but possibly he was attempting to encourage the contemplation of antiquity through depictions of historical themes. If so, these would only be veneers of antiquity, unless the painters also modeled the brushwork or the styles of the ancients.

From the commercial point of view, a wider scope of historical subjects could attract more customers. Considering that subject and style served practically as trademarks in a commercial art market, the Yuan school had succeeded in increasing its competitive power by widening the range of historical subjects. Although historic themes had been traditionally adopted in *jiehua* (such as the Afang Palace, the Palace of Nine Perfections, the Yellow Crane Tower, the Yueyang Tower), the Yuans widened the scope by adding historic estates of renowned scholar-officials (such as the Liang Garden and the Hall of Green Wilderness). This was probably a response to the vogue for private garden construction in Qing Yangzhou.

Imagined Paradise

In this section, I will explore paintings of mythical palaces and inquire how history and myth were used to express contemporary Qing views. Before I analyze the pictorial representations of paradise by the Yuan school, it is important, first, to cite literary descriptions and past representations of the immortals' realm.

According to literary accounts, the realm of the immortals is distinguished by three mountains within a sea. One source says that the mountains are in the shape of clouds; another source compares them to ancient ritual *hu* jars. These mountains were inaccessible, as winds and storms prevented boats from approaching them. The historical text *Shi ji* states,

> The lords of Qi, Weiwang (356–320 B.C.) and Xuanwang (319–301 B.C.), and the lord of Yan, Zhaowang (311–279 B.C.), had sent envoys to the sea in search of Penglai, Fangzhang, and Yingzhou [the three mythical mountains believed to be in the Bo Sea]. Then there were more and more people traveling to these places. One would find immortals and elixirs of everlasting life over there. All the birds and animals were white in color. Palaces were made of gold and silver. From a distance, these mountains looked like clouds. But when one almost reached them, they would suddenly sink into the waters. Storms and winds would draw the boats away from them. In the end, one could never reach these mountains. The lords were never satisfied.[23]

The *Shiyi ji* gives the following account of a fairyland: "The three *hu* are the three mountains in the sea. The first one, *fanghu,* is Mount Fangzhang. The second, *penghu,* is Mount Penglai, and the third, *yinghu,* is Mount Yingzhou. All these mountains are shaped like *hu* jars."[24]

When a fairyland is represented in art, there are always the iconographical elements of

mountains to indicate the realm of the immortals. As early as the Han period, *boshan* censers and hill jars were made in the shape of a mountain to indicate the immortals' land. In painting, one often finds the representation of mountains as a mythical realm detached from mundane reality. Although the pictorial tradition draws inspirations from literature, it is able to take on a life of its own. For example, the number of mountains is not necessarily limited to three. Whereas the texts focus on the fascinating shapes and the magical powers of the mythic mountains, pictorial representations tend to emphasize their heights, as this will convey the idea that mountains are the embodiments of mysterious power and the intermediaries between heaven and earth.[25] An unfailing sense of height is often enhanced by cloud-scrolls that hover around soaring peaks. There is also an immense difference in scale between mountains and transcendent beings. Another noticeable characteristic of fairyland depiction is the use of meticulous blue-and-green painting style to render mythic mountains. The blue-and-green style—which is one of the early methods of landscape depiction—is distinguished by mountain forms outlined with ink or gold pigment and then colored with azurite blue and malachite green pigments.[26] When this blue-and-green style is employed to depict majestic mountains, it alludes to the mysterious realm of the immortals. It also conveys an antique flavor through the association with the landscapes of Li Sixun (651–716) and Li Zhaodao, the Tang masters known for their blue-and-green styles. To further suggest the realm of the immortals, symbols of immortality—such as deer, cranes, fungi (*lingzhi*), peaches, and pine trees—are often added to a monumental landscape. On other occasions, splendid architectural images are added as the palace of the immortals.

While painters made use of blue-and-green landscapes to denote the realm of the immortals, craftsmen in other media emphasized architectural representation. In fact, the materials, techniques, and skills involved in a medium determine how a fairyland is presented. In carved lacquerware, for example, craftsmen never employ blue and green pigments to represent mythic mountains. Instead, a focused depiction of the palace image allows them to display workmanship and narrative details. When meticulous architectural motifs were carved onto a dense background of various patterns indicating air, water, and land, the complex pictorial design was intended to evoke a sense of flamboyance ascribed to fairyland. Besides architectural images, there are often symbols of immortality to suggest the theme.

Given all these various modes of expression adopted traditionally by painters and craftsmen, Qing *jiehua* painters had a range of options at their disposal. They could refer to literary accounts, past paintings, or various art and craft forms for inspiration. What were the artistic solutions of the Yuan school?

The Penglai Isle of the Immortals by Yuan Jiang, dated 1708, is based upon the myth that the immortals live in Penglai, one of the three mythic mountains in the Bo Sea (plate 11). In the foreground, a promontory surges upward to create a strong diagonal movement. Beyond the promontory is the palace of the immortals. In the distance stand the cliffs, the peaks, and the gorges, which mount up to towering heights. Countering the diagonal and the vertical emphases of the landscape is the horizontal movement of the turbulent waves that

swirl and crash round another isle in the rough sea. Obviously, Yuan Jiang's depiction of Penglai is rooted in the pictorial tradition. However, it also departs from this tradition in many ways. A comparison of this painting with the *Dwelling of the Immortals* by the Ming predecessor Qiu Ying (see fig. 1.12) will show the following stylistic changes.

First, Yuan Jiang did not employ a brilliant blue-and-green palette for coloring the mythic mountains. Instead, he used translucent blue and green colors to highlight the painted decorations on the brackets of the architecture. This has the effect of enhancing the splendor of the palace. The substitution of ink and other pale color washes for a blue-and-green palette in landscape depiction, together with the application of bright colors to highlight the architectural details, draw attention from the mountains to the palace. In addition, the architectural compound is not dwarfed by the mountains. As its relative size increases, architecture plays as important a role as landscape in suggesting the realm of the immortals.

Second, the ways Yuan Jiang depicted the architecture are very different from those of Qiu Ying. Although a blue-and-green palette is believed to convey an antique flavor through the association with the landscapes of Li Sixun and Li Zhaodao, the limited use of brilliant blue and green does not mitigate the antique flavor of Yuan Jiang's painting. Significantly, antiquity is here restored by his use of ink lines and brushstrokes to render the architecture. Unlike Qiu Ying's architectural images, the palace rendered by Yuan Jiang looks solid and tangible. It also allows the viewer to travel sequentially or to enter its innermost recesses. In landscape representation, Yuan Jiang's style played a role in casting the theme in an individual manner. A point to emphasize is that such stylistic features in landscape portrayal also appear in his other thematic categories of *jiehua*. When applied to this particular theme, they lend the fairyland a fantastic aura.

The landscape of Yuan Jiang reveals a conscious attempt to revive the Northern Song academic tradition stemming from Guo Xi. Other Yangzhou painters, including Li Yin, Wang Yun, and Yan Yi, also participated in this revival movement. In their depictions of majestic mountains and soaring peaks, these artists tend to twist the mountain forms dramatically, giving the so-called fantastic landscapes.[27] When conceived as the abode of the immortals in Yuan Jiang's representation, these fantastic landscapes feature the flow and flux of mountain movements and are suitable for suggesting the magical power of the mountains. They echo what the literature has mentioned—that the mythic mountains are shaped like clouds or *hu* vessels and disappear when approached by human beings.

As fantastic as they are, Yuan Jiang's landscapes do not seem to be departures from reality —the reality perceived by Qing people. While reviving Song monumental landscapes through a fantastic style, Yuan Jiang seemed to be articulating a contemporary view that marked a Qing stylistic departure from Song landscapes. Qing Neo-Confucian thinkers of the seventeenth and eighteenth centuries had developed a new cosmological view that emphasized the primacy of *qi*, the primordial element in the universe.[28] According to this new perception of nature, *qi* was itself sufficient to account for all phenomena. The continuous motions of *qi*, or the interactions of *yinyang* and *wuxing* (five elements), produced all things.

Everything resulted from this process of change and had its own internal structure, and this was what Qing Neo-Confucian thinkers designated as *li* or principle.[29] These prevailing cosmological views probably influenced the Orthodox school of landscape painting, as indicated by the writings and paintings of the school. For example, Wang Hui and Wang Yuanqi regarded "the source of structural forces" in a painting as the "dragon vein" *(longmo)*, which was the "substance" *(ti)* to be brought out by such compositional methods as "opening and closing" and "rising and falling" *(qifu)*, the "operation" *(yong)*.[30]

Yuan Jiang's landscape configuration shows convulsive movements of rock masses activated internally by thrusts and counterthrusts.[31] The mountain forms flow and ebb, rise and fall. Could such metamorphoses be related to the aforementioned Qing cosmological ideas? When *qi* is inherent in landscape, dramatic movements of rock masses—twisting, turning, rising, and falling—are discernible patterns. Thus the serpentine mountain movement in Yuan Jiang's painting can be interpreted as another artistic expression of the Qing idea that *li* was manifested by the changes of *qi*. It is conceivable that Yuan Jiang was also responding to the prevailing ethos of his time through his landscape depiction. Transforming the real into the fantastic, and turning the fantastic into the real, he explored these ambiguities and dramatized what the literature had mentioned—that the fairyland was not far away, and yet it could never be approached. The subtle changes of light, mist, and colors in his paintings not only create a cool, hazy environment but also lend the fairyland a dreamlike quality. The rich atmospheric effect is achieved through the subtle gradation of pale washes in the background as well as the fading of the washes between forms. When the clear ink brings out the color of the silk in the background, the scene is illuminated and the architecture looks radiant.

When Yuan Yao interpreted the theme of fairyland, he basically inherited from Yuan Jiang the same set of motifs and schemata. It has been suggested that Yuan Yao continued with the mature styles of his master, retaining the stillness of contorted rocks as well as the profound quietude shown in Yuan Jiang's later paintings.[32] However, when he interpreted the theme of fairyland, as in the *Penglai* of 1777 (fig. 6.6), he did not seem to be contented with the stillness of landscape but instead reverted to the invigorating movement of rocks and hills. His mountains are as restless as turbulent seas, and these two different forms suggest the pluralistic nature of an underlying reality in the eyes of the Qing painter. Evidently, there were continuity and variation of the theme as it was constantly reinterpreted, but the various reinterpretations by Yuan Yao were simply extensions of the earlier conventions practiced by the school.

As we have seen, Yuan Jiang formulated the methods for representing the theme, and Yuan Yao continued them in the next generation. That artistic production of the Yuan school was operated on a studio basis attested to the popularity of its works. But as many early writings and paintings show, the quest for immortality in Chinese culture can be traced back to historical days. What, in particular, had led to massive productions of these paintings in Qing Yangzhou? How do these paintings tell us about new meanings of the theme?

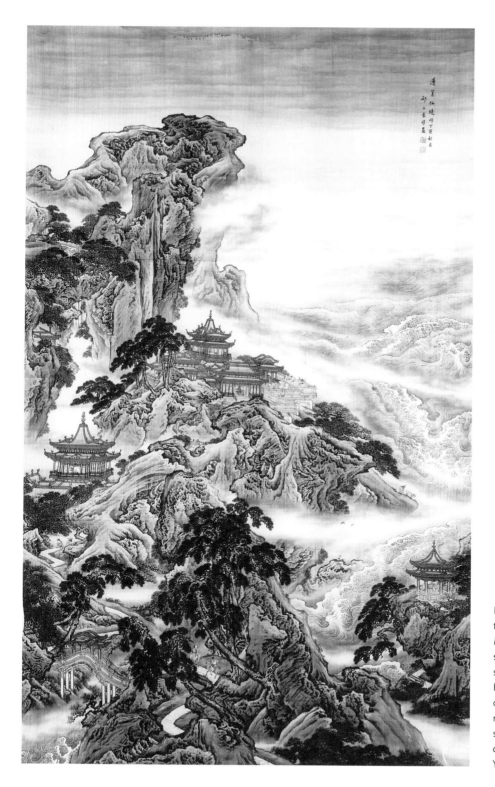

Fig. 6.6. Yuan Yao (active ca. 1740–ca. 1780): *Penglai.* 1777. Hanging scroll, ink and color on silk. Palace Museum, Beijing. The visual excitement from this metamorphosing landscape by Yuan Yao is as dramatic as that from Yuan Jiang's painting.

In these paintings of the Yuans, the dwellings of the immortals does not merely comprise soaring mountains. A grand, magnificent palace is always an essential iconographical component of the theme. This tendency implies that *jiehua* elements in such paintings must be meaningful to both painter and patron. The Yuans—who were *jiehua* specialists—could make use of an elaborate palace image to display skill and virtuosity in architectural representation. They presented palaces of extraordinary splendor that were similar to their renderings of historic palaces. These works probably also responded to the pursuit of luxury and extravagance by a segment of the Qing population.

It was no coincidence that wealthy merchants and nouveaux riches led a luxurious life in Qing Yangzhou, indulging in all sorts of extravagant activities in their quest for immortality. The *Yangzhou huafang lu* records the construction of a dew terrace *(lutai)* in a Yangzhou garden.[33] *Jiehua* artists including Li Yin, Yuan Jiang, and Yuan Yao also depicted this unique structure in their works (plate 12).[34] Standing splendidly against the sky, the dew terrace is a lone structure consisting of a tiered terrace and a basin supported by a tall pillar. It was designed for collecting morning dew, which was taken as the elixir of everlasting life. Besides revealing the cult of immortality in Qing Yangzhou, a dew basin was also a symbol of wealth and an outward display of the extravagant lifestyle of the social elite. While some wealthy people might indulge in the pleasure of collecting morning dew, others constructed private gardens in imitation of a fairyland. In garden design, as suggested by the garden manual *Yuan ye*, there could be various artistic endeavors to transcend an earthly scene and evoke associations with a fairyland:

> To have mountains situated beside a pool is the finest sight in a garden. When the mountains vary in size, it is an even finer spectacle. You may set stepping-stones in the water or build a flying bridge across from the mountainside. Caves and fissures may be concealed within the mountain, running right through the cliffs or leading down to the water. The shimmering mountaintops let the moonlight through and gather the clouds. Never say there are no immortals on earth, for this is a fairyland in the world of men.[35]

However, only the wealthy and the privileged could afford "a fairyland in the world of men." The belief in immortality might sustain interest in the theme of fairyland. Yet it was the contemporary social and material circumstances that played a significant role in giving this traditional theme a new look when reinterpreted pictorially. Like court productions, Yangzhou representations of fairyland seemed to reveal the material world surrounding the patrons. The grand vision of fairyland probably enabled these patrons to express the wish for everlasting *luxurious* enjoyment. As Kiyohiko Munakata noted about the vision of a luxurious paradise, "It is ironic that Daoism, which championed the freedom of individuals against the strict social order, derived its image of the ideal world from the lifestyle of the imperial court, or at least from the society of high officials. In fact, it is most likely that this type of image developed in such a high society."[36]

We do not know if the demand for this thematic category of architectural painting was

correlated to actual possession of a man-made paradise on earth. But we do observe huge demands for this particular category outside the court. Why? In the commercial art market, there were more private patrons demanding such works. Moreover, in the cultural discourses in which different individuals and groups participated, the choice of symbols and forms might vary. Outside the court, the meanings projected onto such paintings could be very different from those projected onto court paintings. We may speculate that besides expressing the wish for a prolonged life, *jiehua* of this thematic category had another level of meaning that was unique outside the court. Possibly, while the emperor was actually constructing the "paradise" on earth, private patrons were seeking Daoist eremitism through architectural paintings because of discontent for the political reality.[37]

Conclusion

7

AS WE HAVE SEEN, the impressive upsurge of architectural painting during the seventeenth and eighteenth centuries occurred in response to the political, social, and economic changes that took place after the Qing conquest of China. One of the major reasons for its resurgence was that architectural images functioned as symbolic forms for articulating Qing contemporary views and transmitting messages that were meaningful to diverse audiences. The Qing adaptation of Chinese culture and patronage of the arts during the process of imperial centralization was effective in stimulating architectural representation within the court. Outside the court, economic rehabilitation and urban prosperity provided the economic foundation for artistic developments. Because of the relative fluidity of social boundaries and the desire to mark status distinction, architectural images became sites of active social claims. All these factors fostered the development of architectural painting in major cities. Geographical mobility of the population and trade networks made possible diffusion of an urban culture. Thus architectural painting flourished throughout the whole empire, and its resurgence was not confined only to the cities of Beijing and Yangzhou.

Meaning Construction

Two particular aspects of Qing life were related directly to the representation of architectural images in paintings. The first was the conscious attempt of some members of Qing society to assert power and status within political and social milieus. The second was the pursuit of an extravagant material life to accompany their status. This was true for the Qing rulers, for a segment of the wealthy class (especially merchants and nouveaux riches), and for *jiehua* painters themselves, court and noncourt alike. In these Qing cultural discourses, the Confucian notion of order, past splendors, Daoist fancies, art, and architecture were

the relevant key symbols chosen for construction of meaning. These cultural traditions were kept alive but transformed to fit the present.

The Qing rulers were conscious of the need to affirm legitimacy and to consolidate imperial control over diverse peoples in the Qing empire. Ritual actions, state ceremonies, and palace construction were the major vehicles through which the rulers enhanced imperial authority and perpetuated the pattern of dominance and subservence. Here, power and status were related to Qing emperorship, ideologies of rulership, the visions of the emperors, and their different imperial roles assumed in different architectural and cultural settings.

Merchants and nouveaux riches actively sought acceptance of their economic power by pursuing social status. With tremendous wealth, some of them constructed private gardens in which they undertook refined activities to cultivate connections with the literati. The walls of their gardens defined the boundaries of their domains and also separated them from the others who did not share their culture. Power and status were here associated with wealth and property and were reinforced by the many social and cultural engagements made possible through garden representations.

Paintings of contemporary architecture or paintings that contained architectural motifs as narrative units answered to these particular needs. And when *jiehua* painters were employed to produce paintings, they were simultaneously acquiring their own statuses through selling their specialized skills. Their skills were traded in transactions that allowed them to enter the court academy, to establish their names in the commercial art market, to improve their financial positions, and to befriend wealthy private patrons. If we compare the variety of contemporary themes rendered by *jiehua* painters under different patrons, we find that court painters experimented with a wider scope of architectural subjects. The contemporary architectural images they portrayed included ritual spaces, palaces, and cities, and their scope was not only confined to the regional but also extended to the empire, including both imperial and vernacular architecture. By contrast, when *jiehua* painters portrayed actual private gardens outside the court, the scope was limited to the regional.

History and myth were also invoked in Qing architectural paintings. Pictorial representations of historic and mythic architecture supposedly drew the audiences into worlds of the past and fantasy worlds. Yet visions of the past and fantasy visions in Qing architectural paintings were artifacts of the contemporary and the conjugations of form types in conventionalized pictorial languages. Familiarity with the present suggests that the reconstructed historical and mythical realms were not spatially remote and could be used to serve the present. The Qing rulers employed the Han Chinese past in order to exercise control, whereas other private patrons identified with various cultural traditions to augment their worth. As the renderings of historic and mythic architecture were all characterized by a grand conception and a courtly flavor, it is likely that these images shed light on the patrons' preferences and the material conditions actually pursued under particular political and economic circumstances. Generally speaking, in a society that was organized hierarchically, certain individuals or groups were particularly concerned with how their material conditions dis-

played power and social status so that their glories could be seen, be felt, and be accepted. The material possessions celebrated in these Qing architectural paintings—which suggest wealth, power, and status—were probably the essential ingredients contributing to the meaningfulness of the lives of those who commissioned the works. Thus, even though architectural painting had been used traditionally to express a cultural conception of order, beyond the order presented in orderly architectural images were the social tensions among different strata and the anxieties about power, status, and material possessions.

As to whether the meanings of Qing architectural images were also negotiated in the literary realm, we have to consider many other factors. Political matters, such as justification by Heaven's blessing, certainly led to a common acceptance of the supremacy of imperial authority and the idea that grand imperial architecture was crucial to national greatness and political diplomacy. The idea that is summarized in the line "the pavilion at the central state (*zhongbang*) is to overlook the four directions" best exemplifies how the literary agrees with the pictorial in expressing the political symbolism of imperial architecture.[1]

Equally significant are the differences between the pictorial and the literary realms in construction of meaning. Because of such differences, one cannot necessarily assume that the meanings invested in paintings have parallels in literary discourses. Notably, the *fu* rhapsody as a courtly celebration of the majesty of imperial palaces during the Han was not a popular literary form for writing about architecture during the Qing. But poems and essays devoted to travel accounts—which include objective or subjective descriptions of specially built environments—were plentiful in the Qing period.[2] The Qing rulers themselves, especially the Qianlong emperor, contributed a number of literary works on imperial palaces. In writing, however, the Qianlong emperor assumed the role of the Confucian scholar and "took on the highly conventionalized ideal of lofty literatus simplicity."[3] By emphasizing the rustic simplicity of the scenes, by citing historical references, or by celebrating the feeling of transcendence while in a paradise, the emperor seemed to have saved himself from being criticized for luxury and extravagance. In fact, as Fredrick Mote observed, the imperial poems were "a record of extravagant sham," testifying to "the false minimization sought by the emperor."[4] The grand conception of the architectural images in Qing court paintings, by contrast, offered a glimpse of another mode of Qing imperial life, one that contradicted the Confucian lofty ideal held in a different context.

The literary works on private gardens that scholars contributed might be seen as a discharge of social obligations. Scholars often held an attitude of connoisseurship toward architectural landscapes,[5] and garden owners relied on these writings for social approval of their taste. The meanings that garden owners projected onto their garden images might depend upon, and yet could be very different from, those in literary discourses because scholars tended to employ their writings as vehicles for expressing broader views about nature or intellectual thoughts or their personal emotions—and those broader views might not have been the original motivations for garden constructions and representations.[6] Historical palaces and imagined paradises were also beloved icons in literature. Yet to many scholars

(except historians and antiquarians), defining the specific forms and appearances of the past and of the immortals' land was not as significant as melancholy reflections on moral history and attainment of transcendence while wandering in imagination in the mystical realm. Thus the meanings invested in one medium may not be easily transposed into the other, partly because the different media of painting and literature might serve different individuals and groups and partly because these were produced by those having varied backgrounds, motivations, and social stations.

The New Aesthetics

Qing architectural representations also translated the period's sensibility toward the external world—toward the substance of things, natural and man-made objects alike—into visual images. Such sensibility was probably related to a new cosmological view developed in the Qing period. This new view departed from the old idea of the superiority of *li* and advocated, instead, the primacy of *qi*. According to this new view, everything produced in the interaction of *yinyang* and *wuxing*, or the motion of *qi*, showed an internal structure designated by the Qing Neo-Confucians as *li*.[7] Thus it was the business of the Qing intellectual mind to discover in this world the substance or the internal structure of things.

Pictorial evidence suggests that Qing architectural paintings—which were mostly done by professional painters—also manifest this new view of nature held by the intellectuals. Although it is difficult to demonstrate how ideas were moving between levels of consciousness, architectural paintings of this period, interestingly, demonstrate the translation between abstract and concrete. The Qing manner of architectural representation played an active role in revealing this sensibility toward the external world. We observe a deliberate attempt to evoke a sense of grandeur by rendering physical space in its substantiality. Clear directional invitations and interpenetrations of architectural space evoke a sense of scale and monumentality. The effect is particularly awe-inspiring when clusters of buildings are connected and conjoined along the horizontal format of a handscroll, along a twelve-panel screen, or along a set of hanging scrolls. A clear indication of the relationship between open areas and buildings allows the viewer to step in, to enter, and to experience a sequence of physical spaces, indoor and outdoor. When the ground plane of a large area is exposed, space appears to stretch far and wide. When human activities are included, the built environment becomes utilitarian. The feeling of being in a place is also enhanced. While emphasizing the accessibility and interpenetration of physical space within a grand architectural compound, Qing painters were simultaneously abandoning a particular Ming manner of architectural configuration that featured blocklike, impenetrable compounds. By providing large extensions of physical space for buildings to be set in and for viewers to move around in, Qing painters were restoring a degree of clarity to architectural configuration. Even when images of buildings are scattered in a grand landscape setting, there are

specific routes to suggest continuity of architectural space within localized space-time continuum.

The deep awareness of the substance of things in Qing architectural paintings was reflected not only in the configuration of a vast architectural compound but also in the representation of individual structures. While Qing architectural painters were concerned with the effect of mass and substance for every building, they were transforming small, delicate Ming architectural images into more solid, tangible structures. Artists also paid attention to the physical characteristics of every architectural component: its mass, texture, and material. They followed the pictorial conventions of presenting—or indeed suggesting—the rules governing the links of parts in an overall architectural structure. But Qing architectural painters moved a step further by stressing the importance of matter that made up the substance of things, and this is most evident in works done with heavy application of opaque colors. Consequently, there was not only clarity in architectural structure but also clarity in the representation of the substance of things.

The quest for verisimilitude was central to the substantial renderings of architectural images in Qing paintings. Past concepts such as faultless calculation and right proportion—which were embodied in the pictorial conventions for architectural representation—were deemed relevant for Qing painters and continued to live on in a new era. Yet the significance of these traditional concepts should not be viewed as if there are absolute standards against which one can evaluate how "correct" or "accurate" Qing architectural renderings are. It is more important to consider the likelihood that these were convincing images in the eyes of the Qing people and that they successfully conveyed the quality of solidity and stability required for architectural representation.

When these grand architectural images are placed in landscape settings that also express the new cosmological view, the result is a remarkable substantial quality in Qing architectural landscapes. As a result of collaborations of landscape and architectural painters within the court academy, architectural landscapes demonstrate the various ways in which contemporary theories of landscape depiction interacted with the period's distinctive manner of architectural representation. Besides showing the joint effort of painters in translating the period's sensibility into a diversity of artistic expressions, architectural landscapes of the Qing resolve the pictorial tensions resulting from the incorporation of architectonic structures with ethereal landscapes in Ming paintings.

The introduction of European representational techniques provided Qing Chinese artists with new possibilities of novelty in architectural representation, not just "a few clever techniques" as some might think.[8] Despite the incompatibility of post-Renaissance European and Chinese systems of representation, selective borrowing from the West enabled Qing painters to achieve solid renderings of things. Painters were fascinated by how European linear perspective could create an illusory space that induced viewers to walk into it, and they applied the newly imported foreign methods to Chinese architectural represen-

Conclusion

tation. This, in turn, enhanced the tangible quality of physical space in Qing architectural paintings. Although this borrowing was selective (because there was no attempt to organize the whole composition with perspectival construction), it was in line with the aesthetic conception of the period. And when painters displayed plasticity of forms through the effects of light and shade on the objects' surfaces, they were actually employing the new techniques to construct pictorial images that allowed the acting out of the period's sensibility.

The borrowing of the foreign techniques was evident in the paintings of court painters such as Jiao Bingzhen, Leng Mei, Chen Mei, Shen Yuan, and Xu Yang. Painters working outside the court also had the opportunity to learn about the new techniques from imperial publications (e.g., *Album of Agriculture and Sericulture*) or other woodblock prints. Significantly, once the borrowing had succeeded in seeking a meaningful place in society, it also influenced the formation or substantiation of the period's sensibility. The importation offered new visual habits and experiences to painters, court and noncourt alike, even if the effect of borrowing was not an obvious direct application of the foreign techniques to Chinese paintings.

Implied from the different receptiveness toward the foreign techniques is the issue of stylistic variations in Qing architectural representation. I have not attempted to use institutional differences as the basis to draw comparisons between "court" and "Yangzhou" styles, as various styles had been adopted by painters working inside and outside the court in various regions. Generally speaking, a diversity of styles results from the interplay of ink, colors, lines, and washes in architectural representation. For example, *jiehua* painters may favor the use of pale ink lines for outlining and a bright, mineral-based color palette for coloring. Because of the intensity and brightness of the colors, the prominence of the ink lines is reduced, but the colorful architectural images stand out vividly. The introduction of oil painting within the court had led to a greater concern for the play of light and colors, even though painters continued to work with the Chinese media of ink, brush, paper, and silk. The impact of light gives striking clarity to the building materials, as evident in the gleaming roof tiles of the architectural images.

On the other hand, *jiehua* painters sometimes relied on ink lines of varied thickness and tonality to render buildings. They then tinged the linear structure with dilute ink and color washes, intensifying the effect of mass and volume. In the words of Xie Kun, this style would make an architectural painting look "austere and antique,"[9] and the Yuan school was credited with the revival of this "antique" style. Moreover, the Yuan school was particularly concerned with the atmospheric effect achieved by the subtle changes of ink and color washes. A deep valley filled with mist, a portion of clear ink revealing the silk background, a touch of reddish hue in the ink-washed recess areas—all these stylistic characteristics adorn their works with a rich atmospheric effect. They also give a luminous quality as though the architectural landscapes are illuminated internally by intense light.

From an art-historical viewpoint, the achievements made by Qing *jiehua* specialists are reflected in such aspects as verisimilitude, structural clarity, spatial organization, integra-

tion with nature, and antiquity. All of these were the principal concerns of the ancients. The venerable *jiehua* tradition suggested a range of possibilities without discouraging transformations. Qing painters centered themselves on these aspects and developed new, distinctive styles for the period. Moreover, the importation of European representational techniques probably made Chinese painters become more conscious of their own cultural traditions than ever. *Jiehua* painters were themselves defining Chinese styles in architectural representation. Native conceptions and conventions were revived, and foreign techniques were borrowed and transformed. Although diverse, the cultural styles adopted by these artists fall within certain parameters. There are the uses of linear brushwork and "a hundred" lines in architectural configuration, the concerns for "faultless calculation" and "right proportion," structural clarity, a close relationship with nature, and antiquity in *jiehua*. But these conceptions were given new expressions in the Qing period. The new styles made manifest the period's sensitivity and its cultural changes and also catered to the diverse needs of patrons. Architectural paintings of the Qing are therefore sites of diverse discourses. They offer a window—a metaphor that is more than apt in this context—onto the changes taking place in the Qing world.

Notes

Introduction

1. See Wai-kam Ho's discussion of concepts of value as products of society in "The Literary Concepts of 'Picture-like' *(Ju-hua)* and 'Picture-Idea' *(Hua-i)* in the Relationship between Poetry and Painting," 362.

2. See Liang Sicheng, A *Pictorial History of Chinese Architecture*; Xiao Mo, *Dunhuang jianzhu yanjiu*; Jin Feng, "Wonders of the Eastern Garden."

3. See William Trousdale, "Architectural Landscapes attributed to Chao Po-chu"; Else Glahn, "Palaces and Paintings in Sung"; Fu Xinian, "Guanyu Zhan Ziqian *Youchun tu* niandai de tantao."

4. See Glahn, "Palaces and Paintings in Sung," 46.

5. Trousdale, "Architectural Landscapes Attributed to Chao Po-chu," 285.

6. See Susan Wright, "The Politicization of 'Culture,'" 14. Wright distinguishes between the "old" and the "new" meanings of "culture" in social anthropology: "An older set of ideas which equates 'a culture' with 'a people' which can be delineated with a boundary and a checklist of characteristics; and new meanings of 'culture,' as not a 'thing' but a political process of contestation over the power to define key concepts, including that of 'culture' itself." Also see the definition of "culture" by Grant Evans and Maria Siu-mi Tam, eds., in *Hong Kong: The Anthropology of a Chinese Metropolis*, 11–13.

7. As Evans and Tam observed, this process of meaning construction is done in terms of culturally identifiable parameters: "For example, Chinese people differ greatly among themselves about the significance and importance and interpretation of 'Confucianism'—most in fact know little of the formal philosophy. But almost everyone agrees that its ideas (however they are identified) are important to discuss and debate. Whereas, for example, Confucius is not central to French cultural debates, but the French philosopher Rousseau is. In other words, different cultures do have *distinct symbolic reference points* in their discourses about culture." See Evans and Tam, *Hong Kong*, 12.

8. See Raymond Williams, *Keywords*, 90–91.

9. Ibid., 92. The usage of the word "culture" in this context involves claims to superior knowledge and refinement.

10. Clifford Geertz, "Art as a Cultural System," 109.

11. Pamela Kyle Crossley, A *Translucent Mirror*, 36.

12. Wang Gai, *Yuanban yingyin Jieziyuan huazhuan*, 4:16. This edition is a reprint of the seventeenth-century edition. English translation adapted from Mai Mai Sze, *The Mustard Seed Garden Manual of Painting*, 294–295.

Chapter 1: The *Jiehua* Tradition

1. Zhang Yanyuan, *Lidai minghua ji*, 26; all subsequent citations are to this edition.

2. Puay-peng Ho, "Paradise on Earth, 24.

3. Zhang Yanyuan, *Lidai minghua ji*, 26. English translation cited from William R. B. Acker, *Some Tang and Pre-Tang Texts on Chinese Painting*, 182–183.

4. Guo Ruoxu introduces a number of concepts in this passage without further elaboration. Ambiguities arise when modern scholars interpret the terms *"shenyuan toukong"* and *"yiqu baixie."* For example, Alexander C. Soper's interpretation is "Perspective distances will penetrate the space, with a hundred [lines] converging on a single point." See Alexander C. Soper, trans., *Kuo Jo-hsu's Experiences in Painting*, 12.

5. This and the next paragraphs on architectural painting are separated by another paragraph on flower and bird painting. The discontinuity in discussion, or misplacement of an unrelated paragraph, is probably a result of textual corruption.

6. Guo Ruoxu, *Tuhua jianwen zhi*, 152–153; all subsequent citations are to this edition. English translation adapted from Robert J. Maeda, "Chieh-hua: Ruled Line Painting in China," 123–124; and Soper, *Kuo Jo-hsu's Experiences in Painting*, 12.

7. Marsha Smith Weidner, "Painting and Patronage at the Mongol Court of China," 151–152.

8. Zhu Jingxuan wrote, "For painting, priority should be given to human figures, and thereafter rank in descending order birds and beasts, landscapes, and architectural subjects." See *Tangchao minghua lu*, 1:161. English translation cited from Alexander C. Soper, "T'ang Ch'ao Ming Hua Lu," 204.

9. Zhang Yanyuan, *Lidai minghua ji*, 19. English translation cited from Acker, *Some Tang and Pre-Tang Texts*, 150.

10. *Xuanhe huapu*, 455; all subsequent citations are to this edition. English translation cited from Susan Bush and Hsio-yen Shih, *Early Chinese Texts on Painting*, 112.

11. Tang Hou, *Hualun*, 75; all subsequent citations are to this edition. English translation cited from Bush and Shih, *Early Chinese Texts*, 112.

12. See Bush and Shih, *Early Chinese Texts*, 248.

13. Tao Zongyi, *Nancun chuogeng lu*.

14. Tang Hou, *Hualun*, 75.

15. Guo Ruoxu, *Tuhua jianwen zhi*, 181–182.

16. Ibid.

17. Ibid., 151, 182.

18. See Yuan Jue, *Qingrong Jushi ji*, 45:9a, inscription on Wang Zhenpeng's *Dragon Boat Regatta on the Jinming Lake*.

19. Marsha Smith Weidner, "Aspects of Painting and Patronage at the Mongol Court, 1260–1368," 48.

20. Weidner has commented on the problem of using "ruled line painting" to designate architec-

tural painting. If "*jiehua*" is translated as "ruled line painting" and Guo Zhongshu's paintings are also included for discussion, this implies that "there was a stage in the history of 'ruled line painting' when rulers were not used." According to Weidner, "only later (12th century and later) painters would be referred to as masters of *chieh-hua (jiehua)*, while earlier artists might still be described as painters of architectural subjects." See Weidner, "Painting and Patronage," 234n. 40.

21. For the different interpretations of the term "boundary painting," see Herbert A. Giles, *An Introduction to the History of Chinese Pictorial Art*, 201.

22. Li Zhi, *Huapin*, 1:991. English translation cited from Bush and Shih, *Early Chinese Texts*, 202.

23. Li Jie, ed., *Yingzao fashi*, 673:442; all subsequent citations are to this edition.

24. Guo Ruoxu, *Tuhua jianwen zhi*, 174. Also see Soper, *Kuo Jo-hsi's Experiences in Painting*, 35.

25. Liu Daochun, *Shengchao minghua ping*, 3:14b; all subsequent citations are to this edition.

26. E. H. Gombrich, *Art and Illusion*, 73–74.

27. Ibid.

28. Ibid., 171–172.

29. Shen Kuo, *Mengxi bitan*, 113; all subsequent citations are to this edition.

30. Ibid. The calculations are recorded as follows:

The length of the cross-beams will naturally govern the lengths of the uppermost cross-beams as well as the rafters, etc. Thus for a [main] cross-beam of 8 ft. length, an uppermost cross-beam of 3.5 ft. length will be needed. [The proportions are maintained] in larger and smaller halls. This [2.28] is the Upperwork Unit. Similarly, the dimensions of the foundations must match the dimensions of the columns to be used, as also those of the [side-] rafters, etc. For example, a column 11 ft. high will need a platform 4.5 ft. high. So also for all the other components, corbelled brackets (*gong*), projecting rafters (*cui*), other rafters (*jue*), all have their fixed proportions. All these follow the Middlework Unit. Now below of ramps [and steps] there are three kinds, steep, easy-going and intermediate. In palaces these gradients are based upon a unit derived from the imperial litters. Steep ramps are ramps for ascending which the leading and trailing bearers have to extend their arms fully down and up respectively [ratio 3.35]. Easy-going ramps are those for which the leaders use elbow length and the trailers shoulder height [ratio 1.38]; intermediate ones are negotiated by the leaders with downstretched arms and trailers at shoulder height [ratio 2.18]. These are the Lowerwork Units.

English translation cited from Needham, *Science and Civilization in China*, vol. 4, pt. 3, 81–82.

31. Shen Kuo, *Mengxi bitan*, 113. English translation cited from Needham, *Science and Civilization in China*, vol. 4, pt. 3, 81–82.

32. According to the *Yingzao fashi*, a module is called *cai*. The height of each *cai* is to be divided into fifteen equal parts called *fen*, whereas the width is to be ten *fen*. Thus one *cai* measures fifteen by ten *fen*. When two *cai* are used one above another, a block of six *fen* in height called a *qi* (six by ten *fen*) will be added to fill the gap. A member measuring one *cai* and one *qi* in height is called a *zucai* or a full *cai* (twenty-one by ten *fen*). *Fen* is a relative dimension corresponding to various standard sizes of the timber which are also called *cai*. There are eight standard sizes of timber (or *cai*) with which the height and thickness of a corbel bracket have to correspond. The grades of *cai* are determined by the type and the official rank of the building to be erected. So, under the modular system, the dimensions and proportions of different parts of a building are expressed in terms of *cai*, *qi*,

and *fen* of the grade of the *cai*. See Liang Ssu-cheng, *A Pictorial History of Chinese Architecture*, 15, 198.

33. See Gombrich, *Art and Illusion*, 221.

34. Li Zhi, *Huapin*, 185–186. English translation cited from Bush and Shih, *Early Chinese Texts*, 202.

35. In a recent study of these two scrolls, Roderick Whitfield revises a previous view that *Going up the River on the Qingming Festival* was a work of the early twelfth century. Considering that the *Qingming* scroll contains many echoes of the *Transport Carts at the Mill* and Zhang Zeduan was the student of Wei Xian, Whitfield suggests that Zhang Zeduan "almost certainly learnt his trade not merely at the capital but from Wei Xian himself." Thus the *Qingming* scroll could possibly have been done in the middle of the eleventh century. Whitfield also suggests the possibility that Zhang Zeduan presented his teacher's work, *Transport Carts at the Mill*, to the Song court. See his article "Material Culture in the Northern Song Dynasty," 63–64.

36. The *Yingzao fashi* was first published in 1103 and then reprinted in 1145. It was included in the *Yongle dadian* during the Ming and the *Siku quanshu* during the Qing. In 1919 a modern edition was published. This edition was a reproduction of a manuscript copy, whose drawings had suffered considerably from successive copying. A revised edition was published in 1925, incorporating new illustrations done by an aged master carpenter who had long been in charge of the maintenance of the palace buildings in Beijing. His drawings were therefore different from those of the original Song version. Fortunately, the Song drawings were also included in the new edition of 1925, and the later drawings were added as appendixes. Another feature of the 1925 edition was the color illustrations of the painted decorations, with the palette based on the decor of Beijing palaces. See Else Glahn, "Unfolding the Chinese Building Standards," 51. Also see Chen Mingda, *Yingzao fashi damuzuo yanjiu*, 1:2.

37. For the technical progress in Song architecture, see the Institute of the History of Natural Sciences and Chinese Academy of Sciences, comps., *History and Development of Ancient Chinese Architecture*, 98–99. Also see Liang, *Pictorial History*, 205.

38. Liang, *Pictorial History*, 205.

39. The other supporting evidence is the representation of the brackets in this example which does not show the same degree of structural clarity as to be found in the city gate of *Going up the River on the Qingming Festival*.

40. See James Cahill, *An Index of Early Chinese Painters and Paintings*, 50. Also Wu Zhefu, ed., *Five Thousand Years of Chinese Art Series*, 160–162.

41. We are assuming the occasion where the original signature of a lesser painter was removed and replaced with the name of a major master to enhance the value of a painting. This is often a problem in traditional Chinese painting. However, in a recent study of this painting, Roderick Whitfield offers a new interpretation of the signature. He suggests that the family name "Zhang" refers to Zhang Zeduan who "submitted" Wei Xian's work to the Song court. See Whitfield, "Material Culture," 64.

42. Liu Daochun, *Shengchao minghua ping*, 3:12a.

43. This is similar to cross-section drawing in building practice. A cross-section drawing shows the relative positions of mortises and tenons in a timber framework, which allows builders to determine the lengths of beams and purlins. See Li Jie, *Yingzao fashi*, 673:442.

44. According to Puay-peng Ho, the illusion of space serves the following functions: "The linear elements [such as the platforms] are designed to induce a movement, leading the eyes of the viewer

into the central space, the focus of construction, where the preaching Buddha is located. The side pavilions constructed with oblique projection suggest a formal enclosure that is necessary to create a visual locus between the buildings. The most important formal building is the central hall, which is the stage set for the preaching Buddha." Puay-peng Ho, "Constructing Paradise: Heavenly Buildings in the Silk Paintings of Dunhuang" (paper delivered at the Department of Fine Arts, University of Hong Kong, June 1996).

45. For the adoption of the moving focus in Chinese painting, see George Rowley, *Principles of Chinese Painting*, 61–63.

46. Shen Kuo, *Mengxi bitan*, 108–109. English translation cited from Bush and Shih, *Early Chinese Texts*, 112.

47. Rowley, *Principles of Chinese Painting*, 62.

48. Ibid., 57.

49. Refer to *Windblown Willows by the Water Kiosk* by Zhu Guangpu (active ca. 1127) and *Night Excursion by Candlelight* by Ma Lin (active early to mid-thirteenth century) in the National Palace Museum, Taipei. Published in Guoli gugong bowuyuan bianji weiyuanhui, ed., *Yuanlin minghua tezhan tulu*, plates 4 and 5.

50. The Chinese believe that *yin* and *yang* produce *wuxing* (water, fire, wood, metal, and earth). These five elements have specific positions in the *Hetu* in which they are immediately associated with directions, numbers, colors, and every conceivable aspect of things in the universe, such as seasons, constellations, taste, smell, parts of body, grain, domestic animals, and so on. Hence the four cardinal points and the center of a Chinese building reflect the symbolic correlation between *wuxing* and all things in the universe. See Ho Peng Yoke, *Li, Qi and Shu*, 18–19.

51. All traditional Chinese constructions begin with "level finding" and "orientation." The Chinese builder first finds out the level by using the surface of still water as the standard. He then erects the marker poles at the four corners of the site, measures the sun's shadows, and observes the Pole Star to determine the four positions in relation to nature. See the Institute of the History of Natural Sciences and Chinese Academy of Sciences, comps., *History and Development of Ancient Chinese Architecture*, 479.

52. Guo Zhengyi, *Pidian Kaogong ji*, 2:12.

53. Ibid.

54. Stephan Feuchtwang defines *fengshui* as follows: "*Fengshui (feng* = wind, *shui* = water) as a single term stands for the power of the natural environment, the wind and the airs of the mountains and hills; the streams and the rain; and much more than that: the composite influence of the natural processes. Behind it is a whole cosmology of metaphysical concepts and symbols. By placing oneself well in the environment *fengshui* will bring good fortune." See Stephan Feuchtwang, *An Anthropological Analysis of Chinese Geomancy*, 2. According to Richard T. Smith, *fengshui* deals with "the Chinese siting techniques which are based on the principles of harmonizing dwellings for both the living and the dead with the immediate physical environment as well as the larger cosmic scheme. Such attunement, most Chinese believed, brought good fortune to everyone concerned." See Smith, *Fortune-Tellers and Philosophers*, 131.

55. Li Zhi, *Huapin*, 185–186. English translation cited from Bush and Shih, *Early Chinese Texts*, 202.

56. *Xuanhe huapu*, 458.

57. Ibid.

58. See Liu Daochun, *Shengchao minghua ping*, 3:12a; *Xuanhe huapu*, 458.

59. See Yang Renkai, "Yemaotai Liaomu chutu guhua de shidai ji qita," 37–39.

60. As Alexander C. Soper observed, the notion of *gu* was a relatively late phenomenon that was built up gradually from the Tang period onward. This notion did not become an important concern in painting until the generation that included Li Gonglin, Mi Fu, and Emperor Huizong in the late eleventh century and early twelfth century. See Soper, "The Relationship of Early Chinese Painting to Its Own Past," 21.

61. Wen Fong observes that "a return to the archaic" occurred after "a primary evolutionary phrase" had been attained in the history of figure painting, landscape painting, and calligraphy. See Fong, "Archaism as a 'Primitive' Style," 89.

62. Xu Qin, *Minghua lu*, 12; all subsequent citations are to this edition.

63. See Ju-hsi Chou's discussion of the hierarchy of Chinese art in the introductory essay to *Chinese Folk Art*, 16.

64. Published in Gugong bowuyuan, ed., *Mingdai gongting yu Zhepai huihua xuanji*, 51.

65. Published in Zhongguo meishu quanji bianji weiyuanhui, ed., *Mingdai huihua (shang)*, Zhongguo meishu quanji huihuabian 6, 105–107.

66. Published in Na Chih-Liang, *The Emperor's Procession*.

67. Given the presence of *jiehua* artists such as An Zhengwen in the Ming court, Richard Barnhart questions whether landscape painters who served at court had ever used the services of *jiehua* specialists. See Barnhart, *Painters of the Great Ming*, 265.

68. Xu Qin, *Minghua lu*, 12.

69. Tang Zhiqi, *Huishi weiyan*, 2:19b–20a; all subsequent citations are to this edition.

Chapter 2: Patrons and Painters

1. See Pamela K. Crossley's discussion of the creation of the "Manchu" identity in relation to the growth of the Qing state in *The Manchus* (Oxford and Malden, Mass.: Blackwell Publishers, 2002), 6, 13.

2. Ibid., 106. Also see Crossley, *A Translucent Mirror*, 44.

3. See the biography of Li Sen in Chen Shouqi et al., comps., *Fujian tongzhi*, 9:4496.

4. Hu Jing, *Guochao yuanhua lu*, 1:1a, 2:30a; all subsequent citations are to this edition.

5. Some contemporary Chinese scholars deny the existence of a painting academy within the Qing court, as they believe that there was no formal organization with an internal structure similar to that of the Song Hanlin Painting Academy. Yet they all agree that there were court painters serving at the Qing palace. For the various views held by contemporary Chinese scholars, see Yang Boda, *Qingdai yuanhua*, 7–8.

6. See Hu Jing's preface to *Guochao yuanhua lu*, English translation cited from Ju-hsi Chou and Claudia Brown, eds., *The Elegant Brush*, 335.

7. Cited in Daphne Lange Rosenzweig, "Court Painting and the Kang Hsi Emperor," 60.

8. Howard Rogers, "Court Painting under the Qianlong Emperor," 307.

9. Ferdinand Verbiest (1623–1688) was working in the Imperial Bureau of Astronomy during the Kangxi era. He was the assistant of Johann Adam Schall von Bell (1592–1666) who, after a dispute with

Yang Guangxian (1597–1669) about astrological calculations, died in prison. When the Kangxi emperor became interested in Western astronomy, he pardoned Verbiest and gave him back his official position. For the activities of other Western missionaries in the Kangxi court, see Jonathan D. Spence, *Emperor of China*, 72–85. Also see George Loehr, "Missionary-Artists at the Manchu Court," 51–66.

10. See Hu Jing, *Guochao yuanhua lu*, 1:1–2a.

11. Ibid., 1:2a.

12. Ibid., 1:1–2a.

13. Titled *Gengzhi tu* in Chinese, the *Album of Agriculture and Sericulture* is published in full in *Xiyong xuan congshu* (Taipei: Guangwen shuju, 1983). The *Album of Virtuous Empresses in Successive Dynasties* is published in Gugong bowuyuan, ed., *Qingdai gongting huihua*, 33–34.

14. See Zhang Zhao et al., *Shiqu baoji*, 451, 751.

15. Published with *Yuzhi Bishu shanzhuang shi* (1712) in Li Yimang, ed., *Bishu shanzhuang sanshiliu Jing*.

16. For the biography of Wang Yun, see Wang Fengyuan, comp., *Jiangdu xian xuzhi*, 12:18b–19a. Also see Wang Jun, *Yangzhou huayuan lu*, 1:6. It is to be noted that Wang Yun entered the court in 1687, well before Wang Hui and his entourage were summoned to Beijing for the *Kangxi Southern Inspection Tour*. This is to clarify another saying that Wang Yun was a member of Wang Hui's entourage which traveled to Beijing for this particular commission. See Alfreda Murck, "Yuan Jiang," 237.

17. Xu Chengtian et al., comps., *Guangxu zengxiu Ganquan xianzhi*, 15:16b. The same source also records Wang Yun's participation in the painting project *The Kangxi Emperor's Sixtieth Birthday Celebration*. But this contradicts the allegation that Wang Yun left the court in 1704; see Wang Fengyuan, *Jiangdu xian xuzhi*, 12:18b–19a.

18. See Hu Jing, *Guochao yuanhua lu*, 2:25b. The paintings are currently in the Palace Museum.

19. Ibid, 2:25b–26a.

20. Ibid. The *Guochao yuanhua lu* records a total of nine artists who had participated in *The Kangxi Emperor's Sixtieth Birthday Celebration*. Besides Leng Mei and other painters who were the pupils of Wang Yuanqi (e.g., Xu Mei, She Xizhang, Jin Yongxi), there were additional artists whose biographies and specialties were unknown.

21. See Charles O. Hucker, *A Dictionary of Official Titles in Imperial China*, 520.

22. *Zaobanchu gezuocheng huoji Qingdang* (hereafter cited as *Qingdang*).

23. See Yang Boda, *Qingdai yuanhua*, 111. Also see Nie Chongzheng, *Gongting yishu de guanghui*, 65–70.

24. See Liu Ruli, "*Shixue*: Woguo zuizao de toushixue zhuzuo," 42.

25. See *Duhua jilue*, in Hong Ye, comp., *Qingdai chuan jiyi sanzhong*, in Zhou Junfu, comp., *Qingdai zhuanji congkan* (hereafter cited as *QDZJCK*), 79:287; all subsequent citations are to this edition. Dai Hong's expertise in the subjects of flowers and birds can be confirmed in his contribution of a flower and bird painting to the *Album of Auspicious Subjects*. This album was a collaborative work by various court artists in celebration of the royal birthday. The specialty of each participant is clearly shown in this album: Sun Hu painted architectural subjects, both Chen Mei and Ding Guanpeng painted figures, Dai Hong painted flowers and birds. See Hu Jing, *Guochao yuanhua lu*, 2:26.

26. See Sheng Shuqing, *Qingdai huashi zengbian* (1922), in *QDZJCK*, 78:24; also see *Duhua jilue*, in Hong Ye, comp., *Qingdai chuan jiyi sanzhong*, in *QDZJCK*, 79:286.

27. See the biography of Gao Qipei in *Baqi tongzhi*, cited in Klaas Ruitenbeek, *Discarding the Brush*, 68.

28. Published in Yang Xin, Shan Guoqiang, and Yang Chenbin, eds., *Gugong bowuyuan cang Ming Qing huihua*, 118, plate 105.

29. Gao Bing, *Zhitou huashuo*, 2a.

30. See Ruitenbeek, *Discarding the Brush*, 68.

31. In 1737 Ding Guanpeng petitioned the Qianlong emperor for a grant of his housing benefit. All the other painters who entered the court academy around the same time had already been given their houses. Obviously, Ding Guanpeng held a low position during his service at the Yongzheng academy. See *Qingdang*, entry dated 29 January, second year of the Qianlong reign (1737), cited in Nie Chongzheng, "Qingdai gongting huajia xutan," 74–75.

32. See Gugong bowuyuan, *Qingdai gongting huihua*, 252–254, entries for plates 38, 63, and 64.

33. The Ruyi Studio (Ruyiguan) and the Painting Academy (Huayuanchu) seemed to be two separate divisions. The Ruyi Studio was located in scene 40 of the Garden of Perfect Brightness, but some of the entries filed under "Ruyiguan" in the *Qingdang* record that painters were commanded to work in the Qixiang Palace of the Forbidden City. Apparently, painters of this division worked in either the Garden of Perfect Brightness or the Qixiang Palace in the Forbidden City. As for the Painting Academy, it did not seem to have any fixed location. Painters of this unit were summoned to paint at various places. For details, see Yang Boda, *Qingdai yuanhua*, 24–28.

34. According to She Cheng's study of the Qianlong academy, the number of court painters was at least 148. Of these, 106 are represented by works in the National Palace Museum, Taipei. The remaining 42 painters are recorded in the literature, but they are not represented by extant paintings in the museum. See She Cheng, "The Painting Academy of the Qianlong Period," 334.

35. Notably, Leng Mei was reappointed after his absence at the Yongzheng academy.

36. Crossley, *The Manchus*, 116. Also see Evelyn S. Rawski, *The Last Emperors: A Social History of Qing Imperial Institutions*, 6.

37. Crossley, *A Translucent Mirror*, 221.

38. Hu Jing, *Guochao yuanhua lu*, 1:1–2a and 1:19b. Also see Hummel, *Eminent Chinese*, 330.

39. Ruitenbeek, *Discarding the Brush*, 68.

40. Wang Jun, *Yangzhou huayuan lu*, 1:6b.

41. *Qingdang*, "Ruyiguan" section, 12 July, sixteenth year of the Qianlong reign (1751). Other first-class painters of the same period included Jin Kun, Sun Hu, Zhang Yusen, and Zhou Kun. The monthly income of a first-class painter in 1741 was a total of eleven *taels* of silver. See Yang Boda, *Qingdai yuanhua*, 43.

42. Hu Jing, *Guochao yuanhua lu*, 2:16a–17b.

43. Ibid., 2:1a–6a. Also see Nie Chongzheng, "Qingdai gongting huajia zatan," 44–45.

44. One is a landscape painting, undated, published in Guoli gugong bowuyuan bianji weiyuanhui, ed., *Gugong shuhua tulu*, 10:233. The other is a flower painting, painted jointly by Wang Yun and Wang Hui, also published in *Gugong shuhua tulu*, 14:337. Also see Zhang Zhao et al., *Shiqu baoji*, 673, 674.

45. See Wang Fengyuan, *Jiangdu xian xuzhi*, 12:18b–19a.

46. See a list of collaborative works by Wang Hui and others in Maxwell Hearn, "Document and Portrait," 187n. 40.

47. See Ju-hsi Chou's introduction to *The Elegant Brush*, 2–3. Also see Rogers, "Court Painting," 304.

48. *Qingdang*, "Ruyiguan" section, entries dated 19 May and 26 August, tenth year of the Qianlong reign (1745).

49. Ibid., 14 August, fifteenth year of the Qianlong reign (1750).

50. Xie Tingxun, comp., *Louxian zhi* 27:13a–b.

51. Hu Jing, *Guochao yuanhua lu*, 1:8a.

52. *Qingdang*, cited in Nie, "Qingdai gongting huajia xutan," 72–73.

53. *Qingdang*, "Ruyiguan" section, 9 January, first year of the Qianlong reign (1736).

54. Ibid., "Huayuanchu" section, 9 January, first year of the Qianlong reign (1736).

55. Ibid., "Ruyiguan" section, 5 October, third year of the Qianlong reign (1738).

56. Ibid., "Ruyiguan" section, 11 July, twelfth year of the Qianlong reign (1747).

57. Ibid., "Ruyiguan" section, 27 January, thirteenth year the Qianlong reign (1748).

58. Ibid., "Ruyiguan" section, 17 February, thirteenth year the Qianlong reign (1748).

59. Ibid., "Ruyiguan" section, 13 February, fourteenth year of the Qianlong reign (1749).

60. See Mayching Kao, "European Influences in Chinese Art," 261.

61. See Loehr, "Missionary-Artists," 52, 61.

62. See Spence, *Emperor of China*, 72.

63. Loehr, "Missionary-Artists," 61.

64. See Yang Boda, *Qingdai yuanhua*, 29, 51. It is recorded in the *Qingdang* that Shen Yuan was asked "to use linear perspective *(xianfa)* to rework the architectural painting by Gao Qipei, which was hung at the Baohe taihe." *Qingdang*, "Ruyiguan" section, 18 June, eleventh year of the Qianlong reign (1746).

65. On the use of linear perspective in European paintings, see Erwin Panofsky, *Perspective as Symbolic Form*. Also see Benjamin March, "Linear Perspective in Chinese Painting," 113–139.

66. As Panofsky observes, linear perspective is a factor of style in European paintings: "Spiritual meaning is attached to a concrete, material sign and intrinsically given to this sign" (Panofsky, *Perspective as Symbolic Form*, 40–41).

67. Nian Xiyao, *Shixue*, 1735, Beijing Library.

68. See Nie Chongzheng, "Xianfahua xiaokao," 85–88; idem, "Architectural Decoration in the Forbidden City," 51–55.

69. Zou Yigui, *Xiaoshan huapu*, 806. English translation cited from Kao, "European Influences in Chinese Art," 273.

70. On the geographical regions and marketing networks of traditional China, see William G. Skinner, "Marketing and Social Structure in Rural China," and "Cities and the Hierarchy of Local Systems," in idem, ed., *The City in Late Imperial China*, 275–351.

71. On the factors for cultural diffusion in Qing China, see Susan Naquin and Evelyn S. Rawski, *Chinese Society in the Eighteenth Century*, 56.

72. On the economic success and rising social status of salt merchants in Yangzhou, see Ping-ti Ho, "The Salt Merchants of Yangzhou," 130–168.

73. Li Dou, *Yangzhou huafang lu*, 347; all subsequent citations are to this edition.

74. As Antonia Finnane has pointed out, this association was to place Yangzhou within a broader area that was rich in historical and cultural connotations. See "Yangzhou," 121–123.

75. Ibid., 147.

76. Ibid., 139. Also see Ping-ti Ho, "The Salt Merchants of Yangzhou," 155–168.

77. Mu Yiqin, "An Introduction to Painting in Yangzhou in the Qing Dynasty," 23.

78. According to the *Qing huajia shishi*, Xiao Chen was the nephew of the famous painter Xiao Yuncong (1596–1673). However, their relation cannot be verified by other biographical records of these two artists. See Li Ruizhi, comp., *Qing huajia shishi*, in QDZJCK, 75:370.

79. Li Dou, *Yangzhou huafang lu*, 126. Also see Dou Zhen, comp., *Guochao shuhuajia bilu*, in QDZJCK, 82:252.

80. See Wang Jun, *Yangzhou huayuan lu*, 1:5b–6a. Also see Sheng Shuqing, comp., *Qingdai huashi zengbian*, in QDZJCK, 78:232.

81. See *Duhua jilue*, in Hong Ye, comp., *Qingdai chuan jiyi sanzhong*, in QDZJCK, 79:257.

82. Xie Kun, *Shuhua sojian lu*, in *Meishu congshu*, comp. Huang and Deng, 76; all subsequent citations are to this edition.

83. Yan Yi's brother, Yue, was also a student of Li Yin. Yet surviving paintings of this artist are lacking. See *Huaren buyi*, in Hong Ye, comp., *Qingdai chuan jiyi sanzhong*, in QDZJCK, 79:317; all subsequent citations are to this edition.

84. Wang Jun, *Yangzhou huayuan lu*, 2:8b–9a.

85. This painting is in the Lushun Museum collection. Published in Zhongguo meishu quanji bianji weiyuanhui, ed., *Qingdai huihua (zhong)*, Zhongguo meishu quanji huihuabian 10 (Shanghai: Shanghai renmin meishu chubanshe, 1992), 103.

86. Ibid., 104.

87. See the detailed studies by James Cahill, by Nie Chongzheng, and by Alfreda Murck. Also see Richard Barnhart's discussion of Yuan Jiang's biography in *Peach Blossom Spring*, 104–118; and Ju-hsi Chou's analysis of the relation between Yuan Jiang and Yuan Yao in *The Elegant Brush*, 117–118.

88. Zhang Geng, *Guochao huazheng xulu*, 99; *Huaren buyi*, in Hong Ye, comp., *Qingdai chuan jiyi sanzhong*, in QDZJCK, 79:316.

89. A small album once appeared in a private auction, which shows an official way of signature to suggest that the work was painted by Yuan Jiang for the emperor. However, the painting style of this album shows little relation to Yuan Jiang. See '95 *Spring Auction of Duo Yun Xuan Ancient Calligraphy and Painting* (June 1995), lot 350.

90. Nie Chongzheng, *Zhongguo huajia congshu*, 5.

91. Barnhart, *Peach Blossom Spring*, 117–118.

92. Guo Weiqu, *Song Yuan Ming Qing shuhuajia nianbiao*, 329.

93. See Ju-hsi Chou, *Heritage of the Brush*, plate 23.

94. See Murck, "Yuan Jiang: Image Maker," 229–231.

95. Cahill's study suggests 1694–1743; see Cahill, "Yuan Chiang and His School," 261, "Yuan Chiang and His School—Part II," 210. Nie's study suggests 1693–1743 (a landscape in the Mi style, dated 1746, is given in his list as the latest dated work of Yuan Jiang but is nevertheless considered an early work of Yuan Yao in the caption; see Nie, *Zhongguo huajia congshu*, 20–25, fig. 19. Barnhart's study suggests 1691–1746 or after; see Barnhart, *Peach Blossom Spring*, 104. Murck's study suggests 1680–1730; see Murck, "Yuan Jiang: Image Maker," 251–259.

96. Barnhart has raised this problem in *Peach Blossom Spring*, 104. Also see Chou's discussion in Chou and Brown, *The Elegant Brush*, 117–118.

97. Chou and Brown, *The Elegant Brush*, 117.

98. According to Cahill,

Perhaps these pictures had best seen not merely as works of an artist long past his prime . . . but rather as those of one who has wasted years of his life in the routine performance of some simple decorative function that required no freshness or sensitivity and now tries to return to his old calling, only to find that he has prostituted his art too long—that the creative act, like the procreative, can be reduced by constant forced repetition to a mechanical and unfelt exercise.

Cahill, "Yuan Chiang and His School—Part II," 210–211.

99. Chou and Brown, *The Elegant Brush*, 118n. 7.

100. See Murck, "Yuan Jiang: Image Maker," 250–259.

101. See Chou, *Heritage of the Brush*, 13.

102. *Huaren buyi*, 79:316.

103. Cited in Yu Jianhua, comp., *Zhongguo meishujia renming cidian*, 762.

104. Barnhart, *Peach Blossom Spring*, 117.

105. For the work of Yuan Mo, see Group for the Authentication of Ancient Works of Chinese Painting and Calligraphy, ed., *Illustrated Catalogue of Selected Works of Ancient Chinese Painting and Calligraphy*, 1:Jing 2-590. For the work of Yuan Xue, ibid., 10:Jin 7-1133. There is also an unpublished landscape painting by Yuan Shao in the Palace Museum collection. I am indebted to Mr. Nie Chongzheng for showing me this painting.

106. Published in Chou and Brown, *The Elegant Brush*, 127–128.

107. See Nanquin and Rawski, *Chinese Society*, 58.

108. Cited in James Cahill, "Yuan Chiang and His School," 269.

109. Ibid.

110. Li Dou, *Yangzhou huafang lu*, 1:8b.

111. See Li Zhichao, "Jiehua de fazhan he jiehua goutu de yanjiu," 67. Also see Qin Zhongwen, "Qingdai chuqi huihua de fazhan," 56.

112. See Thomas H. C. Lee, "Christianity and Chinese Intellectuals," 12.

113. Li Dou, *Yangzhou huafang lu*, 12:2b-3a. English translation cited from Chen Shou-yi, "Chinese Houses and Gardens in Retrospect," 14.

114. This album appeared in an auction held in New York in 1988. See *Fine Chinese Paintings*, lot 72.

115. Li Dou, *Yangzhou huafang lu*, 2:3–5a.

116. Hiroshi Higuchi, *Chugoku hanga shusei*, 5.

Chapter 3: The Qing Imperial Domains

1. Crossley, *A Translucent Mirror*, 39.

2. On the relation between state religion and power legitimization in traditional China, see C. K. Yang, *Religion in Chinese Society*, 127–133.

3. Richard J. Smith, *China's Cultural Heritage*, 155.

4. See Murray Edelman, *The Symbolic Uses of Politics*, 102.

5. The first scroll is in the Palace Museum, Beijing, whereas the second scroll in the Musee Guimet, Paris.

6. *Daqing huidian*, 46:1b–4b and 9a–11a.

7. Ibid.

8. According to the *Daqing huidian*, the emperor is to perform the ceremony of the first plough after his worship at the altar of agriculture. This is to symbolize the beginning of the agricultural year. While conducting the ceremony, the emperor is attended by three high officials: the viceroy of Shuntian carries a box of seed, the Minister of the Board of Revenue waves the whip, and the vice minister of the Board of Revenue sows in the furrow. The emperor ceremonially tills the soil from east to west, pushing off and returning three times to make a furrow. The whole process is to be accompanied by music and hymns. When this is finished, the emperor ascends to the observation platform where he watches the three princes and nine officials, as well as other selected old farmers, finish the task on the field. Ibid., 46:1b–4b.

9. Rawski, *The Last Emperors*, 7.

10. See Crossley, *A Translucent Mirror*, 11.

11. Unlike scrolls 1–11, which show the direction of travel from right to left, scroll 12 displays a reverse direction.

12. See Maxwell Hearn's discussion of the depiction of the Tiger Hill in scroll 7, "The *Kangxi Southern Inspection Tour*," 126–127.

13. *Shengzu Renhuangdi shilu*, in *Qing shilu*, 459–460, entry dated April, twenty-seventh year of the Kangxi reign (1689).

14. Hearn, "The *Kangxi Southern Inspection Tour*," 173.

15. See Edelman, *The Symbolic Uses of Politics*, 96.

16. Any attempt to assess the so-called Western influence in Qing imperial art should as well consider a reverse of the borrowing as a kind of cultural interchange. In the article "Missionary-Artists at the Manchu Court," Loehr concludes that "the influence was one acting in reverse: the Chinese proving the stronger over the European. The missionary-artists in their efforts to gain the goodwill of the emperors, consciously as well as unconsciously adapted themselves to Chinese requirements and standards, when they realized that their European subjects, methods and techniques were not understood or appreciated." See Loehr, "Missionary-Artists," 66. Also see Lothar Ledderose, "Chinese Influence on European Art," 221–250.

17. Crossley, *The Manchus*, 112.

18. See Gugong bowuyuan ed., *Art Treasures from Birthday Celebrations at the Qing Court*.

19. For example, the *Imperial Banquet in the Garden of Ten Thousand Trees* depicts the reception of foreign envoys at a particular scene in this summer palace.

20. Heshen, Liang Guozhi, et al., comps., *Qin ding Rehe zhi*, 25: 9b–10a.

21. The study of English estate portraiture by Stephen Daniels has provided us with interesting results for further comparisons with Qing Chinese estate portraiture. Daniels' study indicates how eighteenth-century Britain was defined by prospects of the principal seats of the nobility and gentry. See Daniels, "Goodly Prospects," 9.

22. See Crossley, *The Manchus*, 103, 125.

23. A Japanese topographical work, *Ama no Hashidate* by Sesshu (1420–1506), also demonstrates

a similar pictorial effect. Sesshu went to China during the mid-Ming period and learned the painting techniques of the Zhe school. His painting suggests that this kind of spherical configuration was adopted as a topographical convention no later than 1506, the year in which Sesshu died.

24. Heshen, Liang, et al., *Qin ding Rehe zhi*, 26:3.

25. On the design and political symbolism of the Summer Palace at Rehe, see Cary Y. Liu, "Ching Dynasty Architectural Design Methodology at the Imperial Summer Villa at Jehol," 389–422.

26. Laura Hostetler, *Qing Colonial Enterprise*, 70–71.

27. Published in *Yuanming cangsang* (Beijing: Wenhua yishu, 1991).

28. Young-tsu Wong, *A Paradise Lost*, 74.

29. Ibid., 75–76.

30. Ibid., 25.

31. Cited in Hope Danby, *The Garden of Perfect Brightness*, 77.

32. Cited in *Yuanming cangsang*, 23.

33. See Wong, *A Paradise Lost*, 29.

34. See Danby, *The Garden of Perfect Brightness*, 49.

35. See Crossley, *A Translucent Mirror*, 37.

36. This does not imply that a more privileged artist would paint first. The ordering might vary, depending on the pictorial structure of a work.

37. The quest for *qishi* in eighteenth-century landscape paintings can be shown in the treatise by Tangdai, *Huishi fawei*; all subsequent citations are to this edition.

38. According to the study by Ju-hsi Chou, the relationship between *kai* and *he* is "one of tense anticipation and reversal whenever and wherever one pole should reach its optimum end." In other words, when the motion of *kai* reaches a limit and comes to rest, *he* rises in turn. When the potential of *he* is fully exhausted, *kai* runs its course again. *Kai* and *he* alternate. They operate in both the smaller parts and the larger part of the whole composition. See Ju-hsi Chou, "The Cycle of *Fang*," 2: 270.

39. This is recorded in *Qingdang*, entry dated 9 January 1736. Cited in Yang Boda, *Qingdai yuanhua*, 111.

40. See Ronald G. Knapp, *China's Vernacular Architecture*, 39–42, 90–91.

41. See Bruno Zevi, *Architecture as Space*, 30. Also see Kevin Lynch, *The Image of the City*.

42. Tang Zhiqi, *Huishi weiyan*, 2:19b–20a.

43. Hearn, "Document and Portrait," 102.

44. The original title of this painting was *Burgeoning Life in the Prosperous Age*. It has been renamed *Prosperous Suzhou* in present-day China. This painting is in the Liaoning Provincial Museum. Published in full in *Qing Xu Yang Gusu fanhua tu* (Hong Kong: Shangwu yinshuguan, 1988).

45. On the conception of space-time in Chinese architecture, see Needham, *Science and Civilization in China*, vol. 4, pt. 3, 77.

46. Henri Stierlin and Michele Pirazzoli-t'Serstevens, eds., *Architecture of the World*, 10.

47. Ibid.

48. See Daniels, "Goodly Prospects," 12.

49. Dong Zuobin (Tung Tso-pin), *Qingming shanghe tu*. Notably, the Yuan date of this scroll is questionable.

50. This scroll is in the National Palace Museum, Taipei.

51. Both paintings are in the National Palace Museum, Taipei.

52. See Hu Jing, *Guochao yuanhua lu*, 1:7b, entry on Zhou Kun. This painting is now in the National Palace Museum, Taipei.

53. Crossley, *A Translucent Mirror*, 223.

54. Ibid., 224.

55. Philip A. Kuhn, *Soulstealers*, 70.

Chapter 4: The Idealized Scheme

1. See Crossley, *The Manchus*, 6.

2. Ibid., 116.

3. Notably, the ladies' pursuits differ across time. See the discussion of the painting *One Hundred Beauties* by Fei Danxu in Ju-hsi Chou, *Scent of Ink*, 132.

4. The tendency to include simple architectural elements to define a physical setting is also shown in a painting by You Qiu (sixteenth century), now in the Shanghai Museum. You Qiu set the story of Zhao Feiyan against a palatial background (see Group for the Authentication of Ancient Works of Chinese Painting and Calligraphy, *Illustrated Catalogue*, 3:Hu 1-1096). The influence of Qiu Ying in the art of You Qiu could be further suggested by the marriage of You Qiu to Qiu Ying's daughter.

5. A painting of the same theme by Lu Huancheng (b. 1630), a Zhejiang artist working outside the court, also indicates a contemporary interest toward representing a Han palace when reinterpreting the theme. Dated 1682, this work is now in the Shanghai Museum. Ibid., 4:Hu 1–2802.

6. For the various reconstructions of Western Han Chang'an, see Wu Hung, *Monumentality in Early Chinese Art and Architecture*, 149–150.

7. Ibid., 148.

8. Ibid.

9. Leng Mei and Ding Guanpeng each painted a version in the style of Qiu Ying. See Guoli gugong bowuyuan bianji weiyuanhui, ed., *Gugong shuhua lu: zeng ding ben*, 2: juan 4, 267; 4: juan 8, 50. The archival records also indicate that Shen Yuan was commanded to paint a version in 1736. In the same year, Chen Mei was asked to paint a scroll in which Tangdai was responsible for depicting mountains and rocks. In 1738 Chen Mei and other *huahuaren* were asked to submit draft versions based on a prototype by Qiu Ying. See *Qingdang*, "Ruyiguan" section, entries dated 9 and 11 January 1736; "Huayuanchu" section, 10 March 1738.

10. *Fu* or rhapsody, a literary form designed to be chanted or recited, should not be confused with the *fu*—which is often mentioned together with *bi* and *xing*—in Mao's commentary of the *Shijing*. See Xu Fuguan, *Zhongguo wenxue lunji*, 353.

11. *Fu* writers might deliberately couch the language in such a way that the reprimands or the didactic purposes were not immediately apparent. See Burton Watson, *Early Chinese Literature*, 254–285.

12. Wu Hung, *Monumentality*, 144.

13. Wang Wenkao, *Lu Lingguang dian fu*, in Xiao Tong, ed., *Wen xuan*, 11:17a. English translation cited from David R. Knechtges, trans., *Wen xuan*, 2:263.

14. Cited from Knechtges, *Wen xuan*, 2:265–267.

15. See the discussion of the Shanglin Park and *Rhapsody on the Shanglin Park* in Wu Hung, *Monumentality*, 175.

16. Cited from Knechtges, *Wen xuan*, 2:269.

17. Wang Gai, *Yuanban yingyin Jieziyuan huazhuan*, 4:16–19.

18. For example, flying galleries—which are commonly found in early *jiehua*—are actually constructed in the "Palace of Harmony and Peace" and the "Garden of Perfect Brightness" (scene 29).

19. This is the idea of "garden within a garden" in Qing imperial garden design. See the Department of Architecture of Tianjin University and Municipal Bureau of Park Administration, Beijing, eds., *The Best Specimens of Imperial Garden of the Qing Dynasty*, 11.

20. Such pictorial conventions reflect the cultural conceptions of time-space in traditional China. See Li-chen Lin, "The Concepts of Time and Space in the *Book of Changes* and Their Development," 92–93.

21. This group of buildings was constructed during the years 1748–1750. The design was probably done no later than 1748, the year in which *Spring Morning in the Han Palace* was completed.

22. Crossley, *The Manchus*, 113–116.

23. Wei Shou, *Wei shu*, 15:1453.

24. Yang Jialuo, ed., *Sanfu huangtu*, 23.

25. Ban Mengjian, *Xidu fu*, in Xiao Tong, ed., *Wen xuan*, 1:18b–19a. English translation cited from Knechtges, *Wen xuan*, 1:135.

Chapter 5: Moving Gardens

1. See the study of mercantile patronage of the arts in seventeenth-century Anhui by Sandi Chin and Cheng-chi Hsu, "Anhui Merchant, Culture and Patronage," 19–24.

2. Li Yu, *Xianqing ouqi*, 6:2431, the section on dwelling.

3. One example is *The Ninth-Day Literary Gathering at Xing'an* painted jointly by Fang Shishu (1692–1751) and Ye Fanglin (active late seventeenth–early eighteenth century), which records a literary gathering held in the estate of Ma Yueguan and Ma Yuelu. This painting is now in the Cleveland Museum of Art. For a detailed study of this painting, see *Eight Dynasties of Chinese Painting*, 373–376.

4. See Richard Vinograd, *Boundaries of the Self*, 11–13.

5. Wu Hung, *The Double Screen*, 18.

6. See the study of Chinese portraits in Vinograd, *Boundaries of the Self*, 1.

7. Ibid., 13–14.

8. See Ake Danga, comp., *Chongxiu Yangzhou fuzhi*, 6:1967–1970. Also refer to Bian Xiaoxuan, "Yuan Jiang *Dongyuan tu* kao," 70–72, 54; and Guo Junlun, comp., *Qingdai yuanlin tulu*, 122–125, for a list of the writings on the East Garden.

9. See Ake Danga, *Chongxiu Yangzhou fuzhi*, 6:1969.

10. This line is taken from the ode *Huangyi* in the *Shijing*, which gives an account of the rise of the Zhou dynasty and of the achievements of King Tai, King Ji, and King Wen. King Tai is said to have "opened up and cleared the tamarisk trees and the stave trees," which means clearing the land for dynastic development. See *Shijing jinzhu*, 388. English translation by James Legge, in *The Sacred Books of China*, 3:389.

11. Zhang Yunzhang, *Yangzhou Dongyuan ji*, cited in Guo Junlun, comp., *Qingdai yuanlin tulu*, 122–123.

12. See George Rowley, *Principles of Chinese Paintings*, 64.

13. Published in He Ruyu, ed., *Masters of Landscape Painting*, fig. 4.

14. Published in Alfreda Murck and Wen Fong, *A Chinese Garden Court*, 28–29. Also see Barnhart, *Peach Blossom Spring*, 116–117. My thanks to Dr. Maxwell Hearn for showing me this painting.

15. See Nie Chongzheng, "Chonglou diege, xuhuan piaomiao," 9.

16. See Guo Junlun, *Qingdai yuanlin tulu*, 122.

17. Xie Kun, *Shuhua sojian lu*, 92.

18. If Yuan Jiang achieved an "antique" flavor in *jiehua* because of his emphasis on linear brushwork, then we may also praise Li Yin and Yan Yi for a similar achievement. Li Yin, Yan Yi, and Yuan Jiang all used heavy ink lines to produce firm contours of architectural images.

19. Wang Shizhen, *Dongyuan ji*, cited in Ake Danga, comp. *Chongxiu Yangzhou fuzhi*, 6:1967.

20. Wang Shizhen was referring to his early career in Yangzhou. He was given the position of police magistrate of Yangzhou in 1659, and he assumed that office in the following year. In this capacity he served for five years from 1660 to 1665. See his biography in Hummel, *Eminent Chinese*, 831.

21. Wang Shizhen called himself "the former official" because he was deprived of all his ranks and offices after a mistrial during his office in the Board of Punishment. He was then seventy-one *sui*. Although he remained in office, he took the opportunity to retire, living quietly at his hometown for the remaining years of his life. Half a year before his death, his formal titles were restored by special decree. Ibid., 832.

22. Wang Shizhen, *Dongyuan ji*, cited in Ake Danga, comp. *Chongxiu Yangzhou fuzhi*, 6:1968.

23. Song Lao, *Dongyuan ji*, ibid.

24. Since 1692, Song Lao had served as governor of Jiangsu, a position that he held for fourteen years. In 1705 he took up the presidency of the Board of Civil Office and then retired after three years of service. After retirement, he built the Old Garden of the Western Slope in his native place Henan. See his biography in Hummel, *Eminent Chinese*, 689.

25. Song Lao, *Dongyuan ji*, cited in Ake Danga, comp. *Chongxiu Yangzhou fuzhi*, 6:1968.

26. For the distinction between "picture" *(tu)* and "painting" *(hua)* and the implications on their different values and meanings, see James Cahill, "Types of Artist-Patron Transactions in Chinese Painting," in *Artists and Patrons*, ed. Chu-tsing Li et al., 8–10.

27. In the Beijing Library, there is an original catalogue of the fans and albums collected by the Zheng family who owned the Garden of Reflection. Compiled by the famous scholar Weng Fanggang (1733–1818), this catalogue includes Yuan Jiang's painting. This confirms that his work was once collected by an elite family. The Garden of Reflection was originally commissioned by Zheng Yuanxun and designed by the famous garden designer Ji Cheng in 1643.

28. This may be compared to another occasion where an artist depicted a garden without actually seeing or visiting the site. See Ju-hsi Chou and Claudia Brown, *Transcending Turmoil*, 70–71, on the rendering of *The Scenes of Yan Garden* by Qian Du (1763–1844).

29. See Naquin and Rawski, *Chinese Society*, 123–127.

30. Li Dou, *Yangzhou huafang lu*, 13:29a.

31. Ibid., 13:21a.

32. See Nie Chongzheng, "Yangzhou huajia Yuan Jiang Yuan Yao he Shanxi yanshang," 70–71.

33. Published in Nie Chongzheng, *Yuan Jiang, Yuan Yao*, 14–15, 28–29.

Chapter 6: Transmitting History and Myth

1. There is no implication that "spring morning in the Han palace" was the only historical theme produced in the court academy. Court *jiehua* artists also adopted the themes "going up the river on the Qingming Festival" and "new Feng."

2. Examples included *Spring Morning in the Han Palace* of 1767 and *Autumn Moon in the Han Palace* of 1775. Both works were painted by Yuan Yao, now in the Palace Museum. See Nie Chongzheng, *Yuan Jiang, Yuan Yao*, 22–23.

3. Qing people were probably aware of this piece of writing, as the stele was recorded by Gu Yanwu (1613–1682) in *Jinshi wenzi ji*, 3:26a.

4. *Ren* is an ancient measure of length that is equal to seven or eight *chi*.

5. *Ouyang Xun shufa quanji*, 40–72.

6. English translation cited from Stephen Owen, ed. and trans., *An Anthology of Chinese Literature*, 452.

7. Ge Hong, *Xijing zaji*, 15.

8. English translation by Elling Eide, in Victor H. Mair, ed., *The Columbia Anthology of Traditional Chinese Literature*, 302.

9. One of Yuan Yao's album leaves, now in the Phoenix Art Museum, shows a focused treatment of human figures in the Deep Fragrance Pavilion. Here, the figures are the key elements for identifying the architecture. See Chou and Brown, *The Elegant Brush*, 120.

10. As Barnhart has observed, "At least two of his [Yuan Jiang's] typical paintings, one in the Palace Museum, Peking, and one in the National Arts Gallery, Peking, bear exactly the same date. . . . Presumably they were both finished and signed on that day, not done from start to finish; still this is a telling fact. Again in the Palace Museum, Peking, are two sets of twelve-panel compositions like the Metropolitan Museum's *Jiucheng Palace* [The Palace of Nine Perfections]. They were both painted in 1723." See Barnhart, *Peach Blossom Spring*, 117.

11. See Group for the Authentication of Ancient Works of Chinese Painting and Calligraphy, *Illustrated Catalogue*, 5:160–163, Hu 1-3515 and Hu 1-3516.

12. Liu Xu et al., *Jiu Tang shu*, 85:9594.

13. See Zhongguo meishu quanji bianji weiyuanhui, ed. *Qingdai huihua (zhong)*, 60.

14. See the carved lacquer dish from the Palace Museum, published in Derek Clifford, *Chinese Carved Lacquer*, 89. The architectural design, the drastic twisting and turning of the tree branches, the patterns on the trunk of the old pine, and the overall visual excitement on this dish suggest a date no earlier than the seventeenth century.

15. See *Ming Qing zaju banhua ji*.

16. See the map of the imperial city published in Fu Zehong, *Xingshui jinjian*. Also see *The Library of Philip Robinson: Part II, The Chinese Collection* (London: Sotheby's, November 1988), lot 107.

17. See Yang Yongyuan, *Shengqing taige jiehua shanshui zhi yanjiu*, 94–95. Also see Murck, "Yuan

Jiang: Image Maker," 245. According to Murck, "What Yuan Jiang added to Li Yin's formula was a more realistic handling of space adapted from Western techniques. From his earliest works, a form of converging perspective can be found in Yuan Jiang's paintings, gracefully integrated with traditional approaches." Barnhart also mentions Yuan Jiang's "expert use of perspective" in *Peach Blossom Spring*, 112.

18. Xu Hun, *Xianyang cheng donglou shi*. English translation cited from Xu Yangzhong, trans., *Songs of the Immortals*, 134–135.

19. Cen Shen, *Shanfang chunshi*. English translation cited from Shih Shun Liu, *One Hundred and One Chinese Poems*, 61.

20. Wang Kaiyun, *Yingshan caotang ming*, in Gao Ming, Zhu Xiuxia, and Yuan Shuainan, eds. *Qing wenhui*, 466.

21. See Murck, "Yuan Jiang: Image Maker," 233–236.

22. See David Lowenthal, *The Past Is a Foreign Country*, 36–52.

23. Sima Qian, *Shi ji*, 1:542.

24. Wang Jia, *Shiyi ji yizhu*, 23.

25. Kiyohiko Munakata, *Sacred Mountains in Chinese Art*, 9.

26. The mineral colors of blue and green, along with cinnabar, were the key ingredients in certain elixirs of immortality. For the use of various materials in Chinese alchemy, see Peng Yoke Ho, *Li, Qi and Shu*, 182, 189.

27. On the fantastic mode of landscape construction by Li Yin and Yuan Jiang, see Cahill, "Yuan Chiang and His School," and "Yuan Chiang and His School — Part II."

28. One may refer to the thoughts of such Qing thinkers as Huang Zongxi (1610–1695), Fang Yizhi (1611–1671), Wang Fuzhi, Yan Yuan (1635–1704), Li Gong (1659–1733), and Dai Zhen (1724–1777).

29. The Qing idea of the primacy of *qi* was very different from the Song cosmological view. The great Song Neo-Confucianist Zhu Xi (1130–1200) stressed that *qi* followed the existence of *li*.

30. Wang Yuanqi, *Yuchang manbi*, 16–17. On how the works of the Orthodox landscape painters express the Qing cosmological view, see Ju-hsi Chou, "In Defence of Qing Orthodoxy," 39.

31. Chou and Brown, *The Elegant Brush*, 118.

32. One example is the album leaf *Palaces of the Immortals* in *Album of Figures, Landscapes and Architecture* of 1740, now in the Phoenix Art Museum. See Chou and Brown, *The Elegant Brush*, 118.

33. Li Dou, *Yangzhou huafang lu*, 15:1b–2a.

34. One may refer to Li Yin's *Architecture in the Style of Song Masters* in the Guangdong Provincial Museum, Yuan Jiang's *Waterside Palace in Spring* in the Shanghai Museum, as well as one of Yuan Yao's album leaves, *Autumn Moon over Dew Terrace*, in the Phoenix Art Museum.

35. English translation cited from Ji Cheng, *Yuan ye*, 107.

36. Munakata, *Sacred Mountains*, 130.

37. In his study of the intellectual climate of Yangzhou in the Qianlong period, Frederick Mote has pointed out that Yangzhou salt merchants were indeed controlled by the Qing government under a combination of "enticements and intimidations." The Qing policy of diverting the interests of these merchants towards gentry ideals and status in officialdom also made the self-identification of this group become ambiguous. Consequently, there were feelings of unease and insecurity among the merchant class. See Frederick Mote, "The Intellectual Climate in Eighteenth-Century China," 36–37.

Chapter 7: Conclusion

1. Hu Tianyou, *Zhendong ge ming*, in Gao, Zhu, and Yuan, eds., *Qing wenhui*, 421.
2. See *Inscribed Landscapes*.
3. Mote, "The Intellectual Climate," 26.
4. Ibid., 27–28.
5. *Inscribed Landscapes*, 56.
6. Ibid.
7. This idea culminated in the thought of Dai Zhen. See Hummel, *Eminent Chinese*, 698.
8. Zou, *Xiaoshan huapu*, 806. English translation cited from Kao, "European Influences in Chinese Art," 273.
9. Xie Kun, *Shuhua sojian lu*, 92.

Glossary

Afang Gong 阿房宮
An (Prince) 安(親王)
An Zhengwen 安正文
Bao (Prince) 寶(親王)
Beihai 北海
Beijing 北京
Bianjing 汴京
Bieyou dongtian 別有洞天
Bishu shanzhuang 避暑山莊
Bo (Sea) 渤(海)
boshan 博山
cai 材
canzhen 參鎮
Cao Kuiyin 曹夔音
Cao Yin 曹寅
Cen Shen 岑參
Chang 閶
Chang'an 長安
Changbaishan 長白山
Changshu 常熟
chen 臣
Chen Mei 陳枚
Cheng Zhidao 程志道
Chengguang dian 承光殿
Chengshi moyuan 程氏墨苑
Chenxiang ting 沉香亭
chi 呎
Chongwen men 崇陽門
cuanjian 攢尖

cun 吋
Dai Hong 戴洪
Daqing huidian 大清會典
Daqing men 大清門
dasi 大祀
Ding Guanpeng 丁觀鵬
Dong Bangda 董邦達
Dong Qichang 董其昌
Dong Yuan 董源
Dong Zuobin (Tung Tso-pin) 董作賓
dongtian 洞天
dou 斗
dougong 斗拱
Du Mu 杜牧
Dunhuang 敦煌
fanghu 方壺
Fanghu shengjing 方壺勝境
Fangzhang 方丈
Fanshi 繁峙
fen 分
Feng (gate) 尌
Feng (historical city) 豐
fengshui 風水
Fenxi ting 分喜亭
fu 賦
fugu 復古
Gao Bing 高秉

Gao Qipei 高其佩
Gaozu (Han emperor) 高祖
Ge Hong 葛洪
gong (craftsmanship) 工
gong (bracket) 拱
gongshi 宮室
gou 勾
Guangdong 廣東
Guangling 廣陵
Guo Huaqing gong jueju sanshou 過華清宮絕句三首
Guo Junlun 郭俊綸
Guo Ruoxu 郭若虛
Guo Weiqu 郭味蕖
Guo Xi 郭熙
Guo Zhongshu 郭忠恕
Guochao yuanhua lu 國朝院畫錄
haixifa 海西法
Hangzhou 杭州
Hanjian 汗簡
Hanlin 翰林
hao 毫
he (gather, close) 合
He (surname) 賀
He (Mount) 和(山)
He Junzhao 賀君昭
Hebei 河北

Hechang 鶴廠

Heilongjiang 黑龍江

Henan 河南

Heng (Mount) 橫(山)

Hongli 弘曆

Hu Jing 胡敬

hu 壺

hua 畫

huagao 畫稿

huahuaren 畫畫人

Hualun 畫論

Huan (name) 煥

Huang Yingchen 黃應諶

Huapin 畫品

Huaqing gong 華清宮

Huaren buyi 畫人補遺

Huayuanchu 畫院處

Huazuo 畫作

Huishi weiyan 繪事微言

Huqiu 虎丘

Huzhou 湖州

Jiang Tingxi 蔣廷錫

Jiangbei 江北

Jiangdu 江都

Jiangnan 江南

Jiangsu 江蘇

Jianzhang gong 建章宮

Jiao Bingzhen 焦秉貞

Jiaozhou 膠州

jie 界

jiebi 界筆

jiehua 界畫

Jiehua tezhan 界畫特展

Jieziyuan huazhuan 芥子園畫傳

Jilin 吉林

jin (submit) 進

Jin (dynasty) 金

Jin Kun 金昆

Jin Tingbiao 金廷標

Jingdezhen 景德鎮

Jinling 金陵

Jinming 金明

Jishan lou 几山樓

Jiu Tang shu 舊唐書

Jiucheng gong 九成宮

Jiujiang 九江

Jiuzhou qingyan 九洲清晏

juanpeng 捲棚

juren 舉人

kai 開

Kaifeng 開封

kaihe 開合

Kang (Prince) 康(親王)

Kangxi 康熙

Kaojong ji 考工記

Lang Shining 郎世寧

Leng Mei 冷枚

li (unit of length = a third of a millimeter) 厘

li (unit of length = half a kilometer) 里

li (principle) 理

Li (Mount) 驪(山)

Li Bo 李勃

Li Cheng 李成

Li Dou 李斗

Li Gonglin 李公麟

Li Jie 李誡

Li Rongjin 李容瑾

Li Shizhuo 李世倬

Li Sixun 李思訓

Li Yin 李寅

Li Yu 李漁

Li Zhaodao 李昭道

Li Zhi 李廌

Li Zicheng 李自成

Liang 梁

Liang Sicheng (Liang Ssu-cheng) 梁思成

Lianghuai 兩淮

Liaoning 遼寧

Lidai minghua ji 歷代名畫記

lidian 離點

Lingyan (Mount) 靈巖(山)

lingzhi 靈芝

Lintong 臨潼

Liu Daochun 劉道醇

Liu Wentong 劉文通

Liu Wu 劉武

Liu Yu 劉餘

longmo 龍脈

Longxing (temple) 隆興(寺)

louge 樓閣

Louxian 婁縣

Lu Lingguang dian fu 魯靈光殿賦

Lu 魯

Lu Zhan 盧湛

lutai 露台

Luyangwan 綠楊灣

Luye tang 綠野堂

Ma Guoxian 馬國賢

Ma Yueguan 馬曰琯

Ma Yuelu 馬曰璐

Mei Cheng 枚乘

Meng Yongguang 孟永光

Mengxi bitan 夢溪筆談

Mi Fu 米芾

Ming 明

Minghua lu 明畫錄

Mogao 莫高

Mudu 木瀆

Mujing 木經

Nancun chuogeng lu 南村輟耕錄

nanjiang 南匠

Nanjing 南京

Nian Xiyao 年希堯

Nie Chongzheng 聶崇正

Niu 牛

Nu 女

Ouyang Xun 歐陽詢

Pan 盤

Panshan 盤山

Pei Du 裴度

Peixi 佩觿

Pengdao yaotai 蓬島瑤台

penghu 蓬壺
Penglai 蓬萊
qi (adjoining block) 契
qi (energy) 氣
Qi (state) 齊
Qian Weichang 錢維成
Qian Xuan 錢選
qianhu 千戶
Qianlong 乾隆
Qianqiu ting 千秋亭
Qiantang 錢塘
Qiao Yu (Yizhai) 喬豫(逸齋)
qifu 起伏
Qiju tang 其椐堂
Qin 秦
Qin Jianquan 秦澗泉
Qing 清
Qingdang 清檔
Qinghua shiyi 清畫拾遺
Qingming 清明
Qingpingdiao 清平調
Qinian dian 祈年殿
Qinzheng qinxian 勤政
　親賢
qishi 氣勢
Qiu Ying 仇英
Quzi (lunar palace) 娵訾
Rehe 熱河
Renzong (Yuan emperor)
　仁宗
Ruyiguan 如意館
Shaanxi 陝西
Shandong 山東
Shang 商
Shangfang (Mount) 上方(山)
shangfen 上分
Shanghai 上海
shangshu 尚書
Shantang 山塘
Shanxi 山西
Shen Kuo 沈括
Shen Yu 沈喻
Shen Yuan 沈源

Shengchao minghua ping
　聖朝名畫評
Shengming tai 神明台
shengshi 盛世
Shengzu 聖祖
shenyuan toukong 深遠透空
Shi (Lake) 石(湖)
Shi (lunar mansion) 室
Shi Rui 石銳
Shijing 詩經
Shiqu baoji 石渠寶笈
Shiqu baoji sanbian 石渠寶
　笈三編
Shiqu baoji xubian 石渠寶
　笈續編
Shixue 視學
Shixue jingyun 視學精蘊
Shiyi ji 拾遺記
Shizhuang 石莊
Shu 蜀
Shuhua sojian lu 書畫所
　見錄
Shuhuafang 書畫舫
Shuntian 順天
Shunzhi 順治
Sima Xiangru 司馬相如
Song 宋
Song Lao 宋犖
Song Yuan Ming Qing
　shuhuajia nianbiao 宋元
　明清書畫家年表
Songjiang 松江
su 俗
sui (years) 歲
Sui (dynasty) 隋
Sun Hu 孫祐
Suzhou 蘇州
Tai (lake) 太(湖)
Taihe dian 太和殿
Taihe men 太和門
Taiyuan 太原
Taizong (Song emperor)
　太宗

Tan Song 譚嵩
Tang 唐
Tang Hou 湯垕
Tang Zhiqi 唐志契
Tangchao minghua lu 唐朝
　名畫錄
Tangdai 唐岱
Tao Zongyi 陶宗儀
Teng 滕
ti 體
Tianan men 天安門
Tianjin 天津
Tiantai 天台
toudian 頭點
tu 圖
Tuhua jianwen zhi 圖畫見
　聞志
Wai bamiao 外八廟
Wai Yangxin dian 外養心殿
Wanchun ting 萬春亭
Wanfu ge 萬福閣
Wang Dao 王道
Wang Gai 王概
Wang Guocai 王國材
Wang Hui 王翬
Wang Kaiyun 王闓運
Wang Kui 王逵
Wang Shiyuan 王士元
Wang Shizhen (Ruanting)
　王士禎(阮亭)
Wang Yanshou 王延壽
Wang Youxue 王幼學
Wang Yuanqi 王原祁
Wang Yun (Hanzao) 王雲
　(漢藻)
Wang Zhenpeng 王振鵬
Wang Zhicheng 王致誠
Wei (lunar mansion) 危
Wei (state) 魏
Wei Xian 衛賢
Weiwang (lord of Qi) 威王
Wenquan gong 溫泉宮
Wenzhou 溫州

Wu Daozi　吳道子

Wu Gui　吳桂

Wu men　午門

Wu Sangui　吳三桂

Wucheng　烏程

wudian　廡殿

wumu　屋木

Wuxian　吳縣

wuxing　五行

Xia　夏

xiafen　下分

Xiangshan　香山

Xiannong　先農

Xianqing ouqi　閑情偶寄

xianren cheng lupan　仙人承
露盤

Xianzong (Ming emperor)
憲宗

Xiao Chen　蕭晨

xiaosi　小祀

Xiaowang (lord of Liang)
孝王

Xichi yinshe　西池吟社

Xidu fu　西都賦

Xie Kun　謝堃

Xie Sui　謝遂

xieshan　歇山

Xijing zaji　西京雜記

Xinjiang　新疆

xinmiao　辛卯

Xinting xuan　心聽軒

Xishu　西墅

Xu　胥

Xu Da　徐達

Xu Hun　許渾

Xu Qin　徐沁

Xu Yang　徐揚

Xuande　宣德

Xuanhe huapu　宣和畫譜

xuanshan　懸山

Xuanwang (lord of Qi)　宣王

Xuanzong (Ming emperor)
宣宗

Xuanzong (Tang emperor)
玄宗

Xunyang　潯陽

ya　雅

Yan　燕

Yan Yanlai　殷彥來

Yan Yi　顏嶧

Yang Dazhang　楊大章

Yang Guifei　楊貴妃

Yangxin Dian　養心殿

Yangzhou huafang lu　揚州
畫舫錄

Yangzhou　揚州

Yangzi (River)　揚子(江)

Yanshan (temple)　巖山(寺)

Yansui ge　延綏閣

Yantai　燕台

Yao Wenhan　姚文瀚

Yemaotai　葉茂台

Yide (Prince)　懿德(太子)

yinghu　瀛壺

yingshan　硬山

Yingshan caotang ming
影山草堂銘

Yingzao fashi　營造法式

Yingzhou　瀛州

yinyang　陰陽

Yinzhen　胤禎

yixie baisui　一斜百隨

yiqu baixie　一去百斜

yong (operation)　用

Yong (name)　雍

Yongding men　永定門

Yonghe gong　雍和宮

Yongkang ge　永康閣

Yongzheng　雍正

Yu　禹

Yu Hao　喻晧

Yu Xing　余省

Yu'an　漁庵

Yuan (dynasty)　元

Yuan (surname)　袁

Yuan Jiang　袁江

Yuan Jue　袁桷

Yuan mifu　元秘府

Yuan Mo　袁模

Yuan Shao　袁杓

Yuan Xue　袁雪

Yuan Yao (Zhaodao)　袁耀
(昭道)

Yuan ye　園冶

yuanjin gaoxia　遠近高下

Yuanming Yuan　圓明園

Yuanxiao　元枵

Yueyang (Tower)　岳陽(樓)

Yuhua ge　雨花閣

*Yuzhi Yuanming yuan sishijing
shi bing tu*　御製圓明園四
十景詩並圖

Zaobanchu　造辦處

*Zaobanchu gezuocheng huoji
Qingdang*　造辦處各作成活
計清檔

Zengxiu Ganquan xianzhi
增修甘泉縣志

Zha Shibao　查士標

zhang　丈

Zhang Gao　張鎬

Zhang Geng　張庚

Zhang Ruocheng　張若澄

Zhang Tingyan　張廷彥

Zhang Weibang　張為邦

Zhang Yanyuan　張彥遠

Zhang Yunzhang (Hanzhan)
張雲章(漢瞻)

Zhang Zeduan　張擇端

Zhanyuan　瞻園

Zhao Mengfu　趙孟頫

Zhao Zhongyi　趙忠義

Zhaowang (lord of Yan)
昭王

Zhejiang　浙江

zheng　徵

Zhengdai Guangming　正大
光明

Zhengding　正定

Zhengyang men　正陽門

Zhengzhi dian　正智殿

Zhenzong (Song emperor)　真宗

zhesuan wukui　折算無虧

zhichi　直尺

Zhijing yunti　芝逕雲隄

Zhitou huashuo　指頭畫說

zhongbang　中邦

zhongfen　中分

zhongsi　中祀

Zhou　周

Zhou Kun　周鯤

Zhu Jingxuan　朱景玄

Zhu Pao　朱珌

Zhuangzi　莊子

zhuo (technical awkwardness)　拙

zhuo (hacking)　斫

Zou Yan　騶衍

Zou Yigui　鄒一桂

zuo　作

Bibliography

Acker, William R. B. *Some T'ang and Pre-T'ang Texts on Chinese Painting*. Leiden: E. J. Brill, 1954.

Ake Danga 阿克當阿, comp. *Chongxiu Yangzhou fuzhi* 重修揚州府志. 1810. Reprint. Taipei: Chengwen chubanshe, 1974.

Barnhart, Richard M. *Painters of the Great Ming: The Imperial Court and the Zhe School*. Dallas, Tex.: Dallas Museum of Art, 1993.

———. *Peach Blossom Spring: Gardens and Flowers in Chinese Paintings*. New York: Metropolitan Museum of Art, 1983.

Bian, Xiaoxuan 卞孝萱. "Yuan Jiang Dongyuan tu kao 袁江東園圖考." *Wenwu* 文物 210, no. 11 (1973): 70–72, 54.

Budde, Hendrik; Christoph Muller-Hofstede; and Gereon Sievernich. *Europa und die Kaiser von China*. Frankfurt am Main: Insel Verlag, 1985. Cambridge: Harvard University Press, 1985.

Bush, Susan, and Hsio-yen Shih. *Early Chinese Texts on Painting*. Cambridge: Harvard University Press, 1985.

Cahill, James. "A Correction." *Ars Orientalis* 7 (1968): 179.

———. *An Index of Early Chinese Painters and Paintings*. Berkeley: University of California Press, 1980.

———. "Types of Artist-Patron Transactions in Chinese Painting." In *Artists and Patrons: Some Social and Economic Aspects of Chinese Painting*, ed. Chu-tsing Li, James Cahill, and Wai-kam Ho, 7–20. Lawrence, Kan.: Kress Foundation Department of Art History, University of Kansas; Kansas City: The Nelson-Atkins Museum of Art, 1989.

———. "Yuan Chiang and His School." *Ars Orientalis* 5 (1963): 259–272.

———. "Yuan Chiang and His School—Part II." *Ars Orientalis* 6 (1966): 191–212.

Chai, Zejun 柴澤俊, and Zhang Chouliang 張丑良, eds. *Fanshi Yanshan si* 繁峙巖山寺. Beijing: Wenwu chubanshe, 1990.

Chen, Mingda 陳明達. *Yingzao fashi damuzuo yanjiu* 營造法式大木作制度研究. 2 vols. Beijing: Wenwu chubanshe, 1981.

Chen, Shouqi 陳壽祺, et al., comps. *Fujian tongzhi* 福建通志. 1871. Reprint. Taipei: Chengwen chubanshe, 1968.

Chen, Shou-yi. "Chinese Houses and Gardens in Retrospect." In *Chinese Houses and Gardens*, ed. Henry Inn and Shao-chung Lee, 3–16. 1940. Reprint. Taipei: SMC Publishing, 1990.

Chin, Sandi, and Cheng-chi Hsu. "Anhui Merchant Culture and Patronage." In *Shadows of Mt. Huang: Chinese Painting and Printing of the Anhui School*, ed. James Cahill, 19–24. Berkeley, Calif.: University Art Museum, 1981.

Chou, Ju-hsi. "The Cycle of *Fang*: Tung Ch'i-Ch'ang Mimetic Cult and Its Legacy." In *Wenlin: Studies in the Chinese Humanities*, ed. Tse-tsung Chow, 2:243–276. Madison: The Department of East Asian Language and Literature, The University of Wisconsin; Hong Kong: Institute of Chinese Studies, The Chinese University of Hong Kong, 1989.

_____. *Heritage of the Brush: The Roy and Marilyn Papp Collection of Chinese Painting*. Phoenix: Phoenix Art Museum, 1991.

_____. "In Defence of Qing Orthodoxy." In *The Jade Studio: Masterpieces of Ming and Qing Painting and Calligraphy from the Wong Nan-ping Collection*, 35–42. New Haven, Conn.: Yale University Art Gallery, 1994.

_____. *Scent of Ink: The Roy and Marilyn Papp Collection of Chinese Painting*. Phoenix: Phoenix Art Museum, 1994.

Chou, Ju-hsi, and Claudia Brown, eds. *The Elegant Brush: Chinese Painting under the Qianlong Emperor*. Phoenix, Ariz.: Phoenix Art Museum, 1985.

_____. *Transcending Turmoil: Painting at the Close of China's Empire, 1796–1911*. Phoenix, Ariz.: Phoenix Art Museum, 1992.

Clifford, Derek. *Chinese Carved Lacquer*. London: Bamboo Publishing, 1992.

Clunas, Craig. *Superfluous Things: Material Culture and Social Status in Early Modern China*. Urbana: University of Illinois Press, 1991.

Crossley, Pamela Kyle. *A Translucent Mirror: History and Identity in Qing Imperial Ideology*. Berkeley: University of California Press, 2002.

_____. *The Manchus*. Oxford and Malden, Mass.: Blackwell Publishers, 2002.

Danby, Hope. *The Garden of Perfect Brightness: The History of the Yuan Ming Yuan and of the Emperors Who Lived There*. London: Henry Regnery, 1950.

Daniels, Stephen. "Goodly Prospects: English Estate Portraiture, 1670–1730." In *Mapping the Landscape: Essays on Art and Cartography*, ed. Nicholas Alfrey and Stephen Daniels, 9–12. Nottingham: University Art Gallery, University of Nottingham, and Castle Museum, 1990.

Daqing huidian 大清會典. 1764. Reprint. N.p., n.d.

The Department of Architecture of Tianjin University and Municipal Bureau of Park Administration, Beijing, eds. *The Best Specimens of Imperial Garden of the Qing Dynasty*. Tianjin: Tianjin daxue chubanshe, 1990.

Dong, Zuobin (Tung Tso-pin) 董作賓. *Qingming shanghe tu* 清明上河圖. Taipei: Dailu zazhi, 1954.

Edelman, Murray. *The Symbolic Uses of Politics*. Urbana: University of Illinois Press, 1964.

Eight Dynasties of Chinese Painting: The Collection of the Nelson Gallery–Atkins Museum, Kansas City, and The Cleveland Museum of Art. Cleveland: The Cleveland Museum of Art, 1980.

Evans, Grant, and Maria Siu-Mi Tam, eds. *Hong Kong: The Anthropology of a Chinese Metropolis*. Richmond: Curzon Press, 1997.

Feuchtwang, Stephan. *An Anthropological Analysis of Chinese Geomancy*. Vientiane: Vithagna, 1974.

Fine Chinese Paintings. New York: Sotheby's, June 1988.

Finnane, Antonia. "Yangzhou: A Central Place in the Qing Empire." In *Cities of Jiangnan in Late Imperial China*, ed. Linda Cooke Johnson, 117–149. Albany: State University of New York Press, 1993.

Fong, Wen C. "Archaism as a 'Primitive' Style." In *Artists and Traditions: Uses of the Past in Chinese Culture*, ed. Christian F. Murck, 89–109. Princeton, N.J.: The Art Museum, Princeton University, 1976.

Fu, Xinian 傅熹年. "Guanyu Zhan Ziqian *Youchun tu* niandai de tantao 關於游春圖年代的探討." *Wenwu* 文物, no. 11 (1978): 40–52.

————. "Survey: Chinese Traditional Architecture." Trans. Virginia Weng. In *Chinese Traditional Architecture*, ed. Nancy Shatzman Steinhardt, 10–31. New York: China Institute in America, China House Gallery, 1984.

————. "Zhongguo gudai di jianzhuhua 中國古代的建築畫." *Wenwu* 文物, no. 3 (1998): 75–94.

Fu, Zehong 傅澤洪. *Xingshui jinjian* 行水金鑑. 1725. Reprint. Taipei: Taiwan Shangwu yinshuguan, 1984.

Gao, Bing 高秉. *Zhitou huashuo* 指頭畫説. In *Meishu congshu* 美術叢書, comp. Huang Binhong 黃賓虹 and Deng Shi 鄧實. Rev. ed. Shanghai: Shenzhou guoguang she, 1947.

Gao, Ming 高明; Zhu Xiuxia 祝秀俠; and Yuan Shuainan 袁帥南, eds. *Qing wenhui* 清文彙. Taipei: Zhonghua congshu weiyuanhui, 1960.

Ge, Hong 葛洪. *Xijing zaji* 西京雜記. Published with an additional book *Yandanzi* 燕丹子. Beijing: Zhonghua shuju, 1985.

Geertz, Clifford. *Local Knowledge: Further Essays in Interpretive Anthropology*. New York: Basic Books, 1983.

Giles, Herbert A. *An Introduction to the History of Chinese Pictorial Art*. Shanghai: Kelly and Walsh, 1918.

Glahn, Else. "Palaces and Paintings in Sung." In *Chinese Painting and the Decorative Style*, ed. Margaret Medley, 39–57. Colloquies on Art and Archaeology in Asia, no. 5. London: Percival David Foundation of Chinese Art, School of Oriental and African Studies, University of London, 1975.

————. "Unfolding the Chinese Building Standards: Research on the *Yingzao fashi*." In *Chinese Traditional Architecture*, ed. Nancy Shatzman Steinhardt, 47–58. New York: China Institute in America, China House Gallery, 1984.

Gombrich, E. H. *Art and Illusion: A Study in the Psychology of Pictorial Representation*. London: Phaidon Press; New York: Pantheon Books, 1960.

Group for the Authentication of Ancient Works of Chinese Painting and Calligraphy, ed. *Illustrated Catalogue of Selected Works of Ancient Chinese Painting and Calligraphy*. Beijing: The Cultural Relics Publishing House, 1986–.

Gu, Yanwu 顧炎武. *Jinshi wenzi ji* 金石文字記. N.p., n.d.

Gugong bowuyuan 故宮博物院 (Palace Museum), ed. *Art Treasures from Birthday Celebrations at the Qing Court*. Hong Kong: Chinese Arts and Crafts, n.d.

_____. *Mingdai gongting yu Zhepai huihua xuanji* 明代宮廷與浙派繪畫選集. Beijing: Wenwu chubanshe, 1983.

_____. *Qingdai gongting huihua* 清代宮廷繪畫. Beijing: Wenwu chubanshe, 1992.

Guo, Junlun 郭俊綸, comp. *Qingdai yuanlin tulu* 清代園林圖錄. Shanghai: Shanghai renmin meishu chubanshe, 1993.

Guo, Ruoxu 郭若虛. *Tuhua jianwen zhi* 圖畫見聞志. In *Huashi congshu* 畫史叢書, ed. Yu Anlan 于安瀾. Taipei: Wenshizhe chubanshe, 1974.

Guo, Weiqu 郭味蕖. *Song Yuan Ming Qing shuhuajia nianbiao* 宋元明清書畫家年表. Taipei: Wenshizhe chubanshe, 1988.

Guo, Zhengyi 郭正域. *Pidian Kaogong ji* 批點考工記. N.p., n.d.

Guoli gugong bowuyuan bianji weiyuanhui 國立故宮博物院編輯委員會, ed. *Gugong shuhua lu: zeng ding ben* 故宮書畫錄:增訂本. 4 vols. Taipei: National Palace Museum, 1965.

_____. *Gugong shuhua tulu* 故宮書畫圖錄. Taipei: National Palace Museum, 1989–.

_____. *Jiehua tezhan tulu* 界畫特展圖錄. Taipei: National Palace Museum, 1986.

_____. *Yuanlin minghua tezhan tulu* 清代園林圖錄. Taipei: National Palace Museum, 1987.

He Ruyu, ed. *Masters of Landscape Painting: Yuan Chiang and Yuan Yao*. Taipei: Art Book, 1984.

Hearn, Maxwell Kessler. "Document and Portrait: The Southern Tour Paintings of Kangxi and Qianlong." In *Chinese Painting under the Qianlong Emperor: The Symposium Papers in Two Volumes*, ed. Ju-hsi Chou and Claudia Brown, 91–131. Phoebus 6, no. 1. Tempe: Arizona State University, 1988.

_____. "The *Kangxi Southern Inspection Tour*: A Narrative Program by Wang Hui." Ph.D. diss., Princeton University, 1990.

Heshen 和珅, Liang Guozhi 梁國治, et al., comps. *Qin ding Rehe zhi* 欽定熱河志. 1781. Reprint. Taipei: Wenhai chubanshe, 1966.

Higuchi, Hiroshi. *Chugoku hanga shusei*. Tokyo: Mito shooku, 1967.

Ho, Peng Yoke. *Li, Qi and Shu: An Introduction to Science and Civilization in China*. Hong Kong: Hong Kong University Press, 1985.

Ho, Ping-ti. "The Salt Merchants of Yangzhou: A Study of Commercial Capitalism in Eighteenth Century China." *Harvard Journal of Asiatic Studies* 17, nos. 1–2 (June 1954): 130–168.

Ho, Puay-peng. "Constructing Paradise: Heavenly Buildings in the Silk Paintings of Dunhuang." Paper delivered at the Department of Fine Arts, University of Hong Kong, June 1996.

_____. "Paradise on Earth: Architectural Depiction in Pure Land Illustrations of High Tang Caves at Dunhuang." *Oriental Art* 41, no. 3 (Autumn 1995): 22–32.

Ho, Wai-kam. "The Literary Concepts of 'Picture-like' (*Ju-hua*) and 'Picture-Idea' (*Hua-i*) in the Relationship between Poetry and Painting." In *Words and Images: Chinese Poetry, Calligraphy, and Painting*, ed. Alfreda Murck and Wen C. Fong, 359–404. New York: Metropolitan Museum of Art; Princeton, N.J.: Princeton University Press, 1991.

Hostetler, Laura. *Qing Colonial Enterprise: Ethnography and Cartography in Early Modern China*. Chicago: The University of Chicago Press, 2001.

Hu, Jing 胡敬. *Guochao yuanhua lu* 國朝院畫錄. 1816. In *Hushi shuhuakao sanzhong* 胡氏書畫考三種. Shanghai: Zhongguo shuhua baocunhui, 1924.

Hucker, Charles O. *A Dictionary of Official Titles in Imperial China*. Stanford, Calif.: Stanford University Press, 1985.

Hummel, Arthur W. *Eminent Chinese of the Ching Period*. 2 vols. 1943–1944. Reprint. Taipei: SMC Publishing, 1991.

Inscribed Landscapes: Travel Writing from Imperial China. Trans. with annotations and an introduction by Richard E. Strassberg. Berkeley: University of California Press, 1994.

The Institute of the History of Natural Sciences and Chinese Academy of Sciences, comps. *History and Development of Ancient Chinese Architecture*. Beijing: Science Press, 1986.

Ji, Cheng 計成. *Yuan ye* 園冶 (*The Crafts of Garden*). Trans. Alison Hardie. New Haven, Conn.: Yale University Press, 1988.

Kao, Mayching. "European Influences in Chinese Art, Sixteenth to Eighteenth Centuries." In *China and Europe: Images and Influences in the Sixteenth to Eighteenth Centuries*, ed. Thomas H. C. Lee, 251–285. Hong Kong: The Chinese University Press, 1991.

Knapp, Ronald G. *China's Vernacular Architecture: House Form and Culture*. Honolulu: University of Hawai'i Press, 1989.

Knechtges, David R., trans. *Wen xuan* (*Selections of Refined Literature*). 3 vols. Princeton, N.J.: Princeton University Press, 1982–1996.

Kuhn, Philip A. *Soulstealer: The Chinese Sorcery Scare of 1768*. Cambridge: Harvard University Press, 1990.

Ledderose, Lothar. "Chinese Influence on European Art." In *China and Europe: Images and Influences in the Sixteenth to Eighteenth Centuries*, ed. Thomas H. C. Lee, 221–250. Hong Kong: The Chinese University Press, 1991.

_____. "Subject Matter in Early Chinese Painting Criticism." *Oriental Art* 19, no. 1 (Spring 1973): 69–83.

Lee, Thomas H. C. "Christianity and Chinese Intellectuals: From the Chinese Point of View." In *China and Europe: Images and Influences in the Sixteenth to Eighteenth Centuries*, ed. Thomas H. C. Lee, 1–28. Hong Kong: The Chinese University Press, 1991.

Legge, James, trans. *The Sacred Books of China: The Texts of Confucianism*. Sacred Books of the East, ed. F. Max Muller, vols. 3, 16, 27–28. Oxford: Clarendon Press, 1879–1885.

Li, Dou 李斗. *Yangzhou huafang lu* 揚州畫舫錄. Preface dated 1795. Reprint. Taipei: Yuehai chubanshe, 1969.

Li, Jie 李誡, ed. *Yingzao fashi* 營造法式. Printed in 1103. In *Qin ding siku quanshu* 欽定四庫全書, vol. 673. Reprint. Shanghai: Shanghai guji chubanshe, 1987.

Li, Yimang 李一氓, ed. *Bishu shanzhuang sanshiliu jing* 避暑山莊三十六景. Beijing: Renmin meishu chubanshe, 1979.

Li, Yu 李漁. *Xianqing ouji* 閑情偶寄. In *Li Yu quanji* 李漁全集. Taipei: Chengwen chubanshe, 1970.

Li, Zhi 李廌. *Huapin* 畫品. In *Zhongguo shuhua quanshu* 中國書畫全書, ed. Lu Fusheng 盧輔聖, Cui Erping 崔爾平, and Jiang Hong 江宏, vol. 1. Shanghai: Shanghai shuhua chubanshe, 1993–.

Li, Zhichao 李智超. "Jiehua de fazhan he jiehua goutu de yanjiu" 界畫的發展和界畫構圖的研究. *Zhongguo hua* 中國畫 1 (1957): 66–68.

Liang, Sicheng (Liang Ssu-cheng) 梁思成. *A Pictorial History of Chinese Architecture: A Study of the Development of Its Structural System and the Evolution of Its Types*. Ed. Wilma Fairbank. Beijing: Chinese Architecture and Building Press, 1991.

Liaoning sheng bowuguan cangbao lu bianji weiyuanhui 遼寧省博物館藏寶錄編輯委員會, ed. *Liaoning sheng bowuguan cangbao lu* 遼寧省博物館藏寶錄. Hong Kong: Sanlian shudian; Shanghai: Shanghai wenyi chubanshe, 1994.

The Library of Philip Robinson: Part II, The Chinese Collection. London: Sotheby's, November 1988.

Lin, Li-chen. "The Concepts of Time and Position in the *Book of Change*, and Their Development." Trans. Kirill Ole Thompson. In *Time and Space in Chinese Culture*, ed. Chun-chieh Huang and Erik Zurcher, 89–113. Leiden: E. J. Brill, 1995.

Lin, Lina. *The Elegance and Elements of Chinese Architecture: Catalogue to the Special Exhibition "The Beauty of Traditional Chinese Architecture in Painting."* Taipei: National Palace Museum, 2000.

Ling, Hubiao 令狐彪. "Jiehua suotan 界畫瑣談." *Zhongguo hua* 中國畫, no. 3 (1982): 60–61.

Liu, Cary Y. "Ching Dynasty Architectural Design Methodology at the Imperial Summer Villa at Jehol." *Soochow University Journal of Chinese Art History* 15 (February 1987): 389–422.

Liu, Daochun 劉道醇. *Shengchao minghua ping* 聖朝名畫評. Named *Songchao minghua ping* 宋朝名畫評 in *Siku quanshu zhenben wuji* 四庫全書珍本五集. Reprint. Taipei: Taiwan shangwu yinshuguan, 1974.

Liu, Ruli 劉汝禮. "*Shixue*: Woguo zuizao de toushixue zhuzuo" 視學:我國最早的透視學著作. *Meishujia* 美術家 9 (1979): 42–44.

Liu, Shih Shun. *One Hundred and One Chinese Poems*. Hong Kong: Hong Kong University Press, 1967.

Liu, Xu 劉昫, et al. *Jiu Tang shu: 200 juan* 舊唐書: 200 卷. Reprint. Beijing: Zhonghua shuju, 1977.

Loehr, George. "Missionary-Artists at the Manchu Court." *Transactions of the Oriental Ceramic Society* 34 (1962–1963): 51–66.

Lowenthal, David. *The Past Is a Foreign Country*. Cambridge and New York: Cambridge University Press, 1985.

Lynch, Kevin. *The Image of the City*. Cambridge, Mass.: M.I.T. Press, 1960.

Maeda, Robert J. "Chieh-hua: Ruled Line Painting in China." *Ars Orientalis* 10 (1975): 123–141.

Mair, Victor H., ed. *The Columbia Anthology of Traditional Chinese Literature*. New York: Columbia University Press, 1994.

March, Benjamin. "Linear Perspective in Chinese Painting." *Eastern Art* 3 (1931): 113–139.

Ming Qing zaju banhua ji 明清雜劇版畫集. Taipei: Guangwen shuju, 1979.

Mote, Frederick W. "The Arts and the 'Theorizing Mode' of the Civilization." In *Artists and Traditions: Uses of the Past in Chinese Culture*, ed. Christian F. Murck, 3–8. Princeton, N.J.: The Art Museum, Princeton University, 1976.

———. "The Intellectual Climate in Eighteenth-Century China." In *Chinese Painting under the Qianlong Emperor: The Symposium Papers in Two Volumes*, ed. Ju-hsi Chou and Claudia Brown, 17–51. Phoebus 6, no. 1. Tempe: Arizona State University, 1988.

Mu, Yiqin. "An Introduction to Painting in Yangzhou in the Qing dynasty." In *Paintings by Yangzhou Artists of the Qing Dynasty from the Palace Museum*, ed. Mayching Kao, 21–32. Beijing: Palace Museum; Hong Kong: The Art Gallery, The Chinese University of Hong Kong, 1984.

Munakata, Kiyohiko. *Sacred Mountains in Chinese Art*. Urbana: University of Illinois Press, 1991.

Murck, Alfreda. "Yuan Jiang: Image Maker." In *Chinese Painting under the Qianlong Emperor: The Symposium Papers in Two Volumes*, ed. Ju-hsi Chou and Claudia Brown, 228–259. Phoebus 6, no. 2. Tempe: Arizona State University, 1991.

Murck, Alfreda, and Wen C. Fong. *A Chinese Garden Court: The Astor Court at the Metropolitan Museum of Art*. New York: Metropolitan Museum of Art, 1985.

Na, Chih-Liang. *The Emperor's Procession: The Scrolls of the Ming Dynasty*. Taipei: National Palace Museum, 1970.

Naquin, Susan, and Evelyn S. Rawski. *Chinese Society in the Eighteenth Century*. 1987. Reprint. Taipei: SMC Publishing, 1989.

Needham, Joseph. *Science and Civilization in China*. Cambridge: Cambridge University Press, 1954–.

Nian, Xiyao 年希堯. *Shixue* 視學. 1735. Beijing Library.

Nie, Chongzheng 聶崇正. "Architectural Decoration in the Forbidden City: *Trompe-l'oeil* Murals in the Lodge of Retiring from Hard Work." *Orientations* (July/August 1995): 51–55.

————. "Chonglou diege, xuhuan piaomiao: Yuan Jiang Yuan Yao shanshui louge jiehua" 重樓疊閣, 虛幻飄渺: 袁江袁耀山水樓閣界畫. In *Masters of Landscape Painting: Yuan Chiang and Yuan Yao*, ed. He Ruyu, 7–37. Taipei: Art Book Co., 1984.

————. *Gongting yishu de guanghui: Qingdai gongting huihua luncong* 宮廷藝術的光輝: 清代宮廷繪畫論叢. Taipei: Dongdai tushu, 1996.

————. "Qingdai gongting huajia xutan" 清代宮廷畫家續談. *Gugong bowuyuan yuankan* 故宮博物院院刊, no. 4 (1987): 72–79.

————. "Qingdai gongting huajia zatan" 清代宮廷畫家雜談. *Gugong bowuyuan yuankan* 故宮博物院院刊, no. 1 (1984): 41–49.

————. "Xianfahua xiaokao" 線法畫小考. *Gugong bowuyuan yuankan* 故宮博物院院刊, no. 3 (1982): 85–88.

————. "Yangzhou huajia Yuan Jiang Yuan Yao he Shanxi yanshang" 揚州畫家袁江袁耀和山西鹽商. *Zhongguo hua* 中國畫 66, no. 1 (1995): 70–71.

————. *Yuan Jiang, Yuan Yao* 袁江, 袁耀. Zhongguo jujiang meishu zhoukan, zhongguo xilie 中國巨匠美術週刊, 中國系列 011. Taipei: Jinxiu chuban, 1994.

————. *Zhongguo huajia congshu: Yuan Jiang yu Yuan Yao* 中國畫家叢書: 袁江與袁耀. Shanghai: Shanghai renmin meishu chubanshe, 1982.

'95 *Spring Auction of Duo Yun Xuan Ancient Calligraphy and Painting*. N.p., June 1995.

Ouyang Xun shufa quanji 歐陽詢書法全集. Beijing: Qunyan, 1993.

Owen, Stephen, ed. and trans. *An Anthology of Chinese Literature: Beginnings to 1911*. New York: W. W. Norton, 1996.

Palastmuseum Peking, Schatze aus der Verbotenen Stadt. Frankfurt am Main: Insel, 1985.

Panofsky, Erwin. *Perspective as Symbolic Form*. Trans. Christopher S. Wood. New York: Zone Books, 1991.

Qin, Zhongwen 秦仲文. "Qingdai chuqi huihua de fazhan" 清代初期繪畫的發展. *Wenwu cankao ziliao* 文物參考資料, no. 8 (1958): 53–58.

Qing shilu 清實錄. Reprint. Beijing: Zhonghua shuju, 1985–1987.

Qing Xu Yang Gusu fanhua tu 清徐揚姑蘇繁華圖 (Prosperous Suzhou). Hong Kong: Shangwu yinshuguan, 1988.

Rawski, Evelyn S. *The Last Emperors: A Social History of Qing Imperial Institutions*. Berkeley: University of California Press, 1998.

Rogers, Howard. "Court Painting under the Qianlong Emperor." In *The Elegant Brush: Chinese Painting under the Qianlong Emperor*, ed. Ju-hsi Chou and Claudia Brown, 303–317. Phoenix, Ariz.: Phoenix Art Museum, 1985.

Rosenzweig, Daphne Lange. "Court Painting and the Kang Hsi Emperor." *Ching-shih Wen-ti* 3, nos. 3–10 (1975–1978): 60–81.

Rowley, George. *Principles of Chinese Painting*. Revised edition. Princeton: Princeton University Press, 1974.

Ruitenbeek, Klaas. *Discarding the Brush: Gao Qipei (1660–1734) and the Art of Chinese Finger Painting*. Amsterdam: Rijkmuseum, 1992.

Shaanxi sheng bowuguan 陝西省博物館 and Shaanxi sheng wenwu guanli weiyuanhui 陝西省文物管理委員會, eds. *Tang Li Zhongrun mu bihua* 唐李重潤墓壁畫. Beijing: Wenwu chubanshe, 1974.

She, Cheng. "The Painting Academy of the Qianlong Period: A Study in Relation to the Taipei National Palace Museum Collection." Trans. Anita Wai-fong Siu. In *The Elegant Brush: Chinese Painting under the Qianlong Emperor*, edited by Ju-hsi Chou and Claudia Brown, 318–342. Phoenix, Ariz.: Phoenix Art Museum, 1985.

Shen, Kuo 沈括. *Mengxi bitan: 26 juan, fu bu bitan ji xu bitan* 夢溪筆談: 26 卷, 附補筆談及續筆談. Taipei: Shangwu yinshuguan, 1956.

Shijing jinzhu 詩經今注, annotated by Gao Heng 高亨. Shanghai: Shanghai guji chubanshe, 1980.

Sima, Qian 司馬遷. *Shi ji* 史記. Ershiwu shi 二十五史. Vols. 1–2. Taipei: Yiwen yinshuguan, 1956–1958.

Skinner, William G., ed. *The City in Late Imperial China*. Stanford, Calif.: Stanford University Press, 1977.

Smith, Richard T. *China's Cultural Heritage: The Qing Dynasty, 1644–1912*. 2nd ed. Boulder, Colo.: Westview Press, 1994.

———. *Fortune-Tellers and Philosophers: Divination in Traditional Chinese Society*. 1991. Reprint. Taipei: SMC Publishing, 1993.

Soper, Alexander C. "The Relationship of Early Chinese Painting to Its Own Past." In *Artists and Traditions: Uses of the Past in Chinese Culture*, ed. Christian F. Murck, 21–47. Princeton, N.J.: The Art Museum, Princeton University, 1976.

———. "T'ang Ch'ao Ming Hua Lu." *Artibus Asiae* 21 (1958): 204–230.

Soper, Alexander C., trans. *Kuo Jo-hsu's Experiences in Painting (T'u-Hua Chien-Wen Chih): An Eleventh Century History of Chinese Painting*. Washington, D.C.: American Council of Learned Societies, 1951.

Spence, Jonathan D. *Emperor of China: Self-Portrait of Kang Hsi*. New York: Vintage Books, 1988.

Stierlin, Henri, and Michele Pirazzoli-t'Serstevens, eds. *Architecture of the World: China*. Lausanne: Benedikt Taschen, n.d.

Sze, Mai Mai. *The Mustard Seed Garden Manual of Painting*. Princeton, N.J.: Princeton University Press, 1956.

Tang, Hou 湯垕. *Hualun* 畫論. In *Huajian* 畫鑒, annotated by Ma Cai 馬采. Beijing: Renmin meishu chubanshe, 1959.

Tang, Zhiqi 唐志契. *Huishi weiyan* 繪事微言. In *Siku quanshu zhenben chuji* 四庫全書珍本初集. Reprint. Taipei: Shangwu yinshuguan, 1979.

Tangdai 唐岱. *Huishi fawei* 繪事發微. In *Meishu congshu* 美術叢書, comp. Huang Binhong 黃賓虹 and Deng Shi 鄧實. Rev. ed. Shanghai: Shenzhou guoguang she, 1947.

Tao, Zongyi 陶宗儀. *Nancun chuogeng lu* 南村輟耕錄. 1366. Reprint. Beijing: Zhonghua shuju, 1959.

Trousdale, William. "Architectural Landscapes Attributed to Chao Po-chu." *Ars Orientalis* 4 (1961): 285–313.

Vinograd, Richard. *Boundaries of the Self: Chinese Portraits, 1600–1900*. Cambridge: Cambridge University Press, 1992.

Wang, Fengyuan 王逢源, comp. *Jiangdu xian xuzhi* 江都縣續志. 1881. Reprint. Taipei: Chengwen chubanshe, 1983.

Wang, Gai 王概. *Yuanban yingyin Jieziyuan huazhuan* 原版影印芥子園畫傳. Shanghai: Tianbao, n.d.

Wang, Jia 王嘉. *Shiyi ji yizhu* 拾遺記譯注. Annotated by Meng Qingxiang 孟慶祥 and Shang Weimei 商微妹. Ha'erbin: Heilongjiang renmin chubanshe, 1988.

Wang, Jun 汪鋆. *Yangzhou huayuan lu* 揚州畫院錄. Preface dated 1883. In *Yangzhou congke* 揚州叢刻, comp. Chen Henghe 陳恒和. Yangzhou: Guangling guji, 1980.

Wang, Teh-yu. "The 'River and Mountains in Autumn Colors' by Zhao Boju, and Associated Attributions." Ph.D. diss., New York University, 1991.

Wang, Yaoting 王耀庭. "Mantan jiehua" 漫談界畫. *The National Palace Museum Monthly Journal of Chinese Art* 2, no. 5 (August 1984): 81–84.

Wang, Yuanqi 王原祁. *Yuchang manbi* 雨窗漫筆. In *Meishu congshu* 美術叢書, comp. Huang Binhong 黃賓虹 and Deng Shi 鄧實. Rev. ed. Shanghai: Shenzhou guoguang she, 1947.

Watson, Burton. *Early Chinese Literature*. New York: Columbia University Press, 1962.

Wei, Shou 魏收. *Wei shu* 魏書. Ershiwu shi 二十五史. Vols. 14–15. Taipei: Yiwen yinshuguan, 1956–1958.

Weidner, Marsha Smith. "Aspects of Painting and Patronage at the Mongol Court, 1260–1368." In *Artists and Patrons: Some Social and Economic Aspects of Chinese Painting*, ed. Chu-tsing Li, James Cahill, and Wai-kam Ho, 37–60. Lawrence, Kan.: Kress Foundation Department of Art History, University of Kansas; Kansas City: The Nelson-Atkins Museum of Art, 1989.

———. "Painting and Patronage at the Mongol Court of China." Ph.D. diss., University of California, Berkeley, 1982.

Whitfield, Roderick. "Material Culture in the Northern Song Dynasty—The World of Zhang Zeduan." In *Bright as Silver, White as Snow: Chinese Ceramics from Late Tang to Yuan Dynasty*, ed. Kai-Yin Lo, 49–70. Hong Kong: Yong Ming Tang, 1998.

Williams, Raymond. *Keywords: A Vocabulary of Culture and Society*. 2nd ed. London: Fontana, 1988.

Wong, Young-tsu. *A Paradise Lost: The Imperial Garden Yuanming Yuan*. Honolulu: University of Hawai'i Press, 2001.

Wright, Susan. "The Politicization of 'Culture.'" *Anthropology Today* 14, no. 1 (February 1998): 7–15.

Wu, Hung. *The Double Screen: Medium and Representation in Chinese Painting*. London: Reaktion Books, 1996.

————. *Monumentality in Early Chinese Art and Architecture*. Stanford, Calif.: Stanford University Press, 1995.

Wu, Zhefu, ed. *Five Thousand Years of Chinese Art Series. Sung Painting: Part I (Five Dynasties to Northern Sung)*. Taipei: Zhonghua wuqiannian wenwu jikan bianji weiyuanhui, 1985–1986.

Xiao, Tong 蕭統, ed. *Wen xuan* 文選. Reprint. Shanghai: Shanghai shangwu yinshuguan, 1929.

Xie, Kun 謝坤. *Shuhua sojian lu* 書畫所見錄. In *Meishu congshu* 美術叢書, comp. Huang Binhong 黃賓虹 and Deng Shi 鄧實. Rev. ed. Shanghai: Shenzhou guoguang she, 1947.

Xie, Tingxun 謝庭薰, comp. *Louxian zhi* 婁縣志. 1788. Reprint. Taipei: Chengwen chubanshe, 1974.

Xiyong xuan congshu 喜詠軒叢書. Taipei: Guangwen, 1983.

Xu, Chengtian 徐成黻, et al., comps. *Guangxu zengxiu Ganquan xianzhi* 光緒增修甘泉縣志. 1885. Reprint. Nanjing: Jiangsu guji, 1991.

Xu, Fuguan 徐復觀. *Zhongguo wenxue lunji* 中國文學論集. Taipei: Taiwan xuesheng shuju, 1976.

Xu, Qin 徐沁. *Minghua lu* 明畫錄. In *Yishu congbian* 藝術叢編, ed. Yang Jialuo 楊家駱. Taipei: Shijie shuju, 1962.

Xu, Yangzhong, trans. *Songs of the Immortals: An Anthology of Classical Chinese Poetry*. Beijing: New World Press, 1994.

Xuanhe huapu 宣和畫譜. In *Huashi congshu* 畫史叢書, ed. Yu Anlan 于安瀾. Taipei: Wenshizhe chubanshe, 1974.

Yang, Boda 楊伯達. *Qingdai yuanhua* 清代院畫. Beijing: Zijincheng chubanshe, 1993.

Yang, C. K. *Religion in Chinese Society: A Study of Contemporary Social Functions of Religion and Some of Their Historical Factors*. Berkeley: University of California Press, 1961.

Yang, Jialuo 楊家駱, ed. *Sanfu huangtu* 三輔黃圖. Taipei: Shijie shuju, 1963.

Yang, Renkai 楊仁愷. "Yemaotai Liaomu chutu guhua de shidai ji qita" 葉茂台遼墓出土古畫的時代及其他. *Wenwu* 文物, no. 12 (1975): 37–39.

Yang, Xin 楊新, Shan Guoqiang 單國強, and Yang Chenbin 楊巨彬, eds. *Gugong bowuyuan cang Ming Qing huihua* 故宮博物院藏明清繪畫. Beijing: Zijincheng chubanshe, 1994.

Yang, Yongyuan 楊永源. *Shengqing taige jiehua shanshui zhi yanjiu* 盛清台閣界畫山水之研究. Taipei: Taibei shili meishuguan, 1987.

Yeung, Chun-tong, ed. *Chinese Folk Art: Prints, Painting, Embroidery*. Hong Kong: University Museum and Art Gallery and Department of Fine Arts, The University of Hong Kong, 1995.

Yu, Jianhua 俞劍華, comp. *Zhongguo meishujia renming cidian* 中國美術家人名辭典. Shanghai: Shanghai renmin meishu chubanshe, 1980.

Yuan Jiang Yuan Yao huaji 袁江袁耀畫集. Tianjin: Tianjin renmin meishu chubanshe, 1996.

Yuan, Jue 袁桷. *Qingrong Jushi ji* 清容居士集. In *Sibu congkan* 四部叢刊. N.p., n.d.

Yuanming cangsang 圓明滄桑. Beijing: Wenhua yishu, 1991.

Yuzhi Yuanming yuan tushi 御製圓明園圖詩. 1887. Reprint. Taipei: Wenhai chubanshe, ca. 1971.

Zaobanchu gezuocheng huoji Qingdang 造辦處各作成活計清檔. China First Historical Archives, Beijing.

Zevi, Bruno. *Architecture as Space: How to Look at Architecture*. New York: Horizon Press, 1974.

Zhang, Geng 張庚. *Guochao huazheng xulu* 國朝畫徵續錄. In *Huashi congshu* 畫史叢書, ed. Yu Anlan 于安瀾. Taipei: Wenshizhe chubanshe, 1974.

Zhang, Yanyuan 張彥遠. *Lidai minghua ji* 歷代名畫記. In *Huashi congshu* 畫史叢書, ed. Yu Anlan 于安瀾. Taipei: Wenshizhe chubanshe, 1974.

Zhang, Zhao 張照, et al. *Shiqu baoji* 石渠寶笈. 1745. Reprint. Taipei: National Palace Museum, 1971.

Zhongguo meishu quanji bianji weiyuanhui 中國美術全集編輯委員會, ed. *Dunhuang bihua (xia)* 敦煌壁畫 (下). Zhongguo meishu quanji huihuabian 中國美術全集繪畫編 15. Shanghai: Shanghai renmin meishu chubanshe, 1988.

———. *Mingdai huihua (shang)* 明代繪畫 (上). Zhongguo meishu quanji huihuabian 中國美術全集繪畫編 6. Shanghai: Shanghai renmin meishu chubanshe, 1988.

———. *Qingdai huihua (zhong)* 清代繪畫 (中). Zhongguo meishu quanji huihuabian 中國美術全集繪畫編 10. Shanghai: Shanghai renmin meishu chubanshe, 1992.

Zhou, Junfu 周駿富, comp. *Qingdai zhuanji congkan* 清代傳記叢刊. 205 vols. Taipei: Mingwen shuju, 1985.

Zhu, Jingxuan 朱景玄. *Tangchao minghua lu* 唐朝名畫錄. In *Zhongguo shuhua quanshu* 中國書畫全書, ed. Lu Fusheng 盧輔聖, Cui Erping 崔爾平, and Jiang Hong 江宏, vol. 1. Shanghai: Shanghai shuhua chubanshe, 1993–.

Zou, Yigui 鄒一桂. *Xiaoshan huapu* 小山畫譜. In *Hualun congkan* 畫論叢刊, comp. Yu Anlan 于安瀾. Taipei: Wenshizhe chubanshe, 1984.

Index

About the Author

Anita Chung received her doctorate in art history from the University of Hong Kong. From 1997 to 2000, she was curator of Chinese art at the National Museums of Scotland and lecturer at the University of Edinburgh. She held the post of curator of Chinese art at the NUS Museums, National University of Singapore, from 2000 to 2001. She is presently a Mellon Research Fellow in Chinese art at the Cleveland Museum of Art. She is author of a number of journal articles and contributions to exhibition catalogs. *Drawing Boundaries* is her first book.

 Production Notes for Chung / DRAWING BOUNDARIES

Cover and interior designed by April Leidig-Higgins in Electra and Scala Sans.

Composition by Copperline Book Services, Inc.

Printing and binding by Thomson-Shore, Inc.

Printed on 70# Fortune Matte, 500 ppi.